Edward Weston

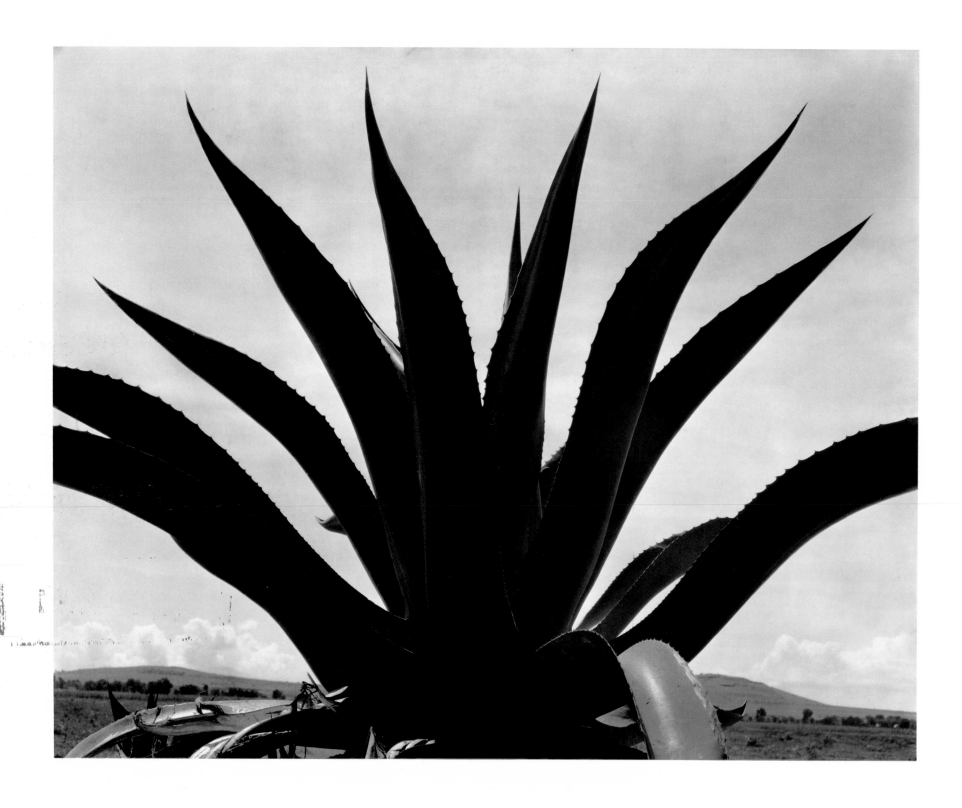

Maguey Cactus, Mexico 1926

Edward Weston: Fifty Years

The definitive volume of his
photographic work
Illustrated biography by Ben Maddow

An Aperture Book

Published in the United States by
Aperture, Inc., Elm Street, Millerton, New York 12546
and simultaneously in Europe by
McGraw-Hill Book Company GmbH, Dusseldorf, Germany

Publisher's Note: The book is set in Linofilm Bodoni. The paper,
Quintessence Gloss Basis 100, and Mountie Velvet Basis 80,
was manufactured by Northwest Paper Company
and distributed by Allan & Gray Corporation.
The book was printed by Rapoport Printing
Corporation and Halliday Lithograph Corporation.
The photographs were sequenced and the book was prepared
under the direction of Michael E. Hoffman.
Publication is supported by a grant from the
National Endowment for the Arts in Washington, D.C.,
a Federal agency, and by grants from the
Florence V. Burden Foundation and the Estate of Vera L. Fraser.
The design is by Peter Bradford and Wendy Byrne.

Aperture, Inc., publishes a Quarterly of Photography,
portfolios, and books to communicate with
serious photographers and creative people everywhere.
A catalog of publications is available upon request.

Publications Committee: Minor White, Editor;
Michael E. Hoffman, Managing Editor-Publisher;
Stevan A. Baron, Production; Hilary Maddux, Copy Editor;
Arthur M. Bullowa, Shirley C. Burden, and Robert Hauslohner.

Library of Congress Catalog Card Number 73-85263
ISBN Numbers: Cloth 0-912334-38-X, Limited Edition 0-912334-39-8
Manufactured in the United States of America First Edition

For those persons interested in reading other books on
Edward Weston, Aperture has published *Daybooks of
Edward Weston: Volume I, Mexico and Volume II, California.*
In 1958 Aperture published, as an issue of the Quarterly,
Edward Weston: The Flame of Recognition, edited by
Nancy Newhall. An enlarged, revised edition was published in 1964;
and it has been re-printed many times over the years.

Acknowledgements: The makers of this book are deeply indebted
to many people for their generous words, letters, insights,
and memories of Edward Weston including Ansel Adams,
Merle Armitage, Ron Bostwick, The Bancroft Library at the
University of California at Berkeley, Jean Charlot,
Mildred Constantine, Dr. and Mrs. Rudolf Kocher, Lottie and
Alan Marcus, Nancy Newhall (whose forthcoming
Aperture book—*The Enduring Moment, Volume II* of the biography
of Ansel Adams—is particularly quoted), Beaumont Newhall,
Sonya Noskowiak, Dody W. Thompson, Willard Van Dyke,
Brett Weston, Cole Weston, Kraig and Neil Weston, Charis Wilson,
Jacob Zeitlin.

CONTENTS

He was pure, one is told, and therefore poor; or even vice versa. But there is considerable testimony—his own—that he wanted to be neither.

In the hilly front yard of the small house and darkroom where he lived until his death in 1958, there is a small wire cage of suet for the visiting birds; on a nearby branch, just out of reach, there is a cat without a tail, chattering with frenzy—a descendant, spiritual if nothing else, of the thirty or forty cats that Edward Weston once kept.

Across the foreground is a rank growth of periwinkle—blue, five-petalled stars, and among them, set on a raised platform, is a locked, funereal shed called, in fact, the Vault. Painted a dull red, it contains, not his ashes, for these were scattered on the beach by his four grown sons, but the sturdier immortal remains of Edward Weston's mind. The inside walls are thick and insulated, like a refrigerator. The aisle is narrow, awkward, encumbered with camera boxes. On one side there are the files with thousands of his negatives, each in its tissue envelope, meticulously numbered and dated and pencilled with instructions on how best to print. No one, not even his sons, has ever seen all of them. He had made, by his own account, upwards of five thousand portraits; and of course there were hundreds, perhaps thousands, which he himself destroyed.

On the right, the Vault is stacked with books of sample prints, bound portfolios of his work, family records, boxes of letters. Among them is a tiny portrait, no more than an inch square, of that extraordinary woman, Tina Modotti, along with a couple of dried flowers sent to a love or to a son—flat, brown, like an x-ray of the flower itself, compressed by the weight of time gone by.

Then, stacked on the corner of one shelf, there are his journals. He began to write them when he was past thirty, but burnt the earliest ones; not the first time an artist has performed the ritual cremation of an earlier self.

Yet he elected to keep, and even to print, an amazing number of journals in his own lifetime. The original sheets are as brown and fragile as the flowers, scribbled, for the most part, in his own large, childish hand. Many, indeed, are letters to and from his friends, his wife Flora, to Ramiel McGehee, to his mistresses, and back and forth to one or another of his sons. Mostly, like Beethoven's letters, they are punctuated with dashes—the pauses, the hurried breathing between phrases. One can hear the voice of the silent man: energetic, sharp, sometimes bitter, generally intelligent, sometimes amazingly narrow and prejudiced, but self critical to the point of exhibitionism—not wholly the image he allowed to his friends or his pupils.

With certain exceptions, the two printed Daybooks are remarkably complete. Almost a hundred pages of Volume I were given to, or possibly dictated to, a young woman named Christel (Weston always called her Cristal) Gang, who ran a stenographic service in Los Angeles where he lived at the time, and who, almost at once, became one in his long procession of loves. She was a very sweet, devoted, and proper secretary; and she corrected the sentences, altered their syntax, and set periods and commas where she thought they belonged. Whether she changed or censored his writing is difficult to say, because the original pages, written down in the heat of immediate memory, were later burnt by Weston.

More crucial, perhaps, was the editorial work of one of Weston's lifelong friends, Ramiel McGehee, who took the original versions and rewrote whole passages, a process that Weston rather resented. On July 25, 1927, he wrote (in Volume II of the Daybooks, commenting on the preparation of Volume I):

> What bothered me yesterday was that never-finished manuscript,—I could not face Cristal's question! When I tell her I would destroy it, I bare myself to a hearty scolding. She is such a fine girl!
>
> So I worked two hours on the ms., protesting the while. One thing that has turned me against it has been Ramiel's corrections. I have to agree they are well considered, and yet I no longer feel myself in the writing: some of the spontaneity is lost, and not having a writer's technique, there is not much left of me after corrections!
>
> I rebel too, reading my opinions of a few years ago, but these I can at least pass with a shrug and a smile, as I will this writing two years hence—

Later, when he became more confident of his own particular style, he let his sentences and phrases stand with no corrections except his own. At first he took a thick pencil and blacked out certain phrases and names, leaving only the initials. These generally referred to women he had "known," yet, in his Record Book, under *Nudes*—for he was extremely neat and orderly in professional matters—he kept the full name and the date. In the later, untyped journals, which form Volume II of the Daybooks, he neatly cut out offending passages with a sharp, single-edged razor, again leaving only the initials to point and tantalize. Nevertheless, an astonishing amount of self revelation remains; a fact of which

he was rather proud, though in a characteristically negative way:

> I am doubting more and more the sincerity of these daily or semi-
> weekly notes as they concern me personally—my real viewpoint and
> feelings uncolored by petty reactions, momentary moods. With the
> passing of time, perhaps the greater part of what I write would not be
> thought worth writing, either forgotten entirely or realized as untrue.
>
> I am sure, nevertheless, that my diary is a safety valve for releas-
> ing corked-up passions which might otherwise explode—though I
> sometimes think storm clouds would sooner break with a thunder of
> words,—but a perspective of months must bring a saner, less hysteri-
> cal, more genuine outlook.

And again:

> A recent evening I thought to read Ramiel passages from my Day-
> book,—those concerning my work. I was appalled and disgusted how
> often I had indulged in self-pity. Most of the writing seemed to be a
> wail over my financial condition, and the rest about my love affairs.

And once again:

> . . . petty personal reactions . . . can be recorded in daybooks,—a
> good place to evacuate, cleanse the heart and head, preparatory to
> an honest, direct, and reverent approach when granted the flash of
> revealment.

Weston was being unfair to himself; neither for the first time, nor the last. The Daybooks range, in fact, from the grand to the nasty. In discussing passages from a letter from Ramiel McGehee, he comments:

> And now some news harking back to the days of just a year ago
> when the leering hypocrite R. S. betrayed me, lied about me. ". . . our
> black magic, our bitches curse was effective. R. and J. have separated.
> She had a place—a tent house in some canyon. Her creditors descended
> upon her and cleaned her out—everything she had. Some rich people
> in Pasadena took her in. Someone else took the child. Ruth has tuber-
> culosis of various organs and Jack is selling tombstones—grieving him-
> self to death." . . . How weird this is! I am neither glad nor sorry, sim-
> ply indifferent, her venom has destroyed her. . . .

One wonders, of course, what the betrayal, or the lie, or both, was about. The Daybooks, for all their detail, still give one the feeling of a two-dimensional man; truthful, as far as they go, but to some degree a self construction. Fortunately, they are not the only records that bear on his personality. The letters he wrote and received, some of astonishing frankness, together with the memo-ries of those who knew him intimately, give us a necessary third dimension. All of us are singular and ultimately unknowable; but I believe we can see Edward Weston, by his own intention, more clearly than most. He is a very American genius, at once selfish

and sublime. Though not a simple man, simplicity was certainly one aspect of his character. His son Cole once said, "Dad was very humble and quiet. Never would force himself, ever. He wasn't loud, like I am. I've got a lot of my mother in me. . . . He was very quiet and subdued. And he made his impact this way."

—Was he ever angry?

"Never, to my knowledge. Really. He never spanked me, ever. My mother always tells how he raised a cane at her in fury and never touched her."

Physically, too, Weston was not an imposing man; he was small, but powerfully built, nor was he, in fact, particularly hand-some. Jacob Zeitlin, a friend from Edward Weston's early days in California, and his dealer and first exhibitor, describes him as "gentle, but extroverted." Nancy Newhall, in a remarkable essay on controversies in photography (1953), describes Edward Weston as "a quiet little man . . . with a big camera." Dody Thompson, who was his student and darkroom assistant in his last years, wrote in her affectionate memoir of the man: "I remember him as one of the nicest human beings I ever knew. . . . Yet he did not have a particularly scintillating personality. He was rather a quiet man, in fact, with a soft voice. . . ." This was not precisely the testimony of Charis Wilson, who lived with him for almost ten years. She felt in him an intense radiation of energy and personal force, which she believes was the source of his famous attraction for women. But that was between 1934 and 1945; while Dody Thompson knew him in his final years, when he was already, slowly, increasingly, and fatally ill.

Small of stature, about five-feet-five-inches tall, and reportedly a frail child, Weston trained himself to be a track athlete; and like any good American, sports were his constant obsession. He went to see the Olympic tryouts in the summer of 1928, when he was forty-two years old:

> I have not been to a track meet since the days when I wore spikes.
> My distance was the century and I was better than average: built for
> distance with the necessary nervous energy, I might have, under a
> wise coach, developed into championship timber. I held for some
> time the Junior record for two laps (I believe about 185 yards) at
> Central YMCA, Chicago. I dreamed and lived on the cinder track!
> But photography entered in and my track days were over.

It was his custom, first thing in the morning, to wrestle and box with his four young sons, and then plunge into a cold bath. Water and nakedness had the beauty of a ritual for Weston. In Mexico:

Oh! But those morning baths at Tacubaya—standing naked on the
sunlit patio, with the musk rose, the twittering birds, pouring buckets
of ice cold well water over me, then basking in the early morning sun.

Nudity, in fact, had a spiritual meaning for Weston—a doctrine which, of course, he didn't invent. It was a maverick and widespread, and curiously enough, a very American dogma: that nakedness was good for the soul as well as the body.

In much the same period, a very old man of my acquaintance carried out a similar ritual, rising late at night and running about naked in the snow; it was a therapeutic and cleansing exercise, like going to an uncorrupted church. And this was Edward Weston's attitude, too. Again, in Mexico:

. . . it rained in Los Angeles, the real estate mongers would call the
weather "unusual" for the rains are supposed to have been over for a
month or more. Llewellyn [one of his students] had a bright idea and
we all "fell for it." The four of us—Tina, Llewellyn, Chandler, and
myself—stripped naked and played tag on the roof in the rain!

Afterwards, a brisk rubdown and we were in a fine glow and ready
to read *Moby Dick*.

And again, back in the United States:

I hope to plan my life so that one hour every day can be spent na-
ked in the sunlight.

We are slowly advancing to an acceptance of nudity. Those with ugly
bodies and dirty minds will make the last protest. Women are be-
coming quite "daring,"—their suits barely cover breasts and the
mount of Venus.

One sees, here, the sexual content of this innocent notion; an interpretation that would have infuriated Weston. Though a great number of his negatives (aside from the portraits) are nudes, they were devoid, for him, of any taint of sex; how far this was true, we shall examine later. He argued, for example, with Minor White, that neither the nudes nor his monumental series of shells, squash, and peppers, had any but the purest abstract intent.

A certain puritan rigor did seem to characterize his self imposed pattern of life. He rose (and felt guilty if he didn't) very early, at five or even four in the morning, and sat down with a huge pot of coffee to write letters or entries into the immensity of his journals, and, as he records, to empty himself internally as well. For breakfast he would (Cole reports) almost invariably have Wheat Chex and milk. At lunch, especially if there were guests, there would be a vast bowl of mixed salad (and this was amazingly characteristic of California intellectuals in the twenties, and particularly of dancers, of whom he was more than fond, and who

are still notorious food faddists), and often the same at dinner:

Supper: aguacates, almonds, persimmons, dates, and crisp fresh
greens. A steak is sordid beside such food for the Gods.

He was a vegetarian—another common California religion, hardly unknown in our own time—but only by fits and starts, and when he did eat meat, he would feel physically ill:

I, who am satisfied with a big salad or a bowl of spinach, or a few
bananas or grapes, cannot put down a baked ham dinner,—with all
the trimmings, and not know it.

It would almost seem he felt guilty of necrophilia when he speaks of "eating a dead pig," and refers to his vegetarian periods as "days of intestinal purity." He connected food very closely with health and illness. Once, when his son Brett broke his leg, Edward Weston visited him daily at the hospital and viewed the food they served his son with true horror. Brett wrote to Ramiel McGehee:

I avoided the hospital meals, eating only what was brought by Dad,
or rather smuggled in, such as dried fruits, nuts, raw vegetables, etc.
Dad would usually show up around mealtimes and slyly devour the
tray dinner, while I ate things that were not only better for me but
tasted better, purer.

As Edward Weston himself noted, he did this because he didn't want the hospital authorities "to hold antagonistic thoughts."

Food, in fact, was one of his minor obsessions. But not all foods:

War, Wonder Drugs, Vitamins, and the quest for comfort, are send-
ing us to hospitals and asylums; soon most of us will be permanent
residents. We are the victims of Packaged, Processed, Pasteurized
foods. We need not fear the "Nazies," nor the "Commies," as much
as our own brains and bellies. We are disintegrating from within.

The journals contain scores of accounts of exactly what he had for lunch, particularly when visiting:

The reunion is over. Anita served chango, cinnamon toast, and tea. It
was delicious.

And again:

Lunch was delicious. Chicarrones, cheese, mescal . . .

His comments on food often sound like a chatty letter from one's aunt. For example, when he went to a banquet at the American Embassy in Mexico City, he sent the menu to his wife Flora in Glendale, California, certain that she would be interested. He added, for her benefit:

I am entering society—this a banquet to the American Ambassador
to Mexico. I trimmed the fringe from my trousers—borrowed a hat
from Rafael—bought a clean collar and "got by" somehow.

From the frequent mention of food in his diaries one gets the im-

pression that eating had a very strong emotional and aesthetic effect on Weston:

> And the dinner!—What a feast—with little pigeons so tender one ate bones and all—fresh mushrooms too—and then for emphasis I repeat—the wine!—the Wine!

He drank, but not regularly nor compulsively; yet liquor was certainly not on his forbidden list. He smoked heavily, and tried over and over again to stop:

> . . . I do not feel the heat these days of my simplified diet.
>
> Not that it has ever been complicated, but lately I have eliminated all excess, and am eating only two meals a day of fruits, vegetables, nuts. Meat I rarely touch,—only when dining out. Cigarettes, which I long ago thought to stop I still use, though some reduced in number.
>
> Is it lack of will? I find myself automatically reaching for the ever ready package, especially when nervous or excited. But one or two puffs and I am through, half disgustedly! The day will come when the last one will be finished!
>
> And why all this intestinal purity? To clear my mind for my work!
>
> I know, absolutely it has helped me to a more sensitive reaction and unobstructed thinking.

When he was fifty years old, he quit smoking. But he continued to drink coffee, that ultimate poison of all vegetarian purists, in huge quantities; this too he fought:

> Should I take just one cup? Or a substitute? But I have always laughed at substitutes! At least I have proved to myself I can stop,—and it's good discipline. I can understand those who have nothing else in life pampering themselves, indulging their physical desires with stimulants and gross eating. But why should I?

These Spartan disciplines—nudity, vegetarianism, trust in the curative value of fasting with or without juices, combined with a distrust of doctors and formal medicine—were not unique with Edward Weston. It was, to go no deeper, invented by Hindu ascetics for somewhat more cosmic purposes; the doctrine was transmitted by Christian mystics of every century; seized, digested, and regurgitated by Tolstoy in his cranky old age; and came to this country in various forms. During the twenty years Edward Weston lived and worked in Glendale, a suburb of Los Angeles, he absorbed these practices from every part of California middle-class society, from intellectuals to (to use a term out of the same period) the "Babbitts."

Edward Weston was a patient of Dr. Lovell, a naturopath who wrote a column for *The Los Angeles Times* for many years, whom he consulted when he was exceptionally ill. Fasting and fruit juices were his common regimen for any illness; and the chief medical tool was the enema. His father was a conventional doctor, and possibly Weston associated sickness and death with orthodoxy. When his own son was ill in Mexico:

> I cannot work with this worry. [Brett] must have an intestinal infection. My heart aches to see him so gaunt and sad. I fear my own judgment, the assumption of authority—but I fear the pill and knife-doctors more.

And he could be much more bitter, particularly when death struck close to one of his friends:

> Rafael must die! I was with Monna when the doctor told her—her face I can never forget. How ironical,—cruel, after these months of heroic sacrifice on her part, and terrible suffering on his. They operated, but could not remove the malignant growth which completely enveloped his kidneys.
>
> Too late now for natural methods,—though I shall consult McCoy today. I have only contempt for these "scientists" who have doped him with serums and drugs and x-ray for months.
> What brilliant minds!

Edward Weston's diaries refer time and time again to natural and self administered cures; all of them involve either fasting or self denial to one degree or another. He would put himself on a diet of orange juice for days at a time, and would claim to feel better mentally as well as physically:

> Have been quite sick—fever and incipient sore throat. Lay all day on my bed in a half stupor, unable to work; fasted and sweat myself and am practically well again. I am ever thankful that doctors play no part in my life—that is, doctors with pills and knives—nor Christian Scientists, nor their like.

He was certain, too, that there were psychological medicines, even for cancer:

> A real shock has come to me in the news from Sybil, that Vasia, long ailing, has been diagnosed as having a cancerous growth in his throat. How ironical for a singer! He cannot be operated on. This latter fact might be his salvation, if he could be convinced of the only possible way to cure or at least stop the progress of the growth,—through natural methods, fasting, inner housecleaning, and a positive mental attitude. I have done all I can to bring some light to Sybil, but I doubt if she will listen, until all else fails, and it may be too late. People must have the witchcraft of drugs, injections, the ballyhoo of new "cures,"—to give nature a chance, even half a chance, is too simple a procedure!

He endowed his own illnesses with magic significance. When his old friend Ramiel McGehee visited Weston when Brett was recovering from a broken leg, he wrote:

Ramiel has been here three weeks! He always brings peace and order, has these past weeks, enabling me to nurse an enormous boil, or carbuncle—I think a doctor would have called it—which appeared on my side, and grew and grew. It came just below the belt on my hip—either I had to go naked or to bed. I'll carry a scar. Whether I became infected from Brett, whose leg "boiled" over after the cast was removed or whether I was depleted and needed purification,—who knows. To me there seemed almost a mystic symbolism indicated—of my close relation to Brett.

His fear and hatred of vaccinations was strange, even bizarre. Upon returning from Mexico after his first trip, he discovered he would have to show proof of a smallpox vaccination. He was extremely anxious to fake the vaccination so that he would not have to have "the pus of sick cows" injected into his arm. The letter he wrote at the time has a certain strained and anxious tone:

My dear Flora—
Would it be possible for you to ascertain from McCoy—if there is a way to "mess up" the arm to simulate fresh vaccination—and if there is how long before reaching the destination should it be done—what kind of a bandage to put on etc.—

—Or if we have to submit to the ordeal at the border—will washing or some application or a poultice—counteract to any extent—or does he know the legal aspect—can one refuse to submit or demand quarantine?—I am only afraid quarantine would take too long and cost too much—perhaps you could obtain for me a fake certificate of course dated after July, 1923 when we left L.A.—be very careful about leaving this letter around or mentioning this to *anyone*—I am being precautionary—. . .

. . . answer this as *soon* as possible—or it will be too late.

Edward Weston, like many of his contemporaries, then as now, was partially (but only partially) convinced that the position of the stars determined one's character from the moment of birth. From Cristal (Christel L. Gang) he got an astrological reading on his own birth date, which was March 24, 1886. She wrote that his sign was Aries, and that he was "born on the cusp." The entire astrological reading runs to six pages in her own script, and is a bit too long to quote in full. Certain passages, however, are interesting because they may have had some influence on the way Edward Weston regarded himself:

Reach highest attainment thru knowledge and regenerative love-action of heart. Love, Beauty, order, harmony, and elegant surroundings. They should not be circumscribed when giving out their true work of genius. . . . Genius of this sign is Intuition! Silent, electromagnetic power by means of hands. These people are large and true but apt to be children of caprice which has sad effect on their destiny. . . .

Whether convinced by this reading or not, he did record, in his journal, the exact date and hour of birth of each of his four sons, and he made a somewhat doubtful reading of his own:

I have my horoscope at last. Mrs. Severy, after making many charts, decided on Gemini as my rising sign; and I have a bad year ahead! Which does not worry me for time passes. Too, the human element enters in. She may be wrong, not having my hour. Eight charts were made before Gemini was decided upon. I am not a skeptic, I am always inclined toward unorthodox viewpoints, I see no reason to doubt that the stars have a definite effect upon the human race, but I wonder whether anyone can interpret them. An orthodox belief is merely a prevailing one, popular at the moment; astrology was no doubt once quite orthodox, just as vaccination is now. And someday vaccination will be generally regarded as a superstition comparable to witchcraft.

He noted, too, that Bach and he were born under the same sign.
A visitor to his studio was a certain Mr. Kendall:

I liked him immediately. He is making an exhaustive study of genes. . . . He said, "I have not yet found an authentic genius, neither in history nor in contemporary life who was not a student of the occult."

On the other hand, Weston had what he called an "intuitive non-acceptance" for the theory of evolution. Another visitor, Dr. Becking, once showed him a book of "primitive drawings, reproduced from a cave in Spain,"—probably the cave of Altamira, near Santander—"50,000 years old." Actually, these drawings are probably no more than 10,000 years old, but, in any case, Weston remarked, "at once, I knew that here was a case against evolution, and that now I was on ground that was common to me, I could speak with authority."

The truth was that Edward Weston had little schooling and even less interest in formal education. His remarkable and acute intelligence was simply directed another way.

Once again, it must be emphasized that this concern with the occult, with ESP, with the stars, creationism, and unnatural poisons was, and to a large extent still is, strictly a middle-class, and indeed, a very American phenomenon. It reflects a human and universal anxiety. Belief in anti-scientific intuitions and the unconventional, seems to be a way of being at once separate from one's culture, and, at the same time, part of a group which supports and corroborates one's aberrations from the conventional.

Once, in the course of making a film, I went on a preliminary visit to a set of tract houses, hundreds of them with identical floor plans, but each angled differently, to give the feeling, but not the substance, of variety. And in one of these small houses was a

pleasantly stout young housewife who was the president of the local branch of a wild animal owners' society. The living room stank like the lion house at the zoo; the source was a spotted cheetah who roamed back and forth from the kitchen, purring like a motorcycle and with legs curiously bent from an early case of rickets. Behind the large window onto the patio, there were a a couple of ocelots (a form of snarling, wild American cat) who once a month were taken to a member's pool to swim back and forth, while their owners drank cokes in the sun and discussed the idiosyncracies of leopards and defanged rattlesnakes.

This one act—owning a wild animal—served to distinguish the woman from her neighbors; but also impelled her to be a member of a club for that very distinction. In this contradiction, American, and particularly Californian society (which is a kind of America in exaggeration), has always been rich and fascinating. How to be different but not alone, is an especially American dilemma; and Edward Weston felt it all his life. He longed to be special, distinct, a romantic genius in the nineteenth-century sense, but, at the same time, he wished, to the point of despair, to be appreciated, praised, and loved—a workman among workmen. To a large measure, he succeeded in this marvelously contradictory aim.

Another curious coincidence of this desire to be both separate and sociable was his love of social gatherings. Some such occasions he found to be boring, intellectual, and arty, but when his wild energies could be put on display, he was, in the words of his son Cole, "the life of the party." Sonya Noskowiak, a photographer who lived with Weston for a time, relates that he sometimes staged such elaborate parties that they overflowed from his studio, which was then in the Seven Arts Building in Carmel, California, to his house a block away. During the 1930's, and long after prohibition had been repealed (Carmel was still dry), the Weston household distilled their own supply of liquor from a raisin, rice, orange, and grapefruit mash—Una Jeffers's (Robinson Jeffers's wife's) own recipe.

He loved to dance, particularly the rhumba or the tango. He confided in Ramiel McGehee, a former dancer himself, that he would have loved to be a professional dancer. Often he would perform by himself, mocking female dancers, in much the same manner as I've seen Chaplin do at parties. Cole said, "Oh, he was famous for that kind of thing." Many of the parties, including his own, were costume affairs. Edward Weston almost always chose to wear women's clothes; and did so without the slightest self con-

sciousness, and indeed, with the pride of the amateur. He wrote, for example:

> The Mardi Gras party went off with a bang! Many funny and some quite beautiful costumes. Masking, costuming, and drink loosens up the most sedate. Tina and I exchanged clothes, to the veriest detail. I even squeezed into a pair of mannish shoes which she had just bought. She smoked my pipe and bound down her breasts, while I wore a pair of cotton ones with pink pointed buttons for nipples. We waited for the crowd to gather and then appeared from the street, she carrying my Graflex and I hanging on her arm. The Ku Klux Klan surrounded us and I very properly fainted away. We imitated each other's gestures. She led me in dancing, and for the first few moments everyone was baffled. After awhile I indulged in exaggerations, flaunted my breasts and exposed my pink gartered legs most indecently. Lupe was enraged by my breasts, punched at them, tried to tear them loose, told me I was *sin verguenze*—without shame.

And, again in Mexico:

> "Carnival" week just passed. I "stepped out" but once. If Eric had not shown desire to go, I would have gone to bed and so missed a funfull evening at the Mendizabels. Lacking enthusiasm I planned no costume until almost time to leave. But one idea came at that late hour, to look at Tina's left-behind clothing—dress as I have before—become a girl. So "Miss Weston" took the arm of "her" gentleman friend and walked down Avenida Chapultepec!
>
> Gendarmes eyed us suspiciously—or was it my imagination?—but we wavered not! Once there, my mood changed. Helped by countless drinks of habanero, I became a shameless hussy! Monna, you were a beautiful boy! Frau Goldschmidt, you, balancing on your snub nose a painted, perfumed rose—you were the burgess personified—as always. Herr Blank, you in monkey costume, were a dull monkey. But the antipatico elements left early—and we danced and sang till dawn.
>
> I recall chasing a pretty criada—my specialty—around corners, through doors. She escaped! I recall lying beneath the piano, groaning and shaking with ill-suppressed laughter at the Grand Opera bellowing of some ponderous male.
>
> I remember our genial host placing a revolver at Eric's head, a subtle suggestion to cease embracing his wife. Eric murmured, "Don't kill me yet," and waved away the menace. Of course there were seductive señoritas, and coloured snowfalls of confetti, and tangles of ribbons which wound around and bound us, a laughing, swirling, dizzy whirlwind of "borrachito" fun.

Possibly, the pattern for these gatherings originated in Mexico, but it persisted upon his return to Glendale:

> Peter's party was one of the gayest ever. Dressed as a fine lady, evening gown and trimmings, I had a chance to burlesque the ladies, and did . . . Galka Scheyer [a collector of Klee and the Blue Four, which are now in possession of the Pasadena Museum of Art] had

begged my leather breeches, putees, pistola and Texano, so I got in exchange her outfit even down to panties, and a marvelous make-up job to boot. As a ravishing woman I was a success with the women.

In the late thirties, at his own home in Carmel, he would throw costume parties to which local doctors, artists, and writers (like the better known Lincoln Steffens and his wife Ella Winters) would be invited to dress up like babies and dance to Weston's collection of popular Mexican records. There were prizes awarded, as well—often one of Edward Weston's prints.

This kind of dress-up-and-have-fun was not unusual, given Weston's circle of friends and the general social milieu that existed in California in the 1930's. It was by no means his own invention; and it was certainly common to exchange genders. What is remarkable is the persistence of Weston's habit; for the recurrent caricature of himself as a woman, not once, not several times, but often, is not simply the feminine side of any of us, genius or idiot. Weston actually performed in this transformation on stage:

No stage fright—but I could feel that I was not doing my best—despite laughter and applause—and after congratulations. It was not spontaneous enough. I went cold waiting near an hour for my delayed cue. I danced Rachmaninoff's "Prelude in C Sharp Minor,"—great to satirize; for an encore Mendelssohn's "Spring Song," also an opportunity. Sonya made me a classic Greek tunic—with variations—which I am sure shared with my dancing—the honors. I wore—as several times in Mexican parties—little pointed breasts.

For Weston, who lost his mother when he was five, it might conceivably be read as the wish to return, to be closer, to be as intimate as clothing to skin—for clothing is surely a sort of skin—to his vanished mother. Yet somehow one has the feeling that there is fear and contempt there, too.

I saw an old man in a Mexican town, enamored furiously of a girl of sixteen, though himself past seventy and with grandchildren of the girl's age, who stole her underpants from the washline, and paraded up and down the main road wearing them on his loins as a badge of intimacy, desire, and mockery. Was there something of this quality in Weston's view of women? This is not merely a biographical question, or a point of little or no importance, as simple idolators of Weston would have it. After all, he spent the richness of his time and the intensity of his spirit on his multiple love affairs; and he made hundreds of photographs of the nude. In nearly every case, art and desire were inextricably entwined. Generally, in fact, the model was seen and photographed in the nude, scrutinized in the preternaturally bright world of the ground glass, and made love to, later—a routine that reverses the experience of most men.

In spite of this flattering mixture of scrutiny and passion, one notes Weston's persistent distrust of women. He feared, especially, the effect of the American female on his four sons. For example, when his wife proposed that Brett, who was a rough and stubborn boy, go to Mexico to stay with his father, Weston wrote:

Better with me, to be sure; no woman is fit to bring up a boy. How can they possibly understand them!?

Ron Bostwick, a young writer in Carmel who took care of Weston for a number of months during his last incapacitating illness, reports that Weston told him that he had taught his sons how to masturbate so they wouldn't be wholly dependent on women. This was probably one of Weston's sly jokes—with an edge of psychological truth. Yet, in this view, Weston contradicted the values of the intelligentsia of the twenties; values he learned to adopt, and which he later despised—or said he did. This group had, of course, many bright and talented women, some of whom were his finest friends. So his contempt took the form of hatred for the American middle-class woman: his boyhood family, in short, and his wife Flora, in particular:

. . . the American public want noise, steamroller methods,—they must be forced to buy. Woman, who is the buyer here, is not genuinely interested in art; with her, it is a pose, along with other ways of culture hunting: all she wants is sex, and all her gestures are directed by sex,—she would not spend one cent on art,—yet pretending to be deeply moved, if a new hat would make her more attractive,—for sex sake! And the poor boobs of American men are but money machines to further her ends.

God help me to some day return to a man's land,—Mexico or Japan or Somewhere. . . .

For three days I have not had one penny. I borrowed ten dollars from Rose Krasnow,—that has gone.

His bitterness toward women sometime took a curiously vegetarian form; for example, at a concert at which he fell asleep:

Part of the heat was generated by a jam of hog-fat women,—the same idlers, parasites, curiosity seekers who patronize exhibits but only with their presence,—they never buy!

The whole scene reminds one strongly of Maggie and Jiggs—the great American folk tale of the first third of this century. He wrote, on seeing Sadakichi Hartmann dance:

No woman dancer could have approached his feeling and understanding. Again the male in art transcends the female—and in a field almost monopolized by females.

He knew several female dancers, and at the same time; but since the knowledge was acquired in a biblical sense, it was prejudiced by the convolutions of his own character:

> Sunday found Johan, Brett and me—with no females—by the seaside: a quite perfect day, a restful day. Men alone are more honest,—women I grant the same. No reason for smart persiflage,—effort to strut at one's best—just a relaxed indifference,—each fellow for himself, yet part of an understanding whole.

Yet he fell in love, as other men do: sometimes desperately; sometimes simply for fun; and he could be violently jealous, and often had contradictory feelings in the midst of passion, and longed for an ideal woman who would give him "more than physical relief." He wrote to his friend Johan Hagemeyer that women, using the traditional American phrase, were "good for only one thing"; yet he was obsessed by one passion after another. Certainly his hatred for his wife was deep and permanent; but hate is often a stronger passion, and more lasting, than love; and he didn't divorce her until he was past fifty. He often admired and was grateful to her; although, as Cole Weston says, "She was a maddening, maddening woman," she was the mother of his four sons and an ineradicable part of his life:

> . . .—for you Flora, as the mother of my children and the only person that I could have lived with for some dozen years I have only admiration and love—and what difference should it make that sex—one of the most fleeting of human emotions finally paled—especially in one as complex and many-sided as I am—

Even discounting the natural errors of self appraisal, Edward Weston was by no means just a simple and gentle man. He wrote, when he met the great Chilean poetess Gabriella Mistral, that he hated people who were too nice. He generally took great pains to be kind, wanting people to like and even love him. He thrived in this warmth, though he asserted his bold independence, his love of solitude:

> I'm alone! . . . How precious to be alone! . . . In the early morning, when all the rest are snoringly asleep then one feels strong—untouched—released from the drag of personalities, for one pays a price for beloved friends—. . .

Though he said that he hated the company of any more than one or two persons, the truth was that he felt starved, like anyone else, for human approval and affection.

He was capable of hours, days, even weeks of concentrated work; a darkroom is an especially lonely place: small, dimly lit, poorly ventilated, requiring hours of ferocious attention. One longs for the movement of air, for the excitement of sounds and voices other than one's own. This isolation often made Weston an extremely restless man:

> I don't stand inaction—that's my trouble. I must keep going toward something—if it be but a blind alley or a locked door.

Since the romantic reversal of the nineteenth century, this working alone, by the light of an internal flame, in the paranoia from a solitary room, has been the particular neurosis of the artist.

After his spiritual and professional crisis in 1922, Weston was continually traveling; sometimes in search of photographic subjects, sometimes simply out of an itch to be gone. Nevertheless, he never learned to drive. He remained dependent on friends, on mistresses, or on his sons. He said he never drove because he wanted to be free to look; but it was more like (as Sonya Noskowiak remarked) anxiety.

Neil recounts how they decided to teach Dad how to drive, and chose the flat, salty bed of a dry lake. Edward Weston took the wheel, drove well enough in a straight line; thrilled, he drove rather fast, in fact, his face glowed with excitement; then, told to make a right turn, he pulled the wheel over without slackening speed. The car didn't quite overturn, but the lesson was the last. He hated automobiles, and thought that Henry Ford was Frankenstein, and the Model T, his monster. Ford's horrible progeny polluted Mexico as well as the United States; and Weston was not far wrong. Yet his dislike for cars was more symbolic than actual, for he bought them and rode in them all his life.

Complexity and contradiction is the prerogative of the least of us, as it must be for every living creature that has a nervous system. The famous wildlife cinematographer Jack Couffer told me that every ant, bird, wolf, lion, has its own character, distinct from every other ant, bird, wolf, lion; how much more distinct is the human animal, with its great overblown cortex. And the supreme members of our species, among whom I rate Edward Weston, are certainly as contradictory as any of us. "There might be more than one answer from more than one self," he wrote in his Daybook—or was this written for him by Ramiel McGehee? Still, in his contradictions, there is a certain order; one feels it without fully comprehending it.

For example, he was compulsive about order and neatness. He recorded the dates and locations of all of his thousands of negatives, and was equally meticulous about his home and darkroom which were neat and simple—of this he made a great virtue, and

of the reverse, a sin:

> . . .—hunting for my ink a half an hour and finding it in Brett's
> room. That is the boy's great problem in life. How to overcome care-
> lessness, to create order, without which no one can reach great
> heights as an artist, or anything else. . . . And art is based on order.
> The world is full of sloppy "Bohemians," and their work betrays them.

This is not a notion based on facts: Beethoven's rooms in Vienna
were a stinking mess. There were deeper reasons for Weston's
desire for order and simplicity:

> I am not of the same type of order Ramiel is. His housekeeping is a
> marvel of perfection,—so perfect that he must spend much time in
> the attainment. I do not like dust and cobwebs, but I can overlook
> them, I have to, or spend hours or minutes I cannot spare. My claim
> to order is in keeping things in their place, and knowing the place.

He has great Rabelaisian fun with the toilet arrangements. He
complains, on the occasion of moving to a new studio and living
arrangements in Carmel, California:

> Certainly I am not the writer I have been—writing the above, one
> reason was practically demonstrated: I had to run downstairs to evac-
> uate! What has this to do with writing? Well—it is all quite compli-
> cated! I write while sipping morning coffee, and coffee or habit, or
> both, causes not one, but several evacuations. I have not explained
> yet? Downstairs it is too cold to write, up here there is no W. C.—I
> can piss in the sink but nothing more. Also I must drag up these
> ladder-like stairs, stove, coffeepot, etc. and shiver while the room
> warms. So I have been reading mornings, and evenings too,—for we
> have not yet become involved in Carmel society. Fielding's *Tom
> Jones*, I enjoyed immensely, could hardly put it down!

It's very homey, all this; and anyone who has gone to a gather-
ing with farmers and their wives in the old pre-permissive years,
has overheard the backhouse stories—told mostly by the women,
with shrieks of laughter from the kitchen. It's the patent side of
sexual puritanism, against which Weston rebelled too; not with
ease and amusement, but with venom and hatred:

> Now for the first gossip, scandal re Tina and I living together in
> Mexico. It naturally came from an American who "thought it was
> disgraceful and wouldn't send her daughter to me—to such a house
> to be photographed." Thank goodness I can make the piquant finger-
> to-nose sign of "kiss my arse," there are no rooming house ordi-
> nances in Mexico. I accept the loss of a sitting. I can draw in my
> belt, use one sheet less of toilet paper per day, eat one less tortilla,
> and buy one spike of nardos instead of two. Poor woman, I would
> not hurt your daughter. I am far less dangerous than the sexually
> unemployed. Do you ask of your butcher his moral attitude before
> buying a slice of ham? Do you question how many women Caruso has

slept with before purchasing tickets to the opera? Do you come to me
for a portrait by a craftsman, or to see a marriage certificate gar-
nished with angels?

These common extremes of hatred and tenderness are marvelous-
ly blended in Weston's nightmares:

> A horrible night of dreams. I saw my father put a gun to his head
> and shoot himself—he was holding Cole in his lap at the time.

His relationship to his four sons was always exceedingly close
and warm. He suffered their illnesses more acutely than his own.
For example, when Brett broke his leg:

> The operation considered "successful."—The bones had to be "sewn"
> together. The doctor says he may be able to go on crutches in a week
> if all goes well.
>
> This affliction has brought Brett and me closer together than
> ever,—and that is very close indeed. Half delirious after the ether,
> he clasped me and said, "Dad you are the only person in the world I
> really love." Such a moment is worth all the trials and suffering of a
> lifetime!

He once told Beaumont and Nancy Newhall that the priorities in
his life were: sons, work, love; though, like other observations he
made of himself, it was not always true. When he was away, he
wrote each of them, and rather frequently. In a letter to his son
Neil, in a style so sugary that it is disturbing, because it reveals
the depth of his loneliness, he wrote:

> It so happened that last night I dreamed of you—I held you on my
> lap—I kissed your broad fair forehead—and you cuddled close—
> patted my cheek and asked for stories—your hand crept into mine—
> your grey eyes glanced up shyly—confidingly—wistfully—dear dreamer
> on the lap of one whose dreams elude—you with tender tears in the
> arms of one whose tears are almost spent—we talked long together. . . .
> . . .Well it came to pass that in my dream—you dreamed too—
> the sandman dusted your eyes—they drooped and soon your cheeks
> were flushed with sleep—all quiet now—only a distant mockingbird
> and the sighing of your breath—I watched your sleeping face—ca-
> ressed your fair waved hair—you stirred with pleasure—snuggled
> closer and as I looked down upon you—you became not only Peter
> Pan—my Grey Boy—but the symbol of all in life of tender hopeful-
> ness born to the easy prey of those who gibe and jeer—they will
> flout you—insult you—lynch you—but I will protect you for I have
> masks that you shall wear—a horned and grinning devil—a sharp-
> beaked bird—a ram in solemn mummery—I have them— I shall
> keep them for that hour when it must be you shall need them—to
> hide behind and keep inviolate—untouched the spark within which
> is yourself—they shall be my only legacy to you—cardboard—
> painted masks—thicker than your thin skin—to save it from pollu-
> tion—March 2, 1924.

To Brett, who was three years older, he wrote in more practical terms:

> I suppose you need clothes—even food—more than glass for your butterfly case—but since I am more interested in your spiritual development than in your alimentary needs I herewith after due consideration and deliberation realizing the importance of my gesture— enclose my personal draft for the sum of two dollars and fifty-one cents ($2.51) hoping that this amount—small but honestly earned will be sufficient and requisite for all present needs—God help you if it isn't—but now after so promptly and nobly answering your cry for help—I have a request to make of you—that for some time to come you refrain from patronizing the "movies" in this way you can soon save the amount of this check and also escape softening of the brain—that insidious disease so often attacking "movie fans"—
>
> I remain my dear son your honored and respected sire.

Brett became his partner, and his friend, and, in my opinion, influenced his father's work; father and son exhibited together, and Brett was praised and encouraged. Only occasionally did Edward Weston compete with him. His love for Cole was equally strong:

> Cole!—you rascal—you rogue with laughing eyes! You are right here in my arms *now*—or on my shoulders—while I go prancing around the room like mad—*right here* I tell you!—and then I get a queer feeling when I awaken and wonder if the next time I see you—you'll be too big a boy to ride on daddy's shoulders—
>
> You know—one book I brought with me was the *Child's Garden of Verses*—the old copy which I've read to each of you boys in turn—I like to read it now and do a lot of pretending and dreaming!—well I'm getting suspiciously sentimental—and you—not yet having tasted this unfortunate plight—will not know what I mean. . . .
>
> Kiss your mother for me—be good to her—keep your nose clean and your pants dry—and listen to the little pine trees whisper in the evening breeze—they'll tell you a secret—"I love you"—Daddy.

Chandler, the eldest, and in some ways the toughest and the most recalcitrant, was with him on his first trip to Mexico:

> I showed Rivera some of Chandler's stencil designs and he seemed greatly interested. Chandler has done some very fine things, and out of a clear sky,—at least, I can't figure where the influence came from, if any. Chandler's photographs have been interesting too—one I would have been happy to have made myself. I can see my influence in these, yet they were made entirely unaided. Chandler has had to shift for himself, and having no playmates of baseball or marbles, has amused himself by creating.

As the eldest son, the twin problems of having a great and famous father, and of his father's separation from his mother, were most difficult and painful for him. But when he married at an early age, Edward Weston put aside all his current difficulties and raised enough money for Chandler to open his own studio.

Weston thought a great deal about how to raise his sons; afraid that Flora (herself a third-grade elementary schoolteacher) would raise them up in her own image. His plan was very different:

> I should like to be able to instill in the minds of each boy a profound concern with life itself—with beauty—joy—adventure—comradeship—creation—The trouble with our whole sad—drab—hectic mess we so proudly boast of as "civilization"—is in the fact that we are almost totally concerned with the *means towards life* rather than *life itself*—we are indeed a sorrowful lot to be scorned by the veriest savage—

And to some one or several of his boys, he wrote down the following advice:

> Don't seek security—there is no such thing. You maybe, are, in a period of routine at least to the point of clock punching—but don't let it trap you, at least keep your mind free and ready for fresh adventure.
>
> Don't forget that while we fight for the "little fellow" we do so because we are not concerned with his ends, his petty securities and so have no jealousy [because we] understand him better than his own kind. His own kind?—the innumerable razor-barons, laxative czars, "Pep" tycoons who have risen to power from one suspender because they were a little stronger, a little craftier than their fellow laborers. They fear and hate "labor" because they come from labor—they fear with reason.

It was the universal opinion that Weston was indeed quiet, lovable, and considerate; most people did not notice his ruthless egocentricity. It was a defensive trait that he had in common with many great men and with millions of those who had no talent whatsoever. What is interesting is his frankness; he addresses himself as if before a moral mirror:

> Your individualistic attitude towards life is not selfish, at least not unnatural, in fact it is most natural, a law of nature touching everyone, everything. Are not your thoughts a reconsideration of "the survival of the fittest?"—to consider oneself first is in the last analysis the least selfish attitude. My eternal question over my children is between my emotional, personal love for them, my selfish love!—and the impersonal consideration, realization, that to do the best thing for them—unselfishly—I must think of Edward Weston first.

His powerful and hungry inner self, whatever his gentle sociability, was always at the very center of his life; it was, indeed, the unconscious fascination which drew both men and women to him. He knew it, too; saw it as almost separate and distinct from his outer self. He wrote, when he was almost forty-two:

> I have partially fulfilled a youthful covenant with myself. For—one

day before my twenties—I answered my sister who questioned what I would do in life, "I don't know yet, but I will be successful." I have never forgotten this. My words sounded strange to me then, as though someone spoke for me. This inner conviction I have held and shall always hold. I ask nothing more than to be able to grow in strength, and achieve the ultimate from my possibilities.

With a lifelong goal of this sort, the nightmares, the fiery boredom and inner irritation, the frequent bouts of depression, were only natural. Even his first great and crucial success, his exhibit in Mexico City at "Aztec Land," on the walls of a tourist store in the center of town, produced contradictory feelings:

> I have never before had such an intense and understanding appreciation. Among the visitors have been many of the most important men in Mexico, and it is the men who come, men, men, men, ten of them to each woman; the reverse was always the case in the U. S. The men form the cultural background here, and it is a relief after the average "clubwoman" of America who keeps our culture alive. The intensity of this appreciation and the emotional way in which the Latins express it has keyed me to a high pitch, yet, viewing my work day after day on the walls has depressed me greatly, for I know how few of them are in any degree satisfying to me, how little of what is within me has been released.

This double vision, at once exhilarating and depressing, informed his aesthetic sense as well, and indeed deepened and colored it. He had, in common with many great artists, an existential obsession with death and the symbols of death, which is particularly true in the period from about 1939 on. He began to face his camera inward, toward the dark cliffs on Point Lobos, becoming increasingly aware of the delicate balance of an individual life suspended among mindless and self destructive galaxies:

> I dreamed strangely last night: I went to the studio, found the big French doors had been unhinged, taken off, the place wide open and stripped of everything: cameras, furniture, books, all gone! What now?

The world circled around Edward Weston. In all the singular frankness of his journals, he never said he was only a talented man among others equally talented. He knew quite well that he was an intensely vain man, whatever his modesty; and no other quality would have served him so well—it kept him alive. And yet he was always doubtful of himself, requiring that his worth be attested to, not by the general public (or so he said), but by those whose opinions he valued; yet, if the authorities in his own field had criticisms of his work (as Stieglitz did, for example),

why, the hell with them.

The camera, he said, was his only love:

> One becomes hardened to anything, used to all sensations; blood and death grow eventually commonplace, love and romance too. It is only my work that I return to with never diminishing enthusiasm, with untiring energy.

There is a certain pathos in his account of a simple incident in Mexico:

> If the sky was heavy and gloom-laden, the earth was not. Scarlet snapdragons flamed. We climbed through purple lupin taller than our heads. And all the time the gale swept through the pines. We climbed up and up, stumbling forward, slipping back. I was the rear guard. My camera slowed me down. It is always so. I pay the price of my love,—perhaps my only love.

His journal goes on, almost in free association, and brings with it a summary of his own delights and fears:

> A sheltered spot for lunch down by the convent. Indian women served us hot tortillas and mole, hot with pimienta; arroz, frijoles y cerveza completed our happiness. The afternoon sheltered by the cloister walls. No storm could disturb the calm of the cloister, the old monks built impregnable fortresses. They were protected not only from the elements and beasts of the wilds, but from prying people, meddlesome outsiders who might probe too deeply into their well-ordered lives, who might discover rust on their instruments for self torture. They must have been artists in life as well as master builders. We left early—it might be that danger lurked in the dark.

One thinks, reading this passage, of the dark landscapes of Hawthorne and Melville and Faulkner; it is a tragic gloom which is also part of the American consciousness, the underside, maybe, of our compulsive cheerfulness. Edward Weston's inner morbidity, the flame of his dark egotism, are what one feels in many of his greatest photographs; and these are among the most marvelous ever taken in this country. The truth is, genius has little time to be unselfish—that's not his business in life—and he breaks this rule at peril to his art. Weston's politics, therefore, were simply a defense of himself. He wrote:

> I would probably be a first-class Fascist, *if* I would let my (contempt) for the Masses get the upper hand; but instead I have pity (a very dangerous virtue) just as one feels deeply over a lost dog, cat, child. Often when I dial (radio) to some EXLAX program, I want to tear out the Radio in righteous rage; then hearing such prose come moments later, I wonder what difference does it make whether Pepsi-Cola wins the war, or Kultur.
>
> The eternal internal mess we are in is caused by labor-capital

conflict—two sides of the same rotten apple. The capitalists almost to the man are laboring men who—craftily, greedily—have grown from the ranks to power on one suspender. The capitalist knows the kind he came from too well—he will keep them down; while each laborer has hopes of rising to the height of some soothing Syrup King.

I am in very deep water, deeper than I should be, hardly know where to swim next. Our peculiar American disease is a material one—almost everyone is out to at least keep up with the Joneses. Our aristocracy is one of money, in place of intelligence, and money begets greed, and greed makes sure that the public hears or reads every day that one bottle of Pepi-wunki contains 10 X the. . . .

But again I am side-stepping the issue of the masses, the proletariat, the "little people." I have never been interested in the brand of political communism fostered by a lot of N.Y. intellectuals—though communism as an ideal is almost too high to shoot for in this present world; even Fulton Lewis said so. Granted all the mass stupidities of the masses, the artist must inevitably be on their side. At least from amongst them rise occasional hopes, from individuals of course; but what white hope ever rose from the slime of the Pepi Wuntu group!? Not that I have any objection to money in the hands of some persons, some we know and admire. I am even glad they have it; must be an awful bother for them to care for. But to these persons—money is a secondary issue, they would be just as important without it.

In 1925, when his son Neil was eleven years old, the child had one of his earliest attacks of a severe migraine that have haunted him to this day. The malady, the cause of which is still uncertain, is characterized by a one-sided and nauseating headache. Neil ran into his father's studio and threw himself face down on a velvet couch. Light, too, is exquisitely painful to the migraine sufferer, and Neil covered one eye with his clenched fist. His father was certainly sympathetic, but rushed to get his camera and tripod, focused, exposed, and got a now famous negative. Not a purely paternal action, maybe; but Rembrandt, Breughel, Dürer would do and did much the same thing in observing human pain. There are many kind fathers in the world—too many, perhaps—but few geniuses.

Edward Weston was, by the contradictions and compulsions of his work and character, at once egotistical, sweet, sad, obsessive, sociable, irritable, narrow-minded, intelligent, quiet, mad, merry, generous, and ruthless.

He was a very American artist of the sort who seems to spring suddenly, without nourishment, from our hostile soil. How far this was true, and the human origin of his native genius, we must now examine.

II.

Alfred Stieglitz, the angry prophet of photography, once commented: "Photography as a fad is well nigh on its last legs, thanks principally to the bicycle craze." That was in 1897, and though he was proved wrong, for both bicycles and cameras can somehow coexist, his deeper point is well-taken. Photography is a folk art; and this is true whether it is done well or indifferently. It has its own tradition; its own code of solemnity or horseplay. The mausoleum of the family dead still decorates the top shelf of many a bookcase, or, in less literate homes, is inserted, curling at the free edge, into the intimate mirror of the family bedroom. Resentful, frowning children are frozen forever, as well as funny "Uncle This" and "Cousin That," while their less corporeal bodies decay in nursing homes. The number of photographs possessed by family and friend is staggering to contemplate.

Consider only the United States of America. The camera has been in use, and in geometrically increasing use, for 135 years, since the painter and inventor Samuel Morse met Daguerre in Paris in 1839. That is five generations. Our population has increased tenfold in that time. We are now upward of two hundred million; but certainly there have been, living and dead, a total of twice or even three times that number who lived between our two oceans. Suppose we settle on a middle estimate of five hundred million Americans.

We might form an imaginary catalogue of the faces of all the Americans who ever lived; and though this would be an interesting, perhaps even an invaluable project (for the type of face, like the course of a river, changes from decade to decade), it would be rather impractical; for the grand total of photographs would be better than fifty billion. Surely the rest of the world would be at least equally proliferous. Photographs decay rather slowly, and are kept from generation to generation. So the world sum ought to be close to one hundred billion photographs—a collection of the human race for the past five generations. There is no single type of object, and certainly not an object of art, that has ever been as abundant.

In America particularly, photography became, and still remains, a national obsession. It is part of our hunger for souvenirs, for these fixed and exact shadows commemorate the insubstantial substance. Every household in the United States contains a bit of some other place; bought, even stolen, to commemorate and preserve a vanished occasion. When Lincoln was dying in the up-

stairs bedroom of the rooming house opposite the Ford Theatre, the maid stole a bloody pillowcase from under his head, cut the cloth into small squares, and sold them piece by piece. And such is our objectivity in such matters; that when John Wilkes Booth (whose photographs as a handsome, second-rate actor were already hung in thousands of idolatress's bedrooms) was in turn shot to death in a tobacco barn, and brought to await burial on the deck of an iron-clad moored in the Potomac; and while the carpenters hammered together a pine coffin, the plain people bribed or snuck their way aboard and cut locks of hair from the assassin's head.

So photography, whatever else we think it must be, is also a branch of sociology. The universality of the camera and its product is absolutely unprecedented in the cultural history of the western world. Only death, food, and the earning of money are equally common to mankind; and there are camera fiends, otherwise normal and moderately kind to their wives and children, who take more pictures, and with keener interest, than they give to any more organic act.

Why not? The eye is the most sensitive organ of the human body. Its powers of discrimination, both of the gradation of light and darkness, of the hue and intensity and precise shade of color, are excelled only by the birds. The information that comes through our double, living lens has shaped, far more than touch, smell, or sound, the way we apprehend the world. The camera, of course, is merely a tool or extension of the eye; or more precisely, of the great, swollen, convoluted, visual rear of the human cortex. Photographs are a collaboration of the eye, brain, and hand; the machinery of the camera is almost, if not quite, irrelevant.

"But is it art?" Edward Weston, who thought about this question almost obsessively, remarked in irritation:

> The argument pro and con photography as art has been rehashed for years. Why do photographers continue to revive it? Photography needs no apology though some photographers and their products may be condemned to the ashcan. The same thought applies to painting and painters. Have you ever noticed that all painters are called "artists" because they wield a brush?

His comment, I think, avoids, and at once implies, a much more fundamental question; one that annoyed him, and continues to annoy us: what is, in fact, Art? In the twelfth century, in Europe, this probably would have been an irrelevant question, but since the Renaissance, we have given our respect and praise to the practitioners of art. We see them almost as priests, prophets, or shamans of the ear and eye; and when we (as amateurs) practice one art or another, we become part-time magicians. The magic of the photograph we have taken, half in surprise and half in recognition, is a universal experience.

Certainly an art cannot be defined by the number of its practitioners; and even less by its quality. Nor should we be tempted to define art by the fact of its artificiality; for our very standard of what is real and what is not, is—by the limits of our lives and therefore of our intellect and our perception—not quite certain, nor clearly verifiable.

So we must postpone this weary, troubling, and important question till we have looked further into the exact circumstances of particular photographs, and of particular photographers, and into the illuminating career of Edward Weston.

Edward Weston lived at a time and in a country which bridged the great chasm between the world as it existed prior to the slaughter at Verdun, and the changes which came afterward—an earthquake of our own culture which is not yet done. Edward Weston, too, began as an amateur and a folk artist, and then had his life shaken by the crisis of our culture after World War I. By that necessary amalgam of genius and egotism, he survived and became a full artist. This was not unique, but it was rare.

It is perfectly logical that the inventors of photography should be amateurs. Niépce, who made the first negative as early as 1816, was a lithographer; the Englishman Herschel was an astronomer; Talbot, a mediocre chemist. Only Daguerre was an artist, though an obscure one. His major work was a curious affair called a diorama: a huge length of canvas on which was painted a series of connected scenes which moved past the spectator or vice versa, like a trucking shot with a movie camera. Its folk value was its verisimilitude; and indeed this has been a standard of graphic art for a very long time: Virgil describes painting that is so marvelous that the armed figures on the frescos appear to move. The photograph, since its invention, has had the value, whether mistaken or not, of seeming to be almost, if not quite, real.

For a long time, the practitioners of this art and their public were indistinguishable. They had precisely the same aesthetic—and no shame need be attached to this term—as their audience. Some of these amateurs, of course, were remarkable men, but in other fields.

For example, there is an American photograph of unique inten-

sity and complexity, taken by an amateur in the 1890's. It is made inside a room, looking toward two segmented windows; one is half shuttered, and the half shutter is itself half open. A curious black figure on the shade is partly torn. Between the windows, on a hideous flower-papered wall, is a framed, stitched sampler with an immense motto too cramped to read; under the motto is the photographic portrait of a woman inside a false arch. To the left, a doorway opens to a second room with a mysterious window. These are the only rectangular shapes in the picture—all else is twisted, curved, or human in form: the wooden chairs; and on the chairs as well as on the floor, the drapery of unfinished piles of black garments, which have the cheap sheen of newness. To the right of the portrait are three workmen; on the left, three women. The man furthest to the right twists to look at us; he is sweating, fatigued, young. The second man is bearded and seen in profile; his arm bent in the effort of cutting cloth. A third man bends away from us, standing; and his left sleeve, in movement, has the curved strokes of an imaginary painter. One woman furthest away bends to her work, dark, unremarkable; a second woman is like an image in a mirror, again blurred, and with a ghostly smile; the woman in the center of the trio is the magnetic core of the photograph. And not because she is pretty, which she is in a small and common way, but because of her gesture: she is just putting the open points of her scissors to her lips. There is another scissor too, in the working arm of the bearded man, and the four daggers of these two scissors carry an invisible tension between them. Framing the photograph, for at first one doesn't see them, is a curly dog resting his head on the rung under a chair, and on the other side, a dark lap and the stiff, folded, self grabbing hands of a woman whose face we can only imagine. Invisible, but strongly implicit, we breathe the particular human sweat, the closeness, the twelve-hour day, the piecework rates, the labor and the hunger, the coughing, the jokes, the endurance.

I give this elaborate description, not only because the photograph deserves it, but to indicate how emotion, association, and human knowledge and experience all play their part in a photograph—even in all but the most trivial, and perhaps in even them. This rich and remarkable photograph, part of a whole series, was taken by a social worker Jacob Riis, who (as the noted historian of photography Beaumont Newhall pointed out to me), neither before his crusade nor afterward, did photographs of any merit at all.

So motive, drive, and inner propulsion are important qualities for a photographer; and Edward Weston possessed them from early on. He was gentle, soft-spoken, cunning, and fierce. He wrote to his first wife from Mexico describing himself:

> I want to be constructive—but I shall be ruthlessly destructive to those who stand in my way—I am battle-scarred and unafraid—I shall be Machiavellian if necessary—but underneath my capote I will cherish an ever-ready cuchillo— I feel sure all will be well—otherwise I fear disaster—and I do not wish it—I will tolerate no nonsense—I have learned direct action from the Mexicans—

The prospect that he might be cheated out of part of his wife's inherited property infuriated him. He made very little money during his lifetime, but fought for it bitterly. Money was not an abstract matter; it was a simple necessity for the pursuit of his art; and this pursuit, of course, was unreasonable, impractical, egotistical, and in the end, glorious. The fury of Edward Weston's struggle at the edges of poverty did, it seems to me, inform all of his work.

Paul Strand, Weston's contemporary, never had this particular problem. In fact, the very amateur quality of the first half of photographic history made the earning of money more or less irrelevant. There were other drives and more secret motivations. Lewis Carroll was a platonic lover of little Alices, and photographed them in the nude when he could arrange for a chaperone; his photograph of Tennyson is commonplace, but that of Tennyson's niece Agnes Weld, photographed with a dove and with a face as pensive and melancholy as only an eleven-year-old woman can be, is moving and beautiful in every way. The story of the Scotsman D. O. Hill is well-known; an unremarkable painter, he made photographs of men and women that are the earliest classics of portraiture. One especially remembers the woman fish peddler with the striped skirt, vertical bars of light against the horizontal striped crescent of her basket—the theme of stripes that is to recur over and over again in photography. France had a quota of famous amateur photographers: Zola was an adept; Degas quite obviously used photographs in the singular composition of his paintings; Vuillard kept a camera handy at all social occasions; Toulouse Lautrec both photographed and was photographed. One of the finest of all amateurs was Lartigue, whose best photographs of fast women and fast automobiles were done when he was nine years old. At twenty-one, his talent had sunk to snapshot mediocrity.

This persistent, uneven spate of amateurism was born in the nineteenth century, and it is fascinating to see the photographic

apparatus of the time. Each age has its technical instruments designed in its particular taste, severe or elaborate. One has only to look for examples at the astrolabes or the earliest microscopes, or the drawings for blast furnaces or power looms. The camera of the first half of its history was typically a large rectangular box, a cube almost, of hardwood, beautifully finished, with a large lens set in a marvelous brass barrel. They were expensive and, in the middle classes, ubiquitous.

There is something profoundly human about amateur art. It is rich, unpredictable, often mad or odd; and never, of course, consistent. One has only to sift through piles of photographs—visual records of nameless people, untitled scenes, the works of anonymous artists—to feel the slightly boring excitement of all research; and then to have the experience, one in a hundred, of finding a photograph of startling beauty: a child, for example, with a doll in a doll-carriage, where both doll and child have the same glaring intensity; or a daguerreotype (though here one sometimes feels they are all beautiful) of a wedding couple, already hideously unsuited; or a tintype of four merry tennis players with cowboy hats on and a whiskey bottle conspicuously empty in the foreground; or the derby hats—cruel optimism—and dour clothing of men standing idly about in front of a railway station made of sunbaked wood; or the stereopair of a crowd, dense and watchful, from corner to corner of the frame, in a forgotten American exposition—perished, of course, every last one of them.

Then, simultaneously and continuously, there are the multiplied millions of photographs taken anonymously, not intended for the curious purposes of public exhibition. In the Slavic Room at the New York Public Library, there is a collection of czarist police photographs of citizens about to be exiled to Siberia; they stare with curiosity and defiance, manacled as they are with great links of chain, and posed on the identical chair. They remind one of the decisive force of the human personality; of our hidden belief that we do not exist for nothing.

These, and a similar series, could be duplicated from the archives of every punitive institution which has an idiosyncratic craving for photographs; all done, not by amateurs, but by a new and different kind of person—the photographic craftsman. Chance, and the erratic distribution of talent, plays a diminished part in the work of these men. The photographer has become a workman in the older sense of the word; like a cabinetmaker, blacksmith, lithographer, tailor. His eye is quick, alert, and trained. There is

no stifling formalism as yet, and even the boundaries of technique are ingeniously broken. One has only to look at the folios of Muybridge who claimed to be merely documenting the dynamics of animal locomotion, but who made the arabesques of the first cinema. He sometimes used a machine for this purpose, to show a horse galloping or a naked man batting a baseball; but even when one looks at the series of twelve, one gets the impression of a whole film.

All men are better artists than they know; and, if given a thousand chances, will sometimes create a marvel. The chances are not as good as they were for a genius like Edward Weston, but they are still a lot better than for many a fashionable and famous hack.

What the amateur and the craftsman have in common, is the ability to see and record anything of any human interest. Any subject matter, provided it was human or had human connotations, was just as valid as any other. The camera, in their hands, is open to every emotion: to the vulgar, the sentimental, the truthful, and either the sly or the outright pornographic.

There is nothing more magical than the old pornographic stereos. One must be a bit mad to feel even the faintest twitchings of desire, for after managing to cross the eyes sufficiently to blend the two images, one no longer has the illusion of three dimensions at all. One sees, instead, the plump, divided rear and the coy foot as a cut-out plane, mounted a little like an old-fashioned fold-out valentine. The photographs of the New Orleans prostitutes made by Bellocq are something else again; but these are no longer pornographic, rather the most tender of realities.

Up to roughly 1900, photographers did not merely, or even mainly, study photographers; they were directed toward life. They were curious to record the pale, stubbled corpse, as well as the screaming baby; and the emptiest landscapes (as Edward Weston said of his own) were informed, at the very least, by human surprise. One must take exception, of course, to the studio dress-ups, the saccharin allegories from which even the great Julia Margaret Cameron was not immune, as well as the straight-faced and heart-rending photographic enactments that illustrated the novels (in verse, of course) of Ella Wilcox. But these form a small part of the immense number. Reality was the chief food of the camera; and its roughage was a splendid corrective for the generally bad and finicky taste of our gilded age.

And what extraordinary craftsmen we had in this country! Among the greatest photographs in the world are the Southworth

and Hawes portrait of Daniel Webster, the landscape of Canyon de Chelly by Timothy O'Sullivan, and Alexander Gardner's Confederate Sniper, dead in his stone nest.

Up to the 1920's, these amateurs and craftsmen had a tremendous technical advantage with orthochromatic film; a misnomer, for it rendered no colors, but was sensitive to all except red. But the lips, the edge of the eyelids, the inner nostrils of the nose, and the lines and fingernails of the human hand were red. Where they registered blank on the developed negative, they were black on the print. The result was a kind of secret play in every visage. In fact, in the early silent films, rouge was put in the nostrils, and everyone, male or female, looked a bit like Nazimova. The simplest snapshot of Little Uncle Joe and Big Aunt Minnie had this somewhat sinister and erotic air. In the hands of the commercial craftsman William Notman, "Carpenter's Gothic" is set like a jewel in the pale sky. In the hands of the far greater amateur A. C. Vroman, these patterns of black and white, unnatural, of course, made the ordinary photograph a still image from an unknown melodrama. Consider the beautiful pattern of negative space, for example, around the three globes: the face, and the two coils of hair of the Young Hopi Maiden.

And then a necessary catastrophe occurred, almost at the same time, in America and in Europe. Certain of the amateurs, with their huge portable boxes (the photographer's definition of "portable" is anything in the world with a handle on it), and the craftsmen with their horsedrawn darkrooms, began to think of themselves as artists; as indeed the very earliest inventors had done. Talbot referred to photography as, "The Pencil of Nature." Strangely enough, one of the "first" photographs (there are a number of candidates for this useless honor) of rooftops and buildings, taken in 1826 by Niépce, has a rather cubist manner. (The exposure, notes the omniscient Beaumont Newhall, was eight hours.)

But that is historical accident. The uncomfortable truth is, that as lonely and superior as the members of the wild animal society, photographers as early as the 1860's began to form clubs and associations; and these associations quite naturally staged exhibits which were actually competitions. Both commercial craftsmen and amateurs began to standardize their values. But where did they find them? The name "artist" has always been broad and loose enough to cover a multitude of vanities; and if one was an artist, one looked to Art for values, and by Art, one meant painting. There was, already, a growing procession of great painters in America: Catlin, Thomas Eakins (himself a photographer), Bierstadt, John Copley. Just as committees take an average and mediocre view, so the associations of photographers, and the resulting current of influences, tended to take an easy and mediocre course. What is generally imitated is not human truth: response to reality, but the easier exercise of make-believe and sentimentality and a faint, and somewhat sickly, eroticism. There would be no more of this tide of innocent amateur truth, of the fierce, often ugly, and generally tragic views of battlefield and man by Gardner and Brady; no more of the ordinary man, photographed in the doorway of his shaky business (as my father was); no more photographs, printed on metal, of barbers solemn in their trade; and whores posing round their heavy madam in the genteel house in Lawrence, Kansas—no more would these be misnamed Art.

The photographers who covered the American conquest of Cuba and the Philippines were determined to be pretty, or at least, picturesque. If photography was to be an Art, the photograph must look like an etching or a drawing. For models, these photographers looked, not to the French impressionists, for they had never seen them, but to the American imitators of the French impressionists. The technique of inner lighting by the application of small dabs of color put side by side on canvas, was imitated by the use of soft-focus lenses, printing on textured paper, or the manipulation of the negative with a brush.

In 1902, by an edict from Alfred Stieglitz, the movement which incorporated these values was forcibly born. It was called, accurately enough, Photo-Secession. Edward Weston was, at the time, sixteen years old and made his first photograph that year. aesthetic difference between straight photography and pictorialism is still a technical one, and it comes from the very origins of photography. A daguerreotype is a silvered plate and possesses a near infinity of detail. In that sense, it is close to optical reality. But the detail in the paper photographs of Talbot was limited by the very texture of the paper. How tempting, therefore, to use the rough and "interesting," hand-rolled papers of the watercolorist. The world was thus ameliorated, softened, and made milky. Diffusion lenses proceeded in the same direction, and the manipulation of negative, as well as print, was not only useful, but commercially necessary; if only to remove warts, pimples, scars, and wrinkles. As the photographer P. H. Emerson wrote in 1899:

> It is constantly advocated that every detail of a picture should be impartially rendered with a biting accuracy, and this in all cases.

This biting sharpness being, as landscape painters say, "quite fatal from the artistic standpoint." . . .

I feel sure that this general delight in detail, blind sunshiny effects, glossy prints, etc., is chiefly due to the evolution of photography: these tastes have been developed with the art, from the silver plate of Daguerre to the double-albuminized paper of today. But, as the art develops, we find the love for gloss and detail give way before platinotype prints and photo-etchings.

He said (which is perfectly true) that the depth of focus of the human eye is limited, and that the photograph should imitate this insularity. His followers went further, and deliberately made their

Violet Romer, Tropico, California

images a bit out of focus. It was Emerson who first saw, in 1887, the work of the American amateur Stieglitz, and wrote to him enthusiastically.

In 1902, Stieglitz chose a group of photographs by himself and thirty others as part of an exhibit at the National Arts Club. The exhibition, and the movement in general, aimed to apply stringent aesthetic standards, and thus bring photography into the brotherhood of the arts. There was no question that many of the current photographers were simply imitators, not even of paintings, but of reproductions of paintings. One example is Edward Steichen's self-portrait (1902), depicting himself as a painter, with brush and palette, in a print from a negative that shows, and is meant to show, false brush marks.

The world of Frank Eugene, Clarence White, Gertrude Käsebier, and Stieglitz himself (like the famous "Hand of Man"; actually an industrial landscape with a train and a black plume and a network of silver rails) was softly focused. On the other hand, Steiglitz's earliest photographs were another thing altogether: his debonair self-portrait, showing him stretched out on a Venetian staircase; his marvelous "Terminal" (1893), with its horses steaming in the snow; and finally, the bold and monumental "Steerage," certainly sharp in every plane but the furthest, and that print was made in 1907. The pages of *Camera Work*, Stieglitz's house organ, had the same confusion of technical choice.

All of Edward Weston's work during this time, and indeed up to 1922, was in this soft, pictorial mold. Certainly in the clubs and commercial circles, and in the photographic "salons" (itself a fuzzy word), it was an almost universal form.

It is not true that this aesthetic—illogical and domineering though it was—could not produce many very beautiful works. An artist is a born hypocrite; any creed will do: conscious or unconscious. All he asks is to be given enough money to live and create; activities which are almost synonymous with him. Clarence White's "Morning," has a sleepwalking lady with a monstrous glass bubble, wandering under the silhouette of a pine—it is hard to imagine that it was not intended as a joke. But, on the other hand, an earlier photograph of his, "In the Orchard," has a most magical compositon of three women: two of them in black, one bending to the ground in a soft white skirt; it's a print that has grace and purity, but also the peculiar sadness of harvest. This delicacy, this mistiness which pervades so much art at the turn of the century, is not to be uncritically despised simply because it's out of fashion. And when we come to Edward Weston's photographs, done in a similar style, we can see that in this generation of photographs, out of many, many thousands that are mere gauze, there are, perhaps, some hundred of great merit, that have the soft sunlight, the sweet carriage of certain women, the gentle nudes, the gentle landscapes of a serene time (for the middle classes, of course), before the monstrous civilized wars of the twentieth century. Edward Weston's loving portrait of his partner and mistress (for ten days anyway), Margarethe Mather, with her bent profile, and the vortex of the curves of the sofa and the sweeping skirt, would be unthinkable in any but the pictorial style. All of Weston's best work of this period, I suppose, are distant imitations of paintings or etchings; but imitation sometimes has its own life, and, in the

head of a genius, develops its own force and logic.

The movement back to reality arrived once again without particular notice. It was brought about by another man in 1915, and he exhibited in Stieglitz's Gallery 291 the following year. His name was Paul Strand. The photographs of this period are of three kinds. Some are cityscapes; for example, there is the shadow of the Elevated girders, all machine-like, but all soft. These compositions are dictated only by a conception that resembles the rocks and landscapes of Cézanne. Secondly, there are photographs like the poetic, and indeed, mystic white fence, which are sharp only in one plane; all else being purposefully soft. The third class of photographs consists of a most extraordinary series of people taken with a side-view prism on the lens. Having once seen them, even many years ago, it is impossible to forget them: the frightened man with the balloons; the sandwich man with the white beard; a powerful, fat man in a derby hat; and the tremendous image—stolid, frightening in its heroic acceptance—of the woman, labeled BLIND. Until the exhibit of 1916, Stieglitz had shown no photographs for almost three years; but Strand's work had a tremendous effect on the whole previous outlook of the Photo-Secession. Together with World War I, Stieglitz's movement was doomed to be one of those small, powerful storms of aesthetic fashion that trouble the surface of American life. Finally, Stieglitz himself was no longer an influence; only a presence.

I met Stieglitz when I was a very young man and went to an exhibit of paintings at 291. The gallery was blindingly white, and Stieglitz was arguing on the phone about photography with someone in his little inner office. He hung up, grumbling, and came out into the gallery proper, eating an onion sandwich, the pungency of which filled the spaces between the sculptures. He went on talking: "Light! Light! A photograph is nothing but light!" And my mind, irreverent at that age, at once saw the great tufts of hair that thrust out of the center of each of his ears, like rays of angelic effulgence. His last photographs, the "Equivalents," are clotted light, with a vagueness into which other and lesser photographers have stumbled rapidly since then.

But Stieglitz's early "Steerage," his "Ferryboat," with its opposing curves of dark and brilliance, had resolved the technical problem of where and how much depth of focus; or rather, made the problem irrelevant by the strength of observation, choice, structure, and printing. These masterpieces by Strand and Stieglitz, made before the twenties, had the benchmark of the professional artist who chose to be a photographer—a unique phenomenon in America.

It was precisely during this period that Edward Weston's genius began to strain against, and at last burst the harness of his boyhood and early manhood. He recapitulated the history of photography in this century. Beginning as an amateur and a folk artist of some talent and far greater ambition, he became a fine commercial craftsman, and, at the same time, an excellent, but conventional artist. And here is the American miracle once again—he was able to escape the bounds of this narrow success to become a full and splendid artist, with series after series of work flowing out of him for almost twenty years; then to shrink into the curious prints of his last years, the small world of backyard cats and satires. But interspersed with these, like shafts of dark and contradictory lightning, are the Point Lobos cliffs and black and overcast tides: immense fugues of all his craft and insight, the last of them made ten years before his death.

III.

When Edward Weston was in Mexico in 1924, he wrote to his son Cole, then five years old:

> Dearest Babykins Cole—I don't suppose you really are a baby but I must *still* think of you that way—do your eyes *still* sparkle and snap and do you still have your freckles? —when I was a little boy they used to call me "Turkey Egg" because I had so many freckles!

Freckles and all, Weston was, indeed, the very model of the All-American Boy, a Tom Sawyer of the chic suburbs. He hated school, played hookey when he could, tried to make an athlete of himself, went to work when he was seventeen. He was an anachronism, a throwback to a different, more crude and vigorous and mystic American genius. His sister May (Mrs. Mary Weston Seaman) traced the family tree back through nine generations, to its principal founders, John Alden and Priscilla Mullins. "A double-blood line," she wrote to Nancy Newhall, for two of their descendants married one another. Earlier yet, the Westons' had come from Kent, England, some ten years after the *Mayflower* voyage, while the Bretts', on his mother's side, were with the invading French who crossed the Channel in 1066. His grandfather, Edward Payson Weston was, as May wrote in 1950 (in a shaky, left-slanted hand, the result of a recent stroke):

> . . . the principal of the Abbott School for Boys—70 boys there

were at the time — in Framington, Maine. Then afterward he was chosen the first principal of Terry Hall in Lake Forrest, Illinois, and afterwards he opened Highland Hall, Illinois; he was a literary doctor. He had copies of Poe, Sir Walter Scott, Irving, all those boys who wrote at that time. We inherited them.

He had been a graduate of Bowdoin College. He got out the book *Bowdoin Poets* in which Longfellow, etc., wrote to say nothing of one

Chandler Weston on Wall

of the boys. . . . so you can see where you got your talent for writing which is no mean talent, I must say.

Although Edward Weston's memory of his grandfather was vague, his sister's was not. In response to a remark by Nancy Newhall, that the good man was a black Republican, she replied, rather testily:

You are all wrong on my grandfather Weston. He was a dignified old gentleman — in fact all of the men were dignified. . . .

He and his old friend Mr. J. L. Soule used to correspond in Latin . . . he always had high class schools, which the best of the young ladies used to attend.

He was born in the "Sky parlor" of grandfather Weston's school called Highland Hall. The sky parlor was in the dome.

We moved into a house thereafter and in this house Edward was born. We lived in this house until I was eight years old and Edward was a baby, and then we moved to Chicago.

Grandfather Weston was not an abolitionist. He was too quiet for them.

Edward Weston's father was a medical, as opposed to a literary, doctor. In December, 1915, when he was an old man, he typed out a memoir of his own childhood: *Playdays: Incidents in Early Life*. It is a plain, quiet account, as moving in its tone as in its content, reflecting an American as vanished as any Mohican:

For my children and grandchildren, I have to say: When I was a small boy I was interested in everything out of doors. The birds, the insects, and the flowers attracted me, and I soon learned to know the common ones by name. I first collected insects; later, birds and plants.

One Sunday, in early summer, I walked into our lattice-work summer house: an insect was resting on the inside. I was making a collection, and this was new to me. I had been brought up a strict sabbatarian, and I did not disturb it.

Monday morning I found it waiting for me. Of course I considered it an act of providence.

Once I was walking in a vacant lot, with my bow and arrow. I had a fortune in my pocket, a dime; where I got it I do not remember. But I lost it. Probably there was a hole in my pocket. I looked for it a long time, but without success. Then I said to myself, I will shoot my arrow into the air, and it will come down near the lost coin. When I went for the arrow I found the dime near it. Providence again.

I was interested in all children's sports and games. We made bows of barrel hoops, and later of better material. With other boys in the neighborhood, a bow-gun (cross-bow) club was organized.

We made our own bow-guns and arrows; and though very crude, they furnished us much pleasure. We had no targets, and just wandered around, shooting at any object that attracted our attention. I do not remember that we ever killed any wild, living thing. Perhaps we did not try to.

Next came the use of the shotgun. My father had a double-barreled-muzzle loading gun in his study. It had never been used, and why he bought it, I never knew. He was a schoolteacher, and never cared for hunting or fishing. Neither had his ancestors; nor did those of my mother, though they grew up in Oxford County, Maine, where the bears lived.

I longed to shoot the gun, but when I asked to do so, father kindly but firmly said "no." Mother was always afraid he would let me, and that I would kill myself.

Back of the house, [which] was a four-story brick building, a girls' school, there was a pine grove, in which were many grey and red squirrels, and chipmunks. One day I asked my father if I could go out and see if I could get one. He said "yes." I jumped for joy, and started for the gun. There was a sudden reversal of feeling, for he quietly said, "Oh don't take the gun."

But by the time I was thirteen or fourteen years old the gun was mine. The trouble then was to find any game. We lived in Gorham, Maine, ten miles northwest from Portland, and it was a barren country for a sportsman. There were a few partridges, rabbits and squirrels. Red foxes had not been quite exterminated. Those who hunted them were looked upon almost as vagabonds. Now, a fox hunter is generally a gentleman. The wild pigeons were not all gone. I can remember when in that part of the country they were numerous and used to be netted. In fact, one of my boy friends and I, with much

labor, made a pigeon-bed, and caught a few birds. I shot more pigeons in Lake County, Illinois, in the seventies than I did in Maine ten or fifteen years before. When sixteen I went to Eastport and shot sea birds.

My chief pleasure was shooting crows and bluejays, because they were so wild and difficult to approach. They usually saw me first. When I came west in 1870 the jays were tame, and the robins wild.

In addition to the game mentioned, I occasionally shot a woodchuck. It was said of them that they would dodge at the flash of the gun. It is probable, however, that unless killed outright, they would crawl wounded into their nearby holes. Late in the fall I occasionally caught a mink. This was the only game I ever got pay for.

The fishing was poor, but we caught a few brook trout, chubs, horn-pouts, and suckers.

Of course in the winter we skated, slid down hill, and had snowball battles. From 1860 to 1870, baseball took my time and chief interest. We played matches with nearby clubs.

I enjoyed work in the gymnasium, which I had in the second story of the stable. The 100 yard sprint and the standing broad jump were my chief pleasure.

Six weeks of the summer was passed at Mount Blue, twenty miles away. The forenoons were spent in school work, and the afternoons in play, hunting, or fishing. The finest sport which we had was fishing the narrow mountain streams, broken into little cascades, for trout; little beauties they were, six to ten inches long.

I married, came to Illinois and practiced my profession. In my western hometown there was a family named Gray. About 1880, they moved to South Dakota, took up a large tract of land, and built a comfortable home; and for ten years I visited them each fall, taking my shotgun for game, and my rifle and revolver for target practice. Rev. Mr. Gray and his four boys were good sportsmen. Some years I would go early in the season for chickens and snipe, and other years for ducks and geese.

One year I took my daughter May with me, and though only fourteen years old, she became a good shot. As she had never shot at a flying object, I thought I would give her a lesson. I took off her canvas hat, and told her I would throw it into the air, and to shoot at it when I gave the word. She said, "Oh! father, I don't want to spoil my hat." I answered, "Never mind, you won't hurt it." Result, the hat was blown to pieces. The things which interested me have always appealed to her. She is now Mrs. John H. Seaman. Her home is in Tropico, California.

My only son, Edward Henry Weston, has followed his father in a love for outdoor life. He's a well-known photographer, living in Tropico, near Los Angeles, California.

I can't remember when I did not keep a few chickens. I was very proud of a Dorking "rooster" given me by my grandfather Burbank. My love for poultry did not end then. After I had grown to manhood,

I had, as a fad, a fine lot of thoroughbred poultry, and won many first prizes in shows from Ohio to Texas.

We had a fine orchard, and raised small fruit, vegetables, corn, etc. During the summer, it was my duty, and pleasure, to do farm work, "holding the plow or driving"; and hoeing, haying, and harvesting. Sometimes it fell to my lot to care for the horses, cows, and pigs. I have never regretted this experience.

He was also intensely interested all his life in "Archery, the finest of all sports." As his daughter May recalls, speaking of her father, Dr. Edward Burbank Weston:

Too much cannot be said of him!

My father had a large practice in medicine in Highland Park and after, we moved to Chicago. On the side he was interested in all sports. I used to see him shoot with a bow and arrow when I was just a little tot—then it all died out completely and I saw him revive it by his own personal efforts years later.

He rode a nice Columbia bicycle all decked out in his bicycle suit, to say nothing of his dignity, which he never lost no matter what he was doing, nor the well modulated tones of his voice—just like Edward's—

He wanted the best of everything.

I had the best Beagle hounds. He had the best horses—only one of them—it was balky. The townspeople used to say, "Dr. Weston has a horse that walks downtown on his hind legs!" He used to let me ride with him because I would sit still. I played with the corner boys—played baseball and climbed trees, etc. Still I never got to be a tomboy. This was all in Highland Park before we moved to Chicago.

It was nine years before Edward was born, so father had to [make] a boy out of me.

On his time off, he would take me to the ball games and trotting races.

Edward Weston inherited a fine bow from his father, but sold it in the twenties when he desperately needed money:

No sales, though a prospect of selling my father's old bow and his collection of archery scrapbooks. Am I lacking in sentiment? Perhaps—but I will do anything to further my work

But the good doctor was dead by then. He ends his short memoirs thus:

I must say one thing more, tho' it is hardly germane to the subject.

Few happier families have lived than ours. The statements which I am about to make will hardly be credited by some. I never knew my parents to have a wrangle, or an unpleasant word, between them.

I never could tell which of them I loved the better. I had two sisters, one older, and one younger, than myself. With neither of them did I ever have a quarrel. Nor could I tell which of them I loved the more.

The relations between parents and children were as perfect as

anything human could be.

Whatever the ordinary disappointments, and ups and downs of my uneventful life have been, this compensates for them all; and my earnest wish is that the dear ones who may survive me may pursue the "even tenor of their way" with Love and Duty as their safeguards.

It was Midwest Utopia we hear described in these pages; a homey paradise that never quite existed, certainly not for Edward Weston. As his son Cole remarked: "He had a terrible childhood." Edward was five years old when his mother died, and little remained of the memory but pain. "Babykins Cole —," he wrote from Mexico, when the boy was a like age:

It is six months since I have seen you! Do you even remember how I look? I wonder because my mother died when I was five and all that returns to me of her are a pair of black piercing eyes — burning eyes — may be burning with fever —

Dr. Weston remarried, but unfortunately, Edward "never cared for the stepmother particularly, at all." How, indeed, could he? His father's new wife already had a son — his name, and even existence, is never mentioned in Edward Weston's journals. ". . . and so May (Mary Jeanette, his older sister) really sort of took care of him. She was just like his mother . . . she was a great gal, a wonderful person, just a neat person. They were extremely close." Since she was nine years older than Edward, the sense of responsibility was a natural one. Dr. Weston — serious, abstracted, busy as doctors are in every age — nevertheless understood the heavy burden of responsibility placed on his young daughter, and recorded in his scrapbook (*A Book of Family History*) that he had written a birthday letter to May, after she was married and living in Tropico, California:

. . . I spoke of the cares which she assumed when her devoted mother passed away.

May was then thirteen year old and Ed (Ted) was four. From that time she was, for years, more a mother than a sister. A mother could not have cared for a child more faithfully or successfully than she did; and they grew up with a double love, that of mother and son, and sister and brother.

There was also Aunt Emma, whom Edward Weston loved very much, and Uncle Theodore, whom he feared and opposed. And possibly there was a German woman (purely hypothetical perhaps, was she a servant?), who taught him to say, as he wrote thirty-five years later to his friend Miriam Lerner, "*Ich liebe dich mit allen meinen herzen* — I learned this when five years old, but have tried to keep in practice!"

When he was six, in 1892, Edward entered Oakland Grammar School in Chicago and managed, against all his instincts, to graduate and go to high school:

. . . [at school] I had drifted along mechanically — passing from grade to grade — by fair or unfair means — watching the clock for recess or noon hours or vacation time — taking home books for study and returning them unstrapped next morning.

He concluded in a letter to Brett:

[School] is a good place to train and mold the minds of those who are to be the slaves of the world.

His son Brett remembers that his father told him to follow two basic precepts in his life: "Be your own boss, and never believe the newspapers."

Writing in his Daybook in December, 1931, when he was finally aware and confident of his standing as an artist, he recorded a discussion with the photographer Consuela Kanaga, about himself:

I have always felt the great importance of my closest friends as influence: names unsung to the wider public and further back in time, parents, — father, sister, uncle, aunts, — and so on, an endless chain, each link of importance to an impressionable child and man. But — I cannot record, give credit to a single schoolteacher.

Schools, I only remember as dreary wastelands. I cannot believe that I learned anything of value in school, unless it be the will to rebel, to "play hookey" which I have done on numerous occasions since those first days with my camera in the snow-covered Chicago parks: "played hookey" from my first job, from my own business, from my family life, — not without some sense of responsibility, but never with after-regrets.

. . . One more thing: though I once wanted to be an artist — that is to paint; photography was not taken up as a substitute, a compensation, for I always was one of the best painters in my school classes. . . .

One thing I must note: from youth I have taken for granted, accepted the fact, that some day I was to be a leader. This state of mind I held even before I knew what direction my life and work would take.

It is true, in one sense, that the boy is the blueprint of the man: attitudes, values, habits, and especially the private and physical rhythms, are solidified during those first years, ground down into the subterranean mine by the sheer weight of adult experiences, good as well as bad. Yet the deeper and more uncomfortable truth is that the grown man is predetermined by a past which is not even his own. Many talented persons are diverted from great promise in the arts to indifferent careers in merchandising or dentistry; but the reverse is also true. There are plenty of good

advertising men, engineers, fry-cooks, and corporation presidents who quit to become third-rate artists. The development of genius is sometimes as plain as a tree; at other times, abrupt and mysterious. Freud was a doctor who, until he was forty, thought morphine to be a cure for all mental ills; Haydn was a pleasant composer, and a successful one, safely lodged in an unhappy marriage, until he fell in love, at forty-seven, with a married Neopolitan mezzo-soprano, three formidable words that would have stupefied a lesser man, but made a great and innovative composer out of a competent one; Edward Weston was a clever and sensitive commercial photographer until he was past thirty-five, when something very similar happened to him.

Yet the earlier self is never quite dead; it remains watchful and nasty, from inside the later and more sophisticated selves. On August 19, 1950, May wrote to Weston:

[Your father] . . . didn't have much time to laugh and you inherited this trait. Father took "Puck" and "Judge," two funny magazines and you would make me read them to you and explain each joke.

One time when you were a little boy, Cousin Harry Prescott said, "Doesn't he ever laugh?" Our mother, who loved nothing better than you, retorted, "He doesn't see anything to laugh at!"

All through his life, he rarely laughed aloud. Nancy Newhall reports, "He would put his head back, narrow his eyes, and smile."

Tom Sawyer didn't laugh much either, and Edward Weston was stamped in the same pattern. His sister wrote, in her old age, in her shaky handwriting:

Darling Buddy . . . Do you remember your hobby horse? It was so big that I had to lift you up on it. It occupied the alcove off the front bedroom.

I remember you were so fussy about your things that you hardly would let the girl touch them when she was cleaning.

Do you remember how you used to sit on the curb in front of our house on Drexel Boulevard, having put a good-sized rat under your cap and the passers-by would look with the greatest astonishment at your cap to see it moving about on your head. You never cracked a smile.

This was, as one can imagine, a rather two-sided joke. As his sister wrote to him, forty-five years earlier:

About that temper. Hold onto it boy. Don't go into things so *hard*. Relax and take it a little easier. As Uncle George would say, "Well what'll it matter a hundred years from now?"

A long time later, he met an old friend whom he had known when he was twelve. They reminisced:

. . . to youthful days — 3975 Drexel Boulevard — once a fashionable street, — Gertrude, his sister, my first calf love, — Lake Michigan, playing in ice caves, jumping the ice floes, — fishing for perch in the sunrise — the haunted barn. What child does not know some haunted place? Indeed, these are commonplace experiences in America, but Edward Weston was not quite a commonplace boy.

In a letter, written to him when he was nineteen and partly quoted above, May adds this bit of advice: "Save every penny you can, always *eating* enough."

Eating, in fact, seems to have been an early form of rebellion for Weston. One has to have experienced the middle-class table, loaded down with steaming calories, to understand how it was the magnetic center of a certain kind of American life; and what relief it was to escape these great, bosomed aunts and cigar-eating uncles, to ride skates over the uneven sidewalks of cities, bike to the suburbs, or simply hide in an empty lot by oneself:

I recall as a boy, walking miles in bitter winter weather rather than ride on a crowded Cottage Grove Avenue cable car. It was not because I would be physically uncomfortable, jostled or stepped on, but because I became psychically distressed, — though I didn't reason this way in my teens. The same reaction used to come from Christmas shop crowds, the solid, suffocating mass on State Street. And today I have similar reactions when living in a city. Something quite poisonous exudes from people "canned" in dreary rows of ugly houses.

Weston wrote of himself all his life as a healthy, outdoor, countrified, sports-minded man. As Cole writes:

[E.W.] turned out to be a top sprinter in high school, and to this day I can remember being beaten badly along with my brothers, in the 100 yard dash, and the standing broad jump, on the Carmel beach, where most people only think of him as photographing the wonderful kelp forms.

. . . the photograph in which he is shown holding his sister May up with one arm, attests to his fine physical shape, of which he was so proud.

In his later years, his chief pleasure was to watch sporting events, whether it be track, boxing or football on the television. It was a great day in his life when the four-minute mile was broken.

His favorite sporting event was track, with boxing running a close second. One of my earliest memories is that of Dad and I standing in front of a radio store, shivering in the cold, listening to the famous Dempsey/Tunney fight.

Edward Weston's mother, sometime before she died, when he was less than five years old, was said to have wanted Edward to be a businessman like Uncle Ted and the rest of her family. With all the bromides of environmental and class pressure, there is no doubt that he would have become exactly that, except for one quite ordinary circumstance — his father gave him the commonest

present in the world; a Kodak Bulls-Eye **#2**, that took a picture $3\frac{1}{2}'' \times 3\frac{1}{2}''$. Dr. Weston sent it to his son in the summer of 1902, while Edward was staying on a farm in Michigan. He also sent a letter of instruction; well worth quoting in full, if only to show the difference between this cautionary note and the passionate letters that Edward would send to his own four sons:

Dear Ted—I will send the Kodak. I have no book of instructions, but will get one if I can. But I think you can work it. Don't try to take any inside views, which require a time exposure. Take only *snaps*. Then you will not have to pull up any slides. You'll not have to change anything about the Kodak. Always have the sun behind or to the side—never so it shines into the instrument. Don't be too far from the object you wish to take, or it will be very small.

See what you are going to take in the mirror. You can only take twelve pictures, so don't waste any on things of no interest. You'll find enough for the twelve.

After you are ready, and see your picture in the Kodak, all you have to do is press or move the lever sidewise. Press it steadily until you hear a click. Then you have your picture, and the instrument is set for the next. Do not think you must always press the lever the same way. No matter which way it leans when you throw it over, it makes an exposure. The lever is the thing with a saw-edge top to it. After you have made an exposure, you must turn a new film into place. Before you use the Kodak you will see a figure in a hole in the rear, No. 1. After you have taken a picture turn the thumb screw until No. 2 shows. Then you are ready for another picture. Don't forget to turn the film, for then you will have two pictures on the same film—and both spoiled. I hope I have made it plain. I'll get you an album to keep pictures in. You'll like to take snaps at athletic meets.

I got your letter at the office Sunday. I mailed it to May.

Love to All. Your affectionate Father.

When are you coming home?

See if you can snap any birds—even chickens. But you must be close to them.

Two days later, Edward Weston replied:

Dear Papa: Received camera in good shape. It's a dandy. Is it the same one? I think I can work it all right. Took a snap at the chickens. I think it's a good one as I was right near them—they were coming towards me. It makes me feel bad to think of the fine snaps I could have taken if I had had the Kodak the other day. I was within six feet of two swallows perched on a wire fence. It would have made the prettiest imaginable picture. I was only a little distance from a wood dove, and could nearly have touched another little bird. I suppose I'll have plenty of chances and I'm going to wait for good subjects.

Tomorrow I intend to take the house when the sun is right. I would like to take a view of part of the farm but wouldn't it be rath-

er small? I can see a fine picure in the mirror from the ridge—looking down. What do you suggest? May is coming Monday. Aunt Em left today. We are going to help Mazie [May] all we can even if Aunt Em is gone.

I'm so glad to be able to use the camera. I wish I had had it at the "conference" meet.

Must close and meet Aunt Guss at train.

Your loving son—Ed.

It was the beginning of a normal obsession, by no means an uncommon one, for that or any other period in America after George Eastman. We have all felt it, and keenly, too; especially before we were twenty. The mind stares through the eye, is repelled or excited by the world; one stares once more at the same sight repeated in bright miniature on the mirror, or the little round viewer, or the brilliant ground glass. The camera is held tightly between sweating hands, and one extends, and very carefully, too, the right forefinger, and presses a tiny lever. Click! Magic! The vision is frozen forever, or almost forever anyway; one is always hoping "it will come out," but often enough it doesn't. So we wander down dusty Sunday streets, around turns in country roads, looking for something to "snap": the perfect, sudden, devouring world.

To a boy who hated school and was bashful, restless, somewhat morose, with a bad temper who preferred to be alone, this black box was the ideal friend—the Aladdin's lamp of adolescence. Generally made of leatherette on a wooden frame, the little box had three glittering eyes: a lens, a finder, and a red window for watching the numbers. Some months later, dissatisfied with this plain model, Edward Weston saved enough money to buy a new one:

. . . denying myself every luxury—indeed many comforts too . . . money saved penny by penny, walking ten miles to save 10¢, denying sweets, selling rags and bottles . . . until with $11.00 in my pocket I rushed to town—purchasing a second hand, 5 × 7 camera—with a ground glass and tripod! And then what joy! I needed no friends now—I was always alone with my love. . . . Zero weather found me wandering through snow drifts—seeking the elusive patterns in black and white—which covered the ground—or sunsets over the prairie wastes. Sundays, my camera and I would take long car rides into the country around Chicago—and nights we [the camera and E.W.] spent feverishly developing my plates in some makeshift darkroom, and then the first print I made from my first 5 × 7 negative—a snow scene—the tightening, choking sensation in my throat—the blinding tears in my eyes when I realized that a "picture" had really been conceived. . . . I can even record my ecstatic cry as the print developed out, "It's a peach!"—and how I ran, trem-

bling with excitement, to my father's library to show this snow scene made in Washington Park — a tree, a widening stream, snow-covered banks. I slipped into the stream and rode home on the Cottage Grove cable car with my trouser legs frozen stiff as a board . . . I can see every line of the composition yet — and it was not half bad — . . . months of happiness followed — interest was — sustained — yes — without many lapses — is with me yet. . . .

After the first photographs, he also bought a developing tank. His first prints were made on printing-out paper, clamped in a wooden frame and exposed to the sun; his second series of prints he developed indoors in red light.

> . . . My whole life changed — because I became interested in something definite — concrete. Immediately my senses of sight and touch were developed — my imagination keyed up to a high pitch — because — at last after years wasted — accidentally enough, it is sad to relate — I became interested. . .
>
> My enthusiasm for this print would not last long: I soon realized that the tree was too black, the snow too white, and my struggle began, caused by dissatisfaction, to improve my technique, — a long tough struggle without help, for I was a bashful boy, dreading to hear my own voice when making purchases, — to ask questions would have been impossible.

He quit high school, and his father got him a job as a shipping clerk and errand boy at Marshall Field in Chicago in the wholesale dry goods department, working with his Uncle Theodore. He worked for three years, and had, no doubt, a promising future there. But during these three years, between 1902 and 1905, he continued to photograph in his spare time, and indeed, was especially fond of the work he did. He himself wrote:

> I feel that my earliest work of 1903 — though immature — is related more closely, both in technique and conception, to my latest work than are several of the photographs dating from 1913 to 1920; a period in which I was trying to be "artistic."

Two of these earlier photographs were shown at a retrospective of nearly two hundred prints at the Morgan Camera Shop in Hollywood. They are: "Snow Scene," and "Spring;" the latter, a wooded landscape, was also exhibited in Chicago in 1903. He kept these early prints and showed them, in the thirties, to his mistress and pupil, Sonya Noskowiak; she thought them "beautiful and quite lyric." He visited the photographic salons, and in particular, the Ninth American Salon at the Chicago Art Institute in 1903. What he saw, "influenced me deeply." He wrote to the Newhalls:

> I recall vividly the first exhibition of photographs which I went to in the Chicago Art Institute, 1903, that was a thrill. I suppose that now

I would not look twice at any of the photographs then shown, but maybe I would! I can remember some of the names — Eickmayer, Fleckenstein.

These names, of course, are quite meaningless to us now, but they were not bad photographers, by any ordinary standard. Eickmayer's portrait of Sadakichi Hartmann (a half-Japanese dancer, artist, critic-of-all-arts, with an exotic face and a sharp and chatty style) is, in fact, rather beautiful, and not in a soft-focus style at all; that may be why Edward Weston remembered it.

On November 25, 1897, when Edward was eleven-and-a-half, his sister May married John Hancock Seaman, an electrical engineer. They lived in Chicago, at first, and then moved to Los Angeles. She wrote her little brother almost at once:

> Darling little brother. I hear the pictures of the children are good. Are you going to send me some? At first I just hated it here. Our train pulled in, in the midst of a humid fog, and it was more like what I'd heard of London than California. The fogs have disappeared now and it is much better, but as you have probably heard, the heat burns but you never feel oppressed or prostrated.

They lived, then, in a small suburb of Los Angeles called, in the booster lingo of the times, Tropico. On clear days, the sky was an intense desert blue; a rarity now, of course. In those days, Tropico had a rural, almost pioneer look:

> The floor is dusty, oh my — just like Michigan — no sidewalks.

The exact date is uncertain — it may have been 1904, because she already had four children, two of them mere babies — and she goes on to say:

> I know I shall love it out here when I get settled. I shall never be satisfied until I get you out here — I can never live for long without you — my first baby — I have kept your lovely letter and thank you for loving me so much my little brother. I still like the "Old Chicago town" pretty well . . . Love and hugs and kisses — May.

In another letter, dated August 2, 1905, she writes:

> We bought two boxes of berries from a Jap woman and had a fine shortcake for supper. . . .
>
> There is plenty of room to run out here dear. Am glad you are gaining a bit — good luck to you . . . I am so glad you like being superintendent of M. F. & Co. My but I shall be delighted when I hear you have a little bank account and are beginning to save to buy your little bungalow and house.

Prior to October 8, of the same year, she must have received an angry and frustrated letter from Edward Weston — obviously he was eager to come out to California, but no one would lend him the money — for she answers thus:

Poor little brother—You must cheer up and calm down and save
your money or you never will get out here. . . . Expect to see us in
the spring. From all that I hear, expect you will have to pay your
own fare out here. It will keep you scheming to save enough . . . the
mountains make the grandest dark outline against the sky. Abide
your soul in peace little boy. Sister won't let you miss it. You're too
young to wish to have your life to live over again. No matter how old
you are when you get out here, you will think you are just beginning
to live.

When her baby Jeanette was sick with "glands," the treatment
was, again, particularly Californian—"jolts of static electricity:"

Am reading a book on it and am a firm believer in it. My little
quack doctor is an expert with the x-rays and they sent a Chinaman
who had been shot in the hip by an Indian while out plowing, down
from San Bernardino for him to make the place for them to cut the
bullet and they have no machines there. Did I tell you about the Mr.
Nixon who had a tubercular gland open in the front of his neck, the
doctor opened one on the side and he had a couple more about
ready to open? I helped fix him one day and saw him a couple of
weeks later and the swellings had gone down so that they are most
well and won't have to be opened and the other wounds were pro-
gressing in a most miraculous manner. A Mrs. Raven has the same
trouble in her nose and that's nearly cured.

It reminds one strongly of that particular American literary form,
terse and gabby at the same time: the patent medicine endorse-
ment.

In July of 1905, she writes again to Edward, who is now living
with his Uncle Theodore and Aunt Emma:

Dear little boy. Here's howdy to you. Did you ever read *The Virgini-
an*? It's fine and dandy.

. . . Come out here dear and you won't spend a nickel a week on
frills and will enjoy yourself just as much. Save your money and
when you do come you can buy a horse to ride and a lot and John
will help you build a house on it. You can get a nice lot now for
$225. Oh these mountains! You would be wild over them. I'm getting
the fever. More later. Mazie.

On August 1, of the same year, she wrote him with astonishing
frankness:

Darling brother. Don't bring any girl to California with you. Wait a
while and then after you are settled, if there is anyone you want you
can go back and get her. This is hard country on women—I'm afraid
you are a little impulsive. Hold your horses and wait till the right
girl comes along. Then I shall meet her with open arms if she isn't
common, and I know you would never care for anyone who wasn't
nice and refined. Anyway you couldn't live with her, you're too all
right yourself.

My but you are a fine boy! Sister is so proud of you. If I could
find a little wooden box, about four feet high and as long, I'd send
you the finest plum you'd *ever tasted* from a tree in our yard.

Then, before Christmas of 1905, she begins to mention the Chan-
dlers: a Los Angeles family who now own *The Los Angeles Times*
and inherited great chunks of California real estate; they were
prosperous even then. May and her husband went to their dances,
though the guests were "mostly Chandlers." They had a grand
four-piece band; and on one such occasion, May met Flora May
Chandler, one of the Chandler girls.

In April of 1906, she writes:

Darling Ed. I can't think of anything but you are coming. Was going
to send you a swell L. A. horse show poster, but concluded to wait
and give it to you . . . Didn't send you any Kodaks either for the
above-mentioned reason.

In the same month she wrote again:

Darling Ed. Can't you come before June? John . . . says he will
guarantee you a position and of course we wouldn't hear of you stay-
ing anywhere but with us. Eat! Why I'm preparing to eat *you*. . . .

Flora Chandler and I are getting to be great friends. She took me
to see *When Knighthood Was in Flower*—it was *great*.

And in a letter somewhat later:

Dearest Edward. Just a word before I sew like blazes so I won't have
anything to do when you come. It seems just too good to be true. . . .

Clay [one of John Seaman's brothers] came in and spoiled this
letter. He has a girl and he just haunts me to talk about her. It is
Flora Chandler. She is one of the finest girls I ever saw and now,
don't faint, I am going to play the accompaniment to three songs for
her at a concert in May. Haven't I cheek?

Edward Weston arrived in California—"felt hat, flannel trousers,
little trunk," and all—on May 29, 1906. He was twenty, but intel-
lectually and emotionally, he was about to be reborn, although the
gestation was to be long and convulsive.

He was leaving one family and going to another. Yet, in a
deeper sense, he had long ago left his real family, or had been
left by his father and stepmother. He was breaking with his Aunt
Emma, too; though when she was dying years later, he wrote that
she was:

. . . one of the important figures of my life. She has mothered me
since my own mother died, when I was five years old. Even in recent
years a letter almost always held a check or a dollar bill, admonish-
ing me to try a good steak, that I did not eat enough! The dear wom-
an always worried over my vegetarian propensity.

But he was extraordinarily close to May. She wrote to him much

later, in a hand that shook with the first strokes of senility: "Does Nancy (Newhall) know how you have written me a postcard every day for ten years?" In the 1920's, upon receiving Edward's prints of "Ramiel in the Attic" and "The Prologue," among others, she tells him that even her husband now thinks, "Edward has arrived." Once, years later, when she was depressed (they were living in the Midwest again), she wrote to Edward:

> . . . When I feel myself slipping—just to feel that you feel that I have given you any thing and that you still care for my opinion of your work inspires me to struggle to hop on the back seat of the little wagon you have hitched so securely to a star.
>
> *Many many* thanks for the generous words, dear little brother, and don't forget the cultivated taste of our father and his father and so on back, serving as a stepping stone from which your adventurous spirit can make its journey into the regions of shadow and light and bring back the exquisite things for our sight.

Is there too great a burden here? A responsibility too awful in the intensity of its hope and love?

> Go Little Brother, go and fulfill your Destiny. I realize that you have left me for a time—perhaps forever—it is instinct emotion that I see you go.
>
> Go, little frail and inward driven soul—pressed by the mighty urge of your genius—your mind has left the side of mine and gone beyond into the maze of those strange things as yet unknown. This says my *mind*—but, as I write, my *heart* cries out and begs you come again to touch this tired life of mine with one more shock that I may feel the urge of life once more and contact with the things that are.

IV.

"The Pueblo de Los Angeles has a population of several hundred souls; and boasts a church, a padre, and three or four American shops; the streets are narrow, and the houses . . . built of adobe. . . . In most respects, the town differs but little from other Mexican villages." This was written about a visit to Los Angeles, only one hundred and twenty-five years ago, by the young Lieutenant G. D. Brewerton, who was assigned (because he could read) to travel with Kit Carson. The discovery in California of irregular pellets of a perfectly useless, but fatally symbolic metal, changed Los Angeles forever, as indeed it changed the course of the Republic. Gold brought a mob of citizens to the West, and these brought the railroads; and when the railroads were insufficient for the vast distances of the United States, the automobile was invented, which brought with it the common sensation of dream-like speed behind the wheel—and poison from a pipe dragged behind it.

Today Los Angeles is, in a way, a very large model of the United States. A web of crisscrossing, sunken, or elevated roads, holds the city together; and it is easy to imagine, when driving down these eight-lane, concrete arcs, that here is the real city, unwinding under your wheels; that all the edifices—gunnite suburban houses, the flat, windowless factories, the skyscrapers of western insurance, the colonial mortuaries, and the hospitals, motels, supermarkets, banks, and museums—are architecturally interchangeable; and the oil pumps—swarming on the low hills like green steel grasshoppers, each with its own rhythm—are all merely feeders, storage tanks, and distributors for the great cement sprawl of the freeways. Yet the city, however unnatural it looks, is still a cluster of former villages. We all live in a mental precinct of two hundred to five hundred persons at most; we derive our manners and morals almost solely from the people who are listed in our private telephone books. More persons than this are simply incomprehensible; they are about the most we can endure in real human relationships. So a city is, in operation, something of a symbolic entity, somehow unreal. This is particularly true of Los Angeles: it is unique because it is really an imitation of itself. The Mexican has become pseudo-Mexican; the Japanese has become Nisei; and the Iowan has become a Disneylandman. Even the climate has changed, particularly since the first artificial rubber factories were put up in 1941; the ancient and intense blue desert sky has now very often a dun yellow stain at every horizon, and the snow-covered peaks of San Jacinto or San Giorgione, cited by Edward Weston's sister in her letters, are now generally invisible. Yet this collection of overlapping towns is still surprisingly close to the forces of nature: skunk, deer, raccoon, coyote, rattlesnake, and even the stupid opossum, still live happily in the brush-covered hills. Every ten years or so, the earth shakes itself violently; and every year, swift fires consume vegetation, houses, and even swimming pools.

When Weston and his little trunk arrived on the train (at Shriner's special holiday rates), Tropico was still separated from the main part of Los Angeles, as well as from Hollywood, by orange groves and dry hills of decomposed granite, from which sprouted the delicate Spanish broom, or the parasitic, straw-yellow dodder. The light was dusty yet bright; except in the foggy

months of May and June. Weston's folks (May and John Seaman) had a house newly built and a garden, freshly plowed. They were middle Americans in every way, or certainly appeared to be so. Thus Edward Weston, who hated these middle-American values, and fought them out of a stubborn, angry instinct, found he had simply escaped into another wing of the same prison.

Nobody loafed in this America, except for Huckleberry Finn, and we all know his hideous fate. Edward's brother-in-law got him a job as a surveyor's helper; it was healthy open-air work; he drove stakes in California and Nevada, laying out the boundaries of the great, thieving land grants of the railroads. He photographed as an amateur during this time, but we will never know if any of these photos are of value—they haven't survived. He himself remembers one:

> . . . in 1908, or about—a montage (or is collage correct) of Joshua Tree; skull, desert and a stage Indian, titled "We die, we die, there is no hope!"

He saved a little cash and bought a postcard camera, a predecessor of the Polaroid. The film was reversible, and one waited five to ten minutes before giving the customer, in exchange for a quarter, a nice, moist print. Event and photograph were thus close together in time; but, in time, the photograph (being insufficiently washed) faded into brown pale memory.

With this sort of camera, Edward Weston walked or went on horseback from house to house, photographing dogs, cats, horses, and people. There were three kinds of laboring foreigners in California at the time (as indeed there still are), and all at the bottom of the economic pile: Chinese, Japanese, and Mexicans. The poor have always had, out of a mixture of love and insurance, large families; and they would be twice as large if one included the children who died of diphtheria and polio, unchecked at the time. Weston often photographed, for a fee, of course, the dark dead baby in its white lace dress laid out in a white coffin; these photographs, too, lie undiscovered in the backs of cupboards in Mexican homes.

Meantime, he was falling more and more deeply in love with his sister's friend, Flora May Chandler. He was shy, fierce, inward, and had had very little experience with women, aside from a couple of experiences with Chicago prostitutes. Flora was a schoolteacher, and six years older than he. His son Cole recalls that his father told him that Flora "didn't care for him at all. But he kept coming around. . . ." In 1908, he left Tropico and re-

turned, surprisingly, to Chicago, where he attended the Illinois College of Photography for nearly a year. Here he learned the basic principles of the darkroom procedure and adopted chemical formulas for development that he used, with little change, all his life. Nothing remains of his achievements there, if any; but he was unhappy, and never got his degree.

He came back to Tropico and courted Flora Chandler once more. They were married on January 30, 1909; and in 1910 his first son, Edward Chandler, was born (the first name being his own, as well as that of old Dr. Weston's, and the middle name, Flora's surname). His second son, Theodore Brett, was born in 1911 and was named for his late mother's maiden name. Marriage

Flora Chandler Weston

and children pressed Edward Weston back into the normal, middle-class way of life. He had several odd jobs: the first with a George Steckel; the second with a man named Hemmingway, which lasted all of one day (Weston's own note on this job says sharply, "didn't know the terms"); and finally, a job with Mojonier Studios where he did retouching of prints for a whole year.

Several snapshots remain of these years. One is of Edward Weston himself in early manhood, wearing the long jacket and remarkably ill-fitting trousers of the period; he has a tie, a collar, and, above his rather full face, one can see that he is just beginning to go bald. The photos of Flora are, as a completely wrong

presage of her future, rather moving. In one, she is leaning on a grassy slope (perhaps it's a sweethearts' picnic), "gussied up" in a long white dress, and she wears, maybe because the morning is chill, Edward Weston's dark jacket over her shoulders, like a cape. One arm supports her face; she's smiling, at ease, confident of love. Was this photograph taken by Edward Weston? Very probably; but all his life he sharply distinguished between snapshots and serious work. There is, in fact, (mounted in his father's *Book of Family History*), a more formal portrait of Flora, within an oval aura and very slightly diffused. She has a very classic Anglo face, with a rather long and aristocratic nose, wide nostrils, pale eyes, and the decisive jaw so fashionable at the time — 1909. It is signed, and very neatly too, E. H. Weston. Another photograph remains from those days; a portrait of Lillian and Emily Ellias, Edward Weston's nieces. It is a charming and sensitive photograph; not quite pretty, but almost. The two young women are wearing eighteenth-century costumes for a play: one wears man's britches, and the other, a woman's silk dress. Cole Weston recognizes that the photograph was taken inside their old home at 4102 Verdant Street, an address which was to appear and reappear very often.

Two years later, in 1911, Weston quit his persistently hateful job, and not long after Chandler's birth, decided to build his own studio on a parcel of land in Tropico owned by his wife. It was soon overgrown with honeysuckle and morning-glory, for it was far from the center of Los Angeles commerce. The Wollensak Optical Company of Rochester, New York, had a small publication called *Lensology and Shutterisms*. Their issue of May and June, 1916, ran an article headlined: "The Man Who Made Tropico Famous: A Little Journey to the Home of a Noted Photographer." The text itself was destroyed, very likely by Weston, and one can only manage to make out the words, "beautiful products," and recognize the photograph of his studio. In the 1914 issue of *The American Magazine*, there is a portrait of Edward Weston, looking dignified, a bit fierce, and wearing the usual collar and tie and a belted jacket. On the same page, there is a photograph and a brief description of the studio itself:

> In the little shack surrounded with flowers which you see on this page, Mr. Weston makes the photographs which have given him an international reputation for artistic photography. Like David Grayson, he left the routine of city life, and found in the country the inspiration and leisure to work out his ideas.

The studio is indeed small, but there is a dimple on the roof for a curved skylight, like a great half-shut eye. The article itself is a kindly portrait of Edward Weston at age twenty-eight.

> Out in the town of Tropico, a beautiful suburb of Los Angeles, stands a shack studio of rough boarding that is so full of art that its range of influence reaches to the ends of the earth.

> In that studio, which cost perhaps six hundred dollars to build, dreams and works Edward H. Weston, "photographer," as the simple mission-style, brown-stained sign hanging in front of the door announces. . . .

> Last June, to the great London Salon of Photography, held in the galleries of the Royal Society of Painters in Water Colors, in London, Weston sent his six best-loved pictures. Of these, five were deemed worthy by the judges of hanging beside those of the most noted photographic artists in the world.

> But that was not all. Bertram Park, honorary secretary of the Salon, in a burst of enthusiasm and admiration for true art, said that in his opinion the best group of photographs by the same artist at the Salon was that by "Edward H. Weston, of California."

> Weston was awarded first prize at the annual convention of the Photographers' Association of America at Atlanta, Georgia, last June, and one of his pictures was hung in the National Salon. He won a loving cup for the best four photographic prints at the convention of the Northwestern Photographers' Association at St. Paul in September. The Photographic Salon in Toronto, Canada, last May, awarded him second prize and two honorable mentions.

> Now for the David Grayson part of this story:

> "Many of my neighbours do not believe that I am making pictures like these," said Weston one day, "or that I am really exhibiting them at the salons. They think it is some kind of hoax, because, they say, how can a photographer doing his work in a little shack like mine win the great awards? He ought to be in a large city with a splendid studio. We don't believe he makes these pictures at all."

> "Why should I go to the city?" he defended himself quietly. "Suppose I did go there, and had a fine studio with stained-glass windows in one of the largest buildings? My business would probably increase. Many of the wealthy customers who want my pictures do not come out here because it is so far out of the way.

> "But I would have to pay large rents, while here I pay nothing. My worries and troubles would increase as rapidly as my business.

> "But, worst of all," and he glanced again at the "Carlotta," "I would be forced to have many assistants to help me in details. And that would mean my pictures would lose their individuality. Now, you see, I have but one assistant, who does only the minor things for me, and I make each photograph as I want it.

> "I have read David Grayson's *Adventures in Contentment*, and it is fine. I have a little farm, too, of one acre. Sometimes I think I would

like to go out there and make my living from it; but I cannot do two things at once. I have no use for money, either, except when it enables me to study the things I like and make the pictures I wish."

Weston has a way of taking photographs for customers that seems to stamp him as a genius at once. Coming into the four by six reception-room of the shack, the customer prepares his features and necktie in the arrangement that he fancies he wishes them to be in the reproduction.

He is engaged in conversation by Weston, and before the visitor is aware, he is sitting in the skylit room in a big chair, answering Weston's questions as to his likes and dislikes. He talks carelessly and entirely at ease, waiting, as he believes, for Weston to finish preparing the big camera, around which he hovers.

When the sitter has begun to get nervous again, thinking that it is time to arrange his necktie and features once more, Weston quietly asks him to move his chair over a little bit, into that ray of sunlight. He is not quite satisfied with the first six plates he has taken. The visitor realizes that, instead of hovering over the camera, Weston has been caressing it, and coaxing from it the highest form of picture art.

"Plates are nothing to me," he says, "unless I get what I want. I have used thirty of them at a sitting if I did not seem to secure the effect to suit me." By the side of the camera he has a rack holding about two dozen plates, which he slips in and out of the camera at an alarming rate when he sees in the sitter just the expression for which he is watching.

Much like Grayson, Weston was shut up in the city for several years in a huge studio, where he did nothing but print from plates all day long, a cog in the machine. It was not until he tore himself free from the city and built his shack in the country that he began to develop his individuality and widen his artistic horizon to the ends of the earth.

One can feel, in this cheery journalese, certain strains of tension between Edward Weston and his society; the anger and impatience is a sign of masked contempt. He spent most of his working hours either photographing the plain people who came to his studio, or retouching the prints with the tiniest of brushes; his customers demanding plastic surgery for their defects. He longed to make photographs of his own, free from the universal necessity to make a living; but the photographs that he made for himself were also ruled by a kind of conformity.

There has always been, in the wide, vague zone between the amateur and the professional, and in every art, a sweet, soft, easy, nonoffensive aesthetic. Edward Weston followed these standards, even excelled at them, for he knew that even the most foggy, the most false and arbitrary set of values, could give birth to real and moving works: as true in politics and science, as it obviously is

in art. Human illusion is the mysterious broth in which unexpected and beautiful forms can effloresce and astonish us with their strange and temporary truth.

Edward Weston sent his personal prints to literally scores of exhibits. *The Interurban Sentinel* reports on Wednesday, July 7, 1915:

E. H. Weston was last week appointed to represent California at the Congress of Photography, to be held during the Photographic Association of America's Thirty-fifth Annual Convention at Indianapolis, July 19 . . . The appointment of Mr. Weston is through the regards held for him as a recognized artist. Tropico gains by its being his home.

On October 18, 1915, he got a note from Sadakichi Hartmann:

My dear Weston: You are surely one of the annointed. In a class by yourself. The Dolores, Ruth St. Denis, Fantasie Japonaise, and the large head of Margarethe Mather are masterpieces.

I will use the prints to good advantage and write you up as opportunity dictates. Sometimes it takes a long while. But don't lose patience. It seems that I have to get to Tropico one of these days to have myself counterfeited by you, my collection would be incomplete without it. Alas! I see you are married, as we all are. Good Luck!

I am just on my way to New York, so write in great haste. Nude excellent too. Always same address.

At the Fifteenth Annual Exhibit, the Wilkes-Barre Camera Club, February 22 to 26, 1916, the judge was that nimble critic Sadakichi Hartmann. Edward Weston won an Honorable Mention with his portrait of Ruth St. Denis. *The Bangor Daily Commercial* of May 20, 1916, reviewed a local photographic exhibit and particularly admired one John H. Garo, who had four examples of gum bichromate: "Normandy Poplars," "Perfume," "Spring Morning," and "The Art Museum." The better known photographer, Clarence White, entered photographs of Annette Kellerman and the great Russian actress Alla Nazimova, and a study called "The Curtsy." And the account goes on:

A most charming portrait of a child in the softest tones of gray, No. 388, by Edward H. Weston, Tropico, California, which has been hung in the British Salon and which also took a prize at the late exhibit in San Francisco, California, is among the most admired in the exhibit.

Is it possible that this child was his son Chandler? At The Brooklyn Institute of Arts and Sciences, at the Twenty-Sixth Annual Exhibition of the Department of Philosophy, April 27 through May 21, 1916, there were shown, among many others, several prints by the distinguished photographer Gertrude Käsebier, a study of Isadora Duncan by Arnold Genthe, and an outdoor por-

trait of Ruth St. Denis by Edward Weston, entitled "A Fleck of Sunshine."

On May 25, 1916, Weston's father got a letter from a friend of his, J. W. Hoffman, General Secretary of the Photographic Association of America. He wrote:

> You no doubt will be pleased to know that your son made good with a capital "G" at the National Convention. . . . It is certainly gratifying to know you hold the same high esteem of your fellows in archery, that your son holds among his fellows in photography.

Several "fine engravings" by Edward Weston were reprinted in the October, 1916, issue of *The Pacific Printer*, San Francisco.

Ruth St. Denis, 1916

These were two prints: one of them of a woman in a white, flounced dress, wearing black elbow-length gloves and picking roses; and a close-up portrait of the same woman. The first was named "The Eternal Feminine," and the second, "Another of His Creations." On internal evidence, these titles were, one guesses, bestowed by the Editor.

Very few of these exhibited prints still exist; and his son Neil remembers helping his father, in the early twenties, to wash the emulsion off scores of glass plates, and then use them to replace the panes in the studio windows, smashed by his four rowdy sons.

In September of the same year, *Photo Era* of Boston, Massachusetts, wrote in praise:

No. 531, showing beautiful motion and light, handled as only a Weston can, by Edward Weston. This makes the third consecutive year Salon-Honors have been awarded to Mr. Weston.

The next month, the publication of the New York Art Exhibitions and Gallery described his portrait of the dancer Ruth St. Denis:

> . . . And then when we come to portrait studies made by masters of the cameras we are prompted to ask: What have the painters on these, even in the higher attributes of character analysis, expression or psychology? Note Edward Weston's portrait of Ruth St. Denis for aesthetic and intellectual divination seldom registered through any but the instantaneous medium.

America went to war for the first time in this bloody century in 1917. Edward Weston bitterly, and privately, attacked the War; very likely this was the influence of the photographer Johan Hagemeyer who lived with Weston for a while, and who was a member of an anarchist cell which held that World War I was a capitalist scramble for profits. In this way, the group differed from the great Socialist parties of Europe who were solidly patriotic on opposing sides.

When the War ended in 1918, the Salons of photographic art resumed business, almost unchanged in attitude and content. Edward Weston sent prints to London. Mr. Bertram Park, Honorary Secretary of the London Salon, wrote in 1918:

> Which is the best picture in the Salon? That is a truly difficult question to answer, but I can tell you which I think is the best group of pictures by the same artist. They are by Edward Weston, of California.

In the mad ferment of creation after the armistice, there were other exhibits in London. In a comment from the Editor of the magazine *Photography*, there is evident a faint reflection of the earthquake in all the intellectual values that was shaking not only Europe, which was more or less to be expected, but even the great solid rock of English society:

> The work of Edward Weston calls up in the mind severe comparison between the new and the old. Its newness is that of the New World where ideas are free from the modifications and complications of a tradition and convention.

What were these prints, so highly praised? Sadly, it is difficult to know for certain, for they have been lost or destroyed. It is equally difficult to ascertain the undoubtedly strong influence on Edward Weston's photographic ideas of a very bright and neurotic woman, whom he not only photographed, but eventually made his partner at the studio—Margarethe Mather.

He met her as early as 1912; and contemporaries remember

her as a small, very pretty, and exceptionally intelligent woman. She came first to be photographed, then became his pupil, was hired as his assistant, and finally became part of the business. It was not an easy association. She drank increasingly, and her behavior was moody and erratic; she rarely arrived anywhere on time, and most particularly to work. Edward Weston, with a photographer's fondness for the idiocy of words, called her, "The Late Miss Mather." She was mostly, though not wholly, a lesbian.

Edward Weston fell desperately in love with her. The sons remember barging noisily into the studio darkroom in search of dad, to find him locked in embrace with Margarethe; but she would let things go no further, and this semi-platonic relationship tormented him for nearly ten years. He made a number of photographs of her; she wore a hat, and had remarkably beautiful and very large eyes. But she was placed to one side of the frame; the rest of the print was occupied by the shadow of a tree. Taken in 1920, it was certainly a very romantic photograph. None of the earliest photographs of Margarethe, according to his own *Record Book*, were nudes. His first recorded nude, aside from the unknown one mentioned by Sadakichi Hartmann, was made in 1918, of Ruth Wilton (nicknamed "Jo"), whom he was to meet again years later. His famous close shot of breast and shoulder was done in 1920 of Anne Brigman. The following year he got a note from her, sent from Oakland, California; she said she wanted to tell him and Margarethe, "how lovely your prints were," having seen them at an exhibit in San Francisco. She goes on to praise Margarethe's portrait of Weston and Johan Hagemeyer: "Suffice to say they were beautiful intellectual things." She continues by quoting from a letter she got from a friend in Los Angeles, who saw her photograph in a window on downtown Broadway. Her friend wrote: "The picture is a wonderful thing! It's great! And you were a'looking off into space—back into the ages from whence your great soul came thousands of years ago." That, however, was not a nude, but a "lovely hill and willow trees at its base in the morning light—"

> . . . and you knew slowly that Anne was "born of the four wild elements" and you move her into the picture and I thank you for letting me go into its simple beauty . . . Helen McGreggor said with a knowing wink, "wasn't that mother in one of Weston's prints?" meaning the one with breast and arm. And so it goes.

She invites him to come to San Francisco because "the latch is always out for you here—a plate and knife and fork and more than one potato—and a real place for a night's rest—such as it is." She concludes by sending her "Aloha to Flora and the kiddies from Uncle Anne" and sends her love to Margarethe and "much for yourself."

Certainly there were earlier nudes; specifically several of a woman who simply walked into his studio and asked to be photographed nude.

A certain Cyrus Dallin, an acquaintance of his father, wrote a letter of thanks to him on May 6, 1917:

> My dear Mr. Weston. Your note of April 28 was received a few days since, and yesterday the photos came safely. I wish to thank you most sincerely for your charming courtesy in sending me the photos, and also to congratulate you on the photos themselves. I think the "dancing nude" almost the most beautiful photo of a dancing figure I ever saw and it has appealed to me so much from its plastic beauty that I have been tempted to make it in sculpture. It is truly quite a wonder from a sculptor's standpoint. The other pictures are also very beautiful and it occurred to me that should you desire it, that I would probably get the Editor of *Photo Era* to publish them, as I know him quite intimately.
>
> I am most pleased to have these examples of your work, and I assure you I shall prize them not only because you are the son of your good father, but also for their superior merits.

One of the most beautiful nudes he ever did was made in 1920. It is a torso, discreetly cut below the head and above the pubic hair. The light from the window is patterned by the panes and falls in curves upon the volumes of the body. Another strange nude, of Neil as a very small boy, was taken in the studio; again, the composition is strongly asymmetric; the boy stands (and rather sadly, too) off to one side of the print. Three-quarters of the space is occupied by the polished backdrop used over and over again in the studio. In all, his *Record Book* indicates that there were some fifteen negatives of nudes taken between 1918 and 1922.

Yet Edward Weston—for all this long list of trivial honors, in what was essentially a trivial field—was deeply and increasingly dissatisfied with his own work; and not for obscure reasons, but simply because he began to judge it by far more acid standards. He was a close reader of the photographic journals (there were scores of them at that time in the United States), and he boasted, in fact, that he read little else. Unquestionably, he saw the articles written by Paul Strand and Alfred Stieglitz, which tore apart the veiled focus and burned away shadowy sentimentalities: both of these props were of the pictorial school; which included, to

look at it fairly, a good deal of their own early work. Stieglitz was one of the judges (along with Edward Steichen) of the Eleventh Annual American Exhibition of Photography, held in 1917 at the John Wanamaker department store in Philadelphia. Edward Weston won a ten-dollar prize for "Toxophilus" (Toxophilite—a lover of archery) and a five-dollar prize for "Dolores." Stieglitz himself said of the exhibit: "Imitations of paintings and manipulated prints were unanimously condemned by the Judges."

This judgment of Stieglitz, I believe, was more important to Weston than the somewhat vague influence of the new European art at the famous Armory Show in New York in 1913, or the later show of American Paintings in San Francisco. It is certain that he never saw the Armory Show, and there is considerable doubt whether he saw the San Francisco show. Certainly, he never mentions it, and Nancy Newhall, who researched this particular point, doubts that anything was shown in San Francisco except the paintings of conventional American impressionists.

It is interesting, though, that influences need not be primary, nor even secondary. Waves of new sensitivity and new methods go far beyond the original sources; so it is possible that the cubist experiments of Picasso and Braque had a vague, but exhilarating effect on Weston.

In any case, Edward Weston continued to wear the American idea of a European artist's costume: cape, flowing tie, cane, and velvet jacket. Although he reported that he felt uneasy wearing it, it was one of his masks. It was not unique to him, of course; Frank Lloyd Wright, for example, wore the same getup. Weston was often in the company of people with whom he was not quite at home; people who had knowledge of, and violent opinions on, contemporary painting, music, literature, and love. Of these sharp, brightly colored people whom he knew prior to 1923, only four became his close friends. Their relations were complex, for two of them, one man and one woman, were at least homosexual.

He met Johan Hagemeyer, the most neurotic and the straightest of them all, sometime in 1917. Hagemeyer was born in Amsterdam two years before Edward Weston, and had an early interest in horticulture. Influenced by Tolstoy and his disciple Edward Carpenter in England, he became a vegetarian and moved to California in 1911 to start a dwarf-fruit plantation. He'd met the famous anarchist Kropotkin in Europe, and when he went to San Jose, California, he joined a small group of intellectuals who were anarchists. He knew Emma Goldman, Bill Haywood, and Max

Eastman, and felt, like they, that the United States government was his enemy; and, when the war began in Europe, he openly declared his pacificism. He went to Washington in late 1915, fell desperately ill of pneumonia, and while recovering, spent most of this time at The Library of Congress, reading books and looking at "pictures," both paintings and photographs.

Like everyone else, he was an amateur photographer, and when he went to New York City in 1917, he went to meet Alfred Stieglitz, and the painters, Marin, Walkowitz, and Dove, all of whom were in the Stieglitz stable, and each of whom were reviewed and reproduced in the thick, opulent pages of *The Dial*. Hagemeyer's early photographs included some landscapes, but a great many more were "industrials," and even some photographs of garbage cans. He left a job as a photographic assistant in Berkeley, California, signed on as a cook on a coastwise freighter, and jumped ship in the harbor of Los Angeles.

It was 1917 when he met Weston, and they became, almost at once, close friends; and Weston asked him to come and live with him. Hagemeyer was broke, so in return for his meals, he cleaned the studio, and the house as well, for Flora was away much of the time, teaching third grade in an elementary school. And indeed, Flora's work was the chief source of family income for a long time. Hagemeyer and Weston often hitchhiked to San Francisco, but for what reason, except restlessness, is not known. In San Francisco, they met the marvelous photographer Imogen Cunningham, who was then married to another photographer Roi Partridge. On July 27, 1920, Imogen Cunningham wrote Edward Weston from Fruitvale, a suburb of San Francisco. It is worth quoting at length, since it gives such a sharp picture of Weston's work at the time:

Dear Edward Weston: Do you know that from a very indefinite and uncertain personality you emerged into a very vivid one for us up here. Roi and I have often said that, since it was seldom given to anyone to make such a fiery streak, such vivid and warm impressions. You may have thought the people here were cordial and took you in, while we thought it was you who were cordial and open in your personality. . . . I'm thinking of you and your work now. . . . It's brains pure brains and intellect spread all over the photographic surface. This recalls your latest effort brought to us by Mr. Hagemeyer. I think so many things about this "Ramiel in His Attic" that I can't say them all at once as I feel them and should like to say them. Of course it is clever, you know that, but it is much more. If that doesn't make old near-sighted Stieglitz sit up and look around

for and at some one beside the seven constellations, I don't know what could. If has Paul Strand's eccentric efforts, so far as I have seen them, put entirely to shame, because it is more than eccentric. It has all the cubisticly inclined photographers laid low. . . . It is such a contrast to your "Prologue to a Sad Spring" which is so poetic. . . .

Also the prints that Mr. H. brought of Margarethe Mather, gave us great pleasure. She expresses a charming self in her work and a niceness in printing which just makes me grieve that I cannot have a piece of raw platinum in my hand. I liked particularly and very very much her wiggly woman with the wiggly branch. Since seeing the work of you two, I feel, when I let myself think about it, as if I had a stone in my stomach and my hands tied behind my back. . . . I felt at once that you would understand and appreciate what and why the *Rune of Women* is. Why is all this as it is and when will it not be so?

Anyway I hope you will come along with your plans as you want to. I didn't get a very definite idea from Mr. H., but presume he is going to look for a suitable location while he is abroad this trip. It

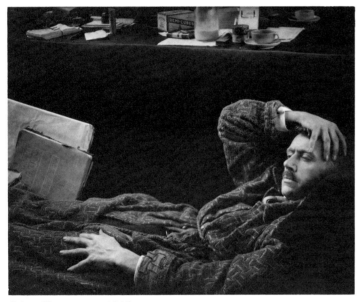

Johan Hagemeyer, 1925

seems like a great adventure, especially when you consider taking a whole family and making a go of it for them, but it will doubtless be good for you all. I see you just conquering worlds in a new environment. It is what we all need at some time in our lives. And won't it be glorious for your boys. . . . I meant to mention MM's portrait of you, which I think very fine and serious. In fact she has made you quite good-looking, not that you aren't, you know. . . .

In 1918, possibly about the time Flora was pregnant with her fourth son Cole, Edward Weston asked Hagemeyer to leave; there just wasn't room enough for another man. But they remained friends, and a well-known photograph by Weston, a landmark in

the new, clean, sharp style he was beginning to develop, is a portrait of Johan Hagemeyer. He has on a velvet jacket and presses his hand to his head; the weight of the world is upon him; and the photograph is at once truthful and affectionate.

Hagemeyer had read a great deal of Jung and his taste in music was Monteverdi, Palestrina, and Bach; and it is very likely that he introduced Weston to these masters. Bach, in fact, became Edward Weston's ideal artist, and though recordings of Bach were rare in those days (being mostly of the "Brandenburg Concertos," or the rather swollen transcriptions by Stokowski of the great organ pieces played by a huge orchestra), Weston bought as many as he could afford and played them over and over again.

Edward Weston's relationship to another Los Angeles intellectual, Ramiel McGehee, was much more delicate and complex. He did not meet him much earlier than July, 1919, for on that date he wrote a rather formal invitation to "Clarence" B. McGehee:

Greetings! Would Sunday—July 20—be a satisfactory time for you and Mr. xxxx (you see my memory!) to visit us? Plan to spend the night if you can stand our poor accommodations—and I should very much like to make a few negatives of you in costume Monday morning. We will endeavour to get a piano over here—and it will be a great delight to us if you can give a few numbers as you suggested. I got such a genuine thrill—I am hungry for more! We will have just a few friends out—I do not like large gatherings—Best wishes—

Weston might have had McGehee's first name wrong, or was Ramiel a sort of nickname, or vice versa? Jacob Zeitlin, a rare book dealer, and a member of the same intellectual order in Los Angeles, describes McGehee as "a curious little fellow"; but extremely bright, sensitive, and self effacing. McGehee, like Margarethe Mather, was a homosexual, and throughout his life sponsored young men with ambition to become artists or writers. As a result, he knew many people in the movie world of the 1920's: Charlie Chaplin, for example. It is more than likely that it was Weston's well-known photograph of the dancer Ruth St. Denis that brought Weston and McGehee together. McGehee himself had been a dancer and had, in fact, toured the Far East with her. He remained there for almost five years, and taught English to the future Emperor Hirohito ("or so he said," Sonia Noskowiak remarked), and then returned to Los Angeles, where Ruth St. Denis had her school. His interest in Buddhism was very great, and he kept in close contact with the Japanese colony in Los Angeles. He lived with his mother in Redondo Beach, California; and his income must have been fairly good, for the only employment he

had during the late twenties and thirties was with the remarkable Merle Armitage, a booking agent (or, as it was called in those days, an impresario) and a publisher of beautiful, and often prepaid, limited editions. McGehee helped him with the design of many of his books and wrote the prefaces to a considerable number of them, though his credits are missing in most.

Weston made several photographs of his friends at this time; those that survive are close Graflex "action" portraits. One, taken in 1920, in the attic where Ramiel McGehee lived (the very concept of "attic" is a Bohemian one, for few Los Angeles houses had attics one could possibly stand up in), is cleverly balanced by the profile of McGehee on the right and the two peaks of pillows on the left; the space above his head is divided by the bevel of the slanted wall or ceiling. McGehee has a fine face with a certain shy awkwardness of the mouth. There is a more common-

Ramiel in Attic

ly reproduced portrait of Weston's other close friend, Hagemeyer, with a similar composition: a rugged face equipped with a pipe, and again the head occupying the lower right-hand corner, with the rest of the print composed of angular shadows.

These photographs are often said to have been made under the influence of cubism. Perhaps so, but it was a misreading of cubism, which is a dissection of the solid as if with scissors, with the successive planes then folded out into two dimensions. Noth-

ing of this sort can possibly be done with a camera. The "cubist" photography of the time—like Paul Outerbridge's work with gabled shadows and sunlight—is merely angular, and as such, it is superficially different from pictorialism, which divided the plane into soft, romantic curves.

There is no question that McGehee was very much in love with Edward Weston; and utterly devoted to him, which is not the same thing. Weston, in turn, had the deepest affection for the man. Where Hagemeyer was rude, blistering, and strongly opinionated, whether right or wrong, McGehee was tender, corrective, nurturing. They both were intellectuals of considerable taste and wide interest, but neither was in any way an important artist.

Lesser, but intriguing friends from the same circle, from the early twenties and thirties, were Weston's neighbors—the painter and sculptor Peter Krasnow and his wife Rosa—who bought the lot next door and lived there for many years. They, too, knew Ramiel McGehee and Johan Hagemeyer; and this basic group, plus a number of more or less unattached women, were Edward Weston's intellectual village. Two other friends were a curiously matched couple—the woman was a concert pianist, and her husband, a professional burglar. Ruth Shaw, who taught, or tried to teach, piano to the boys, and whom Edward Weston once accused of slapping Neil, was a close friend of Flora's, and felt duty-bound to tell her of Weston's adulteries. He hated her particularly—love affairs, then as now, were the standard gossip of any group; but indignant and moralistic gossip was something else again, a reversion to mid-American standards.

On the other hand, the burglar Jack Black (what a marvelously burglarian name) was a man that Edward Weston admired extravagantly. His photographs of "Jack Black, ex-convict, five-timer," are quite remarkable; and he looked forward with glee to seeing this "tough, tender" face glaring down from the wall at the middle-class ladies who would attend an exhibit where one of the pictures was shown.

Edward Weston's bitterness about Glendale, California, and, by backward implication, about America itself in the early twenties, was always very plainly recorded by him:

My disgust for that impossible village of Los Angeles grows daily. Give me Mexico, revolution, smallpox, poverty, anything but the plague spot of America—Los Angeles. All sensitive, self-respecting persons should leave there, abandon the city of the up-lifters—it must happen then that the sexually unemployed [one of Weston's favorite phrases] would cut

each other's throats in a final effort to fulfill their mission in life, that of destroying others—they are the same gang who not so many years ago in the history of our country, burned witches on the Salem Green. Neither he, nor indeed Mencken, nor Sinclair Lewis, invented this assiduous view of America; it was part of the intellectual equipment of the time. Weston puts it in particularly concrete terms:

. . . each of us is moral or unmoral to our fancy or convenience—to me—gorging a Sunday dinner after a session with Christ is immoral compared to the sipping of a glass of wine or drinking a cocktail—picture the two indulgents—the glutton retiring to sleep off his gorge

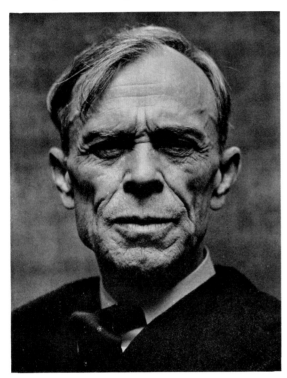

Jack Black–Burglar, Author, 1930

with farting bowels and stinking breath—he snores away with pork roast rotting in his belly—and then the other picture—the winebibber flying up and up—with each refilled cup—into his rosy heaven—full of Christian humility and brotherly love for his neighbors—overflowing with illusions from this magical gift of the Gods—contrast then the stupefied supine slug—and the intoxicated "immoralist"—which kind friend is the prettiest picture?

This might bring us finally to a discussion of the Einstein theory of "Relativity"—perhaps it could be arranged at the "Tuesday Morning Club" awakening much excitement among the cultured—for everything is relative—surely chewing ten pieces of gum at once is quite as immoral and more disgusting than drinking ten cocktails—and a pork roast judiciously garnished with garlic and hauntingly fragrant might be a fit theme for prose poetry—while an empty wine glass could be righteously smashed on a preacher's pulpit—in either case—"let the mouthing Puritans pass—they have their comic side"—which brings

to mind that I have decided to immortalize certain of my former "neighbors"—I shall amaze and amuse incredulous posterity with their portraits—so unbelievable—so inconsistent—so ludicrous will be the tale —that I shall be accused of fanciful exaggerations—Alas—I shall tell only the truth—. . .

The sentiments are repeated in Stieglitz's publication *Camera Work*, and over and over again. Similar sentiments were expressed by Ezra Pound in *The Little Review*, to which Edward Weston subscribed for years; and the passages of which he underscored like any furious autodidact. These opinions were vulgarized (if that is possible) in Stieglitz's famous photograph of the rear end of a castrated horse, which he labeled, "Spiritual America." However, these sentiments were not only violent, bitter, obscene, and indiscriminating; they were also true. Glendale, in particular, was appalling.

It is certainly important for any small group to retain its identity by repelling its environment; but the group in which Weston found himself also enjoyed it. Ramiel McGehee, Margarethe Mather, Johan Hagemeyer, and Edward Weston were four constant members of a nuclear community. They went to parties, drank wine, and made daring excursions together. Besides the intense discussions—which were not only theoretical, but crucial, in fact, to their own daily professions—there was also a good deal of kissing and dancing at impromptu parties, and the various sexes were not clearly delineated. Everyone knew everyone, and the permutations of the love affairs—like an electric current—attracted one person to another.

Together or with Tina or Margarethe—sometimes all four of us—we spent many vivid hours—at Stojana's—the Philharmonic—once an evening with Buhlig listening to his reading of that amazing poem "Waste Land" by T. S. Eliot—and looking over Billy Justema's drawings—listening too—to his reading—That night it rained—and returning to the studio still keyed to adventure—we donned old hats and walked into the rain—I took him to the river—winding our way among the dripping willows—around us the silence of hours past midnight—Bedraggled and drenched we reached home—but thrilled with the beauty we had had—

After the Philharmonic we desired a corner to sit and smoke and sip coffee—but to the shame of Los Angeles could think of barely a place but deadly respectable ice-cream parlors with smug people—sickening sweets—noisy clatter—commercial haste—and most likely bad music—

Margarethe, ever curious, had heard of a Greek coffeehouse near Los Angeles Street where sailors gathered—there had been a murder committed there and fights were a nightly occurrence—So we went—

and though not favored with a murder or fight, had a sufficiently exciting night—yes a fascinating night—A room full of sailors with here and there a collarless nondescript—but mostly those not in uniform were that type of effeminate male who seeks the husky sailor to complement their lacking vigor—One such fastidiously-dressed—unmistakable person—presented to us a most lascivious picture of impatient desire—his foot twitched continually—his whole body quivered—his lips fairly drooled—until finally with several others of his kind—a bunch of sailors were "dated up" and off they went in a limousine—Sailors danced together with biting of ears and open caresses—some sprawled over their tables down and out—every one had a bottle on the hip—while an officer of the law amiably overlooked his opportunity to enforce the 18th amendment—

A negro droned on the saxophone—or "sexaphone" as Margarethe calls it—another picked the banjo—the four or five waitresses watched their chance to pocket tips or pick the pockets of drunken "gobs"—one sailor prize fighter reeled to our table loudly confiding his troubles—the quarrel he had "with that 'gold digger' over there"—had us feel his muscles and related his life history—

Margarethe was the only girl in the place besides the waitresses—But we were too differently dressed—too conspicuous and I wonder we did not land in the street—I should like to go again under different circumstances.

In 1921, McGehee arranged an exhibit at a Japanese men's club, the Shaku-Do-Sha. The photographs included a number of Weston's "cubist" images, but a few nudes were shown as well. It was an astonishing success; ordinary Japanese nurserymen, farmers, clerks, and laundrymen, paid hard cash for the prints. Edward Weston, all his life, desired and thrived on praise, and hated and fought even the slightest critical disapproval. But he kept an honest craftsman's interest in hard cash; for his life and career always traveled uncomfortably close to the grinding realities of rent, food, and automobile. His exhibit in San Francisco in July, 1921 did not do nearly as well for him, but his life was about to be shifted into a brilliant new direction.

At some time in the early twenties, Edward Weston, perhaps through McGehee's contacts with the movie colony, met a truly extraordinary woman who was to shatter and then reconstruct his life. An early photograph that he took of her is very much in the pictorial mold. Against a background of glittering, Chinese-style screens, five objects are placed at various distances; four of them are a kind of oriental, wicker stool, and on one is seated a buxom young woman with an intense face, and lowered eyelids. At the extreme right there is another stool with a bowl of flowers, and over it, a round lamp suspended from the ceiling. The woman is Tina Modotti, born in Udine, Italy, and married to an American of French ancestry, via New Orleans. Her parents had settled in San Francisco, where she took part in amateur theatre, and after that, went to Hollywood. She was an actress who played small, and generally villainous parts in silent movies. It is not certain whether she began to take photographs before or after she met Weston; but, in any case, she soon became his pupil, his model, his admirer, and his mistress; all more or less at the same time.

She wrote Edward on April 25, 1921:

Once more I have been reading your letter and as at every other time my eyes are full of tears—I never realized before that a letter—a mere sheet of paper—could be such a spiritual thing—could emanate so much feeling—you gave a soul to it! Oh! If I could be with you now at this hour I love so much, I would try to tell you how much beauty has been added to my life lately! When may I come over? I am waiting for your call.

We can only speculate on the effect such passion had on a man as restless, and as restrained, as Edward Weston. There was no question that this was adultery, that he had betrayed the mother of his four children; and his guilt made him furiously impatient with Flora. He loved his four children tenderly, and had, in fact (in Cole's opinion), an almost pathological need for them. How could he—the boy abandoned by the death of his own mother—abandon his own sons? Yet he had to, somehow or other; there was the drama of secret letters, secret meetings, the taste of wine and love; and his passion for Tina grew through the months of 1921. She wrote him often; but he kept only some of the letters. On January 27, 1922, she wrote:

Edward: With tenderness I speak your name over and over to myself—in a way that brings you nearer to me tonight as I sit here alone remembering. . . .

Last night—at this hour you were reading to me from an exquisite volume—or were we sipping wine and smoking?—or had darkness enveloped us and were you—the memory of this thrills me to the point of swooning!—tell me, were you at this hour—kissing my left breast?

Oh! The beauty of it all! Wine—books—pictures—music—candlelight—eyes to look into—and then darkness—and kisses—

At times it seems I cannot endure so much beauty—it overwhelms me—and then tears come—and sadness—but that sadness comes as a blessing and as a new form of beauty—

Oh Edward—how much beauty you have added to my life! And do you know—it is almost a year now since on a late afternoon—saki was spilt on my hand—(do you remember?) and we listened to Sarasate's "Romance" for the first time together—?

How vividly I can recall each episode—each one stands before me strong and lifelike with all the vagueness of a dream and unreality.

Your last letter laid under my head till morning—was it its faint fragrance that awoke me? or the spirit of your desires and mine—that seemed to emanate from it?

Yes—to be drunk with desires—to crave their attainment—and yet to fear it—to delay it—*that* is the supreme form of love—

It is very late now—and I am exhausted from the intensity of my feelings—my eyelids are heavy with sleep but in my heart there is a hidden joy for the hours that will still be ours. . . .

Tina Modotti had other admirers, and Weston was furiously jealous. One of them was, of course, her husband, the artist Roubain de Richey, nicknamed "Robo." He had seen Weston's prints through Tina Modotti, and admired them greatly. He went to Mexico City in late 1921 and wrote Weston a long and friendly letter. He described Mexico as "the artists' paradise":

This, as I write, is the time of day when the heavy-lidded señoritas lean from their balconies—The sun inclines toward the western hills—the street is filled with a golden dust. Carts and donkeys pass and boys driving turkeys—shouts arise from brown little boys and girls at play in the gutter. An old woman pats her tortillas at the curb—a beggar is snoring on the sidewalk under my window—Three great automobiles laden with aristocrats wind over the rough stones. A detachment of rurales dashes by with great sombreros and clattering sabers. I am watching the girl in the opposite balcony who is also watching me—a charming little thing of "silk and bronze." But now it is dark and the pulque shops at the corner give forth a yellow glow against which I make out a mass of crowding men and women. Porters and labourers stagger by holding onto each other. A hundred church bells begin to toll—The air is chilly so must close the heavy shutters and lock the window.

. . . There is a great turning backward to original sources here—They have grown tired of trying to imitate foreign art and are now seeking to find their selves in themselves.

A friend of his was Chief of the Department of Fine Arts at the Academia de Bellas Artes, and this gentleman promised to exhibit Weston's prints, though with the customary endless delays. Robo wrote to Weston of his plan:

I shall post notices saying that if a sufficient number will order your photos you will come and make them here. What do you say?

He went on to describe Mexico with enthusiastic detail, and urged Weston to come to Mexico City himself. Then, quite suddenly, he became ill of cholera, and died five days later on February 9.

Tina went to Mexico City to see her husband's tomb, and Edward Weston sent with her a group of his prints. They were shown at the Academia de Bellas Artes. The public response was extraordinary, and his life, already shaken from within by the furious restlessness of his own character, was jolted onto a new track. Yet he could still find no plausible way to break his old pattern.

By October, 1922, Tina had been back from Mexico for several months. He made a portrait of her; one of Ruth Shaw; and the now famous portrait of the cameraman Karl Struss, which includ-

Ruth Shaw, 1922

ed a movie camera as part of the composition. Tina then went to San Francisco to visit her mother, and to investigate the possibility of opening a studio there. The affair between Tina and Edward was already shaky. She wrote (from the train to San Francisco):

I looked out at the black night—at the houses lit from within—at the trees shadowy and mysterious—I thought of you—of your trip—of your dear letters to me and the desire to draw near you was so intense—I suffered—the best in me goes out to you my dear one—Good-bye—good-bye Edward—may you attain all you deserve—but is that possible—you give so much—how can "Life" ever pay you back? I can only send a few rose petals and a kiss—

The same month (who left first?—a crucial matter—but we don't know), Edward Weston left by himself to visit his sister/mother May Seaman, and her husband John, in Ohio. It was during this visit to the Midwest that he made his first industrial landscapes. Weston destroyed the journals he wrote before 1923, but kept certain interesting passages:

The Middletown visit was something to remember with auto drives

through the hills and dales of Miami Valley, all resplendent in autumn colors; and over the river into Kentucky, to Dayton and Cincinnati too. . . . But most of all in importance was my photographing of "Armco," the great plant and giant stacks of the American Rolling Mill Co.

These were not, of course, the first industrial photographs, but they were the first that Edward Weston had ever made. Alvin Coburn, born four years earlier than Edward Weston, had photographed the Pittsburg Steel Mills in 1910, but they were as distant and atmospheric as mountains in a haze. Coburn was concerned far more with the pillars of steam and smoke and the shimmer of the river than with the strong shapes of stack and pipe. Stieglitz's similar studies of steaming railway yards were also in soft focus.

Weston, astonished and intense at thirty-six—in the midst of psychological turmoil, and infected with the discontent with his professional life that all really serious photographers had felt since the Wanamaker Salon of 1917—didn't view these mills from a high bridge or from across a river. He went right up to them, and stood below the giant installations themselves. In his photographs, the stacks loom upward, and the great pipes cross and counterpoint the main verticals; they are not outlines, but sculptural volumes. And they are sharply, brilliantly, in focus. "That day I made great photographs," he wrote. Edward Weston's modesty was never a great burden, but, of course, he was quite right. The closeness of these photographs to the object, their uncompromising focus, their volumetric composition—these are the principles on which Weston was to shape his work from that time forward.

The whole idea was hastening in his head; and as ever with Weston (and indeed with most artists, and certainly all great ones), the work came first, the aesthetic justification later, and often as a rationalization, though not necessarily untrue.

Stieglitz, and therefore New York City, had been the center of the storm in photography, and Edward Weston wanted very much to go there and show his prints. His sister May and his brother-in-law John "got their heads together and decided to help me on to New York since I was already almost there. . . ."

The New York visit was not really crucial, and Weston was right in saying that it merely confirmed the direction in which he was already going. He got a room in downtown Brooklyn, near the famous bridges, and "haunted them." He spent a lot of time there

with a love who has remained rather obscure. It was very likely Ruth Wilton, whose nickname, we must guess, was "Jo." Weston wrote: "Morning coffee with Jo from the purple cup sister gave me"—so one presumes breakfast was in his room. While he was there, Tina Modotti sent him, special delivery, forty dollars, so that he could go and see the current Broadway hit, *Chauve Souris.* He showed his photographs "all over New York," but he didn't record where or when. He phoned Stieglitz, whose mother was dying, and "he promised to see me as soon as his mother was dead." When the redoubtable Stieglitz did meet Weston and Jo, he gave a four-hour monologue. The gist of it was, wrote Edward Weston: "A maximum of detail with a maximum of simplification."

Stieglitz didn't like all the Weston prints he saw; but he praised the Armco photographs, though they were only unmounted proofs. He also showed a group of his own photographs to Weston. "Ah, you do feel deeply," Stieglitz said, "and that little girl over there trembles with emotion."

He wrote to his wife of his meeting with Stieglitz. Margarethe Mather later reported (in a letter to Ramiel McGehee):

She [Flora] wept around here one a.m. after Edward's first Stieglitz letter [from N. Y.]—blaming herself for holding Edward back—I told her—in front of Tina—that she was responsible for Edward's success—without the balance of her and the children—the forced responsibility—Edward would have been like the rest of us—dreaming—living in attics—living a free life (O God!) etc. etc. not growing and producing as he had. Opinions to the contrary Edward is as gregarious as anyone I know—Flora seemed grateful for my words but soon forgot them. . . .

While he was in New York City, he went, at Stieglitz's suggestion, to see the painter and photographer Charles Sheeler. whose rendering of American factory landscapes had the flat, burning surface of industrial America, as if viewed in the relentless sunlight of certain August afternoons. The great and intense photographer Paul Strand dropped in while he was there and invited Weston to see his work. Weston wrote: "It was splendid and a worthy carrying on of the master's tradition " But "Strand," reported Stieglitz, "thought [Weston's work] . . . was no good." Weston had mixed and even angry feelings about Stieglitz, and more than a year later. he dreamt:

If dreams have any symbolic significance, the one I had last night must be of great import. I only have a thread to go on, I cannot recall nor reconstruct the whole dream. It was this: someone, and it is impossible to remember who, said to me, or rather I understood them to say,

"Alfred Stieglitz is dead." "Alfred Stieglitz dead!" I exclaimed. "No," said the person, referring to a newspaper, "not dead but dying."

Weston could not tolerate a guru. He left New York reluctantly:

We took our last bus ride . . . good-bye New York, good-bye Jo. I shall not forget.

He went from New York back to Chicago, and visited his Aunt Emma's and Uncle Ted's home, where he had lived until 1903:

. . . it had gone to seed, a forlorn shadow of the past. I was still "Eddie" to the old folks, I must wear this or that, be in by 12, eat, drink, read as they do, vote Republican straight. But they had not lost their sharp tongues nor dry humor. . . .

He was back in Glendale for Christmas, and celebrated it with his four sons and his wife. He wrote to Ramiel:

Dear—dear Ramiel how beautiful your letter was! What would I do without you and Tina these days—I fear the whirlwind is upon me—and perhaps if it comes too near engulfing me I shall call for you in my distress—for I have fought so long—I am weary—so tired—O why all this—when beauty is everywhere—To those who are not blinded—know that I have seldom loved as I love you.

Tina Modotti was back in Los Angeles. She put out a private edition of her late husband's poems. They were passionate and mediocre, but she wrote a long and moving dedication for the volume, dated December, 1922. The old group of Los Angeles intellectuals resumed their alarums and excursions. Edward Weston's theoretical views were now strong and consistent, and, in fact, were to change little for the rest of his life:

Johan is here—has been here for over a week—Days and nights of intensity—burning discourses on many topics—of course mostly photography!

Johan brought new work—fine industrial things—nicely seen—but lacking in definition—an inexcusable fault when it comes to photographing modern architecture and machinery—even the "mood" could be better interpreted with sharp—clean lines—"But if I see things this way—Edward—I must render them as I see them."—"Nevertheless—Johan—photography has certain inherent qualities which are only possible with photography—one being the delineation of detail—So why not take advantage of this attribute? Why limit yourself to what your eyes see when you have such an opportunity to extend your vision?—now this fine head of your sister—if it was focused sharper you would have expressed your idea even more profoundly—Here is a proof [Bertha Wardell] which may explain what I mean."—"By God! I do see now—in this case at least—that a more clearly defined—searching definition would have unveiled and exposed the very suffering and strife I have tried to portray—but in some other prints I show you—it seems almost necessary that there should not be so much revealed—however in the portrait under consideration I realize that I skimmed over the surface and did not penetrate as I might have—I do not accept—swallow—what you say as a whole—but I have gotten something from the talk which makes me see more clearly and will make me surer of what I wish to do—Let me question again—if in a certain mood why should I not interpret that state through my picture and not merely photograph what is before me? In such instances the use of diffusion would aid me—"

"Yes, it would aid you—to cloud and befog the real issue—and prevent you from telling the truth about the life towards which your lens is pointing—if you wish to 'interpret' why not use a medium better suited to interpretation or subjective expression—or—let someone else do it—Photography is an objective means to an end—and as such is unequaled—It comes finally to the question: For what purpose should the camera be used?—and I believe you have misused it—along with many others—including myself!" And so—on we went pro and con—

Somewhere in the first six months of 1923, Edward Weston got enough strength to break open the already cracked mold of his life. Nothing—and this is a fairly commonplace experience, surely—is ever decisive about decisions. In Weston's case, he was still locked in by the necessities of the first thirty-six years of his life: to earn a good living in "the charming and chemically pure city of Glendale"; to be a devoted, if not a loving husband; to be a father and an example to his wild, quarreling brood of sons. His affair went on with Tina Modotti, and he was still laying siege to the impenetrable Margarethe. All the time, he was working hard at his studio, simply to get enough money to live. He made at least five important portraits in Glendale in 1923; and eleven nudes, all of Margarethe Mather. When Margarethe was faced with his impending departure for Mexico, she suddenly realized that she was losing a close friend, and someone she, in her own way, loved. Margarethe yielded, and spent "that last terrific week" at the beach with Weston. He made love to her and photographed her; one of the nudes has a parasol and a stretch of sand. Love and photography was a combination that was natural to him all his life; certainly the results were effective on all counts.

On July 30, he boarded the S.S. *Colima*, bound coastwise for Mazatlan in Mexico. Leaving with him on the boat were Tina Modotti and a hostage to his past, his thirteen-year-old son Chandler. Down below, waving good-bye, were his wife Flora, his other three sons, and Ramiel. Margarethe wasn't there.

Cole, then four years old, says he was "left on the damn dock . . . it was more than I could handle."

V.

Every mature human being has before him, like Odysseus, a psychic voyage—a circuit of escape from himself that returns him to the home where he started; altered, of course, and not necessarily for the better. Men generally take this journey somewhere between the ages of thirty-five and forty-five, but it could be at any time of life. It is a marvelous, agonizing crisis of the deepest self; it propels him outward and away. He craves astonishment, takes new loves like apples from a tree, meets monsters and sirens, and, if lucky, surmounts them all. Dangerous trips; but then they are not undertaken by the modest who can generally not, in a psychological sense, afford them: Klee went to Algeria, and returned with a head so full of color that it lasted him the rest of his life; Dürer got decently married and immediately went to Italy with his boyfriend; Gauguin went to Tahiti; and Van Gogh, to an insane asylum.

Weston was thirty-seven when he went to Mexico. He denied the fact, over and over again for two years, that it was surely the end of his marriage, and his former way of life as well—the murder in absentia of one part of him by another. He wrote of this period:

> Nor was it easy to uproot oneself and part with friends and family—there were farewells that hurt like knife thrusts.
>
> But I adapt myself to change—already Los Angeles seems part of a distant past. The uneventful days—the balmy air has relaxed me—my overstrained nerves are eased. I begin to feel the actuality of this voyage.

When he wrote home for the first time, from on board the ship, he made an astonishing remark at the very top of the page:

> I got off the boat without your address—am forced to send this to the studio for remailing. . . .

The letter immediately continues:

> Dearest family—I still see you waving "good-bye" at the docks—your faces disappearing—then the forms—till finally only the gleam of white from a handkerchief told me you still were there—"pulling up of roots"—is indeed hard! I wonder how difficult the transplanting will be!

He then praises the Mexican ship as picturesque, rather than respectable, describes the food, relates how Chandler is doing, and ends thus:

> To all of you deep and tender love—I think of you by day and dream of you by night—Edward.
>
> Was the celebration of Glendale—honoring my departure a success? I was quite thrilled at this unlooked-for glory!

On September 1, 1923, he wrote, and still not to Flora personally:

> My dearest ones—What a thrill to hear some word from home—I say "home" only because you are there—for I cannot imagine Los Angeles or its surrounding country ever again being home to me—though I love the memory of that little house under the mountain and my studio as it used to be—not now—hemmed in on all sides by real-estate sharks and other despoilers of beauty—

Tina and he had found a place to live and work on the outskirts of Mexico City. The letter is really, finally, and apologetically, to Flora:

> My exhibit is already being planned—Tina has arranged for it—she is invaluable—I could do nothing alone—details to you when I am sure—. . . Let me repeat what I once told you—that it was I who planned this whole trip—upon hearing that she intended coming here to live—I saw my opportunity—just as I did when Robo was alive and was to share his studio—a fine friendship exists between Tina and myself—nothing else—However, I am not so hypocritical as to say I shall not "fall in love" with some dark-skinned señorita!—at least I am not looking for any entanglement—not going out of my way! What a fool I have been not to be a hypocrite!

He is concerned about the boys' schooling; he is against it, in fact, but:

> I can only wish that money would enable me to figuratively put my thumb to my nose (literally too, for added contempt) and make Rabelaisian remarks to a nosy-psalm-singing evangelistic group of drab people, who at present control our schools—and inflict their middle-class minds and attitudes on our children.

Flora was no fool; and she loved him very much. Her despair at his departure was real and deep, and Weston felt obliged to justify himself in the same letter:

> If I had not loved my work more than sex—would I not have commercialized my business and afforded half-a-dozen mistresses and a wine cellar?

He ends this troubled letter thus:

> Enough! To all my defamers I send a roll of toilet paper—I hope it will not "skid"—if they can't clean their minds—let them at least wipe their "bums."
>
> To you and three sweet boys—always deep love—Edward.

He was swept up now in the beautiful, sad, brutal, intense life of Mexico City; qualities which have hardly changed since Montezuma met Cortez in the Zocalo. He heard the sounds of the street, flutes, and vendors; saw the same colors of flower and face:

> I cannot imagine a finer climate—and, because of the kaleidoscopic heavens, the play of light and shade over the landscape, monotony is precluded. I found the unvarying sky of Southern California more

trying than the lack of decisive seasonal changes . . . I am to have one of my dreams fulfilled—a whitewashed room; the furniture shall be black, the doors have been left as they were, a greenish-blue, and then in a blue Puebla vase, I will keep red geraniums.

He became astonishingly fond of bullfights—"the most stupendous, electrifying pageant of my life"; those contests in which the bulls generally lose, 6 to 0. He saw it as a dance of blood and death:

El Toreo—yesterday for the first time in many weeks, and for the last time in Mexico, I am sure. A perfect day—cloudless—hot. A great crowd, expectant and enthusiastic, for it was the season's first appearance of Chicuelo, last year's idol. The music! The suspense! The great empty arena, like a blank sheet of paper ready for the recording of comedy or tragedy, beauty or ugliness, life or death! The bugle! Chicuela—Barajas—Rayito! Chicuela acclaimed with a roar of applause and a rain of hats, canes, flowers. The bugle! The first bull! A magnificent brute. But Chicuela killed in bad form and was hooted

Mexico City, 1926

and hissed. The bugle! Another superb bull. Barajas—an unknown quantity. A whirlwind fight—a perfect kill—a new hero. Twenty thousand white handkerchiefs, a swirling snowstorm of acknowledgment —a thunderstorm of voices. Each bull was a fighting bull—tremendous animals.

There are those who see a bullfight—for example, D. H. Lawrence— and all they see with their unseeing eyes and all they feel in their unfeeling stolidity is a fight between a man and a bull with a few gored horses to groan over. Sentimental? an abused word—flung around too easily by modern "intellectuals." Bourgeoisie? also lovingly mouthed by

those who read *The Dial*—what then? Apathy to the aesthetic quality of the fight—granting its undeniable sordidness—bars such persons from feeling and understanding its symbolic pageantry. Perhaps they are more humane, if less human, but they miss in life those fearful forbidden heights from which some see beauty masked and arrayed in alien guise. Refinement of aesthetic response or shocking sensuality; one may seek and find, each in his own fashion, in *El Toreo*.

He and Tina, and his son Chandler, made numerous excursions to the countryside, often as guests of the redoubtable General (and Senator) Galvan. On one such trip, he traveled for weeks from one small town to another to make photographs for Anita Brenner's book on the folk arts of Mexico. He also visited the Museo Nacional (not, of course, the present monumental Museo Anthropologio) with Tina:

I had expected much, but what I saw was far beyond my expectations. Besides the gigantic sculptured pieces hewn from rock, more or less familiar through reproductions, things overwhelming in their grandeur, their imaginative attributes, their fineness of conceptions and execution, there were exposed exquisite jewelry of the most delicate craftsmanship; gold, silver, jade, sculptured heads in obsidian, alabaster, of a simplicity and economy of approach quite a revelation. Even pieces in that perishable medium, wood, remained, a few examples only, to exemplify the supreme art and civilization of the early races who once glorified Mexico! We were fortunate in having Jorge Enciso, supervisor of public buildings, as our guide, and through him were admitted to the phallic room. This was intensely interesting; figures masturbating and "going down" on themselves, hermaphrodites, seated figures in cohabitation, one stone phallus four feet high, an imposing thing indeed!—and many conventionalized symbolic figures. There was no note of frivolity in them, they had a religious austerity.

His total impression of Mexico was not wholly one of admiration, however:

Mexico breaks one's heart. Mixed with the love I had felt was a growing bitterness—a hatred I tried to resist. I have seen faces, the most sensitive, tender faces the Gods could possibly create, and I have seen faces to freeze one's blood, so cruel, so savage, so capable of any crime. Yet the Mexican bandit may be preferable, and at least more picturesque, than certain sleek American businessmen.

He wrote long letters to each of his sons. One to Brett, was written a month after his arrival, when he was still under the curse of his conscience:

It is good to know we have had such a civilization here on our own continent—one wearies of the Greek ideal—but let's don't copy the Aztec either—we must be ourselves—much greater selves than we are now—but first and last true to our day "a poor thing perhaps but our own"—it's the only way to grow—

. . . a New York skyscraper is finer as is also a Chicago grain elevator, than a library patterned after a Greek temple.

Dad loves you—misses you—thinks of you often—will send for you if he can—Study hard—you have a fine mind—grasp every moment of life and make the most of it—each tick of the clock is different from the last, and never the same—"There is no Good, there is no Bad; these be the whims of mortal will: What works me weal that I call good, what harms and hurts I hold as 'ill'"—pretty strong stuff to hand an eleven-year-old boy—but just remember this—only the strongest and finest minds—the cleanest minds—are fit to make their own laws—"Do what thy manhood bids thee do—from none but self expect applause"—is a dangerous precept and only to be used by those with a stiff backbone—a willingness to suffer and a sense of humor! I realize I have written over your head.

Mexico, at the time (the last year of Obregón's formal term as President), was a volcano of rebellion. Obregón's problem was a classic one: how to curb the local authority of the various regional chiefs, some of whom were outright bandits, and all of whom were provincial tyrants, with the right of monetary and sexual primacy over peons and schoolteachers. Obregón was then forming a National Revolutionary Party, whose power has since endured, unbroken now, for fifty years. In the process, Obregón attacked the Catholic Church of Mexico to capture its jewels, gold, and rich landholdings, and his successor, Calles, continued this campaign. Both sides were bloody and fanatic; the soldiers of the church were largely women, and their rallying cry— "*Viva Cristo Rey*!" Weston wrote of all he saw, felt, and heard:

Wires are cut between here and Vera Cruz, Tampico and western points; trains are halted except those to El Paso which are filled with fleeing Americans. De la Huerta has 15,000 men against the government, several states have gone over to him, artillery is being rushed to defend Chapultepec Castle. Obregón arrived on a special train last night. Soldiers are marching with beating of drums and blowing of bugles. Food prices are soaring—and this is our only concern—for if we tend to our business, danger is unlikely.

On a visit to Guadalajara, he records that black prevailed:

—the Catholics in mourning. A boycott of all luxuries, all pleasures, emptied the streets and stores. Street fighting between soldiers and Catholics,—the majority women, armed with bricks, clubs, machetes,—resulted in bloodshed and death.

To work in such a belligerent atmosphere was embarrassing. Every movement out of the ordinary was noted. Setting up my camera in front of a church was next to training a gun upon it. . .

. . . A group of women challenged a passing Frenchman with, "*Que viva Cristo Rey!*" Lost in thought, he paid no attention. Again they called, and more emphatically, "*Que viva Cristo Rey!*" "Bueno," he re-

torted. "Que viva." But his enthusiasm was not apparent and the women became threatening. So he shouted, "*Que viva Cristo Rey—chinga tu madre!*" At that they clubbed him insensible. . . .

. . . Sporadic rebellions everywhere—talk of another real revolution. Better to leave soon. No place this, to work in a peaceful frame of mind.

In the beautiful colonial town of Guanajuato:

Every time a church was entered a spy would follow us,—usually a woman. She would drop to her knees simulating prayer but watching our every move. I became nauseated by churches. I offered my prayer that Calles would blow up every one, that the priests would rape every fanatical old hag that followed us—probably what they needed.

Social unrest took a farcical and particularly Mexican turn:

. . . two girls, friends, had published a manifesto against men in general. A warning to long-suffering women to awaken. They published, even to intimate details, their relations with men and also the names of their betrayers! Then personally distributed the propaganda to prove their courage.

This story was related to him by Guadalupe de Rivera, Diego Rivera's wife at the time.

Almost from the beginning, Edward Weston was introduced to that group of beautiful painters who were given license by a government that was devoted, in rhetoric anyway, to the Indian, the mestizo, and the poor. Tina took Weston to see Rivera's earlier work. Rivera wanted to use her as a model, but Weston, jealous, furnished him with nude photographs of her, instead. Using these photographs, Rivera painted a gigantic figure, which lies prone in one of the murals at the National School of Agriculture.

I cannot imagine his having the opportunity in any American municipal building. Government "of the people, by the people, and for the people" does not foster great art. . . .

It was the work of a great artist which we viewed; and he was great in another way, tall and generous girth—a striking figure! . . .

The article on Diego Rivera in *The Freeman* is re his work in the Preparatory School. His later painting in the Ministry of Public Education is much finer, and now he tells us he is more pleased with his murals at Chapingo than any he has done. The article goes on about the "Union of Technical Workers, Painters and Sculptors" which adheres to the Moscow International, with Rivera as the leader. It speaks of painting on canvas as painting degenerated, and further— "While feeling that he belongs to the future, one is glad that he lives today. Rivera is humble with the humility that comes to those who, having confidence in their own worth, recognize worth in others, who out of disillusion create beauty, out of human suffering, the future—"

Rivera is a vegetarian. He appeared at the Braniff banquet carrying his own dinner of grapes and apples tied up in a red bandana

handkerchief . . . I rather envied him his meal and remembered my own days of intestinal purity. I may return to them again. I have a feeling that eventually I shall. This country with its abundance of tropical fruits should be paradise for the vegetarian.

Weston also met Jean Charlot, an extremely intelligent and sensitive man, as indeed most painters are, whatever their public lunacies; and Carlos Merida; and later, almost at the end of his second visit to Mexico, the painter José Orozco:

> . . . His work . . . I found fine and strong. His cartoons—splendid drawings, in which he spared no one, neither capitalist nor revolutionary leader—were scathing satires, quite as helpful in destroying a "cause," heroes and villains alike, as a machine gun. I would place Orozco among the first four or five painters in Mexico, perhaps higher. Monday eve he came to see my work. I have no complaint over his response.

In desperate daily need, both of money and justification, Weston was once again doing portraits for commission:

> My days pass monotonously enough, trying to make an ancient American woman, dressed in a black mantilla, look like a Spanish señorita, retouching hours at a time—bah! for professional portraiture! This jotting down of impressions helps to relax and prevents mental stagnation. I write a few words, then retouch a few wrinkles. My writing does not help me physically, however, my eyes suffer and my body is cramped. My only salvation has been fifteen minutes hard exercise and my morning cold bath.

But at the same time, the undiluted personalities of Mexico, which remind one of similar personalities in America in the mid-nineteenth century, restored his interest in the human face. For the first time, he was no longer arranging a head as if it were simply an interesting object inside the planar landscape of a room. He now felt strongly the impact of the face itself, the head as a sculptured object, within which the springs of hate and love continually wound and unwound. His new portraits occupied three quarters of the photographic space. They are, with few exceptions, disembodied at the neck and concentrated into an explosion of character itself. Their force is direct, blunt, overwhelming. Shot with a hand-held Graflex, the exposures were very short, due to the intense sunlight, but none, as Ansel Adams has accurately pointed out, are really optically sharp; nor could it matter less. Weston photographed General Galvan in this way:

> I wanted to catch Galvan's expression while shooting. We stopped by an old wall, the trigger to his Colt fell, and I released my shutter. Thirty paces away a peso dropped to the ground—"un recuerdo," said Galvan handing it to Tina. . . . (on the way back home from a picnic)—it grew cold—"I should enjoy a half-hour battle to warm me up," said General Galvan.

One Sunday evening, D. H. Lawrence visited him with the artist Louis Quintanilla. Of D. H. Lawrence, he commented:

> My first impression was a most agreeable one . . . a tall, slender, rather reserved individual with a brick-red beard. He was amiable enough and we parted in a friendly way, but the contact was too brief for either of us to penetrate more than superficially the other: no way to make a sitting . . . I actually lack sufficient interest to develop my plates.
>
> Unless I pull a technically fine print from a technically fine negative, the emotional or intellectual value of the photograph is for me almost negated, no matter how fine the original feeling and impulse.

In fact, the D. H. Lawrence negatives were definitely blurred. But they are no more blurred than the pictorial portraits still being made all over the world. D. H. Lawrence himself was rather pleased with them, for they were deeply observed:

> Lawrence's abnormal sadness and intensity shine darkly through.

He also photographed Rivera from various distances. The closer portrait is extremely interesting: behind Rivera is the blurred suggestion of a round, decorated dish, part of the mural he was painting; he himself wears a broad-brimmed country hat; his face is frowning, pudgy, even pouting. It has great vitality and a strong will, but, at the same time, there is something there of a serious, famous little boy. Edward Weston relates:

> A painter and an acquaintance were discussing Diego at a saloon— "I hope you don't paint like Diego Rivera," said the one—the artist incensed, drew a knife and stabbed him—he's now in the hospital.

He photographed Guadalupe:

> Tall, proud of bearing, almost haughty; her walk was like a panther's, her complexion almost green with eyes to match—gray-green, dark-circled, eyes and skin such as I have never seen but on some Mexican señoritas. . . . Her dark hair was like a tousled mane, her strong voice almost coarse, dominating.

He thought very well of his photograph of "Lupe" Rivera:

> It is a heroic head, the best I have done in Mexico; with the Graflex, in direct sunlight, I caught her, mouth open, talking, and what could be more characteristic of Lupe! Singing or talking I must always remember her.

He still remained obsessed with Tina and took a number of close portraits: one while she was reading poetry; one in the morning, after a night of frustration:

> The night before we had been alone—so seldom it happens now. She called me to her room and our lips met for the first time since New Year's Eve—she threw herself upon my prone body, pressing hard—

hard—exquisite possibilities—then the doorbell rang, Chandler and a friend—our mood was gone—a restless night—unfulfilled desires —morning came clear and brilliant—"I will do some heads of you today, Zinnia"—The Mexican sun—I thought—will reveal every-thing—something of the tragedy of our present life may be captured —nothing can be hidden under this cloudless cruel sky—and so it was that she leaned against a whitewashed wall—lips quivering —nostrils dilating—eyes heavy with the gloom of unspent rainclouds —I drew close—I whispered something and kissed her—a tear rolled down her cheek—and then I captured forever the moment—let me

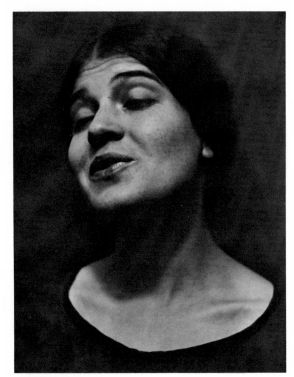

Tina Reciting

see—*f*.8—1/10 sec. K I filter—panchromatic film—how brutally me-chanical and calculated it sounds—yet really how spontaneous and genuine—for I have so overcome the mechanics of my camera that it functions responsive to my desires—my shutter coordinating with my brain is released in a way—as natural as I might move my arm —I am beginning to approach an actual attainment in photography —that in my ego of two or three years ago I had thought to have already reached—it will be necessary for me to destroy, to unlearn and then rebuild upon the mistaken presumptuousness of my past —the moment of our mutual emotion was recorded on the silver film —the release of those emotions followed—we pass from the glare of sun on white walls into Tina's darkened room—her olive skin and sombre nipples were revealed beneath a black mantilla—I drew the lace aside—

His views on what he was doing at this time are remarkably clear and cogent:

. . . the camera should be used for a recording of *life*, for rendering the very substance and quintessence of the *thing itself*, whether it be polished steel or palpitating flesh. I see in my recent negatives of the circus tent and of the glass roof and stairway at San Pablo—pleasant and beautiful abstractions, intellectual juggleries which presented no profound problem. But in the several new heads of Lupe, Galvan, and Tina, I have caught fractions of seconds of emotional intensity which a worker in no other medium could have done as well. I shall let no chance pass to record interesting abstractions, but I feel defi-nite in my belief that the approach to photography is through real-ism, and its most difficult approach.

The proof of his belief in photographic realism, however, is in the print itself; and it is especially forceful in his photograph of a woman called Nahui Olin. It is very close, looking directly into the eyes of the woman. Actually her name was Carmen Mondra-gon, and she was from Paris; but she had given herself an Indian name, along with her lover, who had named himself Dr. Atl, and whose real name was Gerardo Murillo. In Brett's memory, Dr. Atl was a phoney and the woman, a whore. Both may be true; but in Nahui Olin's case, there is (as ever) more to the person than can be said in a single word, and Edward Weston saw a lot more, es-pecially in his photograph of her; the sensuality is direct, and almost feline in its urgency.

It seems to me that this is a crucial matter. What is revealed in these very great photographic portraits by Edward Weston is not the personality of the sitter; and not the personality of the photographer either. Instead, it is an invisible, indefinable inter-action of the two. There are portraits by other photographers which are portraits not of the sitter, but of the photographer, ei-ther dignified or clownish; and there are competent portraits which are neither; merely, and generally, a highly commercial image. But photographs become something more when they are a record of the interaction of photographer and subject. It is argua-ble that all great photographs, not merely portraits, have this quality—that what we see, what we respond to, is the dialogue between subject and artist, unspoken, unspeakable.

This was not Weston's view at the time. He aimed only for the truth. No doubt General Galvan really was this keen-eyed, watch-ful, egotistical soldier and politician who Weston represented in his portrait. But there is also his admiration for the man. Galvan, quick and accurate with the American Colt, died by the gun, too:

Shot by political opponents, as I had guessed. The murder took place in "The Royalty" where three years ago Llewellyn and I used to sit

over hot rum punches. He had no chance—fell dead across his table, shooting as he fell, but shooting with eyes already dead. I suppose one might say he died as should a man of action,—but it was a monstrous tragedy.

Several years later, in notes taken by Edward Weston's friend and Los Angeles dealer Jacob Zeitlin, Weston stated his approach somewhat differently:

> I am a realist, but not a literalist. To me good composition is simply the strongest way to put over my emotional reaction. I do not consciously compose, I make my negative entirely under the effect of my emotion in response to a given subject. I do not stop to analyse composition even in print. I saw a thing well or I did not see it.

Of course, one should not expect philosophical consistency from an artist; unless one is looking for mediocrity. Weston was a different man with his sons than with Flora; different with McGehee than he was with Hagemeyer; different in Glendale than he was in Mexico. His work comes first, and after that, various branching

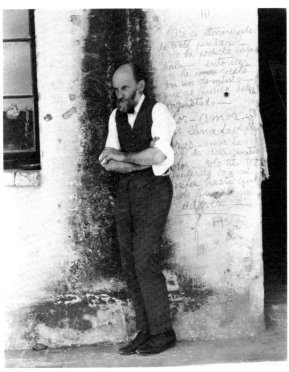

Dr. Atl, Mexico, 1926

rationalizations; and these, only on demand. The reverse is never true. One cannot, from the keenest essay on Shakespeare, deduce one line of Hamlet. The artist, whether alive or dead, will always slightly elude the biographer; and this is precisely what is interesting.

Edward Weston's visit to Mexico coincided with the brash and beautiful renaissance of Mexican Art. He was welcomed and em-braced, literally. His exhibit at the Academia de Bellas Artes, before he arrived in Mexico, was succeeded by the exhibit at Aztec Land:

> First Exhibit at "Aztec Land." The exhibit has been open for over a week; it is a success. I have done what I expected to do, created a a sensation in Mexico City. Roubicek, the owner of "Aztec Land," told me he has never had such an attendance to any previous exhibition. I have never before had such an intense and understanding appreciation. Among the visitors have been many of the most important men in Mexico, and it is the men who come, men, men, men, ten of them to each woman; the reverse was always the case in the U. S. The men form the cultural background here, and it is a relief after the average "clubwoman" of America who keeps our culture alive. The intensity of this appreciation and the emotional way in which the Latins express it has keyed me to a high pitch, yet, viewing my work day after day on the walls, has depressed me greatly, for I know how few of them are in any degree satisfying to me, how little of what is within me has been released. . . .

> Last evening, Diego Rivera visited the exhibit. Nothing has pleased me more than Rivera's enthusiasm. Not voluble emotion, but a quiet, keen enjoyment, pausing long before several of my prints, the ones which I know are my best. Looking at the sand in one of my beach nudes, a torso of Margarethe, he said, "This is what some of us 'moderns' were trying to do when we sprinkled real sand on our paintings or stuck on pieces of lace, paper, or other bits of realism."

> Just now an American girl came in for an appointment. "Do you know," she said, "that you are the talk of Mexico City? No matter where I go—to afternoon tea, to card parties—your exhibit seems to be the principal topic for discussion. You have started out with a bang!—already famous in Mexico!"

He had exhibits of forty prints at Guadalajara, and another of six prints at El Café de Nadie:

> It is the same café where months ago de la Pena took Llewellyn, Tina, and myself to dine and I watched the pale prostitute with the scarlet mouth.

At his exhibit almost a year later, October 15, 1924, the enthusiasm was still very great, if sometimes odd. Dr. Atl said of some of the photographs: "This means nothing, yet it means everything." And, commenting on a local photographer named Silva:

> . . . After raving and waving and tearing his hair [he] went up to a certain "Torso," exclaiming, "Ah, this is mine—it was made for me—I could—" and with that he clawed the print from top to bottom with his nails, utterly ruining it. Tina was horrified and furious, but it was too late. "I will talk to Sr. Weston," said Silva. "The print is mine, I must have it!" Tina was called away and later found that the mount had been signed—"Propiedad de Silva." I don't know whether Silva

is really mad or only staging pretended temperament; if the latter, I could quite graciously murder him. Either way the print is ruined.

Press notices hailed him as, "Weston the Emperor of Photography," but the Emperor badly needed new clothes, eventually exchanging photographs for garments at a local clothing store. As usual, he was intermittently depressed:

I stole silently away from our *casa* and walked for hours alone . . . to assuage my "blues." I did my first bargaining alone, purchasing two lovely dishes of jalisco ware.

In December, with Christmas approaching, he wrote:

I can't go on this way. I must acquire a formula for my portraits. I compromise anyway—and give far too much of myself to an unappreciative audience.

Yesterday, I quit—put down my prints on which I had spotted all morning. Poor technique? Yes, but not my fault—fingerprints and scratches and bad retouching done by others—retouching necessary to make an American of questionable age look like a vivacious señorita. I quit, I say, and paced the floor the afternoon—the worst reaction to professional portraiture I ever had. It made no difference to me that rent was due and the work had to go on.

As I walked back and forth in my two-by-four room with its ugly wall paper, its cold cheerless aspect, I pondered much, and a new philosophy of life was presented to me—probably by the devil—that of the Indians who lie in the sun all day and pawn their blankets for the price of a bullfight—they, at least, must be happy, no thought beyond the day, no desires, no ambitions. I became obsessed—overwhelmed by the desire to quit, realizing the futility of effort.

Yet here I am this morning at my desk, working harder than ever, attacking this negative almost with ferocity, as though it were one of the tasks of Hercules. The outward and superficial reason that if it is not done by tomorrow I cannot go to *El Toreo* Sunday!—and five foot letters announce *Silveti y Nacional!*

Strange humor, living from week to week in anticipation of the Sunday bullfight, acknowledging its cruelty, shuddering when a mortally gored horse careens across the arena with its guts wrapped around its legs, but watching the pageant or orgy, nevertheless, in fascinated horror. The Latins have evolved a sport which symbolizes life, its glorious moments and its sordid ones, its dreams and deliriums—and futility, and they can return from such an afternoon to tenderly pet their birds and water their geraniums—

In March, dead-broke, unable even to sell or pawn one of his lenses, he records:

I danced many times and furiously,—it was distraction I needed. The best dance of the evening was with Elisa, yes, our servant Elisa. I dragged her to the floor, despite her protesting cry, "No, no, Sr.

Don Eduardo," and we whirled around at a great rate while the crowd applauded. I am most assuredly not mentally calm. The ghosts of my children haunt; their voices, their very accents, ring in my ears. Cole's merry laugh, Neil's wistful smile, and blue-eyed Brett's gestures. Some solution must come, I need them, they need me.

Nevertheless, he still felt that he could never go back to Glendale:

Just now a letter from Bertha Wardell—"We are finding life interesting in the midst of a Righteous Crusade against the Wicked Dance. It has so far deprived us of the use of our studio but not of our legs so we have nothing really to complain of." Christ! Is this possible! O how sickening! My disgust for that impossible village, Los Angeles, grows daily. To think that Mexico had to abandon the fair country of California to such a fate. I ask every Mexican, "Do you like the conditions here? If not, then fight American influence in Mexico!" But being an American I like to believe that only in Los Angeles could such a situation exist.

Edward Weston's generalities, like those of the rest of us self pardoners, were directed against specific people: in this case, against his wife's relatives. The Chandlers were busy constructing their collective fortune; they already owned great chunks of the orange groves that would metamorphose into savings banks. They had the land, the capital, and, therefore, the foresight. Other Los Angeles citizens were content, like most everyone else, to work for a living. My great uncle-in-law, a farmer of Tolstoyan persuasion, was offered cheap acreage at the corner of Sunset Boulevard and Vine Street in the heart of Hollywood, which by now is worth some thousand dollars a square foot; an honest man, he didn't buy it because the soil was no good for sweet potatoes; he was right, too.

Flora May Chandler had inherited parcels of land worth about forty thousand dollars; and Weston, off in Mexico, grew desperate about this property:

There has been something on my mind for long—this seems an opportune time to speak of it—in case of your death I fear a legal mess with your relatives—I hate to put it this way—but at least with some of them there is no love lost on me—it might be claimed that I deserted—or that I was degenerate or had contributed to the children's delinquency—and they might attempt to assume at least a guardianship of the estate—even if I won out it would mean a legal fight—time and money—my suggestion would be that you change the deeds to the property from your name to a joint holding of them in both our names—or since I am "weak" on legal knowledge, make some step to assure my control or possession without trouble in case

of your passing—then I will do the same with whatever comes my way—and something is sure to—ponder over this—

What is so difficult about personal decisions is that one is always reconsidering them. The emotional and economic storm Weston endured in his Mexican exile is certainly a justification for his curious paranoia over money and property and inheritance and all the solid Midwestern values.

Edward Weston never did a self portrait (there is said to be one of himself with Margarethe, but very likely it was taken by Hagemeyer), but he did depict himself in words. Here is one of the most brutal, written to McGehee:

Ramiel!—this note—to you and M [Margarethe]—you two know the best of me—and the worst of me—you two closest locked in my secret shrine—now—having written *so* much—in my wrath—in my helplessness—my inability to convey to you everything I would say—I would destroy this receptive piece of paper—and snap my pencil in two! Oh for just one hour actual contact with you—but I'll go on and make the best of this secondhand contact—beseeching you at the very start to burn at once this letter—and all others recently sent you—first of all I have—or had—things just as I wished—in re Flora—it took some very careful calculating—either of you would have done a lot of thinking with a $40,000 estate at stake!—*now* I have played my last card—for I am not willing to sell my soul for $40,000—nor for a woman's legs!—so I posted recently a letter in which I poured forth every bit of venom I could muster upon the heads of Flora's relatives—I spared no-one—I told the story of each dirty hypocrite in turn—and let her know that I refused to have my friends and myself made "the goats" to satisfy *their* envy and jealousy and designs—Flora knows from this letter that I am on the offensive—that I am unpenitent and uncompromising—I hope I did the psychological thing—and at the psychological moment—I await! Now a few words about myself—I have written so much to you two lately that I may repeat—Willy-nilly I am here till next September—when the lease expires—but I would stay that long anyway—for no matter how futile I may consider it—I shall fulfill my part of the contract and teach Tina photography—by that time I may know whether I would wish to live here—up till now I have had little chance to find out—and here let me speak to you M—you write, "I envy you—your beautiful and exciting life"—yes M—I have had my wonderful moments—I have had a change of a sort—I am not unappreciative either—I know that I am better off than either you or Ramiel—and I have tried to share my interesting moments with you—by writing—hoping you might get at least a vicarious thrill—On the other hand—I have never before had such a struggle nor such reactions—and this has nothing to do with sentiment—in fact I am sure my sentimental reactions were largely a direct result of my economic condition! Sitting here as I am at this moment—retouching and cursing—and doing it from dawn to dusk day after day—gives me too much time to brood—I am busy to be sure—but busy as an automaton—I never hated professional portraiture so before—the fact is I have "taken out" most of my bitterness on May rather than worry either of you with it—Self pity is a kind of soothing syrup—and in my sane moments I am sure that I am better off than most of those around me—my reactions may have been intensified because of the beauty and opportunity for excitement on all sides in which I was unable to participate—I usually tumble into bed disgusted and my awakenings have been rotten—for almost the first time in my life—and worst of all my eyes have suffered greatly—So—I have told you the worst of my troubles—take them all not too seriously. I have no intention of giving up—I want to see Mexico—really live here—I have made it plain to Flora that I shall never return to Glendale—I should enjoy returning to fling my pot of paint in the public's face—One thing I feel sure of M—that you will never see Ellias [one of Flora's brothers] in *our* studio—I think I fixed him forever—unless Mrs. W wishes to sever all diplomatic relations—so put a chip on your shoulder and laugh a little if you can—(dear "Polly Anna")—*otra cosa*—I have missed human contact—even those I might have made friends with were denied me—we were separated through our difference in speech—I never realized how much the spoken word meant—it was a wise God who planned the confusion of tongues—for it takes more than the pleasantries of a language to bring close contact—perhaps you felt this R—when first living in Japan! I have had L—T—and C—yes! L—a lovely naïve boy—C—a difficult child—Tina a beautiful flower—I need stronger medicine—in other words—R & M—I have missed *you*—and wanted *you both*—to play with and enjoy Mexico with—I have had the three mentioned—and perpetually—yet I have been alone amid confusion—you see I am delicately defensive today—excusing my weaknesses—I might as well continue prompted by this from M. "E. as gregarious as anyone I know"—this was a surprise to myself—and I reflected over my past misadventures—deciding I could truthfully answer that aside from my "conquest" of you Miss Plumblossom—and I sense the humour in writing "conquest" re you—for who indeed could conquer you!—I repeat aside from you—whatever scalps I have added to my belt have been handed me on a silver platter—I haven't wasted ten minutes attaining my "desires" nor in retaining them—but you!—you little ragamuffin—I have spent many a sleepless hour over—but—*you* were worth it!—the rest—let's see—I've even forgotten their names—Well Margarethe—no matter what you think of me—I've always tried to play square with you—if you are not sure of how you have stood in my affections ask R—he knows me as well as any human can ever really know another—and now Ramiel—my turn for a fling at you—defensive again—you scold me—and I deserved it—my now famous letter certainly started

things—poor Tina—if she only knew—and she is such a good kid—would do anything for me—and has—I am humiliated—I was moody and took it out on an innocent bystander—listen! What if you hadn't heard from me—either of you—not a line—for two months?—you at least would have wondered if I were sick or worse!—but you R—have found me you say—in a "horizontal position"—too often—I have only one answer—and it is sort of a Margarethian reply—I have kept on working and producing just the same—and the only reason I am not doing much now—that is "creative" work—is because I have no time—nor many plates nor Platinum paper—believe me my dearest ones—my mind is active and I am full of desire—Will this could go on indefinitely—I have made my little defense—handed you a few groans—if I groaned extra loud to Flora—I had my reasons—for she can act the abused wife—and I sensed that she imagined I was down here having one grand vacation! Do all you can R—to "keep in" with Flora now that she has made the advances—you may save us all—I am so happy you can see my babies—for you M—I can see only "finish" if you hang on to Los Angeles—we have both "made history" there—we are through—no matter if Flora *gave* you the studio—even then you should not stay there—you might just as well die trying a new place as to give L.A. the pleasure of seeing your end—I think this is a place of great possibilities—I think one could live here—as an artist might be willing to live (not as a "fashionable" photographer *has* to live) on very little and with much more grace and less strain than in the U.S.—the climate so far as equability goes—leaves nothing to be desired—I like the food—the cooking—and fruit!!—for instance aquacates [avocados] and tortillas for my lunch—or a chirimoya as big as my two fists—like eating perfume—or mangos or chicozapote or Chinese pomegranate or a dozen other fruits—I could go on with my "likes"—but I have written enough before this to give you some idea—and I still hesitate to say whether I should want to live here the rest of my days—to tie myself here with too many bonds—but I am tied for some time—that seems sure—such as it is I share always with either or both of you—need I tell you that!?—somehow we'll eat—and there's always a roof for you—consider *carefully*—and then act *quickly* and *decisively* —so I may make my plans—gestures and overtures and—keep your mouths shut tight—*not one confidant*—

As you may know a brand new revolution is on—except for the price of food, we go along as usual—but there has been fighting in Tacubaya where we once lived—near Guadalajara 30,000 men are in battle—opinions vary—though most think it will soon be over—wires are cut on all sides—and passenger trains are stopped—I shall write no more till I get some response to *this* certain note—I don't want to waste energy if my letters don't get through—however I seem to get mail with usual promptness. M's letters No's 1-13! at hand—

I seem to have talked a lot and perhaps said nothing—Next letter will be much shorter for your sakes and I hope less of a wail—I told Llewellyn to send you a description I sent him of my second bullfight—I went on Sunday—really expecting nothing—more to get away from my retouching desk—and got the thrill of my life—it was stupendous—I thought of you both—I wish we were all three together this night—driving along in a low-swung coach—down through some narrow walled street—we'd get off occasionally and have a drink—or have a bottle on our hip—and we'd have a kiss around or two—not too many for M's sake!—and we'd curse our ancient enemies—and giggle a little—God! how I *need a good laugh*—

Adios queridos—E—

In his journal, on March 21, 1924, he wrote:
Not yet 5 a.m. I awaken early as in my California days, my mind refuses the sleep my body craves. Last night I wrote a love note to Margarethe and received one from Flora: poor Flora, she has had a dirty deal from life. I must try to be tender to her, it's not easy to thrust aside such a great love as she offers me,—that is when it comes from a distance!

He was broke often, and critically dependent on Flora's occasional money orders:
Dear Flora . . . Today the bank notified me that the money (new draft) awaited me . . . be prepared for a shock—raise for me somehow two hundred dollars instead of the fifty dollar last draft—and then I think I shall not need assistance for a long while!

He was, of course, earning money himself, but the income was scant and uncertain:
A sitting was postponed because the young lady could not wash her hair. I wore a smiling mask and changed the date; a cloudy day and a pretty girl's unwashed hair might change another's life,—tomorrow's tortillas depended on that sitting.

The Gods always save me at some crucial moment, this time through Flora, who wired me two hundred dollars. I hope she sold no land at a loss.

And then, a month later, things were even more desperate:
No money for days—we live on Elisa's (our servant girl's) savings left in our care. The draft from Flora has not arrived, no mail comes through. Persistent thoughts that I must try to leave here, return to Los Angeles,—not to stay there, of course,—merely to use that place as a start towards new fields.

Sometimes, of course, he was impelled to answer Flora's central concern:
. . . did my departure and subsequent life have any of the earmarks of a desertion!? Did I not plan the trip long before Robo's death and with him?—did not he and his mother beg me to accompany Tina!? —when I reached Mexico City my first move was to establish a *business*—why? to attempt to make money—why?—for my family—you know my personal contempt and disregard for money—if I had de-

sired to "desert" I could have gotten myself a room in the most beautiful—impractical old section of Mexico for five dollars a month! —one sitting in two months would have supplied my wants—and I could have worked and dreamed my life away—free from the vulgar contact of the public—instead I made the attempt to make money—gave an exhibit—a great effort and strain—*not for artists*— for the *public*—I wrote for money only after you and I had come to a mutual understanding as to the future—and I wrote for it as I would to a partner who might wish to take a chance on saving the *business* money already invested—I *personally* needed no money—I have innumerable friends—senators—governors—artists who would share with me their homes—the Mexicans are hospitable indeed—as for the remark "let him starve"—I have more invitations to dine than I think of accepting—I care not for the "society act"—preferring a handful of frijoles—as for the remark "let him walk back"—the most amusing of all—I would not return if they loaned me the president's private car—unless the *business* failed and I wished to open another *business* elsewhere—which would be for the sole reason—keeping a contact with my family—. . . as for me—if I were the worst scoundrel on earth I have balanced my discrepancies by improving photography— that should be sufficient! . . .

I still think—no matter what has been the cost—that this separation has been the best thing for us all—it has given a perspective which would not have been possible close at hand—and for me re my work—it has clarified my vision and attitude—enabled me to destroy much of my past and build on firmer future—Ramiel and I have discussed the possibilities of collaborating on a book—Mexico of course—illustrated with my photographs—keep this to yourself— the time is ripe—Mexico is in the limelight! I only hope he can come soon—

Now farewell for a few days my dearest ones—let us all live in a glorious future—it is possible!

His references to Ramiel McGehee are the surface of a much deeper and more complex relationship. There is no doubt that Edward valued Ramiel's friendship and his talent very highly; the relationship went on for many, many years. But it was inevitably one-sided. Ramiel's letters dealt with Weston's deepest anxieties. Most of these letters were burnt by Weston, but he did copy certain passages, and sent them with his own brief comment, years later, to Nancy Newhall. In 1924, Ramiel wrote to him:

In a confession—as your journal should be—we touch upon the most sacred secrets of the soul—let us lower our eyelids and be silent—

Ramiel visited Flora and the boys and reported on each one of them. Of thirteen-year-old Brett, he said:

I felt so sorry for him the day you left—he felt your going more than anyone—there was nothing left for him to cling to—only blind un-

reasoning woe—he knew something inexplicable was happening and as long as it was unexplainable—why should it happen?

And when the letters became more personal, the passages became decidedly purple:

Your going from me still weighs heavily upon me—holding you within the circle of my arms—more than the universe ever held for me— it was precious beyond words—not kisses only nor embraces nor the sweet pain and passion of the flesh alone, but more far more—the creature deep within enshrining its mate united—entranced ages long in light—suffused—all other pleasures fade but to symbols in the memory of that perfect union—dear head and hair and lips and limbs that shrine eternity! I kiss you again and again!

On another occasion, he paid a visit to Weston's old studio in Glendale:

They drove me to Margarethe's I found her there—she had suffered—oh! so terribly—she was still dazed—we sat a long time going over everything—for a moment you seemed a ghost haunting us.

And God—Edward—I can hardly tell you just how your place affects me to go there—it is a vacuum—all your personality is gone from it—it is intensely negative—there is not one vital vibration from its bare walls—how amazingly inanimate things can change— when I go there it is like visiting a tomb—the place was your creation—it was you—when you went away you carried the strength— the personality of your self along with you—seemingly you left nothing behind—perhaps it is well—it enabled you to carry yourself intact. The *I am Edward Weston* is no longer there—the important oneness is in Mexico—perhaps this is my reason for feeling that you will never return to this studio—the drama of it is over—the word *Finish* is written all over the building—the curtain is slowly descending on the present tableau for the last time—

It must be remembered, of course, that the full letters no longer exist: these were the passages from Ramiel's letters that Weston wished preserved. Their style may strike us as funny; but all love letters are amazingly alike—moving and silly at the same time:

If you only knew how pleased I am with the thought of seeing you again—embracing the lips of one I love best of all—I put my arms about you—draw you very close—encircling you with my ecstasy— my unbounded joy—feeling your heart beat against mine—knowing that time nor place—nor person can sever the bonds of our friendship—our love—and I tell you—Edward boy—that all is well between us—things never changed since the time of the Gods—the flowing of water—the way of love—may the Gods bring you safely home again—may they guide and protect you when you are here! Yours in the bowels of wisdom—Ramiel.

And this is the comment which Weston wrote at the end of these copied quotations:

So with many a pang and regret, I destroyed Ramiel's letters.

Weston had left several emotional hurricanes behind him in his flight to Mexico, but naturally, all was not calm there, either. He was deeply in love with Tina Modotti at this time, and while her response to him was tender and passionate, so was her response to other men. Weston was naturally and humanly jealous. Two days after their departure from Los Angeles, while still on board, Tina got seasick. The night before:

> Our ship cut through silent, glassy waters domed by stars—toward what unknown horizons? A night of suspended action—of delayed but imminent climaxes—anything might happen—nothing did. . . . Morning—and we excitedly prepared for shore. Thanks to Tina—her beauty—though I might have wished it otherwise—El Capitan has favored us in many ways.

But Weston was fascinated by her and observed these actions with tender astonishment:

> To watch Tina bargain has been great fun. Often she buys for one-third or even half-off the original price. Last Sunday, we were offered a real bargain, in fact something for nothing—a baby! Curiosity stopped us before a group of Indian women, two evil looking hags and a younger girl, the latter suckling a blanket-wrapped baby only a few weeks old—perhaps I'd better say a few days old! Its frequent cries were stopped by cigarette smoke with one old witch with tooth-less gums and yellow-stained claws. She saw our curious glances and beckoned. Tina talked with her; the baby was ours for the asking, nay, we were importuned to take it away. In the same market, sur-rounded by an enthusiastic crowd, an Indian sang and sold songs, lamenting the death of Pancho Villa. . . .

On another occasion:

> We wandered through the streets of Colima after a well-cooked sa-vory repast. It was there we met little Carmen; she sat on the cement walk, leaning against a pillar under long corridors of arches, in front of her a tray of pumpkin seeds. She dozed, awakening now and then to dish out automatically a dozen seeds or so for un centavo. Again, her heavy lids would droop, once more her pale profile would as-sume its tenderly poignant outline in the flickering torchlight. Tina wanted her. "Will you come with me, Carmen, to Mexico? You shall be my little sister." Carmen's eyes dropped, this time with a shy, almost frightened hesitancy; we must ask her mamma who would soon return.
>
> The mother had evidently been discussing the strange visit and the request of the foreigners; she was belligerent, but softened when we gave presents to Carmen: a fan, a jar of jam, and other dainties. "She is all I have—and then she is sick—chills and fever—we can-not cure her—no—her father would never let her go." So we waved farewell to Carmen.

Tina's reactions were quick, possessive, and changeable. Juan Guerrero, a painter, was one of her loves in Mexico City. Perhaps, as a consequence, Weston took up with Guerrero's sister, Elisa— not to be confused with the other Elisa, Weston's *criada*, or serv-ant. What made it possible and even cruel, was the fact that all four rooms—Chandler's, Edward's, Tina's, and Llewellyn's (his pupil and assistant, who played the piano, taught music to Chan-dler, and had a dog named Panurge)—had separate entrances off the patio. It was not infrequent therefore that Tina's lover would stay the night in her room while Weston lay sleepless in his own. And there were others in Tina's life—and bed—including an absurd "Dr. M" who declared that he was monogamous, but only toward Tina. Weston wrote:

> Last night Dr. M. called to take "us" to the merry-go-round. He was still wearing a flower Tina had pinned to his coat three nights ago; he is very attentive and very insistent. Tina still sticks up her nose, it may be to please me, one never feels sure of a woman, even when they mean to be frank they don't know how! I don't mind being fooled, in fact, I crave illusion, but it must be either absolute frank-ness so that I know how to act or a complete illusion: and they are not clever enough, these women, to fool one completely; even the subtle M failed. Well, I wonder what I want? Certainly not a woman madly in love with me. I have had this and it forces responsibilities I care not to assume. I prefer the very kind of love Tina gives to me, I don't *have* to play the boresome part of a lover, I would rather by far pretend to myself that *I'm* in love. The evening went off quite well considering the triangle. We rode the prancing horses and went up in the big wheel,—then home under a ringed moon and walls overhanging with heliotrope: the door closed on the doctor and I kissed her cheek "goodnight."

His displeasure with Tina went so far as to apply to the objects she had in her room:

> For weeks it hung across her bed, a plaster Christ on a varnished cross, a present of unpardonable taste. How well I remember the night he brought it to her, and how I secretly stuck up my nose. But my position precluded an opinion—might be considered "catty." So I suffered silently, writhing in anguish as it hung there week after week mocking my memories—a Christ symbolizing disillusion. She has removed the cheap vulgar thing and it rests on the floor, dust-covered in another room.

Meanwhile, Weston pursued Elisa Guerrero:

> Last evening, armed with my dictionary, I kept the appointment with Elisa. We dined at La Tapatia. I glanced at the menu, then shutting my eyes, let fate decide the order. My finger pointed out Pozole which with pollo—and tender chicken it was—provided a most de-lectable repast.

Elisa wishes to learn English, and I, Spanish; so discounting other desires, our mutual aim should provide many a pleasant evening. Just how the subject arose is difficult to recall, but Elisa taught me to say, "Yo te amo"—and since she already knew the English, "I love you," I taught her, "Ich liebe Dich!" We parted early—"You have far to go and los ladrones—footpads—are bad"—"But I have a pistol!"—"No—no—for they are three—adios—I give you un clavel blanco—a white carnation—have I satisfied you?"

Ah, Elisa, that last question was delightful.

. . . Elisa is romantic—but I think unsophisticated. "Me qusta la musica y las flores, nada mas." Are you sure, "nada mas," Elisa?—for I recall one evening not long ago, a perfumed evening, the wind fragrant from mosqueta bloom, the moon with its halo of orange, when Elisa displayed desires other than those for music and flowers.

We climbed to the roof that night, up the stone steps from our patio. Over the distant city, blazing parachutes festooned the sky, bombs burst incessantly, flaring rockets died with a shower of stars. From a nearby pulqueria—music, laughter, festive noises, a nation celebrating its independence day, El diez y seis de Septiembre—

"I am going away soon," said Elisa. "Indeed!—why, Elisa—I shall weep." "Yes, Weston, I go to be married. I do not love him but I want experience—the experience of marriage. He is American and loves me very much. If I do not like, I go home to my mamma."

I ponder; if Elisa wants experience only, marriage seems a roundabout way. But should I become involved at this critical period? No—it must not be.

The next moment a soft hand, a sigh, an averted face—all is lost—our lips meet. Approaching footsteps, and the breathless instant is over.

The affair, if it was even that much, ended without further notice. Tina remained:

> After a day of loafing and napping, it is well to let the world slip by occasionally in indolent indifference. The twilight was spent in Tina's room and in her arms, for she had sent me a note by Elisa. "Eduardo: Por que no viene aqui arriba? Es tan bella la luz a esta hora y yo estoy un poco triste."—Why not come up here? The light is beautiful at this hour and I am a little sad.
>
> There is a certain inevitable sadness in the life of a much-sought-for, beautiful woman, one like Tina especially, who, not caring sufficiently for associates among her own sex, craves camaraderie and friendship from men as well as sex love. How well she indicates this desire and the difficulty of attaining it, when, during a discussion last night over a certain woman, homely, repressed, and probably not able to get a lover, but withal popular with both sexes, she exclaimed, I thought pathetically, "At least she has good friends." So we were just friends for that twilight hour and later Chandler brought us naranjas y chirimoyas y pulque still fresh from the party. When I returned to my room for bed, there on my pillow was a new design

by Chandler done for my birthday, a beautiful thing, one of the best he has made.

The next day Weston was thirty-eight-years old, and he got several presents from Tina, including three purple hyacinth buds and a letter with two words: "Edward, Edward!"

It was a new kind of relationship for him. He admired her constantly improving work, and though it pained him, he also admired her freedom, even while suffering the anticipations and furies of his jealousy:

> Clouds have been tempting me again. Next to the recording of a fugitive expression, or revealing the pathology of some human being, is there anything more elusive? . . .
>
> My eyes and thoughts were heavenward indeed—until, glancing down, I saw Tina lying naked on the azotea taking a sun bath. My cloud "sitting" was ended, my camera turned down toward a more earthly theme, and a series of interesting negatives was obtained. Having just examined them again I am enthusiastic and feel that this is the best series of nudes I have done of Tina.

They are indeed remarkable and one is almost unique; it has both the beloved's face and her sex—rare for Weston, perhaps as much for psychological, as compositional reasons. And there was always the sweet, sad certainty that once he returned to Los Angeles and to his family, "Tina and I must surely separate for ever."

He was photographing more than portraits, clouds, and nudes. Mexico is not an easy place to work; the irregular plaster of its walls, its brilliant darks and lights, its mixture of the romantic and the sordid, all are temptations to expose yet another negative and get nothing more than a superior postcard. Weston was well aware of this trap. He began to think in two directions: the first was a group of intimate and homey landscapes; without horizons. Really they are a kind of exterior room; photographs like the pump at Tacubaya and the views from the azotea (the flat, tiled roof of the house) and the laundry yard (casa de vecindad), are new and unique compositions. The rhythms of dark and light are complex and organized around a hollow space. When Weston did his more open landscapes in 1926—conventional clouds and conventional adobes—his grasp had weakened. They are fine, peaceful, but they no longer have their own history contained inside of them, nor does one feel the artist's intellectual agony of composition.

Another, and much worse a dead end, was a series based on his continued fascination with Mexican toys. In his walks through the city, and his travels beyond it, he bought plates, straw and

clay figures, little people, and comic animals. He made scores of negatives of these objects, and he talks about them frequently in his journals. The shots do have a technical beauty, but there is something about the picture of an object that is itself a toy or model of something else that resists the viewer's emotion; one feels only the plaited straw or the rough clay. In the long run, these were studies of what was possible with close-up photography. These ideas were to make possible those awesome vegetable monuments of the late twenties and early thirties.

One's emotional indifference to the *juguetes* (toys) might logically apply to the painted fronts of the *pulquerias* (saloons), as well; but here some stray human element saturates the prints—sordid and illusory, like the coarse, sweet smell and taste of *pulque*, the fermented juice of the maguey, a plant like a fist-full of swords; mingled with the pungence of horses and sunbaked harnesses. Weston never made interiors of these saloons; very likely it was technically impossible, but he felt it would be embarrassing, too:

> I have always had the desire to frequent the pulquerias, to sit down with the Indians, drink with them, make common cause with them. Two things have held me back. First, most of them are dirty! I don't mind a little dirt! But even stronger is my second reason for hesitating; I feel my presence would be resented, even to the point of my landing in the street. Imagine sauntering into the pulqueria named Charros No Fifis, wearing my knickers and carrying my cane!

After being in Mexico a year, Edward Weston wrote:

> I have decided to get out, if for no other reason than I cannot afford to stay through another [revolution]. But there is another reason, the war between my heart and brain. . . . To be sure, within a few hours' ride from Mexico City, one may find towns which are as they were two hundred years or more ago. In them I am sure life would be simple, unconstrained, and colorful. But questioning myself, the answer comes, "No." I could not for any length of time live such a life. It is inevitable that I shall once more be drawn into the maelstrom and complexity of today.

He felt he had many fine images of Mexico still undiscovered in his head, but his visa would expire on July 31, 1924. Measuring ego against duty, he could not decide up to 5 p.m. of that day whether to leave Mexico the next morning or not:

> After a terrific inner struggle, both emotional and intellectual, I finally realized and decided I must stay. From this decision, today, I am having violent reactions, but I still know that I have made the only possible and logical resolve.

Flora, of course, had been pressing for his return. He answered:

> Your letter Flora—was indeed beautiful—but really I think you are less practical than I am—what would I return to in San Francisco or elsewhere?—that is—without capital?—aside from my great desire to see my family, I might much better stay here and work—and perhaps reap some reward from my efforts—

When his decision was finally made, it involved more than a mere extension of his stay:

> . . . my reactions to the old studio are definite—I want none of it—rent it or live there if you wish—it should not stand idle—I can't sit around there waiting for property to rise—one year—two—three—perhaps never—I must make my effort elsewhere—

In spite of this revulsion against his former life, he felt obliged finally to go back—for these seesaw travels were a symbol of contrary emotions. By October, tentative discussions were under way with Flora over the possibility of his returning New Year's for a visit:

> I favor the plan for I cannot remain away much longer from the boys. . . . My "life" in Mexico is already over . . . there can be from now on but little time for excursions or work that I want to do. I have a quite definite feeling that once I leave Mexico I shall never return, at least not for many years; once with the children again, I know how difficult it will be to part with any of them, and I cannot have them all.

One morning, in the wake of this tumult, he woke up from a dream and couldn't remember where he was:

> Why, yes, Mexico, of course! And last night Tina and I had talked and talked for hours, trying once more to reconcile and adjust our lives to each other.
>
> The conversation centered on the future, should I return here or not? "You must not decide now, Edward, wait until you reach California, then you will have more perspective. As for me, my mind is clearly focused, I want to go on with you, to be your 'apprentice' and work in photography—"
>
> Questions and answers back and forth, a quite deep and tender and hopeful final understanding—clearer and closer than ever before. Now some five weeks of hard work; then, California!

And then, three days after Christmas:

> [On the train]—We faced each other speechless at the parting—a hand clasp—tear-filled eyes—a last kiss.
>
> Jean came to the station though I had warned him not to. Of course Elisa we brought with us, dear Elisa, pathetic little figure in black, and she cried too, indeed has wept by spells for two weeks.
>
> I lay in a half stupor all day—emotional exhaustion, the shock of parting, worry and work. Awakening once, I saw a sky as magnificent as any I have seen in Mexico. Twilight came on a superb sunset, long streaks of scarlet clouds over black hills: they changed and

were black against a lemon sky: above all hung the first delicate half circle of the new moon. I think at every station a blind man on his harp has played, the last one at Irapuato. I seemed to realize that I was leaving, not only Tina, but dear friends and the land of my adoption, too.

He had been away eighteen months and was crossing the border into an American desert when he wrote:

Exquisite, fantastic, enticing. I have always been fascinated by barren wastes, even the Midwest prairies—especially in winter. One tries in vain to pierce the distance, the white silent level unrelieved by even a mound. The sky is white, there is no horizon, all is a shroud of white.

In any decently ordered piece of fiction, when the hero takes a decisive journey, either he doesn't come back, ever, or if he does, he accepts and makes a peace with his warring selves. Life, though, is never parsimonious. Edward Weston came back to his studio, back to Flora and his sons, back to Glendale. But it was a strained, impassioned, restless interval:

Sitting here at my old desk, my much loved desk where I have worked and written, where I have shared morning coffee with Tina, Margarethe, Betty, Ramiel, Johan and how many others! But the desk is now in the "ranch," the home place where I am living. Flora has moved to the house of her parents, which was empty.

Joyous greetings with the boys!

The little ones, though taller, have not changed—are still babies. But Brett has; a big strapping fellow with amazing energy and a rebel! To leave him in these surroundings would mean his landing in a reform school; he must return to Mexico with me. Yes, I must return; I have already announced my intention. I walked the streets of Los Angeles and found myself a stranger,—more, I felt myself a foreigner. Who were all these drab grey people!?—not my kind! It was not merely that they were Anglo Saxons, for in New York I am sure the reaction would have been different. No, what I saw was a parade of Christian Scientists, Angels Templeites, Movie Stars, Arty People and Iowa Farmers. To be sure there are in Mexico just as vulgar a class,—but there is also something besides!

Flora?—the same—she tries to be nice—I try to be decent—but underneath a thin skin is irreconcilable antipathy. Margarethe?—the same—almost submerged in mystery and intrigue.

Peter Krasnow saw my work—the first of all my friends—"our" work, I should have said, for his response to Tina's several prints was keen. Now I must see Ramiel at once.

He wrote to Tina, who was still in Mexico:

My little studio presents even a sadder—sorrier aspect—surrounded on all sides by brick blocks—businesslike and efficient—which scorn the falling shack and seem to say,—"Soon, soon we shall crush you,

crowd you out, tear up your garden—cut down your trees—clean out this eyesore to a wholesome—right-thinking community"—the sign Margarethe Mather is falling too—in a week it will be gone forever—I go on—is it my will—am I stronger—or do I have better luck?—even the faces and voices of my old friends come to me as in a dream—yes—I used to know these people—but now who are they—and what have I to do with them? I knew it would be this way—no illusions—

In a city whose blood was gasoline, Edward Weston never, except for the five minutes already noted, drove a car. He relied, like a child in this respect, on others to drive him where he wanted to go—whether it was for business or pleasure. In the society of intellectuals to which he returned, love affairs were as common as ideas, and the question of who rides in what car became a highly personal matter. On one of these occasions, he had met, long before Mexico, a girl friend of Johan Hagemeyer, named Miriam Lerner. She was the personal secretary of Edward Doheny, a multimillionaire oilman. People remember her (Zeitlin, for example) as an exhilarating, warm, impulsive, and intelligent woman. On Weston's return from Mexico for Christmas, 1924, he met her again. Vulnerable, eager for new experience, and sexually frustrated at home (by his own choice), he fell in love with her almost at once:

She had always attracted me. For the last several years she had appeared and reappeared to me in person and in thought,—but the right time delayed. Then came the night on her hilltop. The Rabbi's good wine—God bless him!—the first kiss—the assent—the affirmation. But from the vagrant episode which might have died that night, grew rare affection which has never lessened. Each fresh contact brought me finer appreciation, fuller understanding and ever-increasing ardor. To be with Miriam was a fulfillment.

His first letter to Miriam is a curious mixture of adoration and professional interest:

Though as I told you—for long I held vague premonitions and desires—last night's episode was more or less unexpected—and as beautiful as I had sensed it must be—walking out into the cold night—and curses that it had to be! A fine exhilaration possessed me and I said to myself—"this has been a night compensating for many a drab day—incense to the Gods who fostered it!"—so hail to you lovely Miriam! For you have given me a new beauty to dream upon—I eagerly await the time when I shall attempt to catch concretely this very loveliness of face and form and attitude long felt by me in you—i hasta pronto—muy pronto! I hope—E—

He enclosed a business card with his name and Mexican address on which he had written, on the reverse: "—finally I had to go—the twilight has been of great beauty—but I missed you—"

His next note to Miriam, early in February, 1925, was from San Francisco, informing her that his joint exhibit (with Hagemeyer) was to open at Gump's, the elegant and famous art store in San Francisco. He was to return to Carmel, California (where Hagemeyer had a studio) next day; but he was planning to move to San Francisco permanently. He apologizes:

> It appears as though I might be tied up here for a month—maybe more—I can't call you for many a day á la telephone—please save a thought—a few kisses and embraces for me? . . .—don't let the wicked analyst spoil you! and forgive my occasional flippancies—you are very beautiful—Edward.

The Gump exhibit, as usual, excited and depressed him:

> The opening days have brought many enthusiastic people. There is something vital about photography—*not* "art photography"—that draws and holds people from all walks of life—a significant note is the interest taken by the store's employees who return again and again—Miss Starr in charge of room said: "They are fed up on 'art' and never come to see the exhibits of paintings."—though men come too, it is of course the women who form the majority—some very intelligent ones, but most of them I despise: clubwomen—just curiosity seekers who come to "rubber" and bore one with insane comments on art. And do you suppose they ever ask the price of a print? No! it's a free show in which they idle away a leisure moment of the "shopping hour," a moment stolen from their more important business or buying "fripperies."

Was it on this particular trip to Carmel, or some other, that he hitchhiked down the coast with his eleven-year-old son Neil? They sat on the beach at the foot of Ocean Avenue (Neil remembers) and two women sat with them. Weston decided to go swimming nude in the moon-colored sea; and Neil sensed, for the first time, some type of sexual aura about his father.

Restless and confused, Weston hitched back and forth to San Francisco many times; got drunk with Tina's parents; and lived for a while in Venice, California, an imitation so dismal that it actually has a certain acrid character. He was harassed with continual debts; saddled (literally, sometimes) with his four boys, who fought one another like all good American boys should; and found himself unable to settle down, emotionally or economically. He writes of this period:

> San Francisco—I have been here almost three months, almost four months since leaving Mexico. I had expected to be in San Francisco not longer than a month, had hoped indeed to be in Mexico before this—Yet the end of my stay is not in view—even more indefinite.
>
> Rain has fallen all day—not for one second has the beating on my skylight ceased—it seems to fall directly on my brain—while I—

tied hand and foot—writhe and twist and turn in hopeless effort to escape the seeming symbolism of this incessant downpour.

> I am tired of thinking, my mind is a vortex of negated plans and desires—my thoughts find no rest in coordinate intentness of purpose—whatever the cost—a fusion of apparently incompatible wishes must come—or else some vagrant hope will be buried forever—but to finally dismiss a hope is as sorrowful an act as to inter a beloved friend—I hesitate—and so returns the unanswerable question.

> One does not necessarily act for the best—nor even nobly, in destroying personal aspiration for the sake of others—the greatest if less apparent gain—even for those others—must come from the fulfilling of one's predilection rather than in sentimental sacrifice. Yet I realize that I face sacrifice, no matter what the decision—thus involving the whole situation and complicating any plan or proposal—so all questions remain unanswered today as they have for days past.

> It is the hour before dawn—a time I love—so very still—the whole world sleeps—for aught I know I may be the only living person—for the moment this thought pleases me yet if it were true I imagine one would commit suicide—for—craving aloneness—yet some human contact is necessary to rebound from or identify with—Anyhow at this hour I seem Lord over my dominion and preside in mighty isolation.

He continued to write letters to his sons, but one can feel the melancholy under the joke:

> Dear old Brett Boy—I have not two dollars to my name—everything went smash here—and I am only holding out with faint hope—I wish now that I had stayed in Mexico—I might as well have done so for all that I have seen you boys—my great reason for returning at all—but your mother has seventy dollars I left with her—unless she has had to use it—ask her to give you from it what you need—I want you to be happy—all of you—but before she gives you a cent you spell *"pants"* correctly to her! also *"decent"*—also *"shopping"*—also *"fine"* also *"cafe"*—you write well—you spell badly—you're a dear old fellow and I love you *heaps*—Dad—

But his work continued unabated; and he created marvels:

> The majestic old boats at anchor in an estuary across from San Francisco, [Neil] who—naked—seemed most himself—the full bloom of Miriam's body—responsive and stimulating—the gripping depths of Johan's neurasthenia—the all-over pattern of huddled houses beneath my studio window on Union Street—in these varied approaches I have lately seen life through my camera.

Among the nudes, there are several of Tina's sister Mercedes, and also some of the dancer and dance teacher Bertha Wardell. There was to be an affair with her, too.

He had another exhibit at the same Japanese Club on East First Street in Los Angeles, early in August, 1925:

The exhibit is over—though weary—I am happy—in the three days I
sold prints to the amount of $140.00—American Clubwomen bought in
two weeks $00.00—Japanese men in three days bought $140.00!—
one laundry worker purchased prints amounting to $52.00 and he
borrowed the money to buy with!—it has been, outside of Mexico,
my most interesting exhibit—

I was continually reminded of Mexico—for it was a *man's show*—
what a relief to show before a group of intelligent men! If Los An-
geles "society" wishes to see my work after this, they must come to
the Japanese quarter, and rub elbows with their peers—or no—I
should say their superiors! I owe the idea for this show to Ramiel—
and his help made it a success.

At this exhibit he met Christel (he always called her Cristal)
Gang, a public stenographer, and began an affair with her that
was to continue for several years. In the midst of all this, he had
decided, in his very indecision, that he had to go back to Mexico.
He wrote Miriam Lerner:

When you withdrew from me those certain charms still craved—I
attempted solace in a way well-known—then your renewed desire—
no—hardly that—my desire needed no renewing!—a break is not
always easy—but now I offer you my last hours—four women have
made deep impressions on my life—you are one—Edward.

The other three women, one may guess, were his sister May, his
partner Margarethe, and that Italian flame Tina Modotti.

Miriam Lerner soon left Doheny's employ; she was ambitious to
paint or to write, and went, like other Americans, to Paris. Wes-
ton made many nudes of her, and was careful to send proofs for
her admiration. On August 21, 1925, he left the United States for
Mexico once more; this time taking Brett. He wrote Miriam from
the S.S. *Oaxaca:*

. . . I wish you were with me on this boat—tonight I would ravish
your sweet body—I would kiss you 'til you fainted!—but we are sail-
ing farther and farther apart—it may be years before we meet!—I
am almost sentimentalizing—and that would never do!—how we fear
sentimentality—yet how beautiful it can be! . . .

In his Daybook, he notes:

I have written thirteen letters today. Really I should call them notes
of farewell. What a volume the history of these several persons would
make if detailed episodes of their part in my life were to be recorded.
I did record such from day to day, even as I now am doing, but one
brave moment in San Francisco, three years of writing went into the
flames. No doubt this period will meet the same fate, but write I must,
no matter to what end. It is the safety valve I need in this day when
pistols and poisons are taboo.

He took up residence with Tina Modotti again. There was an

exhibit in the State Museum in Guadalajara:

Every day we went waiting for sales which never happened—every
day we grew more irritable and despondent. . . .

The intensity of his affair with Miriam Lerner still haunted him,
and he wrote her from Buzones, Mexico, on October 15, 1925:

Querida mia—Your letter—the second—yesterday—eagerly I
opened it—with such pleasure I read it—somehow I don't seem so
far away from you as if I were in the States! I wrote you recently but
sent it to the Edendale address—marked "please forward"—you see
I was not *sure* of your Paris address then—about ten days ago I sent
you *eight* photographs—unmounted—from our last sitting—or was it
"lying"? I hope they reach you safely—someone seeing your lovely
body may wish to steal one!—also I enclosed the view from your
well-remembered hilltop—not very good—but for "recuerdos"—of
course—look upon the prints as "proofs" only—They have been well
liked by Charlot—Diego—Tina and others—especially the twisted
torso—in due time I shall print the best in platinum—nor shall I
forget you—When I last wrote you I was very sick—if I did not say
so—you may have sensed an ill-concealed depression—but I am
almost my usual self again—and quite ready for a period of work
which I look forward to with real joy—you may not have realized it
but the work I did of you—the nudes—and those of my little boy—
Neil—I forget if you saw them—were the start of a new period in my
approach and attitude towards photography—you were an ideal per-
son to work with—and too—I felt your beauty so very keenly—and
by this I do not mean just the undeniable physical beauty you pos-
sess—yet of the latter I speak and insist that now I have not the
same enthusiasm to go on in the direction started with you—perhaps
I shall turn for solace to the clouds again—or the Mexican juguetes!
I want to follow you in your travels and in your search for expres-
sion—and I shall write you of myself—I don't expect to travel much
—but thank the Gods the elusive search for "expression" never ends!

Tina's sister [Mercedes] arrived tonight from S. F. so there is
much excitement in the household—to indulge in descriptive matter
is almost impossible as you have found—there is too much to say—
yet if I write aught of possible interest I may send it—then some-
day we may talk until the grey dawn—

I contemplate and visualize you and Betty together—what luck
that you can be in Paris at the same time—and Lois too?—if you
were *here* I would warn you against the pitfalls awaiting unsophisti-
cated maidens in wicked Mexico—of "generales" with great mous-
taches! But also I cannot protect you so far away—are you not glad!?
Te mando todo mi carino—y muchos besos—yo te quiero—if you
cannot read the above I must tell you I said a *great deal!* Edward.

In November, in response to her several letters, he takes the trou-
ble to answer her present problems:

I have lighted my pipe—now to proceed in the pleasurable pursuit

of writing a dear and lovely person in a far-away land.

A week after writing the above! Why? quien save! I don't even remember the cause of the abrupt break in my trend of thought. Necessities, exigencies, trivialities of routine—these only I assure. Your letter came—the familiar, generous "hand"—the postmark "Paris" excites feverish haste in breaking the seal.

So the nudes pleased?—that is well!—before many moons you shall have a few finished prints. Your self questionings provoke me to discussion. Face to face would be more possible than in a letter, for a week of writing would not cover the ground. The fragmentary notes enclosed may indicate to you a few of my own introspections! If they interest I'll send on more. I should like to discuss "schools" with you. We touched on this subject before? They are only worthwhile for discipline and technique. My whole attitude towards schools—"Art" or other—is best presented by quoting from Samuel Butler—"Don't learn to do, but learn in doing." Ah, but he spoke well! And don't forget our much-abused Oscar Wilde—whose epigrams have become almost platitudes—"Nothing worth knowing can be taught." Enough! or you may call me "pedant"—not yet kissed in Paris!—why Miriam how shocking! However I'm no better off. You are yet the last girl I kissed with more than tender friendliness. I find it more difficult always to find or form new liaisons—or new friendships. There is no lack of desire in my attitude, nor, forgive my ego, lack of opportunity, rather it is the hesitancy which comes with a growth of the critical faculty—the same hesitancy and lack of enthusiasm expressed towards many things once held important—even sacred. The "works of art" once indulged in, books, poetry, persons, patter talk, all in the wastebasket. Sad? No!—for when one does discover anew, what exquisite joy! So, querida mia, of many memories, I shall not need to indulge in superlatives over you. If I say that I found real joy in discovering you, and that you still have the same importance to me, I shall have admitted enough?

—this is the next day —so do I get interrupted. Mercedes Modotti is here—suppose Tina told you. We are planning an interesting excursion for today to Texcoco. But the day is cold and cloudy—too much weather of this kind since my return—quite unMexican in brand. It rains much in Paris? Somehow I always picture Paris in the rain—and it must be beautiful.

Lois—Betty—Miriam all together in Paris! I throw you individual and collective kisses across the waters! I wish the kindly Pagan Gods would transport me there for just a week. Could a good American photographer make his salt in Paris? It is time to dress and be off—As I wrote—you may expect prints in a short while—unless this weather continues or some stupid sitting delays my real desires.

Always I remember you tenderly—beautifully—Edward.

But all that emotion was to change by late 1925.

There were now two young servants in Weston's place in Mexico City. One was Elisa, who had been with them before:

Elisa has little beady eyes—she has hands like witches' claws—they were burned as a child—she is keen—uncannily intuitive and full of humor—she buys the flowers with her own money!—really I feel ashamed when I give her wages to her and occasionally ease my conscience by handing her 50 centavos for the "Cine" (movies)—Elisa has my picture on her wall—she always enquires for "la Señora y hijos en Estados Unidos"—when they are coming? and insists I have a life-size enlargement of la Señora over my bed!

The other servant, whom he calls "X," was actually her younger sister Elena, who was sixteen years old:

Rereading letters before burning. Love like art returns in measure the emotion one carries to it—one finds what one seeks—

Well—already I have been compensated for my loss—and surely this is the strangest love of my life. A little brown Indian girl came to live with us, to help. At first it was a timid distant admiration—then she would softly caress my hair—and feeling deeply—I took her to me and kissed her lips; since then our embraces have been often and impassioned—no less genuine from me than from her. There is indeed something exquisite yet sad in this love between such extremes of age and tradition—for what can ever come of it!?. . .

A fresh gingham of checkered pink, a contrast to her brown skin, I admit almost unwillingly, quite agreeable Elena appears on duty after a hot scrub . . . how charming is the pink and brown dissonance of Elena.

Apparently both *criadas* were mad about Don Eduardo, and Weston's delight was perfectly natural:

Elena tiptoes furtively in—a long tender kiss—no! much more than tender!—but the path of love is ever obstructed—she fears Tina! "She is your 'esposa'—you will tell her"—she repeats over and over almost in terror—then sensing in her childlike way, the hopelessness of our association, she adds, "you will go far away north to your children—I must return to my tierra." In vain I assure her that Tina is not my "esposa,"—she looks at me with frightened eyes and retreats, until desire again brings her to my arms.

Three days later:

After all, life is not so difficult for me,—I slip a new disc into my music box of emotions, grind the crank and out speaks another tune. To be sure it may be a more or less familiar melody, but one can always change the tempo and use imagination!

Two days after that striking and self perceptive remark, he noted:

Undressing for bed a hushed voice called me from the next room. What could Elena be doing there!? "Brett is sleeping with Elisa, I had to get in bed here, I feel deeply, come to me." My heart quickened and when the house was dark and asleep I went—Not hesitating I got in bed and clasped her feebly protesting body to me,—an unexpected opportunity. I was greatly excited and quite ready,—but

Elena, though hotly impassioned, was not. It was the same story she had to tell of her love for me which must remain unfulfilled, because "you are rich and famous—I am humble and very poor. You have your esposa and your children, you will go to them,—you have Srita."

I tried to smother her protests with kisses and caresses, she clinging to me desirous, then recoiling with tears of fear and realization. When I would have left her, she drew me back only to once more repulse me. Finally I escaped, and she did! But this must end. I am weary, and must stop this play with fire.

But ten days later:

And Elena has disappeared!—not from the house but from my arms. Maybe, she being catholic, her father confessor warned her of pitfalls ahead, perhaps her own reasoning, but no matter, I am relieved. She was becoming a nuisance, hovering over me continually, hindering my work and arousing me—one moment weeping and accusing, the next clinging and smothering—bah! I had enough.

His mind was full and busy, working on the famous "W.C." series, so all that dark romance began to irritate him:

Well Elena returned. So much for my premonition. Yet I was not far off perhaps—for after two days of tears and kisses—and the consequences, she left again. Her brother came to take her home. I confess being sad—the house is lonesome. She was a nice little plaything to love. I did not need to waste energy *making* love, she brought it to me with outstretched arms and upturned face. She was charmingly wanting in brains,—and that was nice. One needed not to pretend interest in the patter talk of some women.

All merciful God save me from the boredom of intellectual women! Give me many, or one, sweet body to caress, but deliver me from the mental meanderings of emancipated women. One and all they need to be put to bed with hopes that resulting twins or triplets may occupy them to the complete exclusion of their cerebral hysteria.

Like much else in Edward Weston's journals, he was in no way troubled by contradictions.

In November, 1925, he sent Miriam Lerner pages from his journal:

But I only sneer to hide a hurt—my sarcasm is a defense against my emotional self—. . . then came the night on her hilltop, the Rabbi's good wine—God Bless him!—the first kiss—the assent—the affirmation . . . To be with Miriam was a fulfillment. She is in Paris—I am in Mexico—a few thousand miles away. Three months ago we parted . . . I find myself climbing once more to her hilltop, or racing with her over the white sands of Carmel, or listening to Stravinsky, or pointing my camera towards her nude body—then to kiss it in a fine fervor of ecstatic response. . . .

On December 9, Tina Modotti left for San Francisco to visit her mother who was seriously ill. He recorded in his journal:

Well, I have been rebellious enough in another way and do not know just how to handle the situation. Since Tina's departure, X.—Elena and Elisa too, have hovered over me and pestered me till I am half crazy, never knowing a sure half-hour to myself. They imagine that Tina's absence means one long fiesta of play and love-making. If the North American is too much concerned with business, the Mexican is over-steeped in love. Granted it is a more colorful life, one becomes nauseated with "amor" and it becomes quite as boresome as business. The two races might well mix to advantage, attaining an agreeable balance. So I am paying a price for my conquest. . . .

Elena can never understand how one would at times rather work than make love. I was actually driven from the house the other night by her persistency and spent some preferable hours alone wandering the streets and sitting in the Alameda.

Nor did the relationship with Elisa, the older sister, entirely cease:

One does more in Mexico because one dreams; more time for dreams. You can't hurry because no one hurries. No one runs for a camion, they back up a half block—you leisurely swing your baston, puff your pipe, and they wait. "Mi querida"—"Mi morena"—my darling, my dark-haired beauty—they can love—those brown-skinned Inditas. Thank God they don't talk "art." Mexico hasn't a group of "arty" people, mouthing boresome nothings, sitting around at studio teas. Too much talk—not enough work. Life—the passion of love—the passion of work—these count—these and nothing more. . . . Elisa sat near, planning pozole for our fiesta. I patted her cheek, saying, "Que simpatica Elisa." She put her arms around my head. "I don't want you to leave for the States—ever, Don Eduardo." [It sounded nicer in Spanish.] "But Elisa, I may have to go." "What is there to do there—vamanos todos a Guadalajara—let's all go to Guadalajara." "But I can't earn a living there." "We don't need money, we shall have a ranchito, raise chickens and pigs, and you can photograph the chickens and pigs all day long!"

Tina wrote him from San Francisco:

It would be nice if Christel Gang went to Mexico during my absence—on account of the accommodation there at the house—as for the other sides in question—in case she arrives while I am there— Are we not good pals dear? I assure you that I will help you and make it easy for you—really I would even welcome a chance to give my "ego" a lesson—Oh Edward dear—I feel so rich, so fortunate to have known you in life—to have been near you—to have loved and to love you—Blessed be the day we felt that we had each something to give to the other—

How painful these generous letters can be!

Edward Weston was now forty years old, and at 5 a.m. on the day of his birthday:

Elena and Elisa came, bringing coffee. They sat beside me singing

birthday songs. Elena told of the beautiful bedspread she was to buy me. I heard her, horrified! I protested that she should so spend her money—"A little potted plant as greeting if you wish—but nothing more." My protest brought a scene—"One should sacrifice to give pleasure to a loved one"—she almost wept.

The Xmas gift of a ghastly Tlaquepaque water bottle was bad enough—but imagine me with a lace bedspread! I must prevent this catastrophe!

Celebrated my birthday by putting in hellish hours of hard work. First my student—a session of pretended profundity. Then a sitting—members of a wealthy Mexican family—mother, child, and dogs: the mother alone, the daughter alone, the dogs alone, the mother and daughter together, the dogs and daughter together, until my brain was a muddle of mother, daughter and dogs, wriggling and posturing, barking and smirking.

His personal output, with all these mad distractions, continued to flourish. Sexual stimulation (how he would have hated this idea) poured into his work, not from inner imagination, but from all five senses of reality. He began to think deeply and joyfully about his present work:

Ten new platinum prints—result of two day's vacation. My student away—the sun favorable—I worked!

In trying to analyze my present work—as compared to that of several years ago—or even less—I can best summarize by indicating that once my aim was interpretation—now it is presentation. Also I could now, with opportunity, produce one or more significant photographs a day—365 days a year. Any creative work should function as easily and naturally as breathing or evacuating.

The real world, in spite of every theoretical idea that Weston thought and wrote about at this time, still posed serious difficulties for him; and not merely the technical problem of shallow depth of focus (the need to shorten exposure in order to capture movement), but a more profound problem, and one that is difficult to define. For example, he had set up his tripod to photograph a landscape in Mexico when he was interrupted by a loud, drunken wedding procession, trailing down toward him. He made no effort to turn his camera around and photograph it; he gave up for the day. The imperfections of life, whether gross or minute, seemed to trouble him a great deal. Yet, he describes, with enthusiasm, how he had photographed an Indian pissing:

He came out so opportunely, just as I was about to expose, and stood there serenely—as one is wont to do—I uncapped the lens and have him—stream and all—a touch of life quite unexpected. It might be called—remembering Rosenfeld [Paul Rosenfeld, who wrote frequently for *The Dial*]—an "affirmation of the majesty of the moment."

Now, absorbed and mischievous at the same time, he turned his attention to a purely abstract subject:

"Form follows function"—who said this I don't know—but the writer spoke well!

I have been photographing our toilet—that glossy enameled receptacle of extraordinary beauty—it might be suspicioned that I am in a cynical mood to approach such subject matter when I might be doing beautiful women or "God's out-of-doors," or even considered that my mind holds lecherous images from restraint of appetite.

But no!—my excitement was absolute aesthetic response to form. For long I have considered photographing this useful and elegant accessory to modern hygienic life—but not until I actually contemplated its image on my ground glass did I realize the possibilities before me. I was thrilled!—here was every sensuous curve of the "human form divine" but minus imperfections.

Never did the Greeks reach a more significant consummation to their culture—and it somehow reminded me, in the glory of its chaste convolutions and in its swelling, sweeping, forward movement of finely progressing contours—of the "Victory of Samothrace."

Yet the blind will turn longingly back to "classic days" for Art!

Now I eagerly await the development of my exposed film.

In this new venture, he was following a precedent which was perhaps stored below the surface of his memory: the famous urinal that Marcel Duchamp sent to the historic Armory Show in New York City in 1915, and which had been photographed by Stieglitz at the time. He mentions the possibility that Margarethe Mather had been trying some such thing years before; and writes in the Daybook two days after his first exposures:

The portrait of our privy could not have been finer but for a piece of carelessness on my part: during exposure I shoved a sheet of cardboard within range of the lens. So today I am working again with my new enthusiasm. It is not an easy thing to do—requiring exquisite care in focusing—and of course in placing—though the latter I am trying to repeat. Elisa had only this morning polished up the bowl—though hardly in anticipation—so it shines with new glory. The household in general made sarcastic remarks re my efforts—Brett offering to sit upon it during exposure—Mercedes suggesting red roses in the bowl—while both criadas believe me quite crazy.

No use to "kid" myself longer—I am not absolutely happy with the toilet photograph.

My original conception on the ground glass allowed more space on the left side, hardly a quarter inch more—but enough to now distress me in the lack of it. Not my fault either, excepting I should have allowed for the play of holder in the camera back. I finally trimmed the right side to balance and though I admit a satisfying compromise—yet I am unhappy—for what I saw on the ground glass—I have not—the bowl had more space around it.

I spent hours yesterday contemplating the print—trying to say it would do—but I am too stubborn and refused to say. This morning I am no wiser which may mean that I should do it over. Yet if I restrain my impulse and put away the print for a week—I may become perfectly satisfied, not acquiescing to something badly done but accepting a different conception quite as good. And I am anxious to work more!

Trying variations of the W.C.—different viewpoints—another lens. From certain angles it appeared quite obscene: so does presentation change emotional response.

Only one more negative so far—which I might have liked—not having done the first one. However I am not through—the lines seen

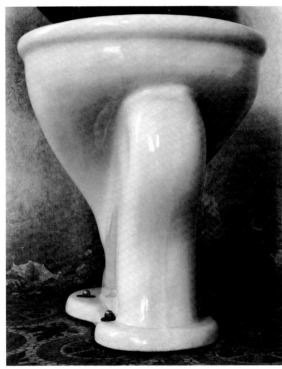

Excusado, 1925

from almost floor level are quite elegant—but to work so low I must rig up some sort of camera-stand other than my tripod.

It was more simple than I had thought. By placing my camera on the floor without tripod I found exactly what I wanted and made four negatives with no change of viewpoint except that which came from substituting my short focus R.R. Unhesitatingly I respond to my new negatives, and shall choose one to print from.

Questioned—I could hardly answer which of my loves—the old or the new privy—I like best: perhaps the first—yet the second—or rather the last which is such a different conception as to be hardly comparable—is quite as elegant in line and as dignified as the other. Taken from floor level the opening circle to the receptacle does not enter into the composition—hence to nice people it may be more acceptable, less suggestive; however—"to the pure"—etc. I like best

the negative made with my R.R. lens of much shorter focus—for by getting closer and underneath the bowl, I attained finer proportions.

But I have one sorrow—all due to my haste—carelessness—stupidity—and I kick myself with pleasure. The wooden cover shows at the top—only a quarter inch—but distracting enough. Of course I noted this on my ground glass—but thought I must make the best of it; such a simple act as unscrewing the cover did not occur to me. I have only one excuse for myself—that I have done all these negatives under great stress—fearing every moment that someone being called by nature would wish to use the toilet for other purposes than mine.

Now shall I retouch the cover away—difficult to do—being black—or go to the effort and expense of doing my "sitting" over? I dislike to touch a pencil to this beautiful negative—yet it is in the unimportant background—and to do the thing over means a half day's work and confusion plus expensive panchromatic films. I shall start to retouch and see how I react!

Now that I am "nicely" stewed from beer imbibed at Mercedes' birthday dinner—for which we bought a keg—I see with more clarity.

To take off the toilet's cover—either by unscrewing or retouching—would make it less a toilet—and I should want it more a toilet rather than less. Photography is realism!—why make excuses?

This series of photographs, in spite of the sly country-boy joke that was part of it, forced open for Weston a whole range of exploration, which obsessed him through the late twenties and the thirties. The monumental shape of a toilet, and the equally more complex, metallic interplay of three-dimensional shapes under the wash basin in the same bathroom, were half-inventions and half-discoveries. They are akin to the "found objects" that have always fascinated artists, and particular sculptors. So it can be said truly (and Weston himself almost says so a number of times) that he, from this point forward, became more and more a sculptor whose shaping tool was a camera.

The famous pear-shaped nude he took that same year of Anita Brenner is proof of the same crucial point—the human imperfections are invisible. More and more, his nudes are indeed examples of strict, yet marvelous form. But the function—and there is no need to specify which function—refuses to vanish, remains inextricable in the photographs, and can never be wholly theorized away, even by the photographer who made them. And this is as true of his nudes as it is of his later photographs of kelp or bones, bowls or pumpkins.

Beginning on June 3, 1926, he was hired to spend a month traveling in Mexico, to do a series of prints for Anita Brenner's

book on Mexican folklore, *Idols and Altars*. His written impressions were strong and various. He recorded the well-known mixture of coarseness and sublimity that is characteristic of most poverty cultures; yet, on the whole, his photographs were simply records; high-class, commercial work, and not to be compared

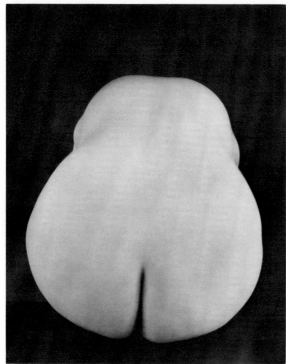

Nude, 1925

with his personal works. In September, 1926, he summarized this experience, reacting in part to the Spring issue of *The Little Review*, which he had just received, and found old-fashioned:

I find myself impatient, irritated, or indifferent to most of the contents. I feel but an attempt to force attention by bizarrerie—or a fierce—puerile effort at being intellectual. Either I am becoming conservative or else I am more discriminate—more aware—less deceived by affectation of knowledge. Naturally I place myself in the latter class—yet—to be fair—or to build a defense—I claim no intellectual aspirations—I even confess a lazy mind. So my reactions may be an admission of weakness.

The photographs of Zwaska are trivial mannerisms, the centre one least offensive. I would quite as soon have a dark smudge by Genthe. The "N.Y." done by Charles Sheeler—had a genuine grandeur—nobility—these photographs by Zwaska are an effort to be smart. Neither do I contact with the photography of Moholy-Nagy—it only brings a question—why?

I would not change one piece of my green loza from Patamban for any thing in *The Little Review* and this may explain my attitude.

These several years in Mexico have influenced my thought and

life. Not so much the contact with my artist friends as the less direct proximity of a primitive race. Before Mexico I had been surrounded by the usual mass of American burgess—sprinkled with a few sophisticated friends. Of simple peasant people I knew nothing. And I have been refreshed by their elemental expression, I have felt the soil.

Soon before leaving to return to California, Weston had a rather hurried affair with a girl identified as M., with "Irish blue eyes." He asked M. to go away with him, but she couldn't decide. She missed an appointment with him (an old familiar symptom to practiced lovers). But his boat was delayed until November 17:

I did not say that the delay would also give me more days with M. For what is the use? I have given up hope that she will "run away" with me. Yesterday she sat to me, and there came moments when we forgot the purpose of her visit, but always her answer to my "Why not," was "Because."

Finally, he saw her at the bullfight:

M. and I ditched the crowd . . . I saw her but once again, alone for a moment, but with nothing more to say. We met at Frank's—a farewell party for me. Successes cannot be repeated—it was a sad and tiresome affair.

He and Brett discovered that the boat they were about to board did not stop at Los Angeles, so they took "that miserable train trip—hot, dusty, and quite uninteresting." On leaving Mexico, he wrote:

The leaving of Mexico will be remembered for the leaving of Tina. The barrier between us was for the moment broken. Not till we were on the Paseo in a taxi, rushing for the train, did I allow myself to see her eyes. But when I did and saw what they had to say, I took her to me—our lips met in an endless kiss—only stopped by a gendarme's whistle. Our driver tactfully hinted that public demonstrations were taboo—for shame: Mexico is surely becoming United Statesized.

Dear friends came to the train—Felipe—Pepe—Roberto—Frances—and M.—others sent messages and love.

Vamanos!—last embraces all around—Tina with tear-filled eyes. This time, Mexico, it must be adios forever. And you, Tina? I feel it must be farewell forever, too.

VI.

For nearly three months, Edward Weston wrote nothing in his journal. For all his bitter resolves, he was back in Glendale, and in his old studio, "a shack, but the most important building in Glendale."

If there were only beautiful places to walk nearby, I would enjoy warming up by a brisk hike through the hills; but one must go through blocks of smug bungalows, or by rows of squat business

blocks to reach any point of open country; and worse, past long-faced, bleary-eyed commuters, going to work after a breakfast of warmed-over potatoes or Bran breakfast food for constipation.

He was living with Flora again, though much of the time she was at her parents' home; and he was earning a living at the studio. The reentry into this penal institution of his pre-Mexican life was unbearable; he escaped over and over again, for he wore a long chain. With a hunger that refused nothing and chose nothing, he accepted the adoration of at least three other women: one was his former "German" secretary, Christel Gang; the second was a new and very young acquaintance, Kathleen; and the third was either Elisa or Elena, or both, for amazingly, they had immigrated to Los Angeles from Mexico City. In addition to these, there would be at least five others. His first entry in his journal, on January 24, 1927, puts the situation clearly enough:

> In my old studio, Glendale. Months have passed since I have sat here at my desk . . . soon a marcelled flapper, aged 70, will sit to me to boil-the-pot.
>
> 8 a.m. the 25th — a late arising. Cristal came. She said, "Women in love never know when to go." Right, Cristal. Too many have been coming, and now Kathleen, tall and fair with gold brown hair, hazel eyes, lovely and 21. For three months, I have focused my camera but not once on subject matter for myself. I could blame three loves — but no, time could have been found. I am not yet a part of my new surroundings; one foot is still in Mexico. New surroundings! Too many faded flowers. I should never have returned to my past. But the boys brought me back here, and here I will stay until I can make some positive, constructive move.

He rejoined, with the fresh fame that Mexico had given him, a wider circle of Los Angeles intelligentsia: Galka Scheyer (a rich collector of Klee and Kandinsky), the composer Ernest Bloch, the fine architect Richard Neutra, and his old friends, Jake Zeitlin, Peter Krasnow, and, of course, McGehee and Hagemeyer:

> Johan and I! You know what that means to me? — of course you do! In his attic — the rain falling through the pines outside, conversation intense and vital inside — my craving to show him my work satisfied, his response — arguments on technique — approach — our quarrel on "definition."

These circles were open to the fresh currents in the graphic arts; fresh for America that is, for they were already familiar in Paris and in New York: the work of Picasso, Matisse, Braque; the sculptors Archipenko, Brancusi, and Městrovíc; the Americans Walkowitz and Macdonald Wright (whom Edward Weston disliked). Friends took Weston to hear new works of Stravinsky, as well as the classics played by touring quartettes.

On February 16, 1927, The University of California gave a joint exhibit of works by Edward Weston and his son Brett. Krasnow came with a local painter named Henrietta (Henry) Shore. Together, Krasnow and Weston visited her home, and "saw fine painting." She worked more or less in the manner of Georgia O'Keeffe, using flowers, shells, and other sea objects; and quite deliberately as phallic designs. She offered to paint Edward's portrait, and they began a long series of discussions in which she tried to correct what she considered to be his aesthetic errors:

> We always have supper together and after, I read from my Daybook at her request. Reading that part written during the period of my toilet photographing she said, "Wait, tell me something frankly — from what motive did you photograph the toilet?"
>
> "Why it was a direct response to form," I unhesitatingly answered. "I felt so — that was my reaction — but others have thought otherwise. I think them very fine."
>
> So! O well, I could expect misunderstanding from the others; — most others . . . I showed Henrietta the last nude of Bertha: legs and feet in action.
>
> I had a direct plain-spoken reproof: "I wish you would not do so many nudes — you are getting *used* to them — the subject no longer amazes you — most of these are *just* nudes. (I knew she did not mean they were *just naked* — but that I *had* lost my "amazement.")
>
> Maybe if I had not shown her the whole series — but one or two selected ones — which is all I would ever finish from a series of Graflex negatives — her reaction might have been different. "You see, Henrietta, with the Graflex I cannot possibly conceive my complete — final result in advance — as you can. I hold to a definite attitude of approach — but the camera can only record what is before it — so I must await and be able to grasp the right moment when it is presented on my ground glass. To a certain point I can, when doing still life — feel my conception before I begin work — but in portraiture — figures — clouds — trying to record ever-changing movement and expression — everything depends upon my clear vision, my intuition at the important instant, which if lost can never be repeated. This is a great limitation and, at the same time, a fascinating problem in photography.
>
> Imagine if you had to create in — at the most, a few seconds of time — without the possibility of pre-visioning — a complete work — supposed to have lasting value. Of course my technique is rapid — and serves me if coordinated at the time with my perception.
>
> So, not being able to anticipate — depending on quick decisions — many negatives are destined to be named failures.
>
> This should not be when dealing with inanimate matter — and the fact is — working so — I discard very few attempts.
>
> However, a quick decision is different from a hasty decision — and

there is danger in acquiring the latter habit—growing from the necessity of having the former ability.

I am explaining the limitations of photography rather than apologizing for it; if a medium needs apology it is already dead. I accept the limitations, trying to make the most of photography's possibilities. At times I have felt the need of a more fluid, less rigid way to release myself—but always I have put aside other desires—and tried to realize all that I can in my own way.

I like the manner in which you speak your mind straight out. It is invaluable to me as coming from you. Please—always do so. Few persons there are whose judgment has more than a passing interest for me—you are a fine stimulus!

This friendship, quite naturally, began to deepen on both sides:

Could not sleep this morning after 4 o'clock, so wrote Henrietta before dawn. I want to see more of her. . . . Sat to Henrietta yesterday. We do have good times together! She is a jolly companion, keenly alive with word and thought besides being a really good artist.

Somewhere during this flowering of their friendship, Henrietta Shore gave him (he recounted this himself) a charcoal nude of herself; and was plainly anxious to continue their friendship on a more sexual level. He wrote her asking that the friendship remain platonic. He noted:

Henrietta has answered my plea: we are to resume our old status!

He prized her work; thought a particular pastel (a nude, again), "placed her among the immortals." The friendship was to remain close, maternal; and therefore, at times, censorious:

Henry irritates me at times: if she had not such fine qualities and great art to counterbalance, I could not easily overlook a certain prosaic, unreasoning way of pigeonholing people. She is apt to be critical in a sort of humorless, puritanical way.

Recent letters indicate that Monna [Salas] and she discussed me, and I am, in some way, excommunicated until I can prove that I am not taking advantage of some "foolish woman's love" for me. . . . My impulse is to say, "I don't care to hear nor explain anything, Henry, take me with my faults or not at all." Henry can be so damnably serious! . . . Henry has a certain possessive sense re her friends or at least re me: she will have them act just so, according to her light, or, they are no longer friends! I hardly knew whether to politely refuse answer to her very personal questions . . . Henry thinks she is a profound psychologist, but does not read me—while I read her as an open book. She is a child in her betrayal of motivating reasons for word and action. She does not hide them, as indeed she should, because she does not realize or know the very causes deep within her . . . Henry has taxed my patience times before this with her entire lack of humor, her positiveness. I have stood that side of her, knowing her preponderance of fine qualities, as one must

with any friend, as I would have friends do with me. . . .

Her funny idolatry of Edward Weston continued to annoy him, however:

Henry wants to accompany us north where she goes to live for two months, and will pay for gas and oil. It would be a trial for me, she wears me out and bores me to death, with attention. But to have the gas paid is no small item and she means so well and has been so kind that I should like to please her. Henry is a bit mad. I see that same wild look in her eye, even as in Flora's and in Mrs. Jones's, my pupil. . . .

And months later:

She is becoming more impossible than ever to be around, or else I have less patience, the fresh interest of a new conquest worn away.

Of course, Henry Shore was not a particularly attractive woman. She was a squat, heavy, homely lady with a deadly serious manner, and an equally serious passion for food. Weston simply had neither time nor energy to give her; but he did value her critical honesty. It was at Henrietta Shore's studio that Edward Weston first saw, and borrowed, a whole group of various shells, the first of which he had seen in one of her paintings:

I was awakened to shells by the painting of Henry. I never saw a Chambered Nautilus before. If I had—my response would have been immediate! If I merely copy Henry's expression, my work will not live. If I am stimulated and work with real ecstasy, it will live.

Henry's influence, or stimulation, I see not just in shell subject matter, it is in all my late work . . . not as an extraneous garnish, but as a freshened tide swelling from within myself.

An amusing tale came to me re the association of Margarethe and Edward: that when she came within my horizon—I was "still doing babies on bearskin rugs." Not true! I could never have afforded a bearskin rug, it must have been imitation. I put myself now on record as owing a great deal to Margarethe—taking from her all she had to offer—and leaving her—not when I had all I could get—but because she was draining me of all I had: it got to be far from an even exchange.

I will take from anyone all they can give me—and try to return them as much more.

The first shell was photographed, in fact, at Henry's studio. After that, he took some of the shells home. On March 10, of that year:

Shells I photographed were so marvelous one could not do other than something of interest. What I did may be only a beginning. . . .

Every day finds me working, or at least thinking of work for myself,—and with more enthusiasm, surety and success than ever before—another shell negative,—another beginning of something, from yesterday.

One of these two new shells, when stood on end, is like a magno-

lia blossom unfolding. The difficulty has been to make it balance on end and not cut off that important end, nor show an irrelevant base. I may have solved the problem.

And finally, they became an obsession:

> I worked all Sunday with the shells,—literally all day . . . I wore myself out trying every conceivable texture and tone for grounds: glass, tin, cardboard, wool, velvet, even my rubber raincoat! . . . The tin was perfect with the lens open; but stopped down I could not see sufficiently to tell, but was positive the surface would come into focus and show a network of scratches—it did. My first photograph

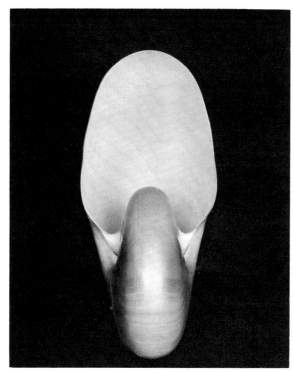

Shell, 1927

of the Chambered Nautilus done at Henry's was perfect all but the two black grounds: yesterday the only available texture was white. Again I recorded to study at leisure the contrast. The feeling of course has been quite changed,—the luminosity of the shell seen against black, gone; but the new negative has a delicate beauty of its own . . . I have my workroom barricaded for there are two shells delicately balanced together awaiting the afternoon light. My first version of the combination was done Sunday: Monday a slight turn of one shell, and I gained strength: Wednesday the second proof decided me to try a lighter ground.

> . . . Seeing, I knew at once I had what I was fighting for! But the hour was late, the light failing, I could not expose another film. So there stands my camera, focused, trained like a gun, commanding the shells not to move a hair's breadth. And death to the person who jars out of place what I know shall be a *very important* negative. . . .

It must be noted, that Edward Weston, in these shell negatives,

stopped down to *f*.256, and since the illumination was indoor, from the skylight, exposures were often as great as four and one-half hours. The slightest jar, a truck passing by, a careless foot-step, might spoil the whole arrangement:

> I took out the Chambered Nautilus thinking to improve on the first negatives: instead there came to me a new group over which I am absolutely enthusiastic! It was too late for an exposure so I must be patient until this afternoon. I find myself, every so often, looking at my ground glass as though the unrecorded image might escape me . . . but I shall enjoy the struggle.

This series of shell photographs (he kept, finally, only fourteen as worthy of printing) are unlike anything ever done in photography, up to that moment. The innovation is not in the closeness, nor in the monumentality of these natural forms; or at least, not in these alone. It is instead in the particular light, almost an inward luminescence, that he saw implicit in them before he put them before the lens. Glowing with interior life, the immense exposures, the various softly or strongly or darkly reflecting backgrounds, the special intensity with which Edward Weston watched them—all contribute to the sense that one is seeing more than mere form.

He had sent Tina Modotti, who was still in Mexico, a number of new shell prints. She had shown them to a number of their mutual friends, including Orozco and Charlot. She wrote Weston:

> Good morning—My last letters to you have been so full of your photographs that I forgot to mention the delightfully quaint business announcement of the "good old days."
>
> Last evening Orozco was here—It had not occurred to me to show him your shell photographs—but we were talking about some of his latest frescos—he was saying that he makes twenty, thirty quick one-minute drawings instead of one carefully finished—so offered to show him all the Graflex nudes you have been sending—They interested him intensely—he said—"they are just like carbon drawings—yet, if an academic painter had made them they would be bad—as photographs they are not only good but strong and bold—they convince." Then I got out the shell prints—well—in few words he liked them better than *all* your other collection put together—of one he said: "This suggests much more 'The hand of God' than the hand Rodin made"—it is the one arrangement that has made everybody, including myself, think of the sexual act—it is hard to describe it—only in one arrangement the standing up shell is front view and in the second it is the back view—I mean the back view—is that clear? . . .

Weston responded to Tina's letter with astonishment:

> Why were all these persons so profoundly affected on the physical side? For I can say with absolute honesty that not once while work-

ing with the shells did I have any physical reaction to them nor did I try to record erotic symbolism. I am not sick and I was never so free from sexual suppression,—which if I had, might easily enter into my work, *as it does* in Henry's paintings.

I am not blind to the sensuous quality in shells with which they combine the deepest spiritual significance: indeed it is this very combination of the physical and spiritual in a shell like the Chambered Nautilus which makes it such an important abstract of life.

No! I had no physical thoughts,—never have. I worked with clearer vision of sheer aesthetic form. I knew that I was recording from within, my feeling for life, as I had never had before. Or better, when the negatives were actually developed, I realized what I felt,—for when I worked, I was never more unconscious of what I was doing. No! The Shells are too much a sublimation of all my work in life to be pigeonholed. Others must get from them what they bring to them: evidently they do!

Very likely everything Weston wrote about himself and his work is true; certainly these shells are pure, whole, and expressive, though of an emotion really too specific to have a designation. They are, like Einstein's equation connecting mass and energy, splendid and simple; a magnificent set of illuminations by the human mind.

Jean Charlot wrote to Edward Weston directly:

Tina showed me your photographs. Of course the shells are beautiful, perhaps finer than your best in that style made in Mexico, but I prefer the studies of legs. The shells are symbols (sex, etc. . . .) or abstract shapes, while the legs are legs described in functions of their utility. There is perhaps the same evolution from your abstract photographs to those legs, as from your ladies' sun-spotted smelling orchids to the abstract photographs. I express badly a thought I think is right.

Edward Weston no longer had "one foot in Mexico." He was occupied by work and the pressure of money problems; but though he complains, one gets the impression that he was surprisingly happy. He was a sensual man and the raptures of skin and nerve were a necessity to him. Even his complaints have a distinctly boastful air:

What have I, that bring these many women to offer themselves to me? I do not go out of my way seeking them—I am not a stalwart virile male, exuding sex, nor am I the romantic, mooning poet-type some love, nor the dashing Don Juan bent on conquest. Now it is B.

"B" was Bertha Wardell, a dancer and teacher of dance; though of what style (certainly it was not ballet), we have little idea. She was described by a contemporary as a thin, spinsterish woman with sandy hair; but this was not Edward Weston's view. She saw his exhibit of photographs at the University of California, and wrote him a note:

My dear Edward Weston:—Your photographs affected me a great deal. Even to think of them gives me a feeling of reality, of things falling—and fallen—into their proper relations.

Someone asked me which studies I had liked. For the life of me I couldn't remember—the effect seemed to be a sum total reaction. Except for the studies of bodies! I shall own some of those one day. I must. It is not often that anything says "dancing" to me as those do. The body—so present—so soft and warm to touch—the source of so many beauties and delights—yet so mysterious.

Barbara Morgan says you are sometimes in need of a model. If I could help I would be happy to lend myself. Tuesday afternoons I have free. Sometimes, Fridays too. Cordially, Bertha Wardell.

He photographed her on two occasions:

Bertha has a mobile body, and unlike many dancers, does not assume forced postures all over the place. She has full nipples. . . .

On the second occasion:

Bertha sat to me again: six negatives exposed, all of some value, three outstanding, but two of the latter slightly moved. However, the

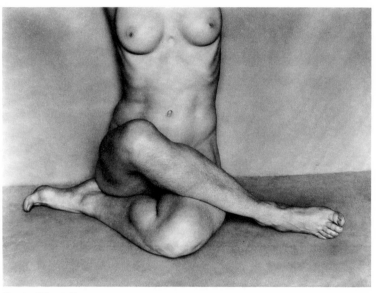

Bertha Wardell

one technically good is the one best seen. As she sat with legs bent under, I saw the repeated curve of thigh and calf—the shin bone—knee and thigh lines forming shapes not unlike great sea shells—the calf curved across the upper leg—the shell's opening. I made this—cutting at waist and above ankle.

After the sitting I fell asleep—sitting bolt upright—supposedly showing Bertha some drawings—I was worn out.

She wrote him the same day:

My dear Edward Weston:—You and your work have been very strongly in my mind since yesterday. You yourself seemed possessed for an instant not only of a physical, but of a psychic fatigue. I wished that you had not worked so long. It disturbed me; I think, especially because of the exceeding delicacy and vitality of your work which is dependent to a certain extent, at least, on the vitality of your body.

What you do awakes in me so strong a response that I must in all joy tell you. Perhaps it will seem out of proportion to you, in whom it has grown gradually, but, on the other hand, perhaps only someone from without can sense what you do in its true proportions. Your photographs are as definite an experience to the spirit as a whiplash to the body. It is as if they said, "Look—here is something you have been waiting for—something you have not found in painting or even in sculptures. Something which has been before only in the thought of dancing." It has so enlivened my own feeling about dancing that something of that may be born yet—and not dead.

I beg of you—do not come to the dancing Sunday. This envelope is very empty of a card. Some day, if you will let me—I would like to dance for you.

It was very happy and restful posing for you. If there is anything you want to do again however—you must feel free to send me away if you find yourself too weary.

There is the danger that this will strike you in the wrong mood, that it may seem sentimental and loquacious when words about your work should in all appropriateness have finesse and reserve.

All of which I risk gladly, hoping that the weariness was not unavailing—that the afternoon may have brought forth something which you can enjoy having made. BBW.

There is certainly more than a hint of personal feelings in this note, but Weston doesn't mention it. His concern, at first, was purely technical:

These simplified forms I search for in the nude body are not easy to find, nor record, when I do find them. There is that element of chance in the body assuming an important movement: then there is the difficulty in focusing close up with a sixteen-inch lens: and finally the possibility of movement in an exposure of from 20 sec. to 2 min.—even the breathing will spoil a line. If I had a workroom, such as the one in San Francisco, with a great overhead and side light equal to out of doors—I would use my Graflex: for there I made 1/10s. exposures with $f.11$—in this way I recorded Neil's body. Perhaps the next nudes I will try by using the Graflex on tripod: the 8 inch Zeiss will be easier to focus—exposures will be shorter—films will be cheaper!

My exhaustion is partly due to eye-strain and nerve-strain. I do not weary so when doing still life and can take my own sweet time.

Bertha has a sensitive body and responsive mind. I would keep on working with her.

And by April 12:

Tuesdays are now definitely Bertha day. She enjoys working with me—and I respond to her. Her beauty in movement is an exquisite sight. Dancing should be always in the nude. I made 12 neg's—for the first time using the Graflex: arrested motion however—for the exposures were three seconds. But these negatives will be different in feeling—for the ease of manipulation of a Graflex allows more spontaneous results.

All this technical concern got inevitably muddled. On April 20, he wrote:

I am having coffee from a new and delightful cup—from Margarethe. It came in yesterday's mail: it was received with mixed emotions. I have been here now over five months, yet I have seen Margarethe but twice. . . .

Bertha came for her Tuesday session: when she went our association had assumed a new aspect! I had before, vague questionings as to whether her coming was an entirely impersonal interest in my work—knowing definitely how strong that response was, but though she has been with me these many afternoons—danced before me naked—I have never felt the slightest physical excitement. I admired her mind, I thought her body, especially in movement—superb—but nothing more.

Even yesterday, it was not until she was dressed and we sat together exchanging thoughts—that I became fully aware of her real feeling for me. Our hands clasped—our lips met—. . . then I had to go before a fulfillment. As an artist, Bertha is more definite than anyone I have met since Mexico, excepting Henrietta Shore. Our association should be constructive to both.

My life may become complicated with three lady loves to consider—I don't want that: quite the contrary—I crave simplicity.

Finally, and inevitably, these Tuesdays became openly sensual:

. . . refined, sensitive, it was to the touch like the inner surface of a sea shell. And her sinews which when dancing must be steel springs were soft and pliable as a baby's. Against her blue-veined, pearl-white thighs and torso was a fire-red focus of wavy hair.

Before the hours of love she danced for me. I felt and saw clearly,—development should bring some fine negatives.

Dancers had been a favorite subject for many American photographers: Genthe, for example, did a whole volume that included not only photographs of Ruth St. Denis, but all of her disciples, and those of Isadora Duncan, as well. These were generally whole figures, even if the outlines were sometimes romantically vague; a fair number, in fact, were dancers in the nude. Weston's studies of nude dancers were, on the contrary, sharp, clear, and faceless!

Yet, more often than not, Weston was intimately involved with the women he photographed. Very rarely did he make nudes of

women as people. None of his studies are, in the least, like Bellocq's compassionate portraits of the whores in New Orleans at the turn of the century, for he had a positive distaste for the imperfect.

Christel Gang, too, fell in love with Weston, and was in love with him for many years:

> Cristal has a body of exaggerated proportions. To overstate her curves became my preoccupation. The ground glass registered sweeping volumes which I shall yet record more surely. Cristal is a fine girl—unusually fine; generous—considerate; really great hearted. I regret diversion.

Since the affair with Bertha Wardell had just begun, and he was already sleeping with Kathleen and the *criadas* from Mexico, a certain amount of scheduling was necessary:

> . . . Now it is Bertha in whom I have kindled a perfect flame! She wrote to me "danse motives," written day by day in a fever of desire. . . .
>
> Bertha came with undiminished enthusiasm, but I did not work so well. I was tired and confused: it was a hectic day! Peter brought me a carving to copy in a rush: Elena arrived with a birthday gift, only six weeks late! Chance found us alone . . . I was quite as excited as if it were the first time—strange how she brings me to a climax in a flash.
>
> Bertha had not gone when Kathleen arrived. I wonder if Kathleen comes out of curiosity over my attitude towards Bertha. It seems more than coincidence that she has called several times on Tuesday. I had to be very diplomatic. Kathleen is a bit of an exhibitionist in love-making. Bertha had no sooner gone than Elena came again!
>
> I call this day a mad one, with three loves to respond to! . . .
>
> Bertha is still I have been fair to her, even when profoundly excited. She would gasp, "No Edward, I can give you no more," and I would stop. . . .

Christel left for Fresno, California, but came back the next month, and spent long hours typing and correcting (to what extent, it is difficult to know) his Mexican Daybooks; but Weston was already weary of her motion:

> Cristal came: I admire and care for her so much that I wish I could respond to her love side more fully. My mental and physical regard for a woman rarely accord: an approximation was attained with Margarethe and Tina. Now, I am most completely satisfied—physically—by Kathleen or E. Or be sure, Kathleen has a good mind for a young girl, but E. has nothing for me but an exciting body! A strange twist of life has found one of my loves working for another. E. is now Bertha's maid—and neither know.
>
> Cristal has opened to me vistas of the metaphysical in which I find myself becoming deeply interested. Years back I would have

scoffed; now my mind is at least open—receptive. Too much that cannot be explained otherwise. . . .

> Cristal and I celebrated "our day," last Sunday. Two years ago she came to take dictation: but the Gods had planned that something else should happen.
>
> Now we are very close: I have not been true to her—but no one else is closer to me.

Kathleen, the young singer, was also in love with him:

> Last night Kathleen held me close and said, "I want to tell you something darling,—that I really love you very, very much."—A sudden change from her flippancy. Just don't grow to care too much dear girl.

However, Kathleen's words stirred his conscience:

> This is a turn unexpected, but too beautiful to be disregarded. When an experienced girl—though she be young—writes "I love you"—one can no longer remain untouched—Love is too rare and precious for flippancy. Her love has changed the incidental attitude I held. Now I would give her all I can spare.

Still, this is not quite what he wanted:

> Kathleen came last night. She was full of eternal love declarations. This is not what I wanted, Kathleen—I cannot respond to an idea of undying emotion—only youth could hold such a beautiful concept.
>
> She is in a state of mind needing tender consideration and devotion. She wants encouragement—a crutch to lean on—and turns to me for help.
>
> . . . Kathleen is writing me the most impassioned love letters. They are very youthful, in the romantic, lyric way of springtime,—yet so genuinely from her heart that I am touched:
>
> "Oh, I would gather the dew from cherry blooms and bathe in their scent that I might be more beautiful to thee. To me this is the most beautiful experience that life can hold."
>
> Here her letters hold back but she had always given me vague half promises, and I had been indifferent enough to never force the issue. Coming the way she did disgusted me.

Still the affair was flattering:

> Kathleen came yesterday. We spent two hours in sensual enjoyment of each other . . . I received by mail from Cristal, a box of lilacs, white and lavender, so exquisite that my eyes filled with tears. I had to hide them when Kathleen came last night: she too brought spring blossoms.

It was all deliciously complicated. Elena or Elisa, or both, maybe because of the strong feudal heritage in Mexican society, made only physical demands on him:

> My heart sank when Elena and Elisa arrived early, all primed for a day at the beach. They had misunderstood the date,—and I was not ready. What could one do but capitulate! To reason with children

would be easier. Once on the way—I was not sorry and certainly I have no after regrets: we all had a good time—especially the girls—actually my pleasure was in watching their joy.

I took them to Redondo—with an ulterior motive: I could visit with Ramiel at the same time. So "my family" and I descended upon Ramiel in holiday mood. After all—there was no opportunity to visit with Ramiel: not with Elena—who would listen to no reason, until she had donned an old purple bathing suit and plunged into the breakers.

Weston's schedule was further confused when Merle Armitage brought three friends to visit him:

One of the party was a girl, a dancer,—Fay Fuquay. She became enthused over my dancing nudes of Bertha and offered herself as a model. I accepted. She interests me.

He photographed her in a whole series of nudes, and, on July 1, he wrote:

I start the new month with a new love! I am not surprised. Fay and I were forecast to have this experience—at least once.

She came to be photographed again. From the last time I have one extraordinary negative. She bent over forward until her body was flat against her legs. I made a back view of her swelling buttocks which tapered to the ankles like an inverted vase—her arms forming handles at the base. Of course it is a thing I can never show to a mixed crowd. I would be considered indecent. How sad when my only thought was the exquisite form. But most persons will only see an ass!—and guffaw as they do over my toilet.

Yesterday was not meant for work though I loaded my magazines in preparation. "I have a pint of liquor at home," said Fay. We drove to Pasadena. We drank. We kissed. She was an artist with those lips—

We should have a few pleasant weeks together—and a very good time it is for me—with Kathleen working—I almost never see her—and Bertha away. Cristal comes occasionally but the physical side is on the wane. Women are presented to me in abundance so that I may suffer from no inhibitions! I never think of them—nor search them out—for they always appear at the right moment. This is well for my work. How different from those years in Mexico!

In February, 1928, Miriam Lerner (with whom he was so strongly in love in 1924, between his two voyages to Mexico) returned from Paris to live in Edendale, a suburb of Los Angeles, on the hill, as Weston noted, just opposite Christel Gang. In fact, many of these loves knew one another; and envy may have played its exciting part. Edward Weston—what with Christel, Kathleen, Miriam, Fay, Elisa, Elena, and Bertha, not to speak of Harriette and another Ruth (whose surname he never knew)—was truly enjoying the middle-aged Saturnalia of the early deprived:

I am having another reaction—from my statement that I could go through life with one woman! Ridiculous thought! Imagine never

again having the thrill of courting—the conquest—new lips to find—new bodies to caress. It would be analogous to making my last print—nailing it to the wall forever—seeing it there—until I would despise it or no longer notice it was there. No!—let me stay free!

And there was still Margarethe; poor melancholy Margarethe:

At last the end has come for Margarethe—and my old studio passes into alien and vulgar hands. A letter from her—"Today—my last Sunday in the Studio—raining softly—like tears—for you and for me—and the willowed river we never walked to—a terrific nostalgia envelops me!"

Why this tide of women? Why do they all come at once? Here I am—isolated—hardly leaving my workrooms—but they come—they seek me out—and yield—(or do I yield?)

Five years ago Margarethe came to this very room for her portrait. Her reason for coming was drowned in kisses—but—nothing more—she would not. Again she came two years after—more kisses—that was all. Yesterday she did not deny me—not after weak protests.

Margarethe had been drinking—I saw this at once—her flaming cheeks—and excited talk—irrelevant words which did not conceal her desire. I knew that now she would have me take her. Maybe she drank to suppress a vigilant, puritan self,—I rather think so. She left me gardenias—and I drifted retrospectively home to fry pork chops for the boys' supper.

He got presents from her "with mixed emotions":

I have been here now over five months, yet I have seen Margarethe but twice. The first day we met—she made a difficult gesture to establish herself once more in my life, where once she was. But the old association should never,—can never be renewed—not just because Margarethe is but a shell of her old self,—rather that any intimate contact with her could only be destructive.

I have carefully, but not too pointedly avoided Margarethe, using her own well-known method of placing the blame on another,—in this case the other. . . .

But on July 22:

Last eve—I spent with Margarethe—the third time we have met in these many months. She had wired—wanting to see me. What were my plans? Of course that I was going into business here,—which could not have pleased Margarethe. Once from Mexico I promised Margarethe that I would never return to start business in L. A. Foolish promise—and quite unjust if she held me to it—which I am sure she wants to do. However we had a long talk on many things—with no hysteria—which I half expected.

Another shell yesterday,—and—the heat continues.

In September, she met Weston in San Francisco:

Margarethe Mather here to buy antiques for a holiday shop. She spent Sunday with us. We drove to Golden Gate Park and spent hours in that marvelous place. The unbelievably exquisite butterfly-

fish—enormous turtles that swim like a bird flying—jolly bull frogs —sinister eels in their ritual dance—the seals! For exhilaration from sheer amazement—the aquarium! We returned here. I warmed Margarethe's soul with a bottle of gin. Five years ago—madly in love with her—what an exciting experience this would have been,—together in S.F.—far away from local discords. Now—light gossip—bantering—but not a thrill. What is love!? Can it not last a lifetime? Will it never for me? Do I only fool myself—thinking I am in love—and really never have been?

 And these girls—all friendly after,—corresponding—meetings. Does it indicate the affair was not so deep: otherwise might not the end come with an explosion—and a parting forever?

He saw her again in December, 1930, but the emotion he felt for her was muddled with business considerations; and in a deeper sense, there was the wish to set himself free from her dependence. Eventually, she opened an antique shop at Fourth and Hope in Los Angeles, but gave it up. Years later, when Brett encountered her in San Francisco, she was swollen with age and drink. A famous pupil and friend of Edward Weston's, the photographer and film director Willard Van Dyke, met her briefly, too, and reported:

> I met Margarethe Mather just once. At that time she was fat and not very attractive, and was living with a homosexual. Edward once said that after they'd had this kind of idyllic love affair, that she confessed to him that she had never been satisfied sexually, and that all of this—what he had taken to be passion in response to his advances—was merely put on. It must have been quite a shock to him. When I met her she had none of that beauty left, and her mind was not at all attractive.

Flora was a much more powerful character, and the constant dalliance of her husband did not escape her attention: how could it?—wives and mistresses have a pretty good physical test for such matters, and there was Ruth Shaw to confirm everything. Weston commented:

> No one had told me we were to appear on the same program. I had not seen my quondam friend since her clacking, wagging tongue caused our estrangement. My bitterness has long ago passed—I am only indifferent—I cannot be bothered with a missionary. I did not avoid her—perhaps she did me—we did not meet—and that was well. Flora in her usual tactless manner saw to it that Kathleen and I went home in different cars. Does she smell a rat? And even so—why should she be a cat!?

Flora's love and care for him was, however, indefatigable:

> Thursday, March 24—41 years I have today,—not 42 when I came to figure! The boys gave me $10—of course it was from Flora, and

indicates her extreme generosity, which I have never denied. . . .
> Cats—yes—two orange kittens Flora brought me: delightful little rascals, but worse than four boys for mischief.

Her devotion to Weston took a simple and direct form: having seen the dancing nudes he was photographing, she came to his studio one afternoon, and took off all her clothes so he could see that she was just as attractive as her rivals. Quite possibly she was, but Weston never photographed her nude. One gets the impression that she represented to him the traditional hysteric mother, to whom one owes the customary claustrophobic emotions of gratitude and hate. It was probably a misconception, for she was certainly not quite, or not wholly, the puritanical scold that people have imagined. Willard Van Dyke spoke of Flora:

> I met Flora on her way back from New Mexico. Sonya (Weston's mistress at the time) and Edward Weston and I stayed at Flora's. That was one of the most terrible days, I guess, in my life. I drove all the way from Flagstaff to Glendale, 600 or more miles, in a Buick that was running on five cylinders. I drove all the way, and I was absolutely exhausted, and Flora provided a nice meal. I fell asleep in the bathtub that night. I saw her briefly two or three other times. She just never really understood what he was about, and yet you certainly had to respect her, because she continued to teach school and provide a home for the boys when they wanted to be with her, and she felt that Edward's work probably was not going to be remunerative, and there wasn't much stability, so she did the best she could to provide a stable household.

Charis Wilson, Weston's second wife, thought that Edward and Flora had much the same background; she was exceptionally struck by this fact when she saw their wedding photograph. Edward told her that during World War I, he and all four sons were ill with the severe influenza that swept over the world in early 1918. Flora, herself ill with the flu, refused to go to bed, and treated them to a sweat bath by pinning their blankets shut. Charis met her, eventually, and described her as a tall, blustery, raw-boned, domineering, nervous woman, who was addicted to shopping sprees. But this might be a prejudiced view.

On the other hand, Flora was not, and under the circumstances, hardly could have been, the silent and understanding wife:

> If I can only control myself, my tendency to match Flora's hysteria with destructive words, until she calms—we will manage to stand each other somehow. I must realize she can no more accept my viewpoint, than I can hers. But one look at her handwriting is enough to destroy my equilibrium!

Their separation was more physical than real. Flora was staying

at "the Ranch," a property she owned that was closer to the mountains, while Edward Weston stayed in town. The outward relationship continued and one has to be only moderately cynical to observe that a wife is a convenient shield against the final importunities of lovers:

> Today Elena and her mother and I go to Topanga Canyon for a visit with my boys — and Flora. Too bad that I dread so to be near Flora and, I must . . . I shall try to come closer to Flora, I want to, but the breach seems ever-widening.

Two days later, he wrote:

> . . . Oh, for money! — Not for a single luxury, not even for food, — money enough to leave here, — to get away from
>
> I am deeply concerned about the return of my old bitterness: it will distort or destroy all that is creatively fine within. I thought I could stand her proximity, — that I was strong enough, but I am being gradually undermined again. We should be miles apart, for her sake as well, for I know I have the same effect upon her, I would want never to hear of her again — not even to see her handwriting on an envelope: that dreaded handwriting!
>
> But the boys!?

A fairly traumatic incident for everybody occurred at 1:30 a.m. on one Sunday in August:

> She found Elena and Elisa with Brett in apparently a compromising situation. But there was no question on her part: she always hangs on circumstantial evidence. She almost forced her way into the studio: her face was one that could have burned witches in the early days of our country. I hunted for a new home all day. When she knew this, she appeared, begging an audience, and asking me to please stay for the children's sake. I am still here; but for how long?

Still, Weston's work was not seriously disturbed, except by a second tragedy which occurred two days later:

> I have been training my camera on a cantaloupe, — a sculptural thing. I know I shall make some good negatives for I feel its form deeply. Then, last eve, green peppers in the market stopped me: they were amazing in every sense of the word, — the three purchased. But a tragedy took place. Brett ate two of them!

It is one of the curious talents that a great artist has in common with an idiot: the ability to function in spite of emotional turmoil; or was his emotion subsumed in his photographs? Edward Weston would, and did, deny it. A week later, there really was a substantial disaster:

> Cole fell from a walnut tree yesterday, when a rotten branch gave way, breaking both wrists, — double fractures. Poor baby! How he suffered. Now he will be helpless for weeks. How we will get through with it all, nursing him every moment, I don't know. And my exhibit only two weeks ahead. I was planning to work every spare moment.
>
> Too, Flora is "broke," and my condition no better, — nay worse. I am disgusted with her extravagance in buying the $2400 car — mortgaging everything — running up bills everywhere — taxes due — not a cent to pay with, — hardly enough to eat —

But the exhibit of his photographs and Brett's, at the University, went on as scheduled, and was a critical success and a financial bust. Three months later, his eldest son Chandler, renowned as a furious driver, was taking his mother somewhere in their $2400 Nash, and stopped suddenly at a light. She was riding in the back seat and was thrown up against the roof, hurt her back, and put herself to bed; mortgaging more property so that she could pay for day and night nursing. It was a plain cry for love as the marriage began to shatter under her feet. Still, she told her sons that, "I could run an army from this bed." Weston was also miserable, with swollen glands in his neck:

> I know that my sickness has been mostly a result of psychic break — when I do not function in my work, my only reason for existence is stopped.
>
> Whether this long inaction — an artificial inaction, for I was not ready to rest, — has deadened my vision, I have yet to find out. Much will depend on whether I can get hold of myself mentally, and whether I can spare time. If I thought myself in a mess before, — what now!?
>
> Flora in bed for six weeks from an auto accident; Cole in bed with measles; my own sickness; and expenses greatly increased. Oh, if I only had a little shack somewhere in the desert or wilderness, with no possessions. But how can I ever achieve this?

He spent most of his working hours, not in photographing, but in retouching:

> I will have my revenge for all the prettified, retouched females I have had to do, for all the portraits I have sent out which were not my work: portraits so nauseating that I have covered them over when signing my name. Some are horrified at physical prostitution, and I agree it must be inconvenient and often disgusting. But I am prostituting my spiritual self every week in the year. A few might feel and share the shame of my degradation.

Money was his constant anxiety: "My tears have been mostly economic." He would sell, when he had to, everything except necessities: his books, his extra lenses, his father's old archery bow. It was payment on the car that most oppressed him, but he felt he had to have one; not for his business, but in his excursions for personal material. He took on extra tasks:

> Of all days in the week I dread Thursday, — the four hours with my pupils, a mother and two children. It is not the children but their mother who exhausts me: an overworked, hysterical woman, who talks from the moment she arrives till she finishes with an extra fifteen minutes on the front porch to say good night, while I stand there,

hand on latch, ready to close and collapse. Most of the work is in the darkroom: four of us closeted together for hours! I earn my ten dollars.

Worse yet, his sitters didn't always pay him:

Not a check in lately. If Cristal with her usual thoughtfulness had not sent five dollars, we would be broke! A ridiculously ironical situation, —$600 outstanding after weeks of steady grind—to be penniless.

Yet, living apart from Flora, or even with one or two of his sons, he didn't require, he reckoned, more than $12.50 a week—presumably for food:

Sunday last we drove to San Francisco, remaining until Wednesday. Only one sitting resulted, and that a dog! Johan is so miserable— physically—mentally—that it is distressing to be near him. We lived there to save hotel bills—and I was glad to leave. If one could help him—but no—

The happiest part of the trip was spent in buying food with which to stock our larder: a gallon of olive oil, twelve lbs. of walnuts, a gallon of honey, a box of apples, and vegetables fresh from the soil.

The thirties, everywhere in the world, even in Carmel, was a time of despair, poverty, strikes, violence, hunger marches; coincidentally, the great dust storms of the Southwest drove thousands off the land and toward the migrant farms of California. A friend of Edward Weston's, Paula ("Paul") Schindler, wrote him at about this time:

Dear Edward: . . . I have lately been sick in soul,—I think my heart almost turned to stone . . . god, it is a frightful world these days to live in. The silent bewildered suffering, hunger more and more gaunt, workmen without tools, human beings without houses or food or plan or hope. In my desperation I am working with a merely ameliorative institution,—I cannot wait for the revolution which will *never* come it appears,—a cooperative exchange through which people exchange their services one for another, and so save a piece of life at least. Now I have set to work on the problem of how to provide basic commodities,—food,—upon this exchange basis. Trying to arrange that our members shall go out to the fields where the fruit and vegetables are rotting on the ground,—and bring it into town to a central exchange grocery. Then my carpenters can work for food for their children. Let the banks take all the real estate,—they've got most of it already,—and pay taxes for governments and wars and commissions. . . .

My love to you always. Paul.

Weston knew of these events, of course:

At noon hour we walk,—to the beach or toward the valley,—the latter straight down Monte Verde to Santa Lucia, from village pines into the open country. There we lie in the secluded bower of wild growth, wind-protected, hot, and watch the river empty into the ocean. Often the tides wash up a natural dam until the river spreads over the lowlands. Before us is a meadow of yellow mustard, sprinkled

with purple, a home for meadowlarks. The background of rounded hills, Point Lobos, foam-washed in the distance, eastward a barn, protected by lone black cypress, sea gulls soaring inland, wisps of swift-sailing fog, or banks of April shower clouds,—all rich in fulfillment. Life. And not so many miles away—"bread lines," hunger, mobs, murder, Death.

But his own personal poverty gave him no feeling of fraternity with the unemployed; and quite certainly he never actually starved, even for a day. Out of personal experience, I must remark, that there is an experiential wall between those who eat every day and those who don't. All of the intellectuals he knew— and those in Carmel were no exception—were forced by fashion, to say nothing of conscience, toward a left political view. Many, including Tina Modotti, joined the Communist Party. He had written Flora from Mexico, years before:

We certainly have been plunged into a swirl of communism here— almost all our acquaintances are active participants in revolutionary activities—and—quite different from the U.S. politician's staunch adherence to our antiquated constitution—the Mexican government encourages such activities—frankly I cannot but foresee an inevitable clash between the U.S. and Mexico—with Mexico a seething melting pot for every radical idea and a refuge for every expatriated radical—and the U.S. sitting tight and powerful in pretended freedom—a new revolutionary newspaper is being published *El Machete*—I know personally nearly everyone among the contributors and editors—most of them appear at our Saturday nights—and most of them are artists—there are no groups of pleasant parlor politicians here in Mexico—the movement is flamingly alive and direct—the leaders open and fearless of consequences—

But Edward Weston had an instinctive hatred for communism and all its associations:

Returning late from the puestos, company awaited. Bert and Ella Wolf had brought to see us Scott Nearing, American Socialist. From one hour's contact I would say that he was a typical labor-leader, a preacher, pedagogic and pedantic—but then that is his mission! And, after all, he may have another side on closer acquaintance. Few of us give ourselves freely on first contact.

Weston had copied quotes from the writers he admired; and one of these mottos he wrote out in his own hand:

"Bolshevism is the last dishonouring of the metaphysical by the social."—Spengler.

He once went so far as to withdraw his photographs from a proposed book called *Five American Photographers* (never actually published) because he read a draft of the foreword and hated its leftwing views:

I am a little bit weary of sitting back and listening to youthful radicals expound. The movement is full of "escapists" goose-stepping in single file through impenetrable walls built of dialectic materialism (whatever that is).

On April 22, 1932, he wrote at great length on the subject of communism and its alternatives:

What is to be the solution, what cure for the hunger, murder, Death? Will our system—Capitalism—fall? Will it slowly die,—evolution, or suddenly end,—revolution? Is Communism the solution? Despite the splendid arguments in its favor, many of which I can agree to, indeed have always held to,—equal opportunity for all, not admitting that all are born free and equal,—the destruction of money value, doing away with the need for making money,—the shortening of necessary working hours by collectively owned machines, leaving time for the individual to develop himself: despite these undeniably fine ideals, which would benefit the capitalist even more than the proletariat, turning his exceptional capacities into finer channels than those of grubbing of grafting for money,—yet I draw back instinctively from communism, at least as I have seen it in the making, not admitting that I have been fooled for a moment by propaganda against it. I know too well how propaganda works, having lived through the disgusting "ballyhoo" of the World War. My record during that period I am proud of; I was against it from the start and remained so, I contributed not one penny in "Liberty Bonds" nor "Red Cross," I was with the aristocratic minority.

But what has been my background, what has conditioned me to draw back from communism? It might be easier if I had been born under a czar, but living in a democracy, watching the antics of popular rule, people fooled by demogogues, bullied by their own paid hirelings, police, soldiers, politicians: the destruction of personal liberty by mass minds, the perpetuation of the weakling, the vulgarization in every walk of life, the cheapening by popular approval. A sensitive person is either swallowed and lost in the grey dead level, or becomes militantly an individual, or retires to an ivory tower. The latter is not as the radicals would have it, a bourgeois artist,—he is a rebel against bourgeois surroundings.

I realize that I have been so conditioned by my fight as an individual in a backslapping, mob-spirited, intolerant, self righteous, familiar, evangelistic, regulating, leveling "democracy,"—that the very thought of collectivism, community ownership of one another, actually sickens me, literally.

I know the communist's answer—their way will work out to a different end—it's too early to judge them yet—and to be fair one must agree. But they have made a bad beginning—blaming necessity—with all the evils of capitalism under another name.

I can, do, love individuals; I dislike and mistrust the sovereign mass. I have sympathy for the underdog, but so have I for real dogs, stray, lost, abused, just as much if not more—

I believe, I know, that the mass, the proletariat, hates the artist, the intelligentsia,—would gladly tear him to pieces. It is envy, fear, will to power. Only a few great souls are really humanitarian.

Who, as an individual, has not experienced the hatred of a group of laborers, say telephone linemen, or a group of corner loafers in a small town,—the muttering insolence, the sneering faces, or outright jibes? Why? Because one dresses differently, walks with assurance, is different, belongs in a world they could never reach.

The ordinary bourgeois type they do not notice, they understand him, for they are bourgeois in the making: with energy, good luck, back scratching, they can rise to foremen, and lord it over their fellow Joneses.

Can communism change human nature? Or am I wrong, has human nature been perverted? Is there a basic fineness that I will not admit?

I look into faces that pass in the street, or gather in crowds,—and feel hopeless.

The foregoing sounds like an all too personal bellyache: as though I were not strong enough to stand, see beyond, the disagreeable episodes of a few crude yokels. Maybe so. Freedom has to be forced upon the mass.

Minorities always have to lead, or even force them to accept freedom as well as slavery, and what seems unsolvable to me is that what means freedom to one spells slavery to another, and conversely. Minorities in turn are led by one great individual, unique, whose mould is destroyed at birth. Even the disciples of a leader, the second lieutenants, are impossible,—arrogant, bigoted, proselyting parrots, who, with no creative understanding, stabilize the master's living thought. This is true whether the disciples follow religion, art, philosophy: Christ, El Greco, or Nietzsche. Always formulae instead of fluid Life.

A "John Reed Club" has been started in Carmel. Many of my friends have joined, or organized it. They want me. I went to a meeting. It was dull, humorless, vague. "Comrade" Weston tickles me: it's so much like "Brother" Weston of the Methodist Church. Both groups are honest, sincere, no doubt, though one must admit the comrades are more intelligent and contemporary. By joining the club one automatically accepts communism, admits its rightness, countenances revolution, collectivization, and so on into the night!

How can I join,—honestly, without reservation agree? "Dialectic materialism"—words and more words, leading where? But maybe this world needs just this materialistic "logical conclusion" (their very words connote a restraint they deny, a crystallization into unyielding reason) before man can "take off" again for fresh heights.

Weston's income was minute. He began by asking ten dollars for the sale of each print; some of which were sold through Jacob Zeitlin's bookstore in Los Angeles. He tried to raise his price to

fifteen dollars a print, but was unable to make sales at that rate. Once Zeitlin had a bargain sale of his photographs. Weston commented:

> Because I have changed my way of mounting, improved (in some cases) the technical quality of these photographs and because some are slightly damaged from exhibitions, I am permitting you to offer these, of which the original prices were $10.00 and $20.00, for a limited time, for $2.00. No duplicates, with the exception of a few in the group, can be had for less than the original price.

Sometime, in mid 1927, he wrote Zeitlin from San Francisco (where he was sharing a business studio with Enrique Jackson) that he was desperate to the point of selling some of his father's archery material:

> Dear Zeitlin: Have been so damnably rushed I have not found time to write you re archery books.
>
> There are 23 or 24 volumes, scrapbook size, containing clippings from all over the world—scores, reproductions, technical articles. There are records, and photographs from various national and English tournaments and Olympic games. There are personal letters from all the great archers contemporary with my father, an especially valuable series from *Will Thompson*. My father practically revived archery in America, and these volumes present an invaluable picture, and intimate record of his time. . . .
>
> As to prices—anything you think right—the same re archery books—
>
> Best wishes Edward Weston.

Three years before, he had written a letter to his son Cole, who was then about five years old:

> I always feel better after a sitting which means money—nothing flourishes, neither art, nor love, nor peace, on an empty pocketbook.

The nasty pinch of money made him furious; because time, an artist's real and only too exhaustible resource, was vanishing, day by day:

> Yesterday's flare-up was over economics,—started by hours in the darkroom printing copies of a drawing for which I am to receive less than a carpenter would ask for his time. I did not need to take this job: but I needed money—I have no one to blame but myself. I made my own bed. I could have been well-to-do—if not rich—by this time, if I had taken advantage of all the publicity I have had these years past,—if I had thought in terms of money instead of my work. I really have just what I deserve, or wanted: a bare living and plenty of time for my work. But I should be getting more than a bare living, and yet have time for myself. When I work for others I should be paid more. How to achieve this I know: go to a big city, get a manager, open a studio,—well-located, do the society stunt, become fashionable—I could make good, I have the personality, and know

how to deliver the goods. I could have been a good businessman: making money is thinking in terms of money. Maybe if I would put all else from mind but money for a few years I could gather together a modest sum, and quit. But those precious years! If I was only clever enough to figure out an easy way to extract the public's nickels, dimes, dollars—a patent medicine, a catchy song,—which reminds me of one I started, and Johan was to set to music, called—"I'm never so homesick as when I'm at home." Just so, do some become rich!

Restless, uncertain, rebellious, he went often to San Francisco, and used Hagemeyer's studio there, sometimes for weeks at a time. But his anger turned inward, to depression:

> What can be the matter with me?—This awful headache,—the nerves at the base of my skull: almost steady for over a week.
>
> I have overworked, strained my eyes and nerves, in my desire to get ahead. I knew I was abusing myself, but thought to counteract by regular hours and much sleep. But every morning I awaken with this maddening tightness. I have not retouched for a week, yet I am no better. If I had the price, a chiropractor might slip something in place. I am usually able to cure myself.

His gloom was periodic, and as Sonya Noskowiak observed, it was, "generally connected with a lack of fresh material to be photographed." He wrote, trying to sound optimistic:

> Thanksgiving Day. Shall I count my blessings? Easy to find I suppose: health fairly good in spite of minor dissipations—food in pantry—near owner of a Packard car!!! Brett as a pal and co-worker—A. as a novia—my work considered by some few as the most important on this coast.
>
> But when I think of my work, I slump mentally, spiritually. Not a pretty picture, this year compared to last. 1927—when I jumped eagerly out of bed to study last night's negatives, or a new shell, vegetable, fruit: 1928—when I lie in bed wondering if a check will arrive "in time." 1929 must bring a change—

Once again, a new love pulled him out of his despair. On October 13, 1928, he went to a party in San Francisco and met a girl he calls "A":

> Hardly a word was exchanged that night, but I noted her beauty of face and form, her fresh loveliness and refinement. We drove her home, and parting, I read her eyes. Next day, all day, she haunted me, until I called up Margaret [Nicol] to get her telephone number. We planned a day together—lucky that Sunday followed—a day far away in the hills, lying in the sun, dreaming, each knowing well the other's thoughts and desires,—and yet I did not touch her,—could not. I am always so, I cannot be aggressive. But I knew the evening was ahead!—and I would have surprises for her: music, a bottle of wine, the beauty of my room. And how we danced!—with the ecstasy

of knowing, yet waiting the moment. What an incorrigible romanticist I am. Who would not be with A.!? Rich chestnut eyes,—frank, open eyes, golden hair to match, a slender, almost fragile body, yet well-rounded,—seldom does one see more exquisite legs—and sensitive hands. All this is A. plus the freshness of youth. She may be virginal,—I almost think so. She is only twenty,—which means nothing, but seems untouched,—mentally wise but bodily inexperienced.

So I have what I wished for in my last entry,—dancing, wine, and a lovely girl. And to make my happiness complete, a check for $120, and new orders to $100.

Two days later:

Always—and at the right time—my wishes are fulfilled: last night I took "A" into my arms, and found her lips were waiting mine. . . .

On Wednesday, she came to supper:

We [he and Brett] served one of our typical meals: a dish of avocados,—five of them, which may have appeared extravagant for a poor artist but cost only 10 cents each, a big bowl of cottage cheese, rye-crisp, gorgonzola, plenty of greens, muscats turned almost to raisins, and coffee with honey.

Later who should appear but Margaret and Irving [Nicol], surprised I'm sure to find who was with me. Dancing followed,—the tango, the danzon, and A. and I renewed our episode of Sunday. She is, I am sure, quite as excited as I am,—and that is enough! We are to have a dance, Saturday night, for which I have a gallon of Burgundy, and Sunday A. will come here. I await what should be our day!

On Friday night, Weston gave a small party:

Just Margaret, Irving, A., Brett, and Edward with a gallon of Burgundy. We danced—A. and I—and loved till I was sick of love—in a flame! Then Margaret suggested a drive to the beach, a run on the sands. "Stay with me," I said to A. "No, not tonight, I have complications. I'll tell you why later," she answered. O hell, I thought, another virgin with inhibitions. I will not try much longer. But I wanted her. I was full of passion. . . .

We drove far and fast, seventy miles an hour at times, until kisses became more like clashing of teeth. And then she left me.

She came next day with evident desire, and I said to her, "I want you, do you want me?" "Yes—I did not stay last night, because we had been drinking, and because the others would guess. I am not an exhibitionist."

I like her delicacy of attitude though it certainly was hard on me and took the edge off our first coming together. I was fooled. She was not a virgin, no indications at least. Maybe I am lucky, there will be no tears and regrets. But she gives me much beauty, and I have desire to reach a closer understanding and finer rhythm with A.

But then the old tapeworm of jealousy took hold:

A new experience is mine! I am wiser than I was. And sadder?—not so very much—a little though. I will miss her dancing most of all.

We danced well together, A. and I. An impassioned courting—the surrender—then the rocks! Sunday night after she had left I was just dozing off, feeling rather balmy over my success, when the phone buzzed—I have it well muffled. "Is Miss there?"

"No."

"Do you know where I can reach her?"

"No."

I hung up and dove into bed. Again the phone—this time I was asleep—and rather peeved to shiver in my nakedness.

"Is Miss there?"

"No!"

"A friend of hers is dying—are you sure she is not there?" Now I was angry,—being called a liar—indirectly, though I would have said "no" if she had been here! I hung up abruptly. But now I was wide awake and smelled a rat. A jealous lover, of course! Well I want no triangles,—no one is worth such a mess.

Two days later, a note from A., certain things had happened, and she thought best not to come again, regrets, etc.

The name given me over the phone was someone Lula Boyd knew. I will go to her, perhaps she will enlighten me.

She did!

A. had been using me to incite jealousy, or perhaps using both of us. So thought Lula. She told the whole long story, in confidence.

Who would have thought it of you, A.? Well, I shall be fortified if you should change your mind or heart and come again—

Meantime, Hagemeyer was leaving his summer studio in Carmel, and Edward Weston conceived the plan of settling in that tourist town:

I am needing, or taking much less sleep than I am used to. Staying out late, arising early. I feel no ill effects. My mind is full of plans. Carmel is assured. We pack everything next week, and down goes the curtain on the stage at 2682 Union Street.

I am quite happy over the prospect—and Brett is overjoyed. At last I am to live within five minutes of the open country and hills, only a short walk from the beach. Yet four hours of steady driving would land us in San Francisco and a day's driving in Los Angeles.

This room, I could never forget,—the magnificent panorama from out the great window, the honest construction, the fine light, a working room but not a living room: no bath, no closet,—the darkroom serving for both, and as a kitchen, besides its intended purpose.

It is just too much to expect, Brett and I living in one room even under normal, convenient conditions. The future looms bright. I am stimulated,—already visualize working again for myself.

I have another reason to be happy. $150 in the bank and $50 more in my pocket, besides outstanding accounts to the amount of $515, and several prospects. This should enable us to make the trip south, give Flora a Xmas check, pay up the car, and have a little left

to live on while starting in Carmel.

There will be those who will criticize me for changing again but I know what I am doing.

On January 12, 1929, he and Brett settled down in Carmel:

An amazing amount of work has been already accomplished: cleaning the three houses, placing our effects to advantage, even printing and developing. Besides work we have had recreation, a dip in the ocean, long walks through the hills and along the beach. This is what I wanted, knew we would have in Carmel. In Glendale there

Weston's Desk, by Dody Warren

was no incentive to walk, or even stick one's head out-of-doors,—nothing but cheap ugliness to face: San Francisco had interest of course, but I wearied of cement walks to clatter and pound along on. But there was another reason I discovered, questioning myself, for leaving the city, any city,—a psychic rather than a physical reason. And when I think of the unbroken rows of houses, people canned as it were, the massed emanation from these huddled thousands, I catch my breath and draw away, and am glad to be here with pine trees instead of people for neighbors. Every time we drove away into the country from S.F.,—returning, nearing again the city streets, my heart would sink, my stomach turn in revulsion. This new life should bring fresh stimulus to my work. Already I have sorted out ten negatives laid aside these many months to finish. And I shall be doing new work too. I feel it in my bones!

Peace again!—the exquisite hour before dawn, here at my old desk—seldom have I realized so keenly, appreciated so fully, these still, dark hours.

With the exception of some trips, and the usual amorous dislocations, Weston remained in Carmel until his death. It was not a new beginning for his art, though; it was a continuation of what he already had done. Along with the shells, he became enamored of the lines and volumes of a bunch of bananas. They were, again, "elusive materials," for they were often devoured by his sons before they could be photographed. He began by making an arrangement, much as a painter might do, of "bananas, an orange, and my black *oaxaca olla*," the pot he had bought in Mexico. He was aware of what he was doing:

I shall watch the markets for other fruits and vegetables. Strange, loving flowers, that I have never used them. Why, I cannot say. Maybe because I was not ready to do them as they should be done. . . .

A Swiss chard, which was a solid, sculpture-like head, and almost white, I did against a light ground, standing alone with no accessories. It pleases me. Then Sunday I did an eggplant but again failed. I bought three to arrange: they did not arrange, except in too-well-known combinations. My greatest danger is in imitating myself—not others. I tried one alone: again it was reminiscent, for the logical way was to center it, and I have used that way of seeing often and am tired of it. But in forcing another viewpoint I failed to convince.

Today I have the eggplants, though some withered, and an exquisite head of lettuce! Good luck to myself!

Nor was he unconscious of the implications, both emotional and aesthetic, of his botanic discoveries; he watched them with exceptional attention, and sometimes sandwiched Bertha between the vegetables:

My subject matter has been squashes. What an ugly word! Pumpkins may be better,—at least sounds humorous. I shall say pumpkins. They are really gorgeous: one exquisite as a Brancusi, another a human embryo,—another wart-like, malignant,—a little one, quite jolly. I found also a cabbage of unusual shape, the leaves folded to a definite point: it is a beauty. Well, believe me, I was excited to be working with them. All three negatives are good.

Bertha came in the late afternoon to dance for me. She made her own music with large cymbals, little-finger cymbals, and tambourine. She danced nude. It was a rare privilege to see her in these several dances,—an inspiration.

I have worked on with cabbages: two more negatives,—one of the two little pointed ones against a tall Mexican basket,—the other of a large round cabbage, a much more cabbage-like cabbage, in a round basket. These sound in description like the usual run of still life, but they have more—

And more than two years later, in Carmel, he tried bananas again:

In rare hours when the sun breaks through the summer fog which blankets Carmel at this time of year, I dash for the roof of Neil's cottage, around which we stretched muslin, strip to the sun and wind, bake and burn until I sweat, then dash back for a cold tub. What a glorious sensation! — the sun penetrates right through me to the board beneath and then back again, until every pore is open and every nerve tingles with joy. My body is tanned to a rich brown, and I am better able to stand the devitalizing darkroom hours. Training for art!

The new banana negative is great! A bunch of five standing on end, still joined at the top, — and how beautiful the fruit is at the point of radiation from the main stalk, — the concave side to the camera. The three centre bananas are perfectly straight, the two outer ones swell out from the top, then almost straighten to cut diagonally across all but the centre fruit. It is a classic conception and I am proud to have made it.

I should have said the front row of the bunch of five, for in the bank several more are hidden, all but a slight curve from the outer two which join and complete at the top the front line sweep.

One more negative of the bananas from Tuesday is important, a close-up, lines radiating from the main stalk, the axis. And two I must confess were undertimed and discarded.

This critical intensity of seeing — this sense of discovery in a miniature world — becomes most exciting in the course of his adventure with green peppers; they are famous, and justly so:

Well, I am joyful of my green pepper negative. If I can get some quality into the background, it will rank with my finest expressions. The cantaloupe is worthy of printing too, but I shall do it again, and of course I am not through with peppers.

No — I am not through with peppers: now I have another as fine or finer, — the same pepper from another angle. Saturday I made the first exposure: it was moved! — not badly, but enough to destroy that precision in my work which I want. I tried to say to myself, it would do; but no, I can't fool myself.

Yesterday, I did the pepper again, — and what a satisfaction to have a clean-lined, brilliant negative! This, and a shell negative, done yesterday too, were made with a $5 R.R. lens bought a few months ago, secondhand. I like the quality, and being of shorter focal length, it is easier to focus and requires less exposure. I stop down to *f*.256.

This pepper sits on top of a milk bottle. It has amazing convolutions. The shell was an accidental find: or at least rather so, for I was working with a cantaloupe, and not feeling fully its form in connection with the olla, I tried the shell which gave me just the swing, the flying quality I wanted.

It may be only enthusiasm for a new negative which causes me to say "one of my best," but I believe that all these recent photographs are "my best," for I am working too surely to expose with indecision.

In July, 1929, he returned to his material:

I am working now with two green peppers of marvelous convolutions. Yesterday's negative will be finished: which indicates its value. . . .

The aforementioned pepper negative will not be finished despite my yesterday morn's enthusiasm: the reason — I have far surpassed it with almost any one of eight negatives made yesterday. July 8, 1929, I will remember as an important day — and I feel the beginning of an important period — in my work. I worked out of doors in the sunlight — a trying but exciting day, for the sun playing through pine branches changed so rapidly the direction of light, that it became a matter of chance as to whether or not the peppers were well illumined: but no chance entered into my decision as to the right moment for exposure.

July 13 — I have been working so enthusiastically with the two peppers, stimulated as I have not been for months.

Again, he sent a number of these prints to Tina in Mexico. Her reaction was generous:

My god Edward, your last photographs surely "took my breath away!" I feel speechless in front of them — what purity of vision they convey — When I first opened the package I couldn't look at them very long — they stirred up all my innermost feelings so that I felt a physical pain from it. . . .

Thank you for the joy and stimulus these prints have given me. . . .

To his mind, her associations were, of course, utterly mistaken. She wrote him again:

Edward — nothing before in art has affected me like these photographs — I just cannot look at them a long while without feeling exceedingly perturbed — they disturb me not only mentally but physically — there is something so pure and at the same time so perverse about them — they contain both the innocence of natural things and the morbidity of a sophisticated distorted mind — they make me think of lillies and of embryos at the same time — mystical and erotic. . . .

Since the creations of an artist are the result of his state of mind and soul at the time of the creation, these last photographs of yours very clearly demonstrate that you at present are leaning toward mysticism — but since the life of the senses is there too, your photographs are, at the same time, very sensuous. . . .

Rene [Harnoncourt], like me, expressed the disturbance these prints caused him — To use his own words, he said he felt, "weak at the knees" — . . .

I hope you take it for granted that in spite of using the words disturbing — erotic, etc. — I am *crazy* about your latest creations — they have been an inspiration and a joy and I thank you for them — . . .

At last Diego Rivera saw your photographs! Do you remember his typical exclamation — "Ah!" whenever a new photograph was laid

before him? The same this time as I slowly held up one print after the other—after the first breath-taking impression was over however, and after a long silent scrutiny of each print, he abruptly asked me: "Is Weston sick at present?" . . .

Then he went on: "These photographs are biological—beside the aesthetic emotion they disturb me physically—see my forehead is sweating—" Then: "Is Weston very sensual?" Then: "Why doesn't Weston go to Paris? Elie Fauré would go wild over these things"—

During this period, his friend Ramiel McGehee was visiting him:

A recent evening I thought to read Ramiel passages from my Daybook,—those concerning my work. I was appalled and disgusted how often I had indulged in self pity. Most of the writing seemed to be a wail over my financial condition, and the rest about my love affairs.

But now I am working again. I must thank Ramiel and Sonya,—each in their own way, for having given me mental and physical freedom. To them I owe much: clearing the way, bringing peace, understanding love, stimulation.

The woman he was referring to, and, in fact, living with, was Sonya Noskowiak. He was, as he often acknowledged, very lucky, because she was as extraordinary in her own quiet way as the

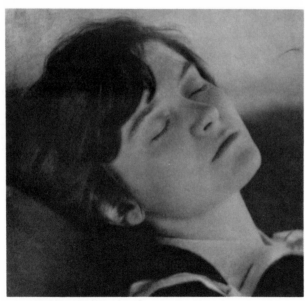

Sonya Noskowiak

more flamboyant Tina Modotti, Margarethe Mather, and Flora Chandler. He had met her sometime before mid April, 1929, through his friend Johan Hagemeyer. She was working at Hagemeyer's studio as a receptionist, but was allowed to watch him at work in the darkroom. Her parents were Polish, but had emigrated to Chile and then to the United States when she was fifteen. Her parents enrolled her at a high school in Sacramento, but she became obsessed with the camera. The summer after her gradua-

tion she visited her married sister in Carmel, met Hagemeyer, and went to work for him. He was a difficult, domineering, and unhappy man at the time. In Willard Van Dyke's opinion:

He was a bitter and sardonic person whose work was faintly reminiscent of Weston's. He was a kind of poseur, I am afraid. He was difficult, very difficult, as a human being.

Sonya was small, thin, with a broad Slavic face and nose, "very sweet, very warm, a very fine person," and she fell, like other women before her, precipitously in love with Edward Weston; and likewise, Weston for her:

Time: 3:30 a.m. Place: the white sands of Carmel shore—the moon setting over the ocean. Characters: Sonya [Noskowiak] and Edward.

Edward: "Sonya!"
Sonya: "Edward!"
—and then the first embrace—the first kiss.

Literally, they were not the first. I have to thank wine and dancing at a party I gave for A. last Saturday for the prelude.

I danced many times with Sonya, there was an immediate, mutual response. I kissed her cheek and neck and ears as we danced—she did not resist. Then she invited me to supper Tuesday night. We talked, played many records, and she sang until way past midnight: but I made no attempt to renew familiarities. I was sober—she was sober,—and I am always backward, afraid to make a false gesture. Perhaps, I thought, the other night her yielding was only due to wine.

"Me voy, Sonya, es tarde!"
"Pero no es tarde, esperate."
How stupid I was! But I put on my coat. She did too!

How wise these women! How subtle was Sonya. I took the cue—and walked with her toward the moonlit water and what I knew was inevitable.

We returned to her "Playhouse,"—for hot coffee.
She resisted just long enough. Wise little Sonya—
No sleep that night,—no desire to. Tender, lovely, passionate Sonya!

Sometime later, she was sleeping over at Weston's rather crowded house, although he had, by no means, made up his mind about the woman he would choose to stay with him in Carmel. He wrote and proposed companionship to young Kathleen, but she wouldn't leave her parents. Christel and Fay Fuguay were each considered—and rejected. He even thought of Miriam Lerner:

Miriam would be a fine person to consider as permanent, but what of Sonya? Yes—she has already become very close to me, and I can easily imagine a lasting association . . . Sonya is young, maybe not ready to settle down. . . .

Sonya began to spend her days there as well, learning Edward Weston's standards of photography. He gave her a camera—a

$4\frac{1}{4} \times 4\frac{1}{4}$, with his old five-inch rectilinear lens—but wouldn't allow her to expose a single negative for several months. He would say, looking at her choice in the ground glass, "Did you feel that?" Finally, one day she focused on, and shot, a calla lily, and Weston made a characteristic remark: "I wish I had done it," (Willard Van Dyke and Cole each report the same words). In return for instruction, Sonya developed portrait negatives for him.

Hagemeyer worked infrequently for himself, and criticized Weston for turning out negatives, "like peanuts." In this period, Weston actually made twenty to twenty-five negatives a day, but he rarely worked more than three times a week on his own material. He stopped down, often, as far as $f.512$. If he worked in the studio (it was in the Seven Arts Studio Building in Carmel proper), he made use of the crosslight from the French windows. His concern with the quality of light was fanatical; experimenting with all sorts of devices, particularly while shooting the peppers. One of his most successful methods was to put the pepper in a large, tin funnel which would reflect diffused light around and behind the pepper.

Sonya was once halving an artichoke in the kitchen (for she became responsible for the meals), and Edward Weston said, "Don't you cook that," and seized and saved it to be devoured by his camera. Sonya went on other treasure hunts for Weston, often returning with subjects for his studies—mushrooms, bones, Swiss chard:

> Sonya brought me a most marvelous chard from the Big Sur,—powerful white stalks and veins running into dark green leaves with a variety of movement—absolutely amazing. I worked despite great handicap, for it would not last for long. I saw well,—but had tragic failures. The leaves would wilt imperceptibly during a 20 minute or more exposure, so that I only got two negatives out of ten, and these two not perfect. I could not work out of doors in the wind, and I had to stop down to the limit, hence my failures. The chard is still fresh, but I do not feel equal to going on with it. And besides, we await the arrival of Brett, Elinore, Neil, Cole, Ramiel!

Sonya also brought likely models to the studio for his nude studies. She herself, or parts of her body, were the subjects of many of his nudes of the period, and with their contorted shapes and multiple lines, the compositions are markedly influenced (an interesting reversal!) by vegetable and banana forms.

These years, between 1929 and as late maybe as 1933, were peaceful, absorbing, industrious, full of praise, and self confidence for Edward Weston:

Correspondence comes from all over the states and Europe too: requests for prints for exhibits and publications, questions to answer, would-be apprentices.

The exhibit at Braxton has brought me two fine notices, from Arthur Millier,—"we believe that the work and influence of this photographer will be written large in the history of art in the West and in America"; and from Merle Armitage,—"The rather small group who have been aware of Edward Weston for some years, know that in him, America is making one of its strongest bids toward an art consciousness."

Whether true or not, and of course I believe they are right, such high praise has a salutory effect upon me. Instead of sitting back and thinking, well I've arrived, I work all the harder, as though I must not fail those who believe in me, that I must go on and on! . . .

These days are golden, the nights silver. Point Lobos in moonlight is enchanted.

Visitors were enchanted, too. After a visit to his studio, one of them wrote:

> God! it was glorious. You as a family, your hospitality, your graciousness, your conversation, your minds that kept mine hopping about like a rabbit, every goddam thing about you is what I have looked for all these years and knew I'd never find. . . .
>
> I'm in love with Sonya too, nuts about Edward, and have wondered how you could possibly raise three boys who are so completely free of inhibitions. Meeting you has been the revelation of my life; a sort of a line of demarcation, for I look forward with a new feeling about this world.

Another, and very frequent visitor, was Willard Van Dyke. He, like all of us, had been interested in photography from boyhood on. The father of his high school sweetheart, John Paul Edwards, a department store buyer, whose real interest was photography, knew Weston and was known by him. When Van Dyke went to a San Francisco exhibit in the late twenties, he saw some of his photographs, notably the shells and the portrait of Galvan; and was stunned by their beauty. When Weston came to give a talk at Berkeley, J. P. Edwards arranged for Van Dyke to meet him and Van Dyke asked whether he could be his pupil. Weston said, "No," but suggested that people did, on occasion, come to work for him.

Encouraged, Van Dyke drove down to Carmel to show his portfolio. About two particular photographs, exceptions in that they were not done with a soft-focus lens, Edward Weston made his standard remark: "I would have been proud to do these." A year later, Weston wrote him that it was an opportune time for him to come down and work for him. Willard Van Dyke took

leave from his filling-station job, packed a sleeping bag and his new 8 × 10 camera, and drove down to Carmel. He spent two weeks in Carmel, in daily work with Weston. His teacher would take no money, so Van Dyke paid him by commissioning a portrait. Thereafter, he drove down every weekend he could get off. Many years later, he spoke of Weston:

> My trips to Carmel were eagerly awaited by me, and they were the most important thing that happened to me during that period . . . of trying to decide what kind of a man I was going to be and whether or not I was going to be an artist. . . .
>
> The atmosphere around Edward was one of quiet, of peace. But when he was at rest, you almost had the feeling that it was like a spring getting tighter and tighter. His whole life centered around work. There was not much else except his love affairs. And the conversation, although wide-ranging, was limited and his responses predictable.
>
> His respect for art, his desire to keep everything very simple so that nothing could interfere with his life as an artist — I learned and respected and it made a focus for me, made me understand things that I never understood before.
>
> He was my spiritual father. He was the person whom I most wanted to emulate. I could have become a pale replica of him had I stayed in California.
>
> He was a gentle, quiet, reserved man with limited but very strong interests. He enjoyed art, but not all art: photography, but not all photography. He liked music, but only a limited range: Bach.
>
> He liked women, but he was also impatient with them. No, that's too strong a word. He liked women as companions, as sexual objects. His numerous affairs are legendary. He found each new sexual adventure vastly stimulating as far as his work was concerned. . . . He needed assurance that he was loved and wanted, and that women were attracted and were satisfied by him.
>
> He was very self centered, as many artists are. . . . What he needed and wanted took precedence. But he was not petulant nor childish. It was recognized by everyone around him that he was unique, that whatever anyone else needed or wanted should take second place to that.
>
> Mealtimes were at his convenience. Food didn't mean much to him. Work was all important. He got up with the dawn and was ready to go to bed after the sun went down.

Van Dyke told of a characteristic incident: Mable Dodge Luhan had come to Carmel to spend a summer with Robinson Jeffers's wife, and she invited Weston to visit her in Taos, New Mexico. He agreed to come, but only if Sonya and Willard Van Dyke came along. She agreed, and the three of them drove to New Mexico and stayed in Mrs. Luhan's guesthouse, but they ate meals with Mrs. Luhan and her Indian husband. For three days, Mrs. Luhan, one of the more aggressive characters in the American intellectual scene of the time, demanded almost complete attention to herself. At dinner on the third night, the main meal had been served and finished by everyone but Weston. He was a slow and careful eater. The table was cleared, and dessert brought on and eaten while he finished his main course. At that point, the whole table was cleared, and Mable Dodge Luhan said, "Edward doesn't want dessert."

Weston had bought a copy of Thomas Wolfe's *Look Homeward Angel*. That same night, he asked Van Dyke to read from this book, as he often did. He interrupted him and said that he was unhappy and not working well. So that night they left a note for Mrs. Luhan and drove away the next morning at dawn.

Sonya remembers with joy the endless discussions that she and Willard Van Dyke (both of them Weston's pupils and disciples) had with Weston on those long, beautiful, Carmel weekends, with the thin, bracing scent of wind coming through the pines, and the fog drifting in across the moonlight. In hindsight, Willard Van Dyke is a bit more matter of fact:

> Only now can I really see some of the failings that he had as a human being, and they were not very great, but he had his limitations, and his attitude toward art was one of these. His tastes were not . . . catholic. His interests were quite narrow but very intense. Edward Weston was not as great an admirer of Stieglitz and Strand as many other people, although he thought they were among the most important photographers of their time, or any time. He was not one to blindly adore. . . . In addition to photography, we talked about the work of Charlot, Rivera, Orozco, Siqueiros, Merida. He was not very fond of Siqueiros . . . and we talked of local Carmel artists, all of this to a background of Bach, and sustained by Monterey Jack [a local cheese] and triscuits and raisins. Sometimes, being a carnivore myself, I would become tired of this diet and go out and buy a bunch of steaks.

Sonya still speaks of those years — that lasted till 1934 — as "the best part of my life," which is not to say they were without trauma. She felt herself to be Edward Weston's second wife — but without benefit of ceremony. Ramiel McGehee's visits to Weston in Carmel (one lasted almost a year) were therefore difficult for her. Ramiel, without really working with paring knife or broom, ruled, or tried to rule the household affairs, so as to give Edward the maximum ease and comfort and time to work. His love for Weston, and perhaps his jealousy, had not diminished with the years. Nor was Ramiel always able to distinguish between the

Text continued on page 253

PHOTOGRAPHS BY EDWARD WESTON

Cole Weston, fourth son of Edward Weston and the executor of his father's estate, has provided the prints to make this book, the captions for each photograph, a list of the photographic periods in the life of Edward Weston, and a brief commentary on each of these periods:
From the time my father took his first photograph with a Bulls-Eye camera given to him by his father in 1902, until he made his first entry in his *Record Book, 1N, Nude, Glendale, 1918*, there are few records left of his work, except for those few in museum collections and in family photo albums; the rest he destroyed.

Although in his Record Books he used only three basic codings to denote the photographic periods of his life, it is more accurate to list five distinct periods:
1. Pre-Mexican, 1918 to 1923: Glendale, California
2. Mexican, 1923 to 1927: Mexico, six months in San Francisco, 1925
3. Pre-Guggenheim, 1927 to 1937: Glendale, 1927, 1928; San Francisco, 1928 to 1929; Carmel, 1929 to 1935; Santa Monica, 1935 to 1937.
4. Guggenheim, 1937 to 1939
5. Post-Guggenheim, 1939 to 1948

The photographs are reproduced at the same size as Edward Weston's original prints.

PRE-MEXICAN 1918 to 1923

This period of Edward Weston's work is characterized by a soft focus, neo-romantic point of view, which was the dominant style of photography at the time. Nevertheless, while visiting his sister, May, in Middleton, Ohio, he made one of his favorites of the Pre-Mexican period, "Armco Steel." This photograph represented a new trend in his work.

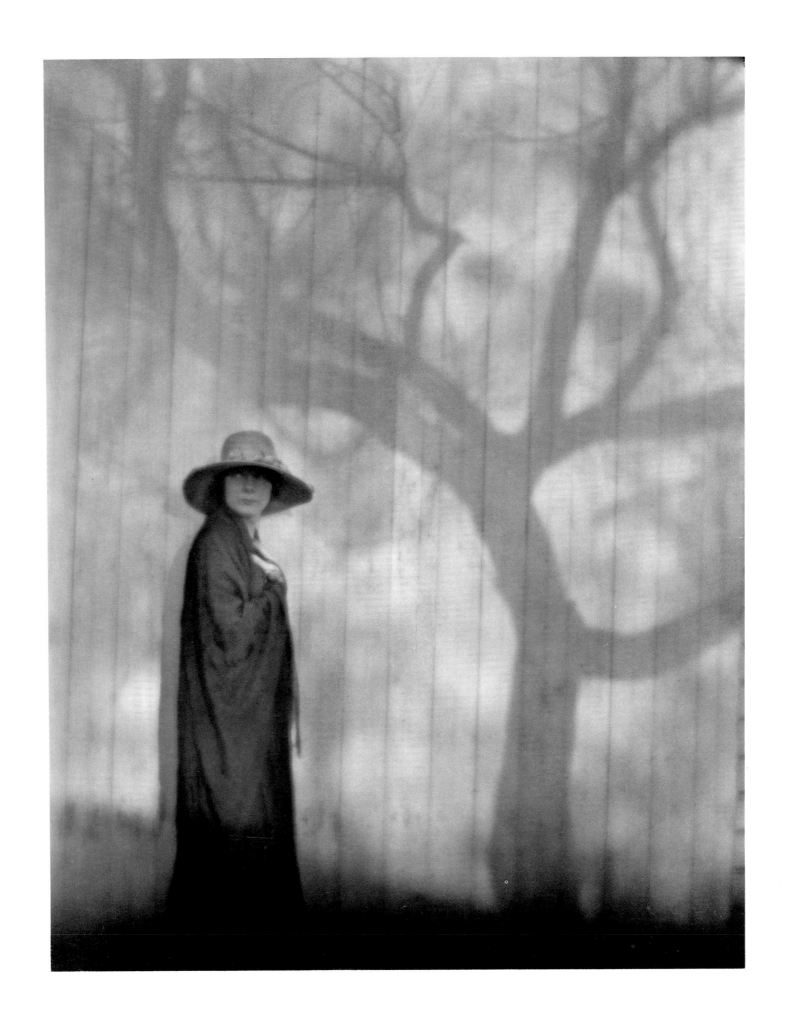

87 *Margarethe, 1920*

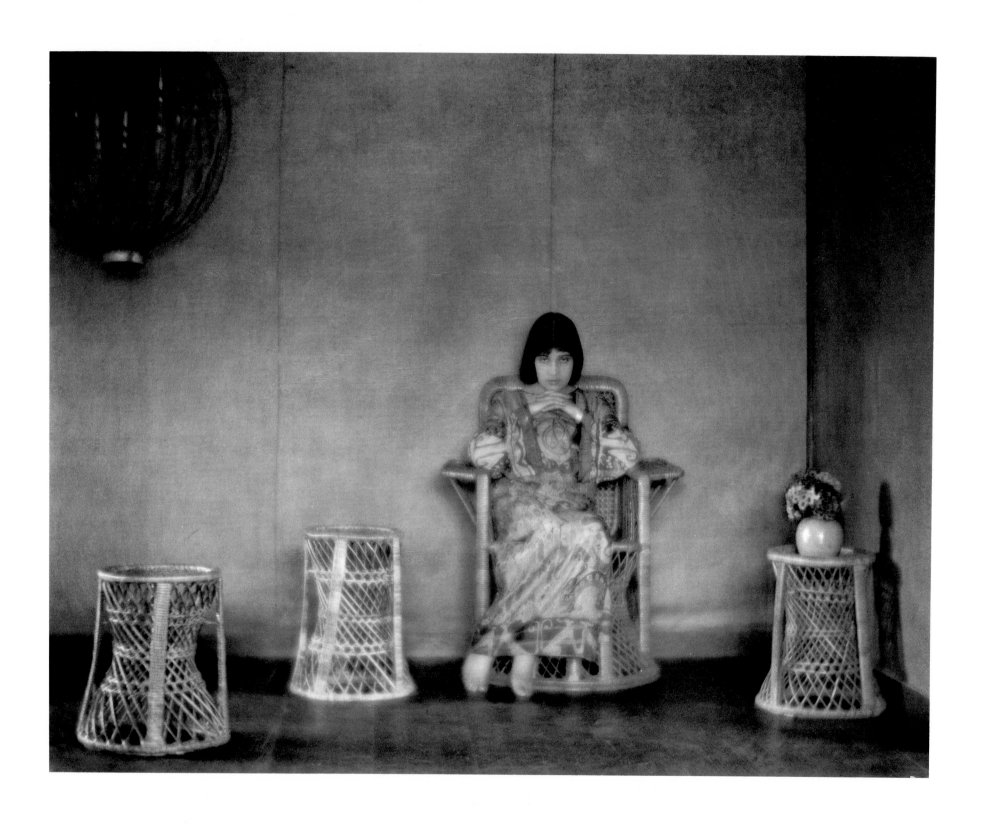

88 *Tina, Glendale, 1922*

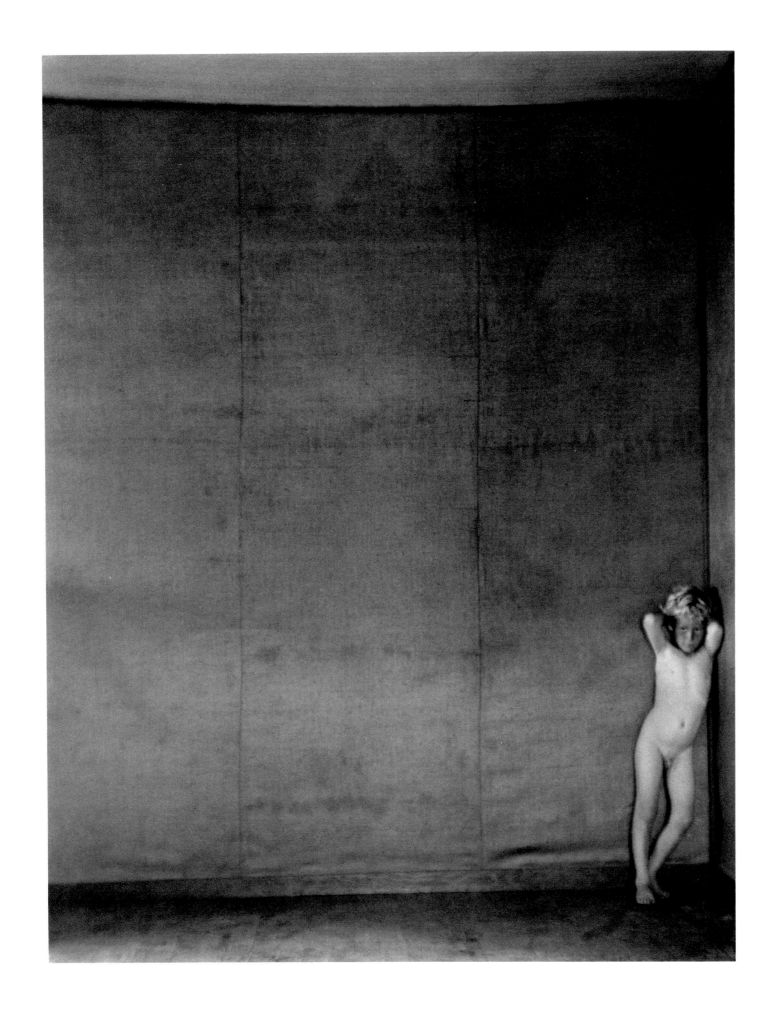

89 *Nude, 1922*

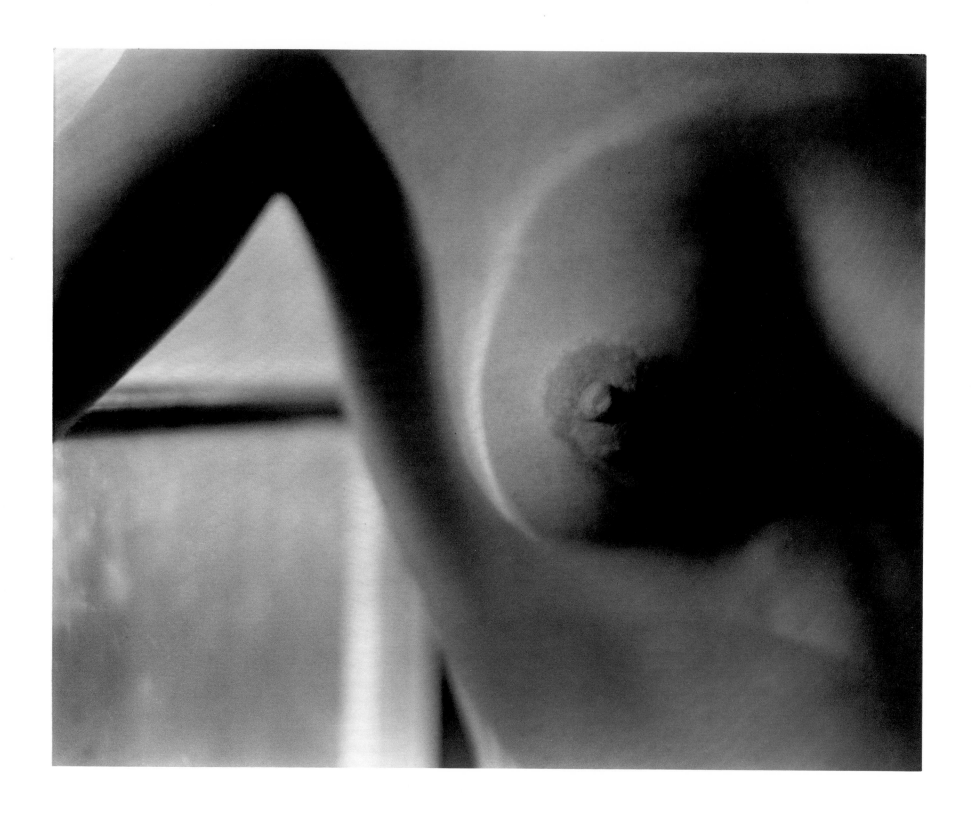

90 *Nude, 1920*

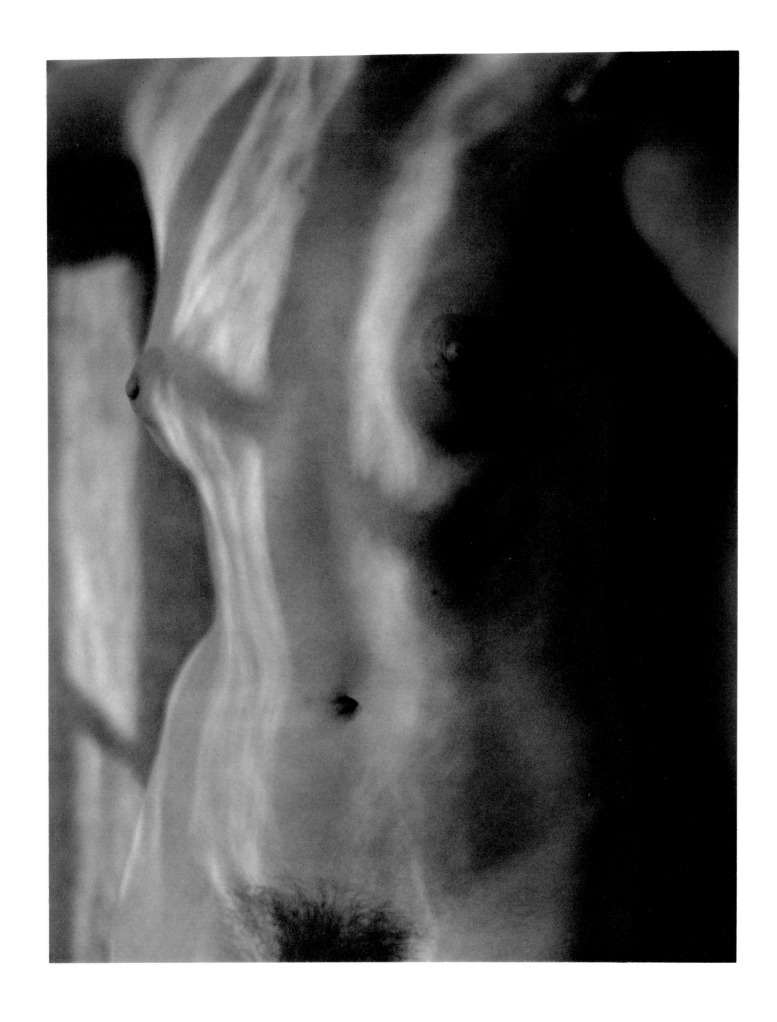

91 *Nude, 1920*

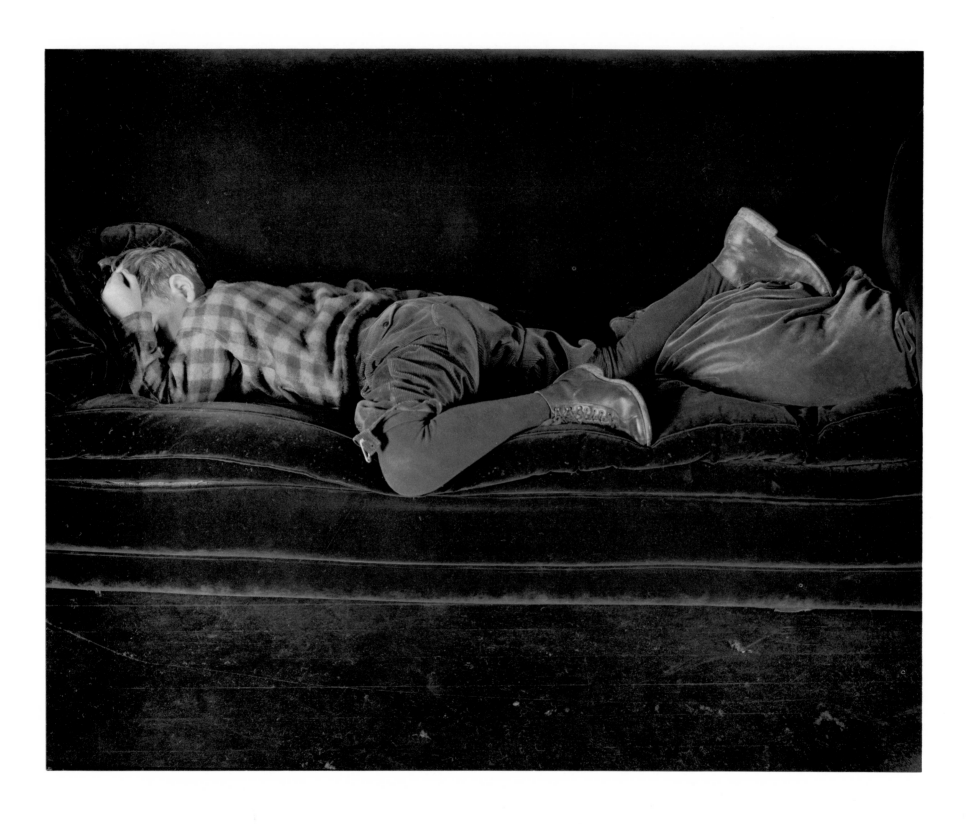

92 *Neil, 1925*

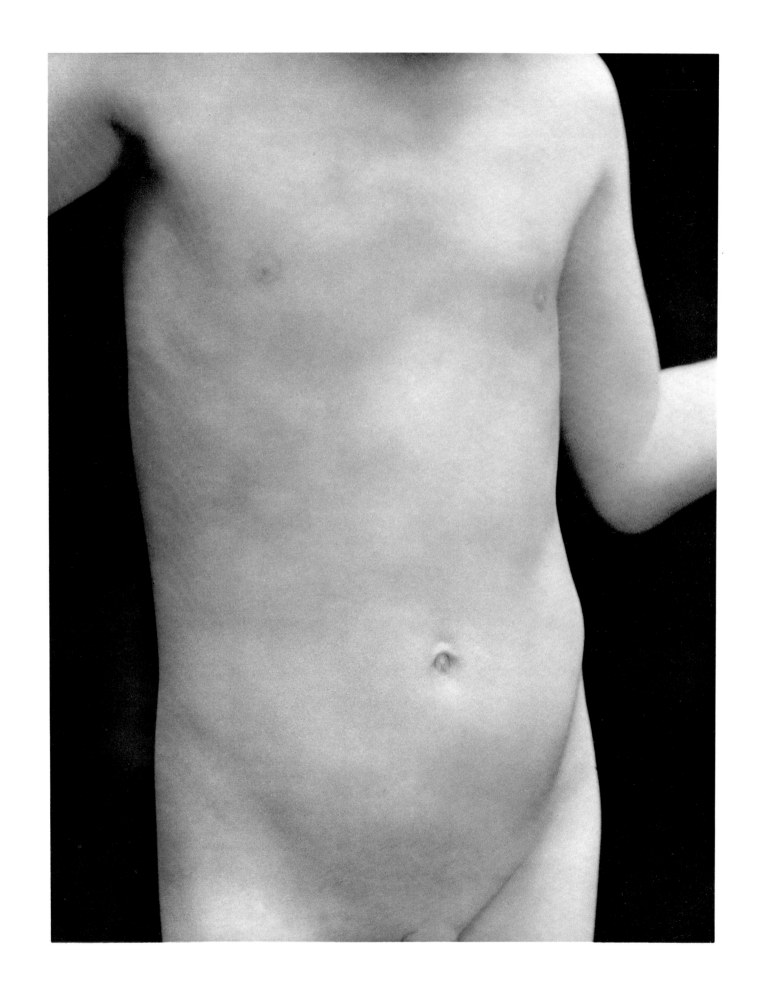

93 *Neil, 1925*

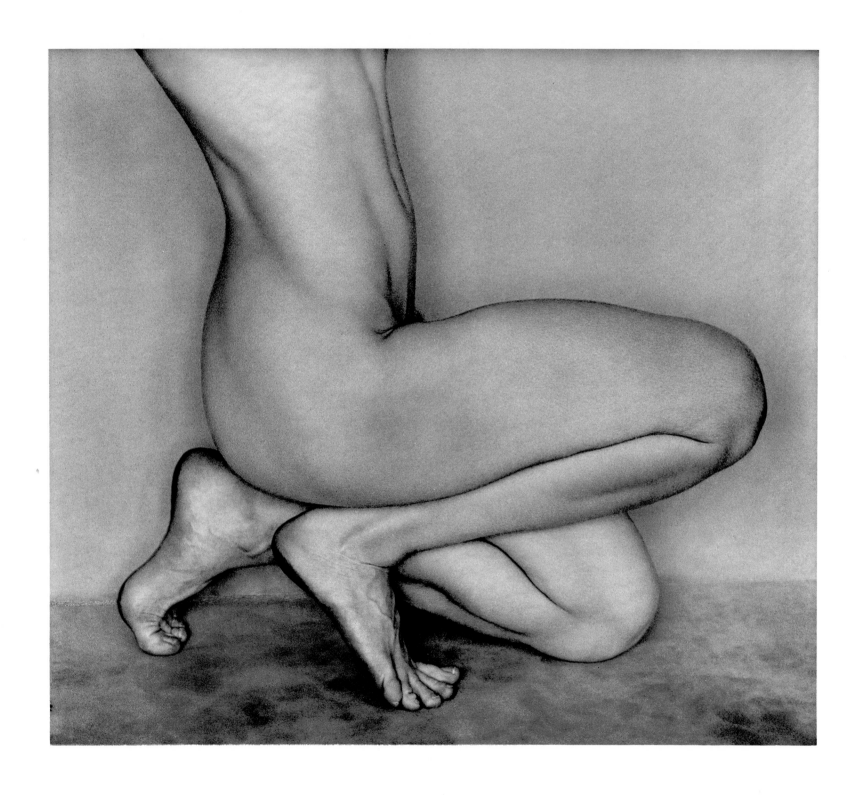

94 *Nude, 1927*

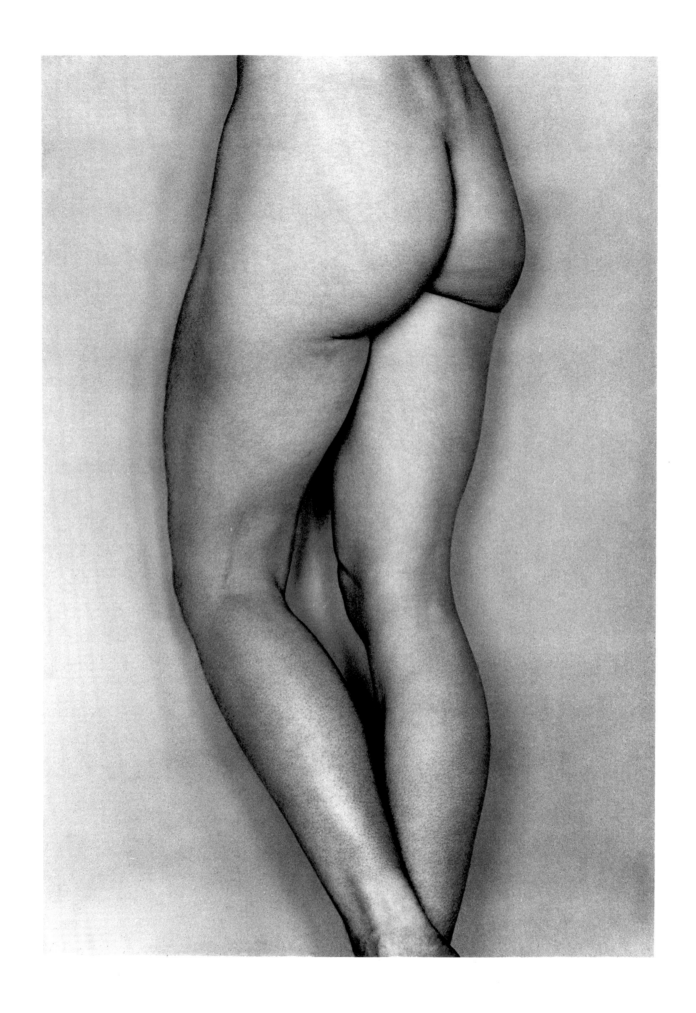

95 *Nude, 1927*

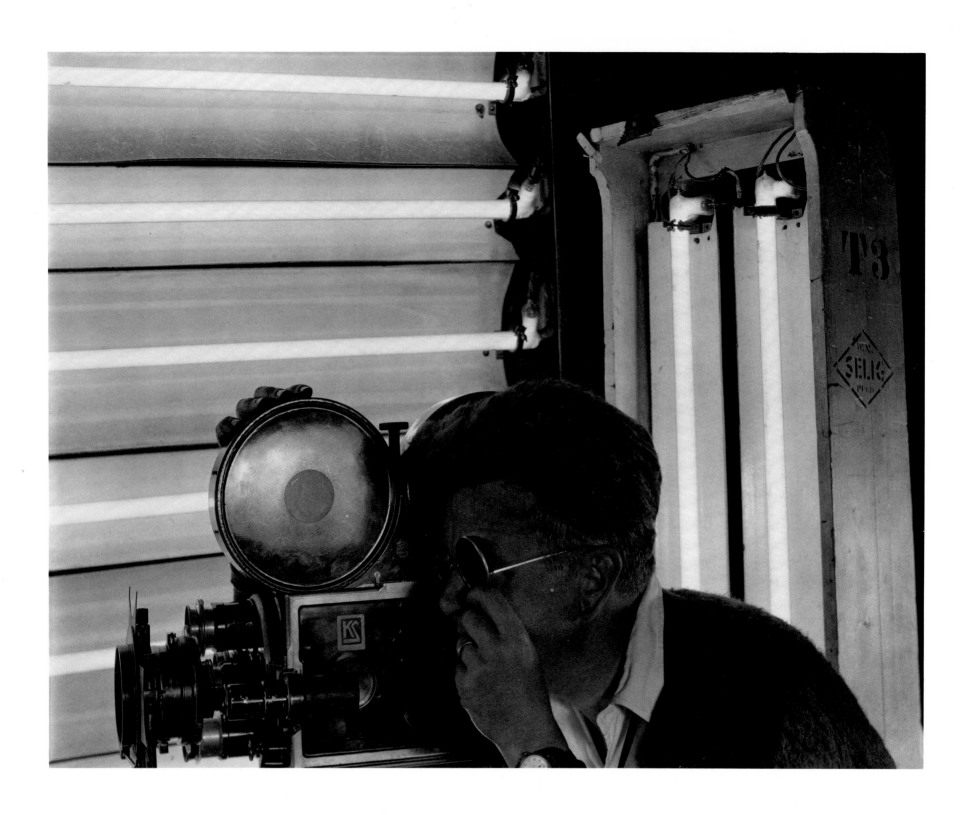

96 *Karl Struss, 1922*

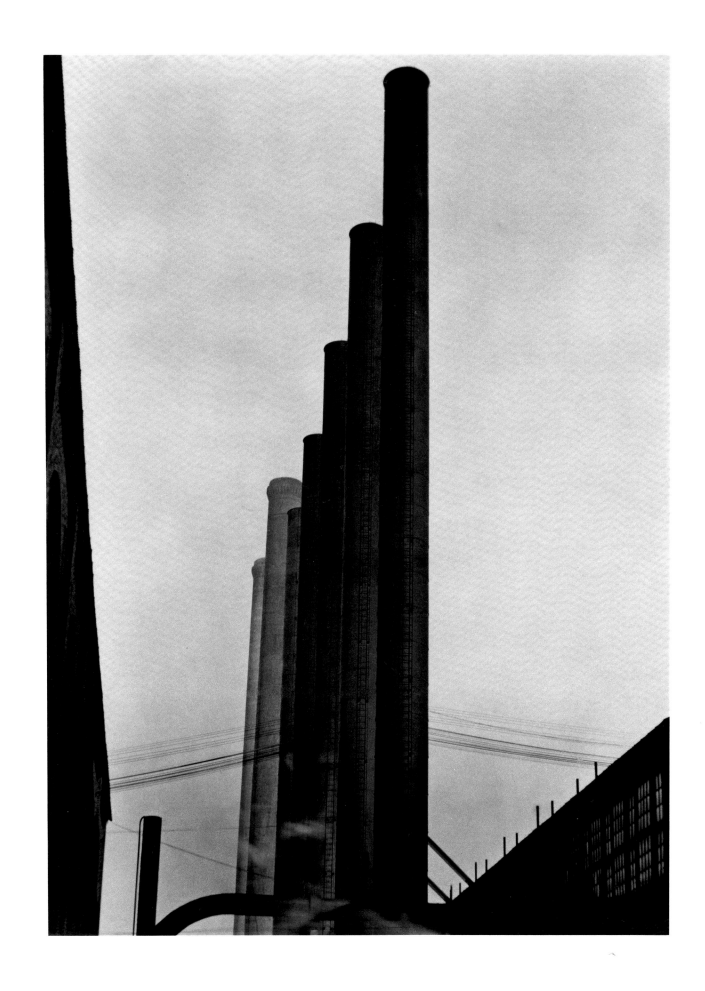

97 *Armco Steel, Ohio, 1922*

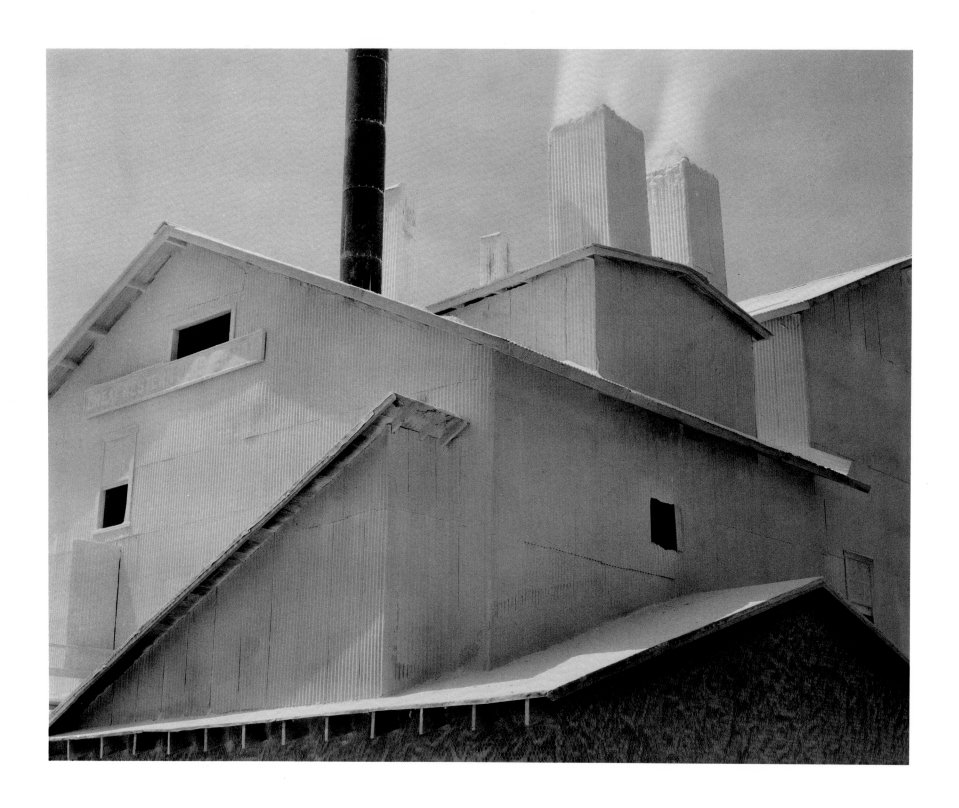

98 *Plasterworks, Los Angeles, 1925*

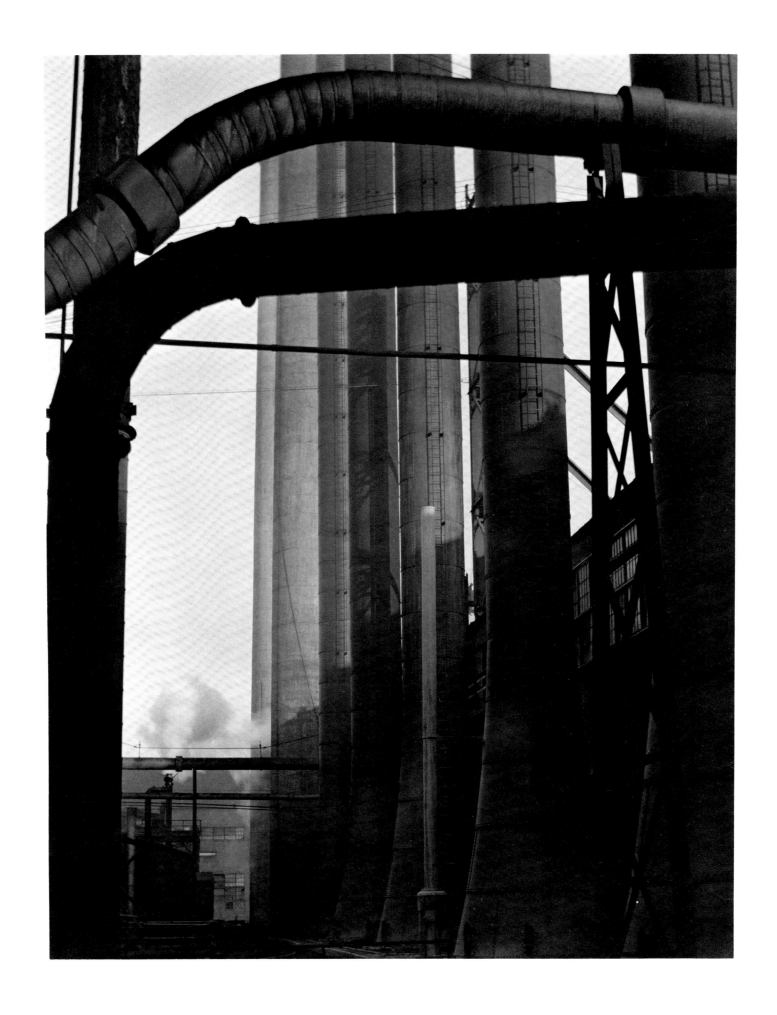

99 *Armco Steel, Ohio, 1922*

MEXICAN 1923 to 1927

During his stay in Mexico from 1923 to 1927, he fell in love with the countryside, the great columns of everchanging clouds, the market-places, the pyramids, and the people. All of these he photographed with renewed excitement and enthusiasm about his work. Although many great photographs came from this period, the portraits of Diego Rivera, Guadelupe Marin de Rivera, D. H. Lawrence, Tina Modotti, and Nahui Olin come to mind when I think of Weston in Mexico. One of his favorites, that he loved to reminisce about, is the portrait of Pancho Villa's lieutenant, Manuel Hernandez Galvan, shooting a peso at fifty paces.

Photography's great difficulty lies in the necessary coincidence of the sitter's revealment, the photographer's realization, the camera's readiness. But when these elements do coincide, portraits in any other medium, sculpture or painting, are cold dead things in comparison. In the very overcoming of the mechanical difficulties which would seem to restrict the camera. . .and in the turning of these apparent barriers to advantage lies its tremendous strength. For when the perfect spontaneous union is consummated, a human document, the very bones of life are bared. E. W.

101 *D. H. Lawrence, 1924*

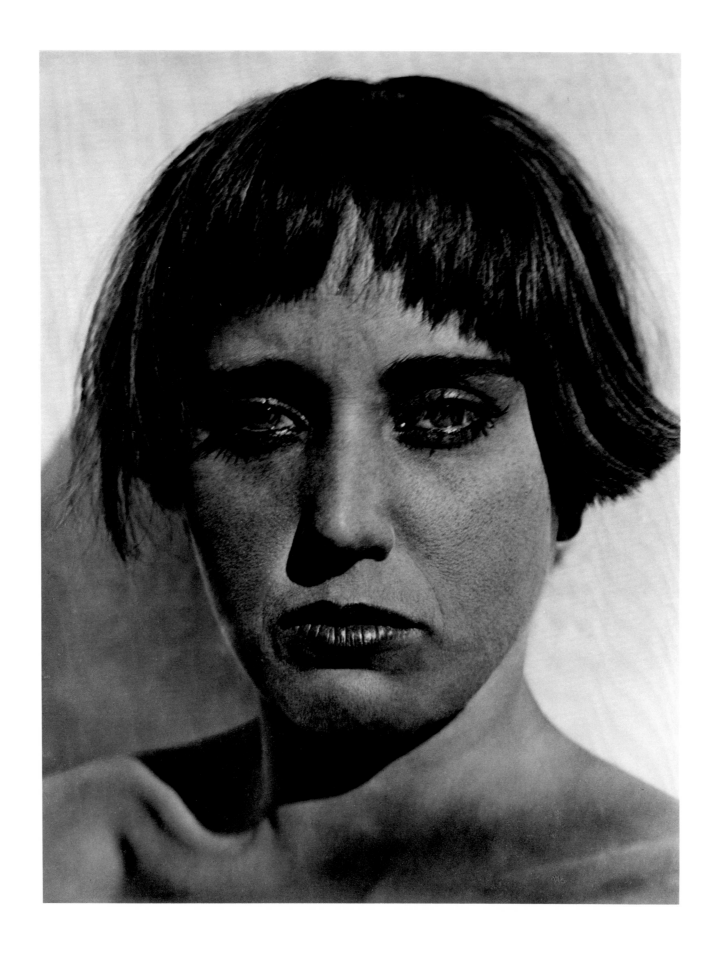

102 *Nahui Olin, 1924*

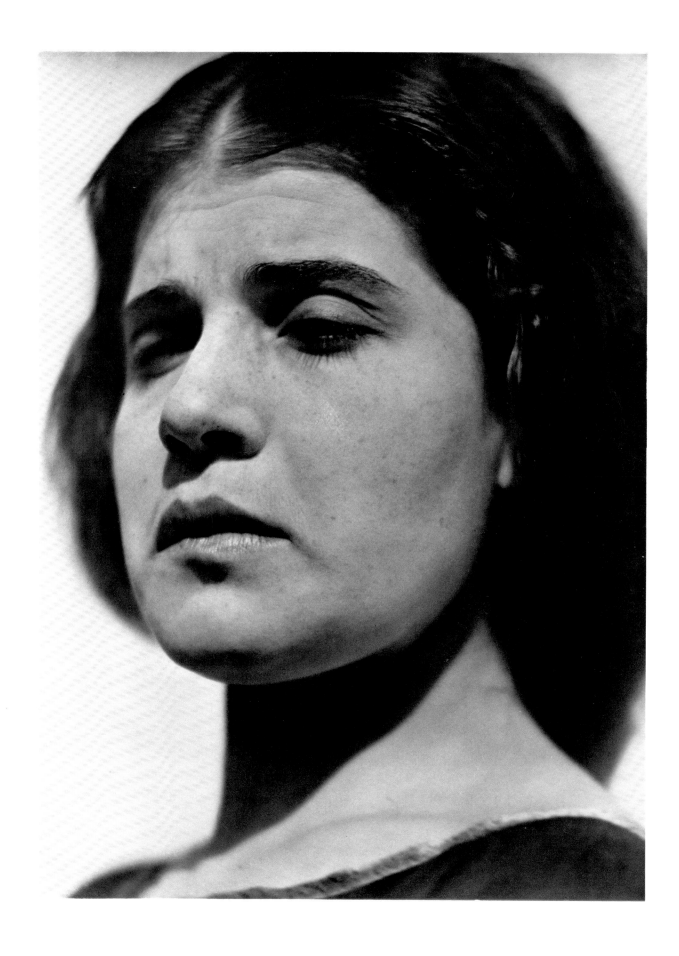

103 *Tina Modotti, 1923*

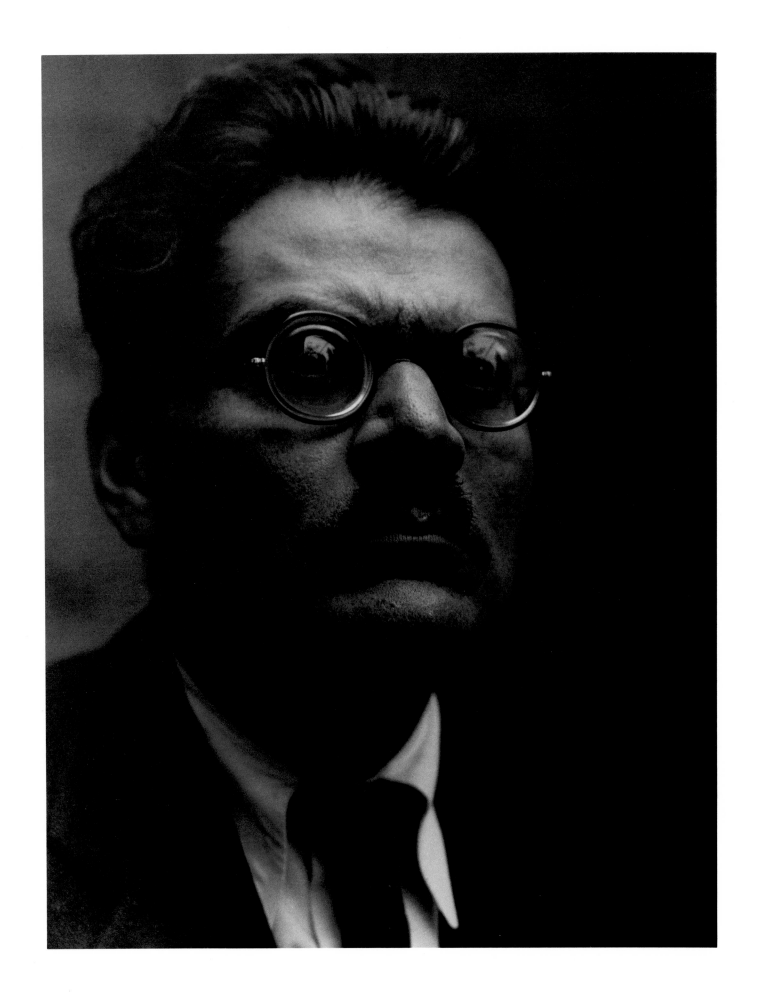

104 *Jose Clemente Orozco, Carmel,*

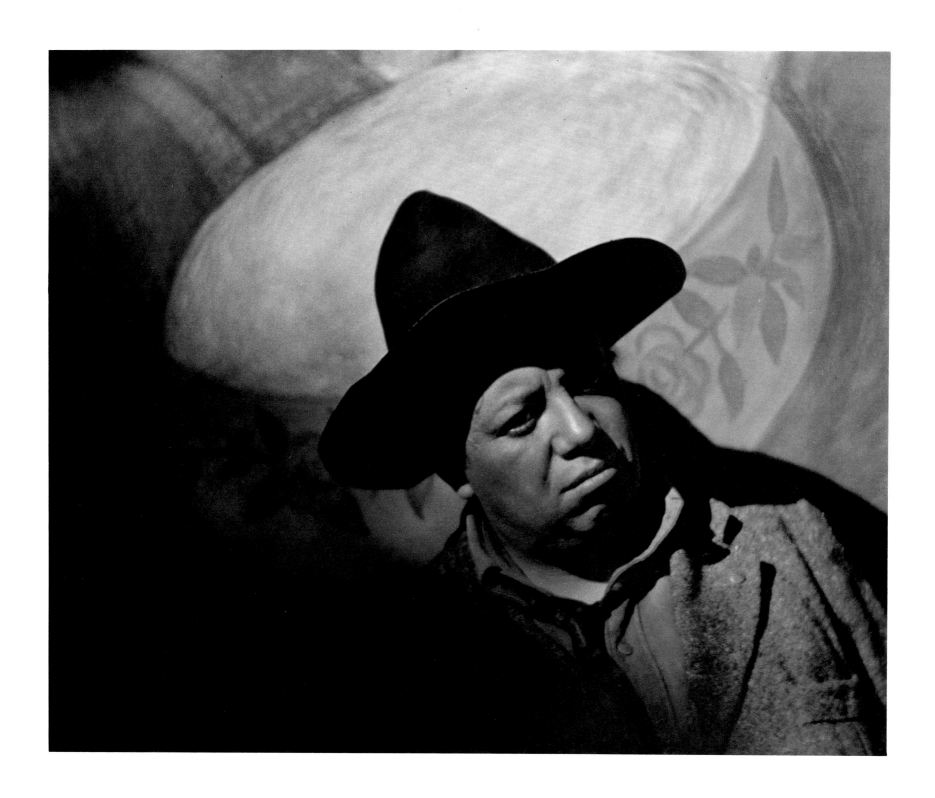

105 *Diego Rivera, 1923*

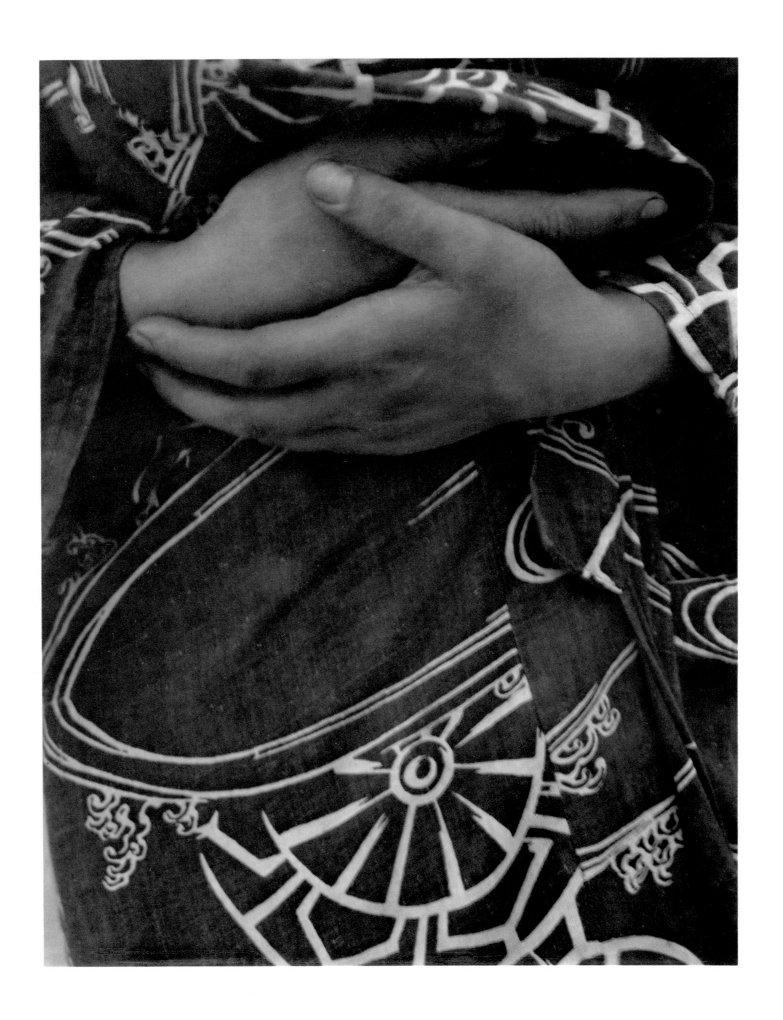

106 *Hands, Mexico, 1924*

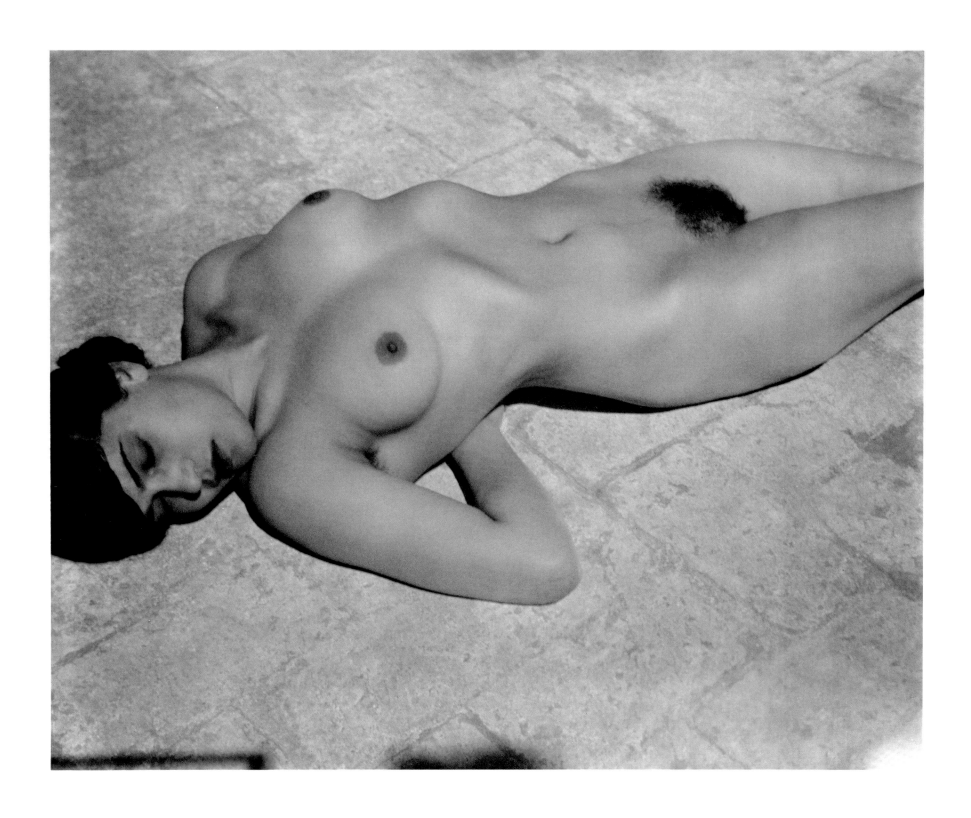

107 *Tina on the Azotea, 1924-5-6*

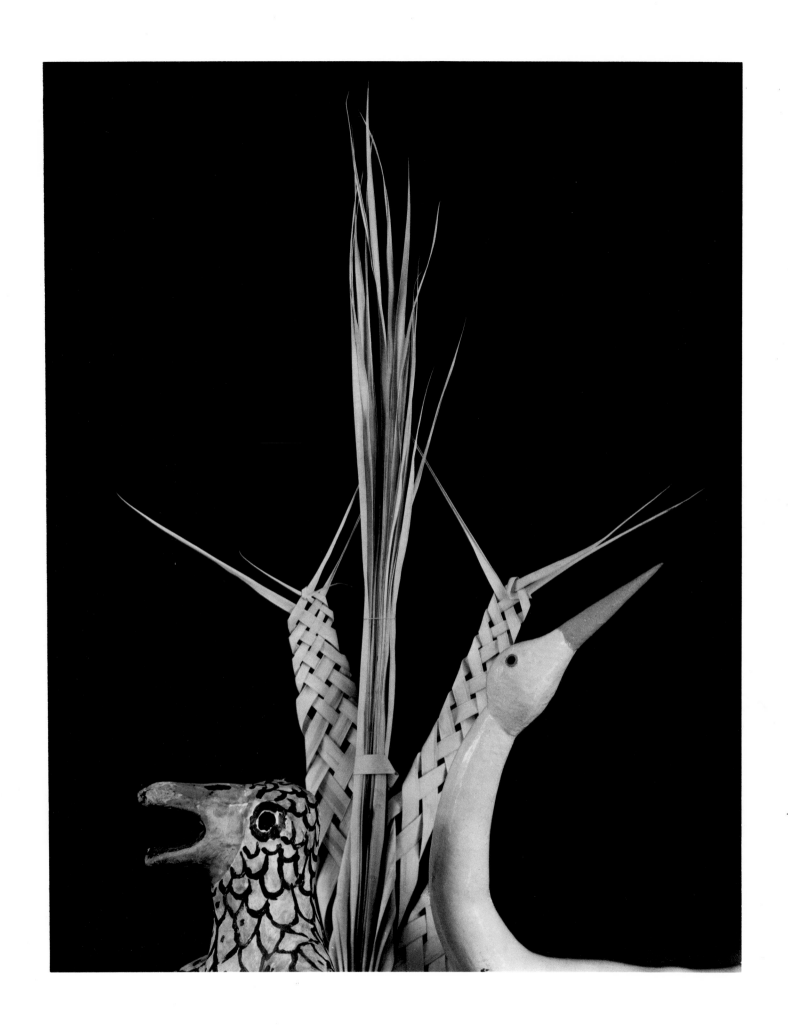

108 *Juguetes, 1926*

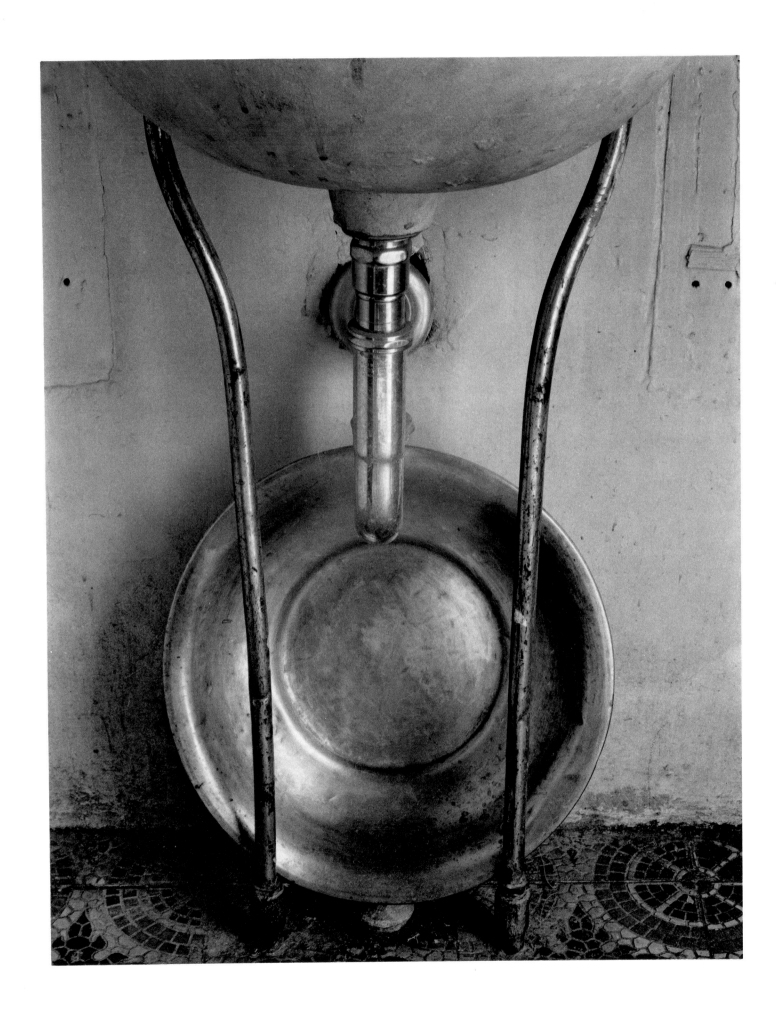

109 *Washbowl, 1926*

I wanted to catch Galvan's expression while shooting. We stopped by an old wall, the trigger to his Colt fell, and I released my shutter. Thirty paces away a peso dropped to the ground—"un recuerdo" said Galvan handing it to Tina (on the way back home from a picnic)—it grew cold—"I should enjoy a half-hour battle to warm me up," said General Galvan.

It is a heroic head, the best I have done in Mexico; with the Graflex, in direct sunlight, I caught her, mouth open, talking, and what could be more characteristic of Lupe! Singing or talking I must always remember her.

 Tall, proud of bearing, almost haughty; her walk was like a panther's, her complexion almost green with eyes to match—gray-green, dark-circled, eyes and skin such as I have never seen but on some Mexican señoritasHer dark hair was like a tousled mane, her strong voice almost coarse, dominating. E.W.

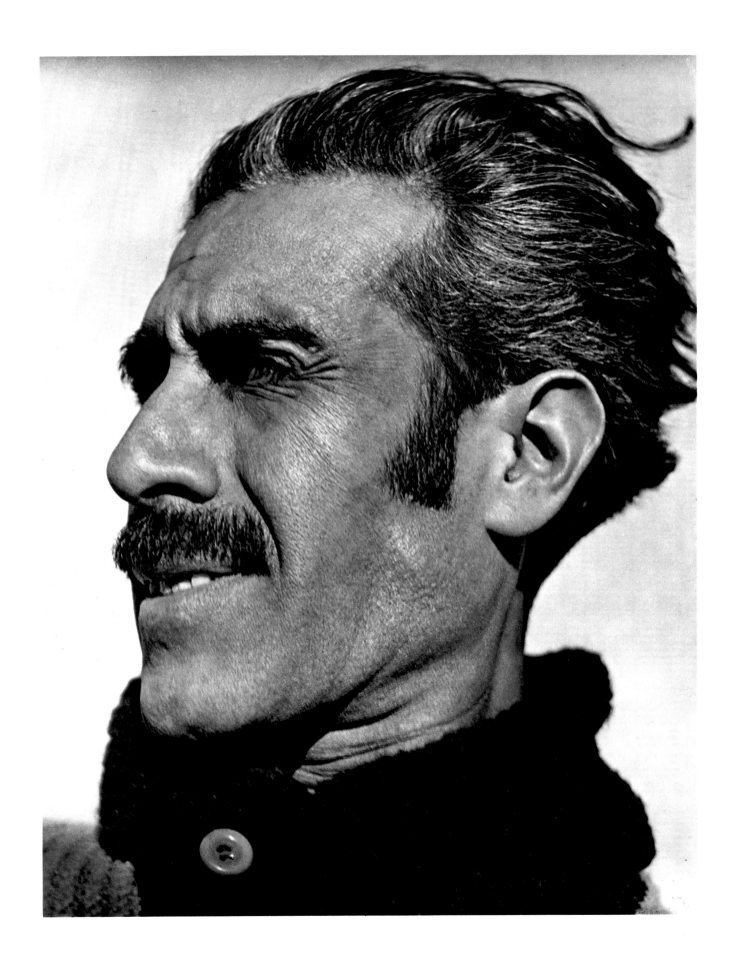

111 *Manuel Hernandez Galvan, 1924*

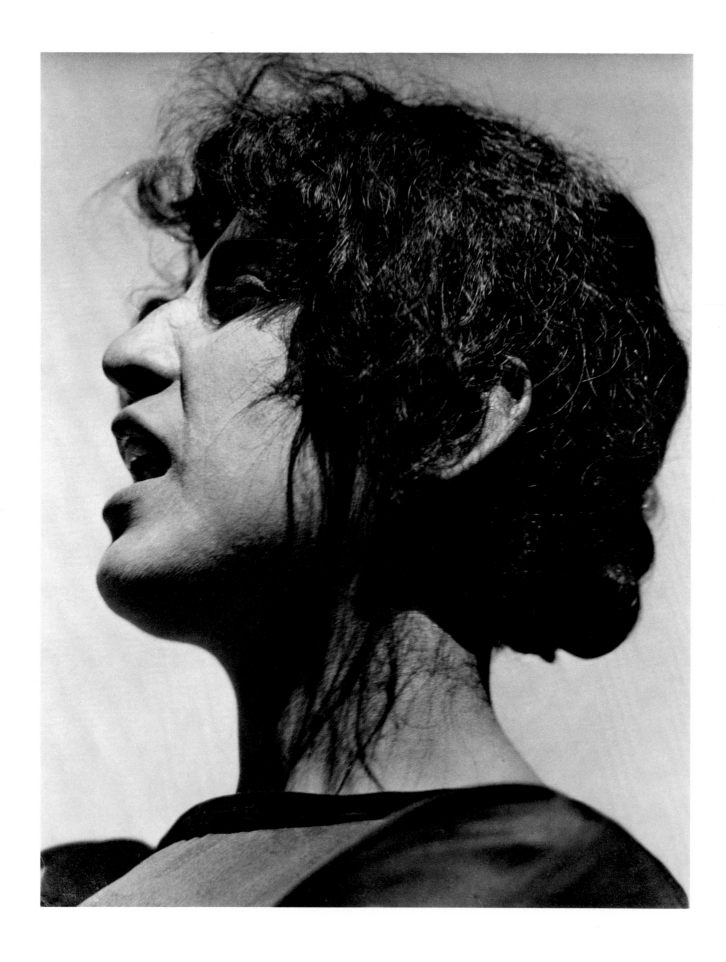

112 *Guadelupe Marin de Rivera*

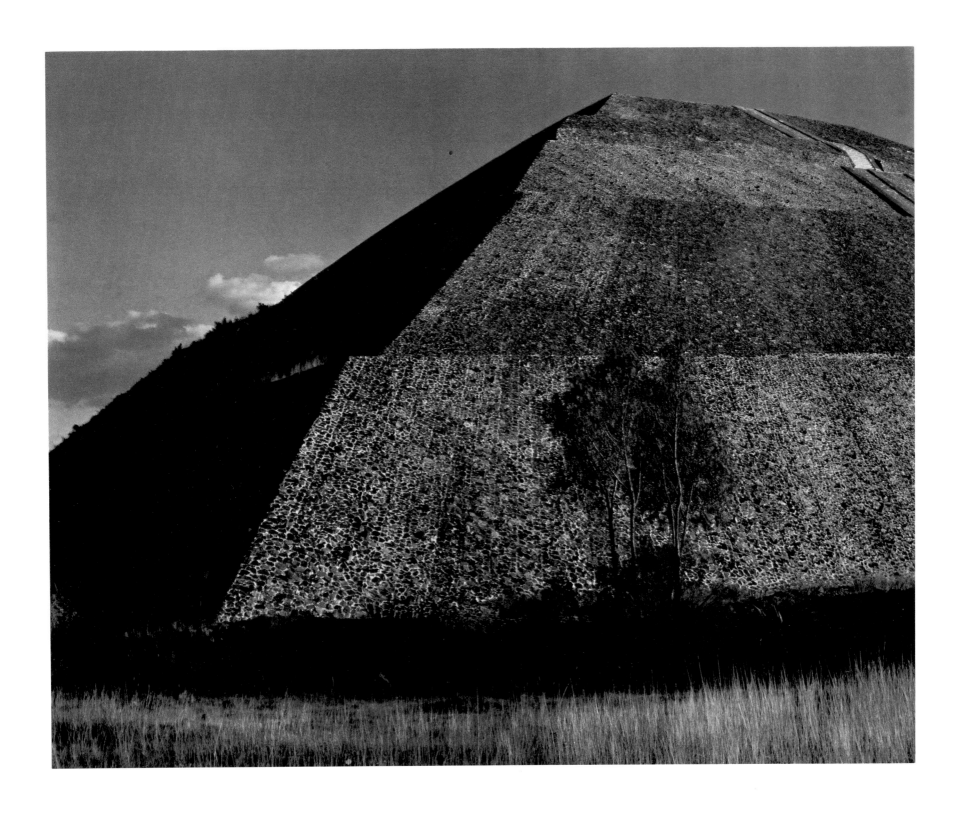

113 *Piramide del Sol, Mexico, 1923*

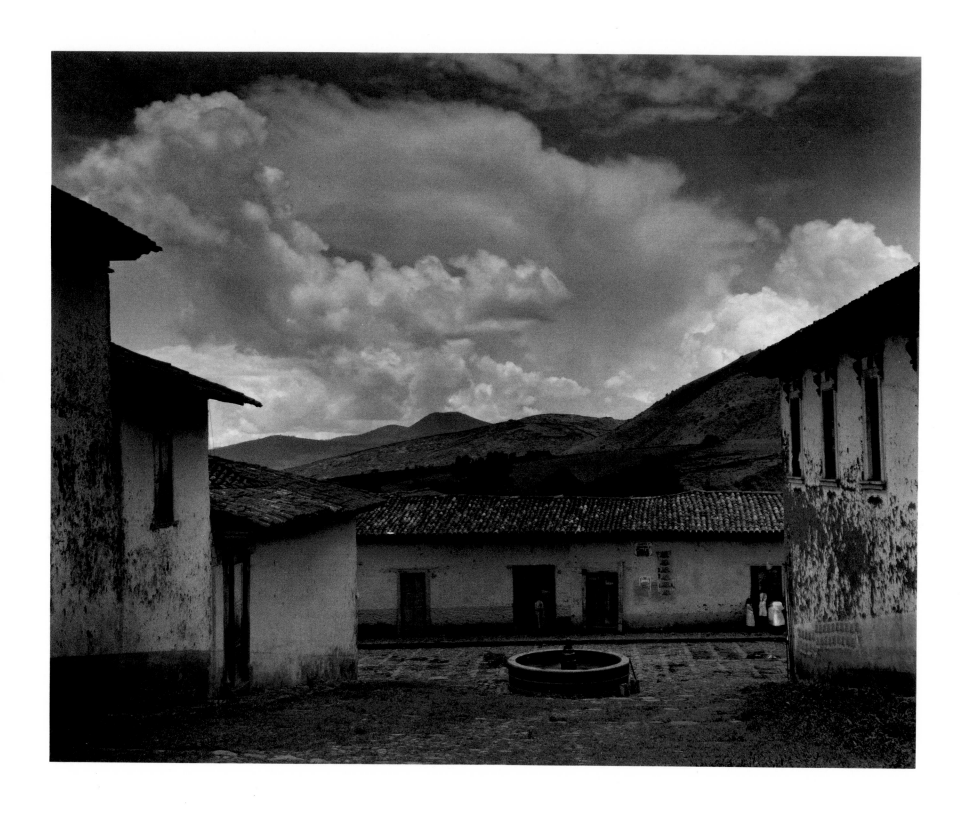

114 Patzcuaro, Mexico, 1926

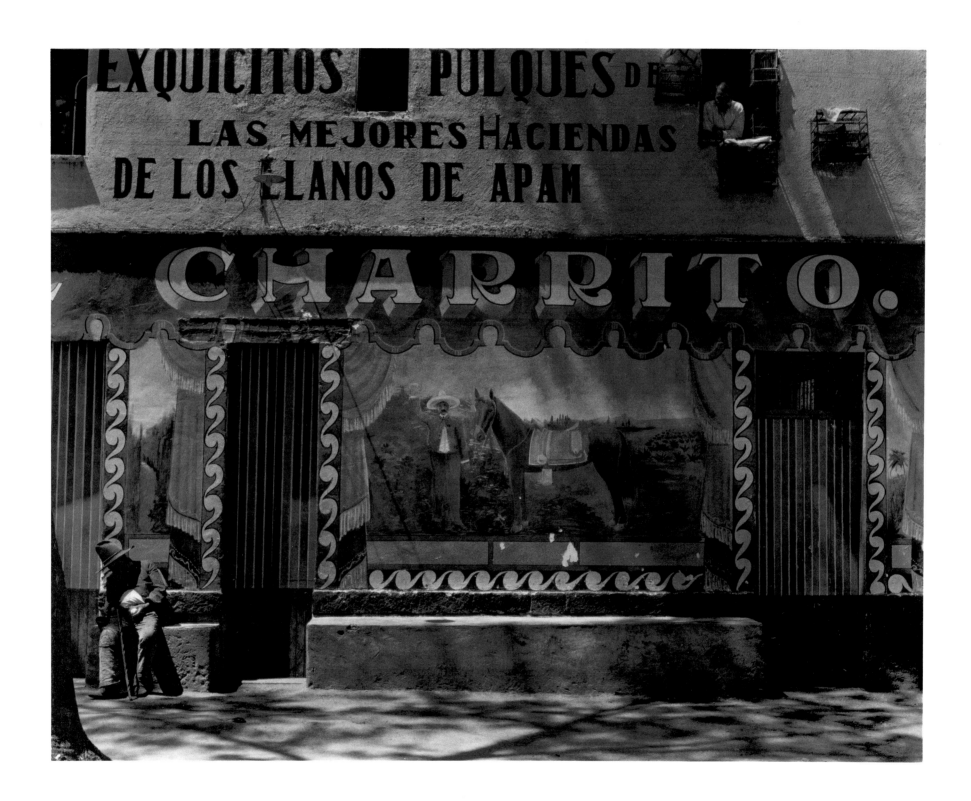

115 *Pulqueria, Mexico, 1926*

116 *Casa de Vecindad D. F., 1926*

117 *Pump, Tacubaya, Mexico, 1924*

118 *Tepotzlan, Mexico, 1924*

119 *Janitzio, Mexico, 1926*

PRE-GUGGENHEIM 1927 to 1937

The ten-year Pre-Guggenheim period, from 1927 to 1937, was one of the most prolific and changing periods of Weston's career.

On his return from Mexico to Glendale, California, in 1927, he started photographing the wonderful shell arrangements and close-ups of vegetables for the first time, and added a new dimension to his already large collection of nudes, which Weston called, "Nudes in Action." In 1928, he worked for the first time with the rocks and joshua trees of the Mojave Desert, little realizing that "Rocks" would be second only to "Nudes" in his preference of subject matter for the rest of his life.

Moving to San Francisco in August, 1928, he opened a portrait studio. For five months he tried vainly to make a living, but met with limited success. Tired of the "Big City," and longing for fresh air and a more simple life, he moved to Carmel in January, 1929, where he remained until 1934.

"The work of Edward Weston" is usually associated with his photographs from this period: the close-ups of the rocks and cypresses of Point Lobos; the storm-washed kelp on the Carmel beach; and the vegetables and the peppers, of which there are over forty. Then, of course, there came his famous 4 × 5 nude series, of 1933 and 1934. It is interesting to note that during the five years from 1928 to 1933, he photographed only one nude, while in contrast, during his last two years in Carmel, 1933 and 1934, he recorded 132 in his Record Book.

The last two years of the Pre-Guggenheim period, 1935 to 1937, were spent in Santa Monica, which he used as a home-base. From there he traveled to Oceano, the Mojave Desert, and Carmel. During this relatively short time, prior to the Guggenheim years, he produced another significant body of work, concentrating mainly on clouds, rocks, and dunes, and concluding with his now famous, "Nude and Dune" series.

Authentic photography needs no defense: it stands alone, fresh and vital—has made the whole world see light through different eyes—has revolutionized contemporary painting by destroying forever the bourgeois art of a decadent culture

Recording the objective physical facts of things does not preclude a communication in the finished work of the primal subjective motive. An abstract idea can be conveyed through exact reproduction: photography can be used as a means.

Self expression is an illusion in which the artist imagines that he can conceive of and create nonexistent forms. On the contrary, the most "abstract" art is derived from forms in nature.

I can now express either reality, or the abstract, with greater facility than heretofore. But should we use "abstract" in describing a photograph? Better "elemental form" or "simplified form.". . .The most abstract line or form is based of necessity on actuality—derived from nature, even as God is pictured a glorified man. E. W.

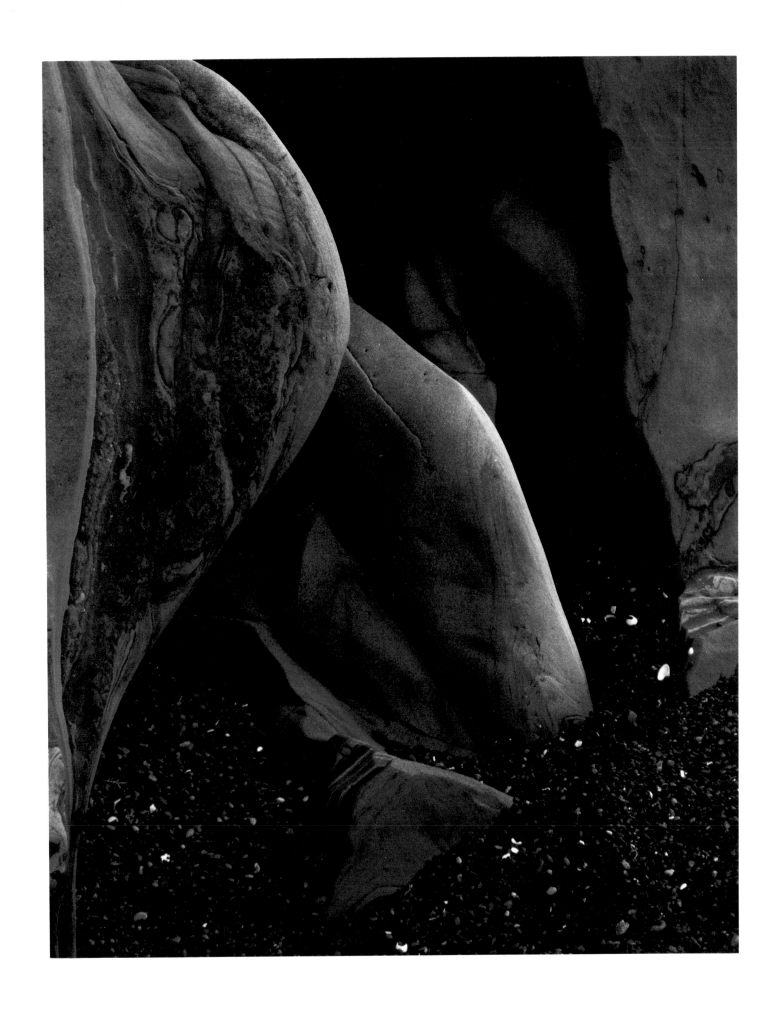

121 *Point Lobos, 1930*

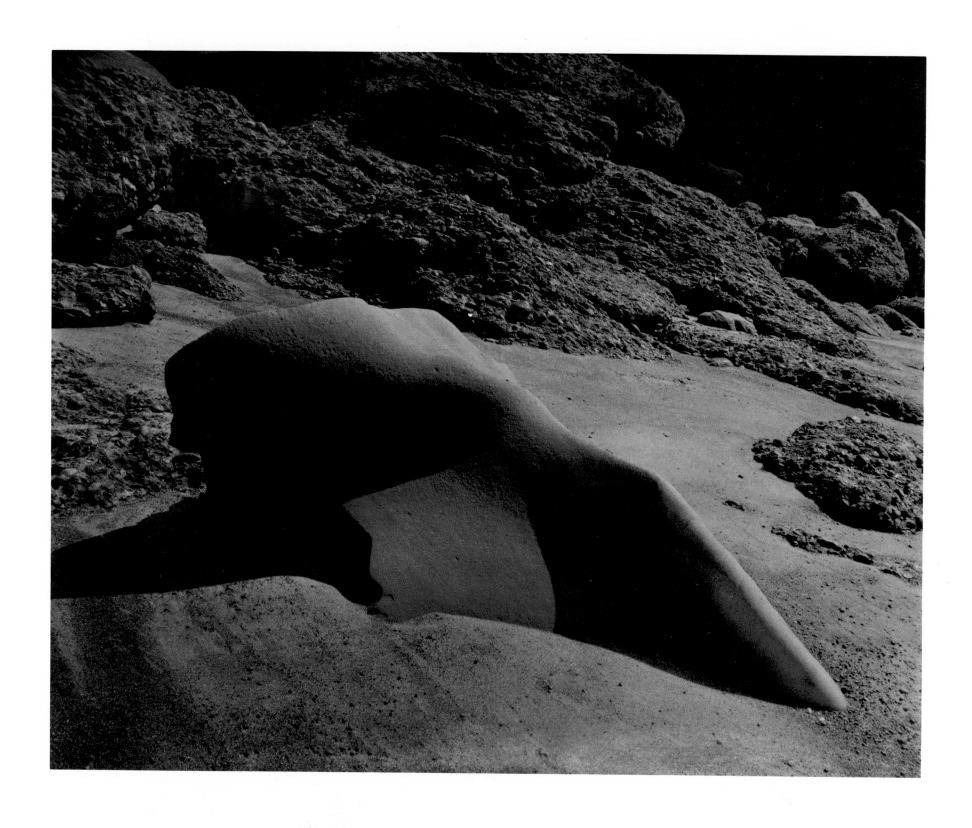

122 *Point Lobos, 1931*

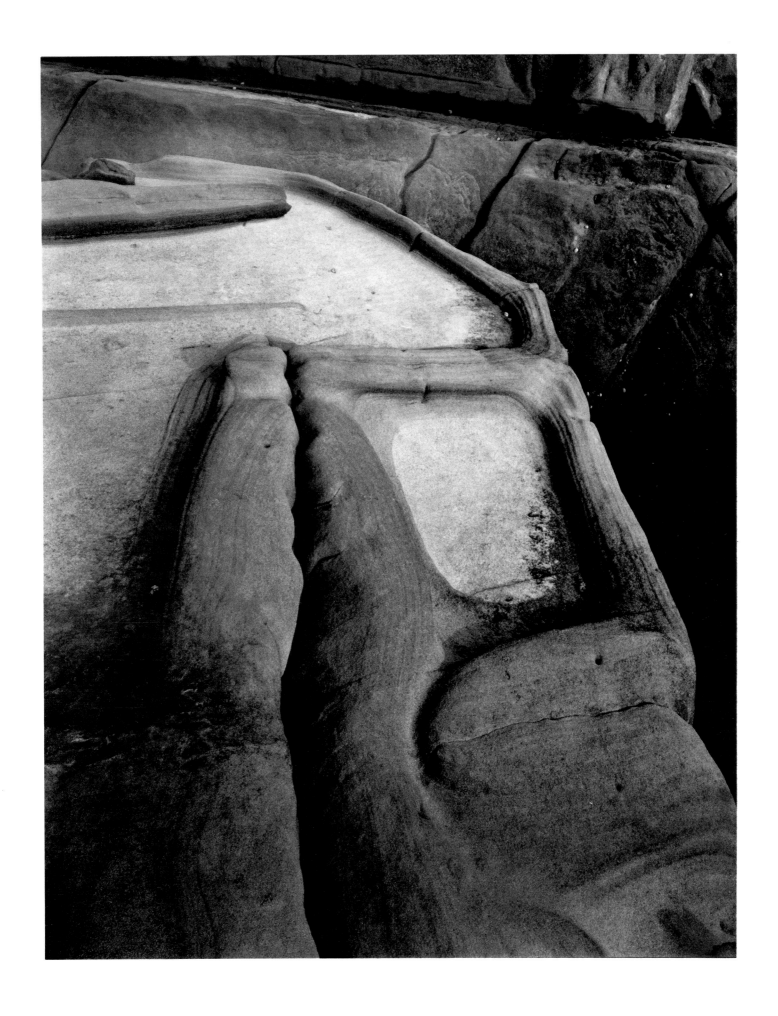

123 *Point Lobos, 1929*

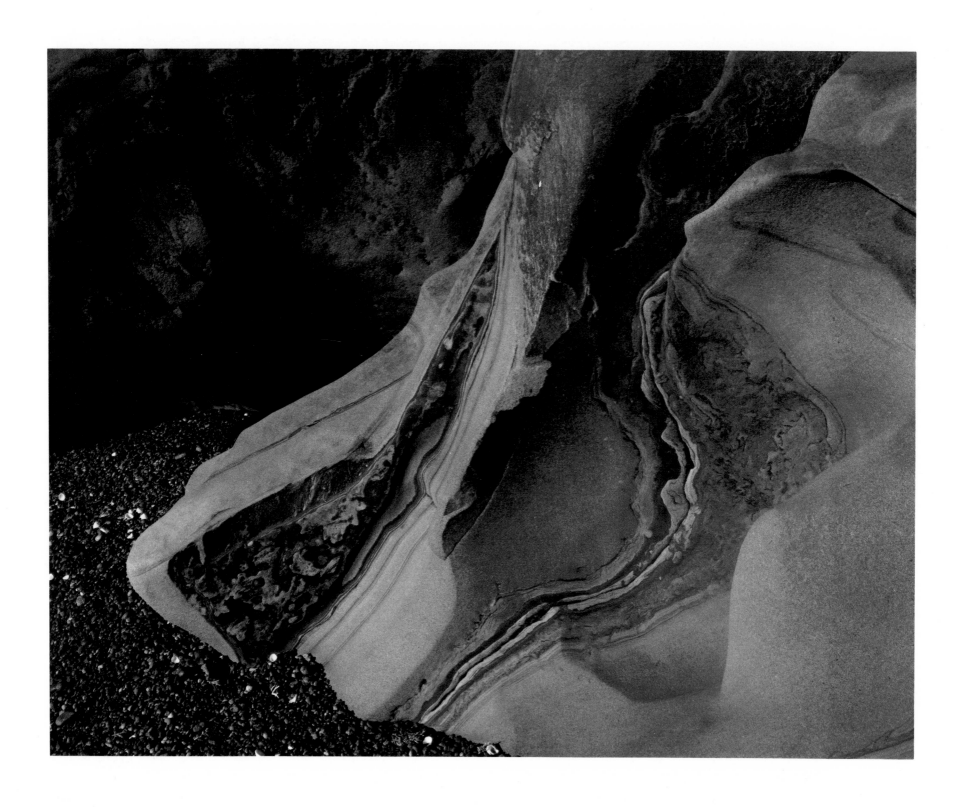

124 *Point Lobos, 1930*

125 *Point Lobos, 1930*

The camera too gives us not the object, but a sign for it written in terms of light and shade, indeed often at odds with the experience gathered through touch, smell, mental knowledge, or even an average human eye.

His destiny was to strip himself still further. In his present work, the last vestiges of self-obsession have disappeared. In the concrete, implacable way which is its own privilege, the camera records which- ever it is, rock, plant, or wood that Edward innocently squares right in the middle of the plate. Jean Charlot.

127 Willow, Santa Cruz, 1933

128 *Cypress, Point Lobos, 1930*

129 *Cypress, Point Lobos, 1930*

130 *Surf, Point Lobos, 1945*

131 Pelican, 1942

132 *Cypress, Point Lobos, 1930*

133 *Boat with Abalone Shells, 1938*

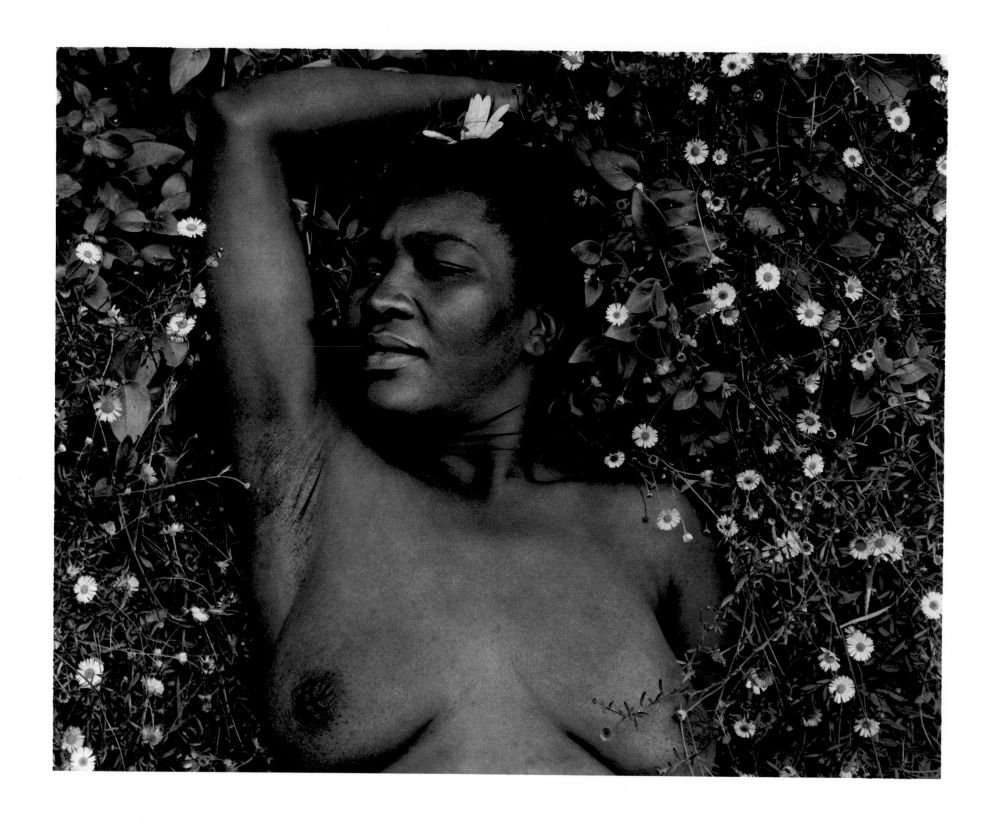

134 *Nude, 1939*

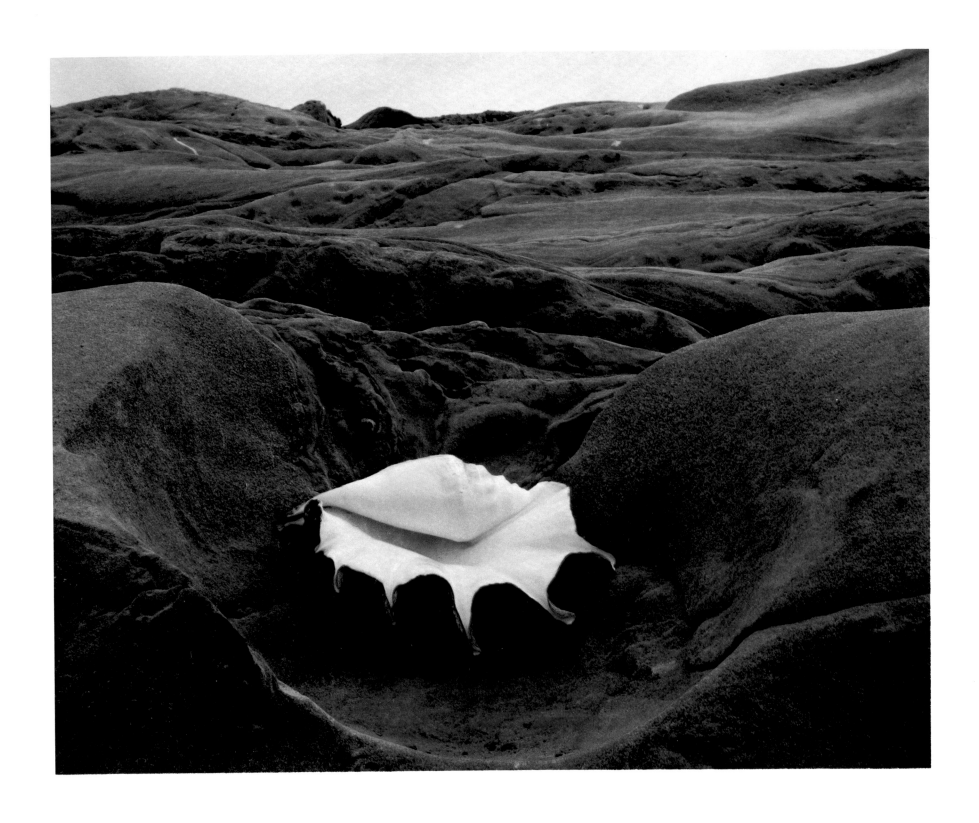

135 *Shell, 1931*

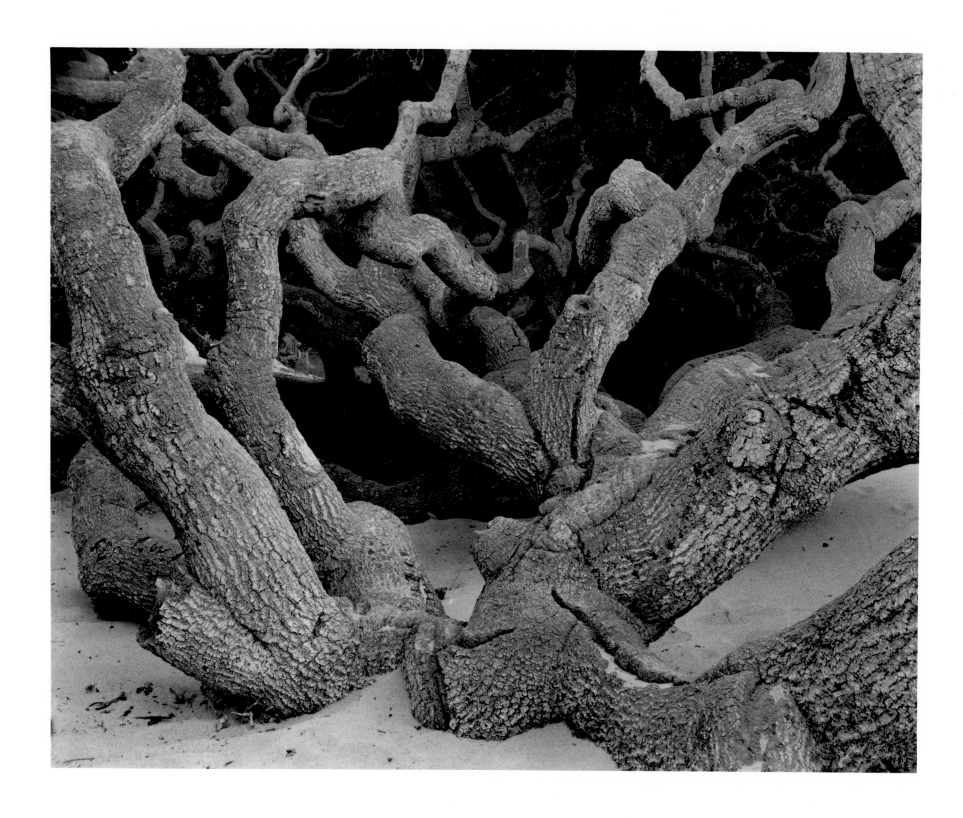

136 *Oak, Monterey, 1939*

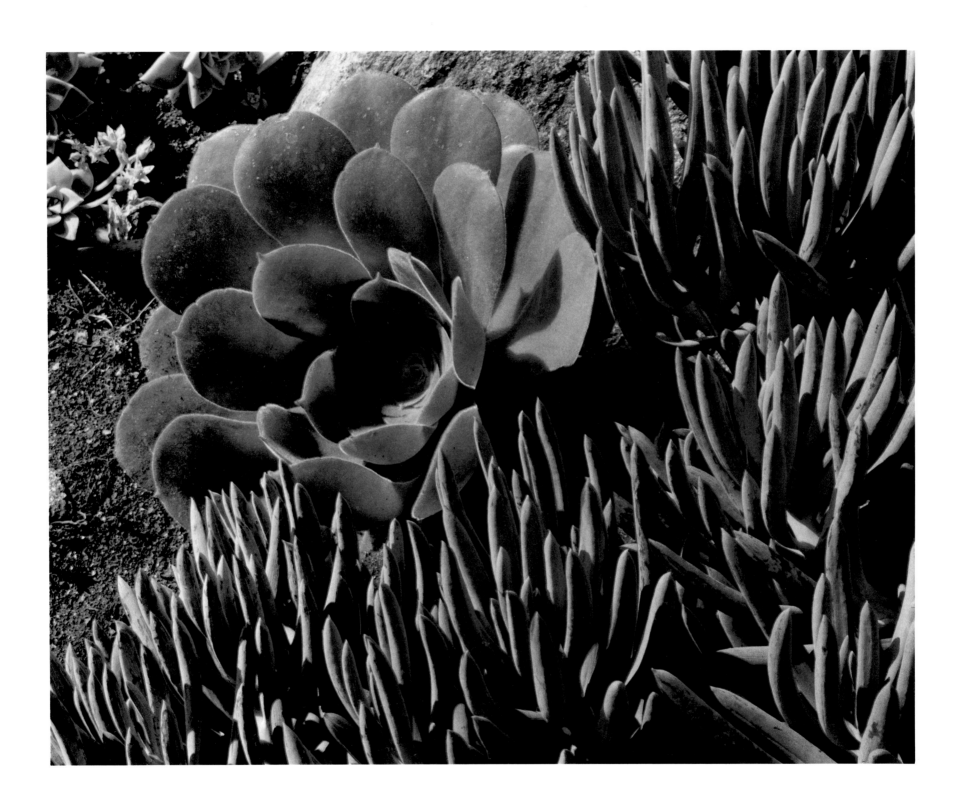

137 *Succulent, 1930*

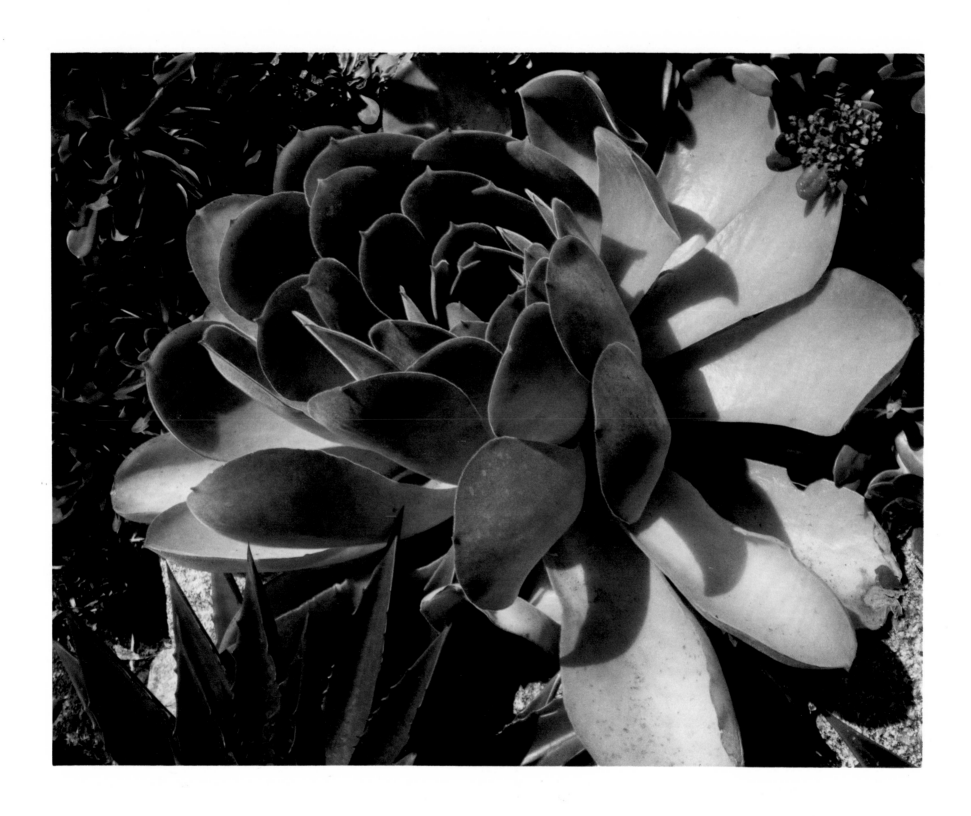

138 *Succulent, 1930*

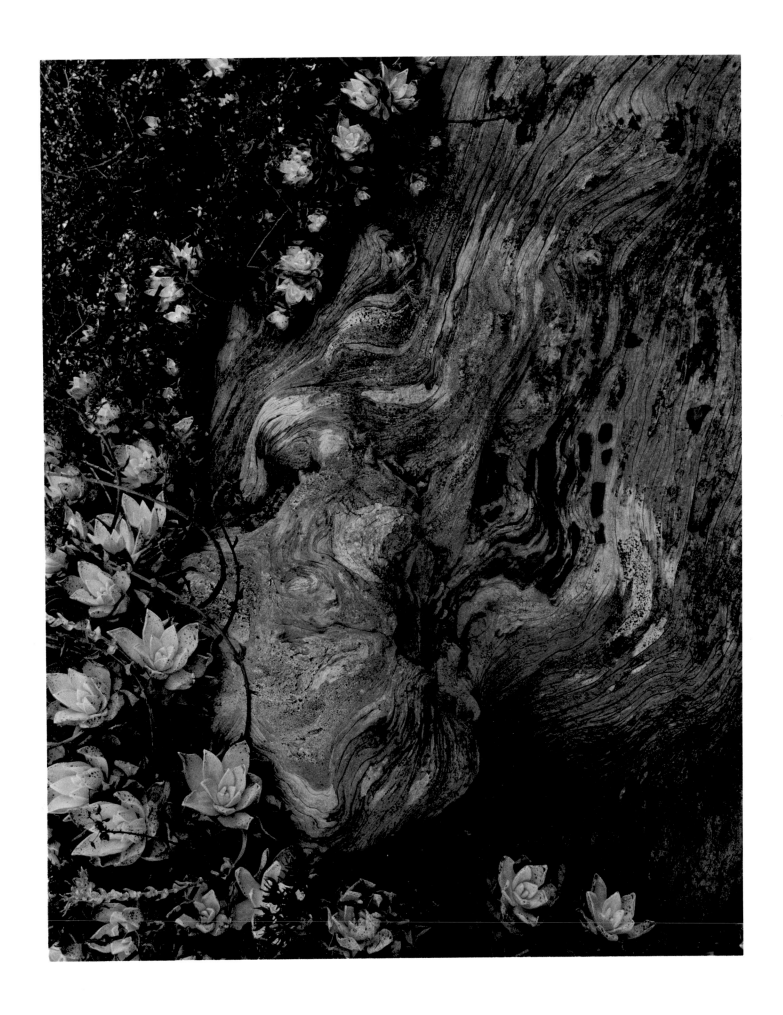

139 *Cypress Root and Succulent, Point Lobos, 1930*

I have come to realize life as a coherent whole, and myself as a part, with rocks, trees, bones, cabbages, smokestacks, all interrelated, interdependent,—each a symbol of the whole. And further, details of these parts have their own integrity, and through them the whole is indicated, so that a pebble becomes a mountain, a twig is seen as a tree. E.W.

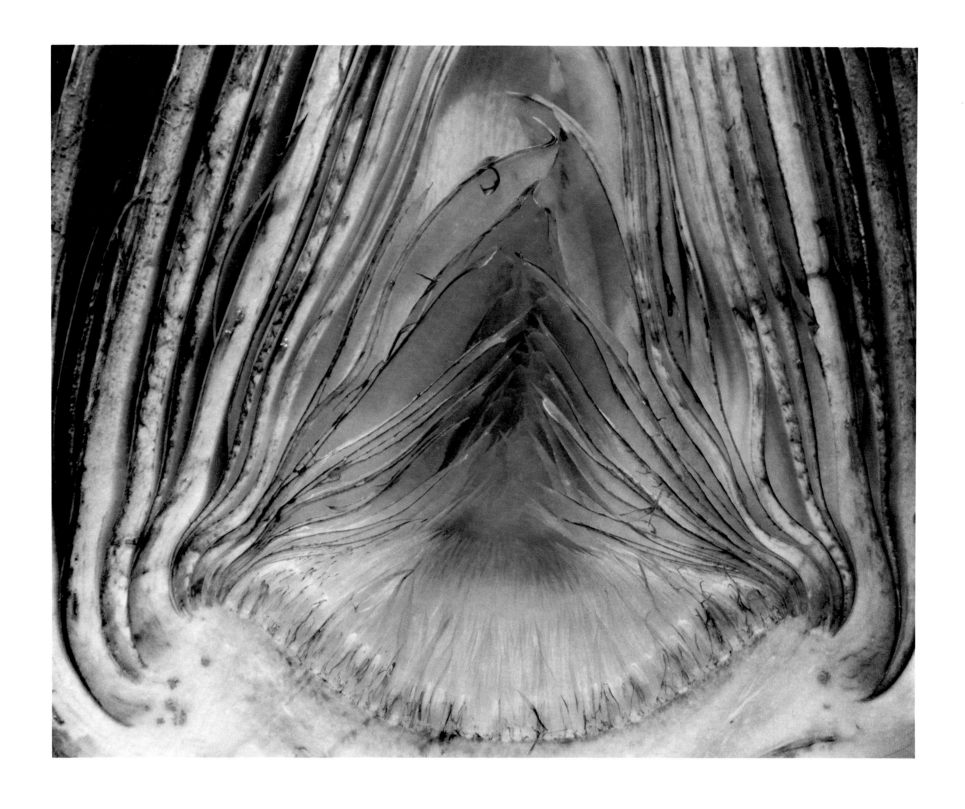

147 *Artichoke Halved, 1930*

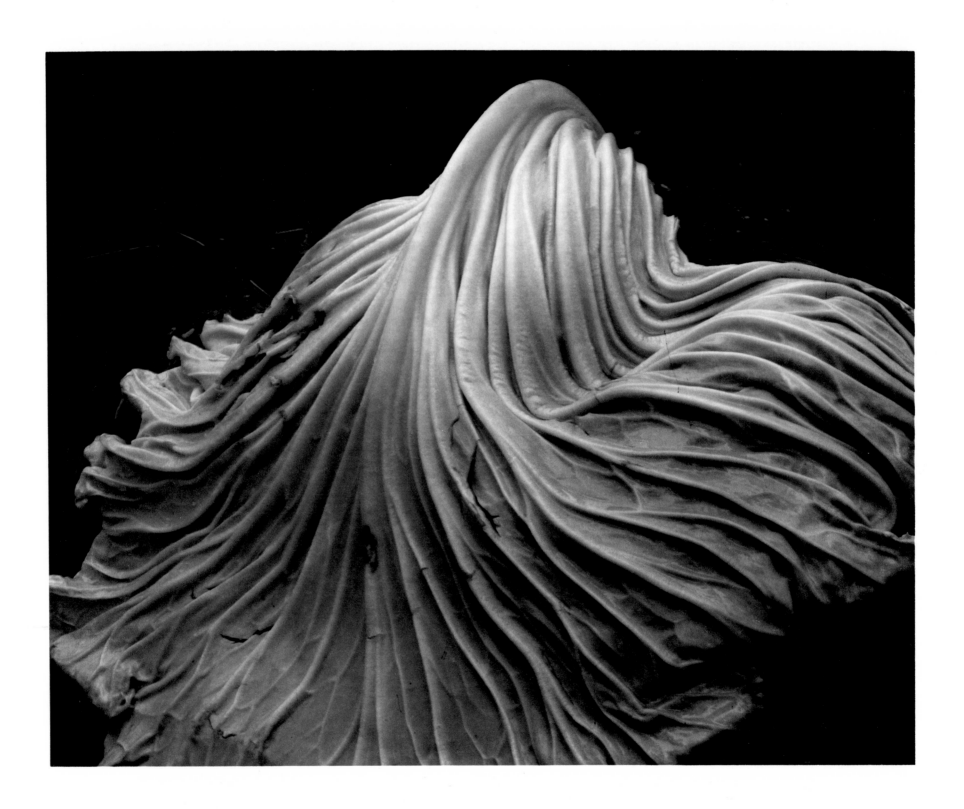

148 *Cabbage Leaf, 1931*

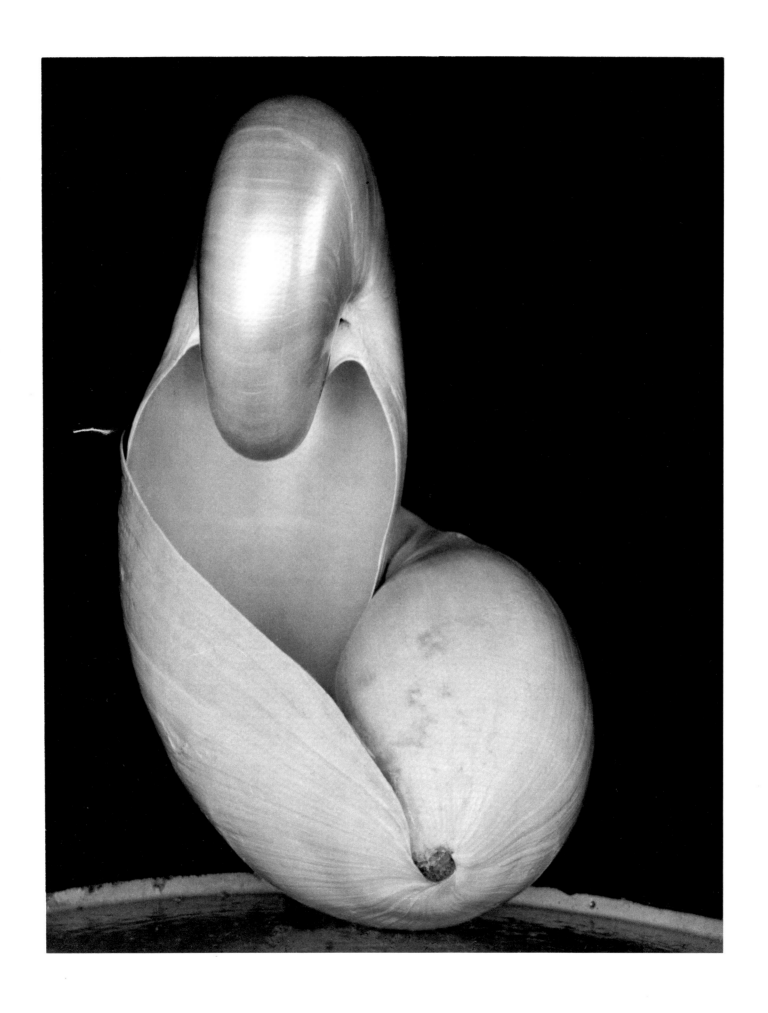

149 *Two Shells, 1927*

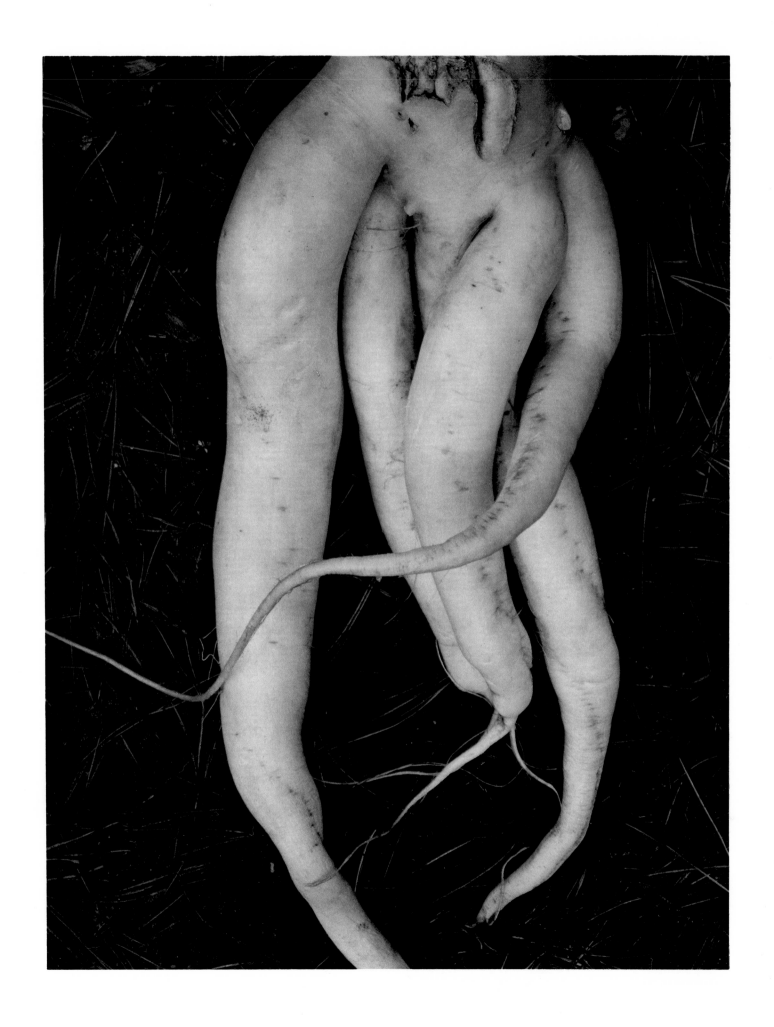

150 *White Radish, 1933*

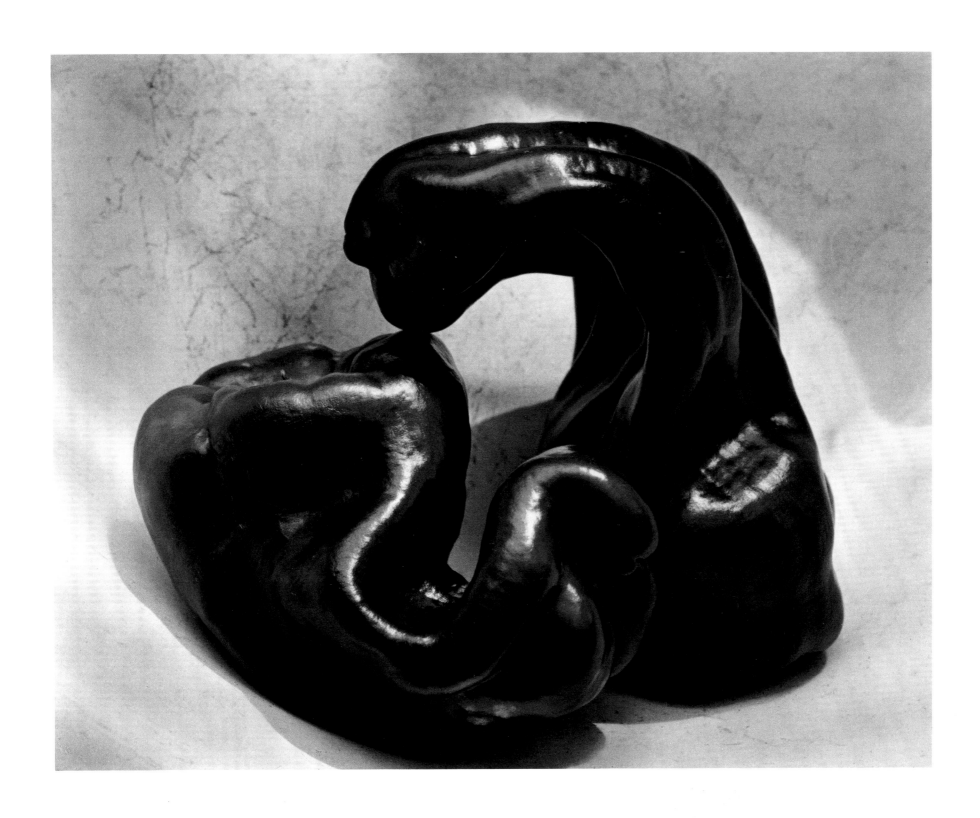

151 *Peppers, 1929*

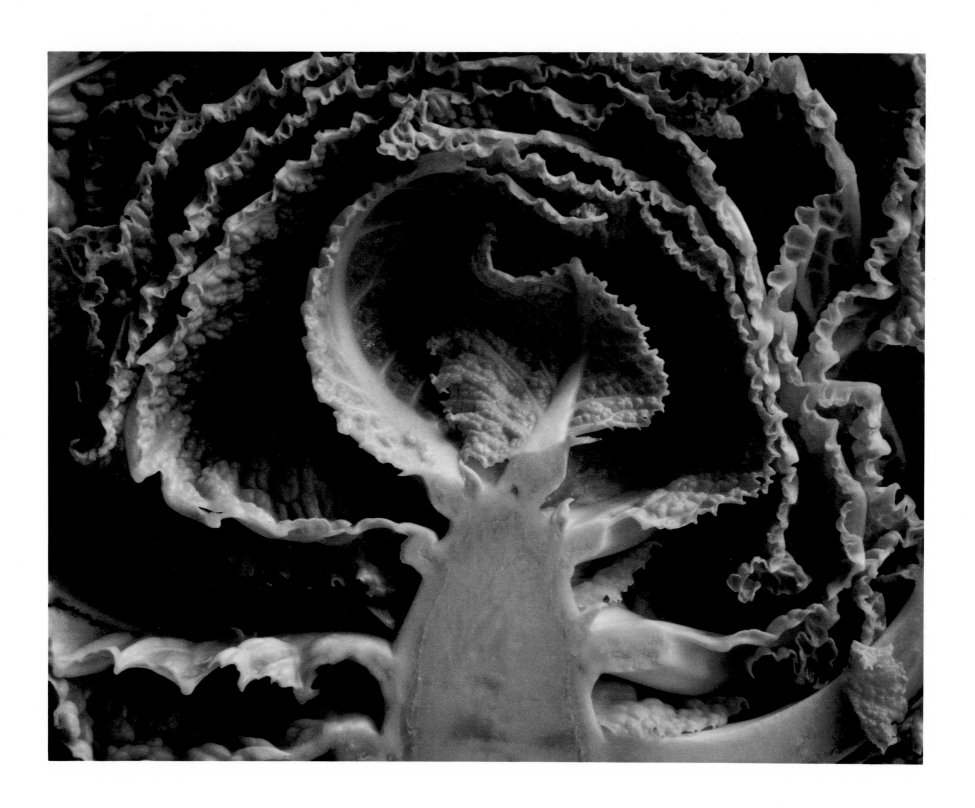

152 *Kale Halved, 1930*

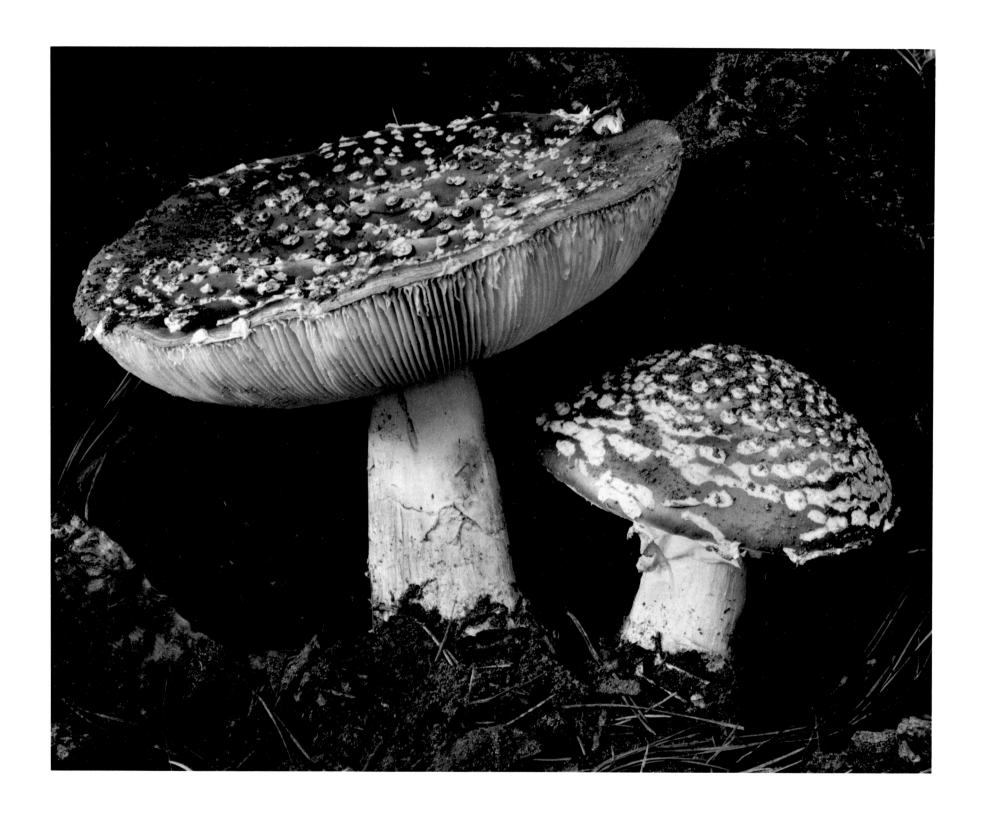

153 *Toadstool, 1934*

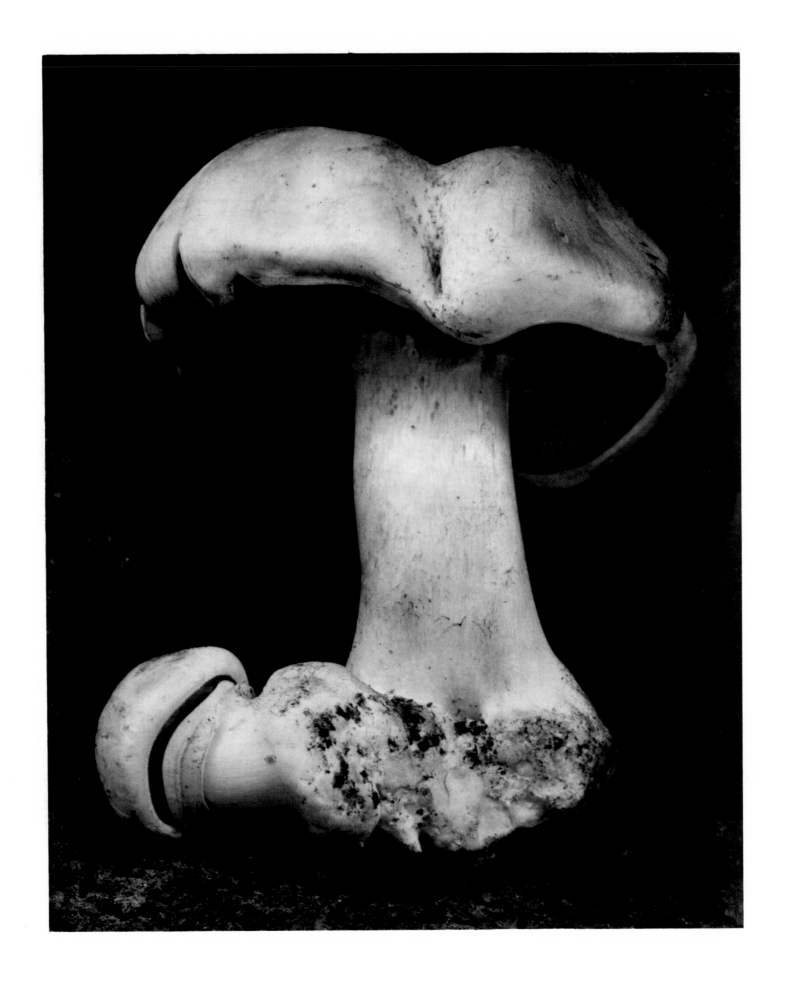

154 *Toadstool, 1931*

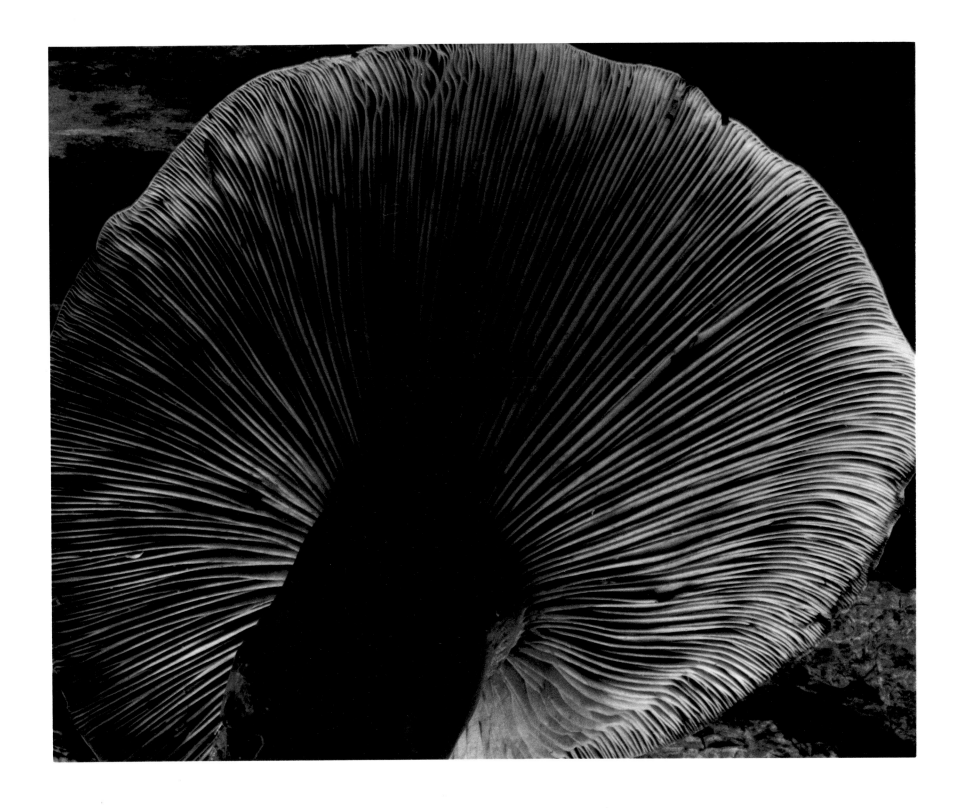

155 *Toadstool, 1931*

One must prevision and feel, before exposure, *the finished print—complete in all values, in every detail—when focusing upon the camera ground glass. Then the shutter's release fixes for all time this image, this conception, never to be changed by afterthought, by subsequent manipulation.* E.W.

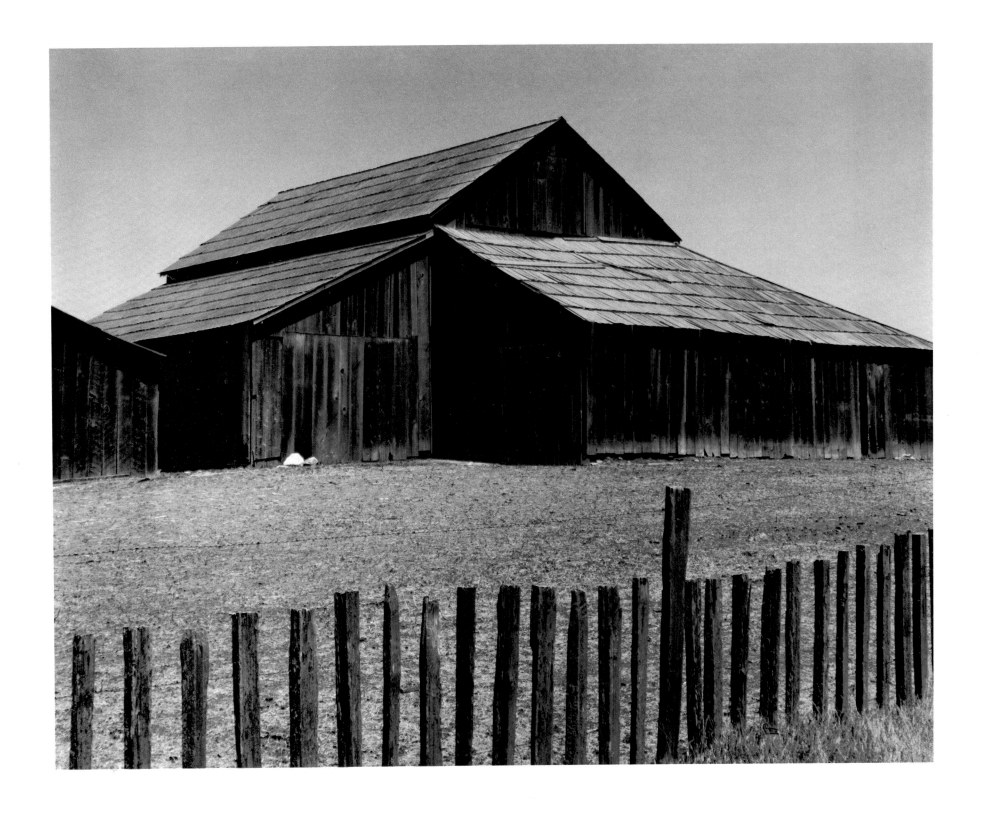

157 Barn, Castroville, 1934

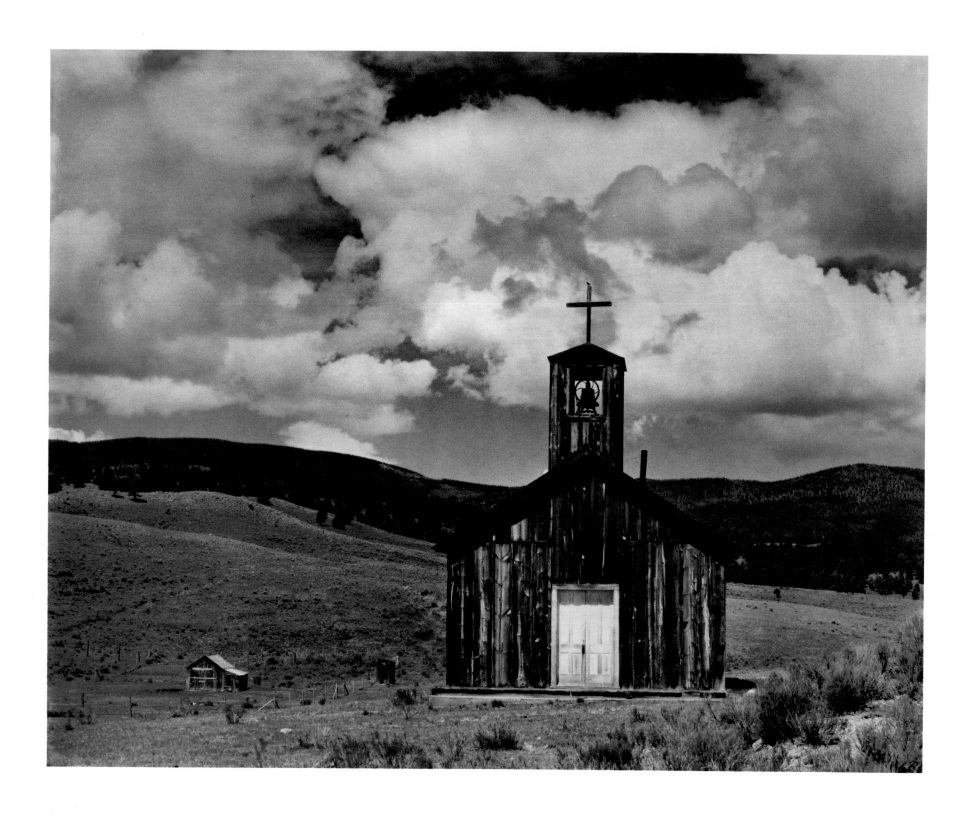

158 *"E" Town. New Mexico, 1933*

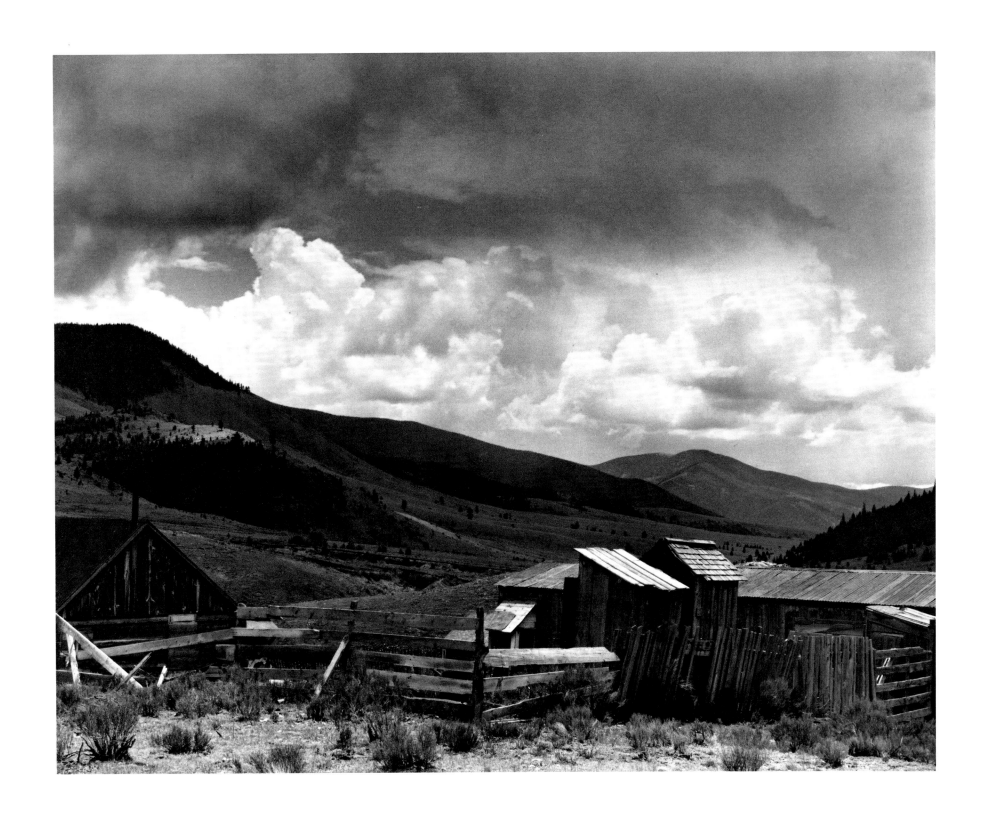

159 *"E" Town, New Mexico, 1930*

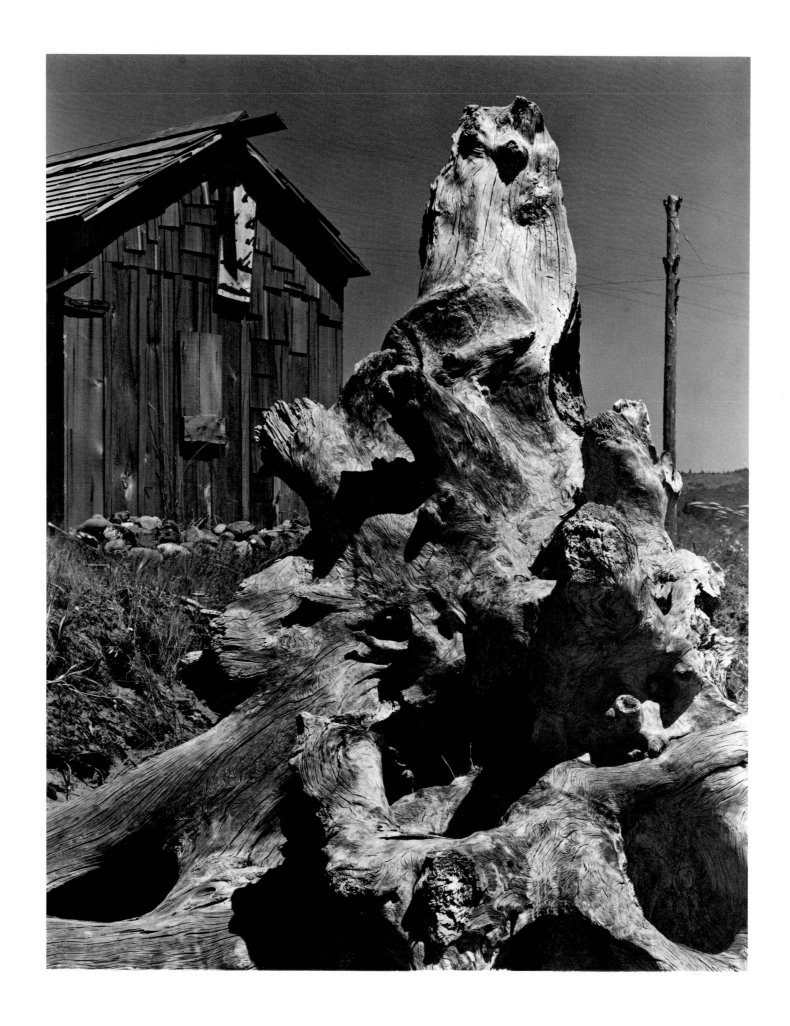

160 *Crescent Beach, 1937*

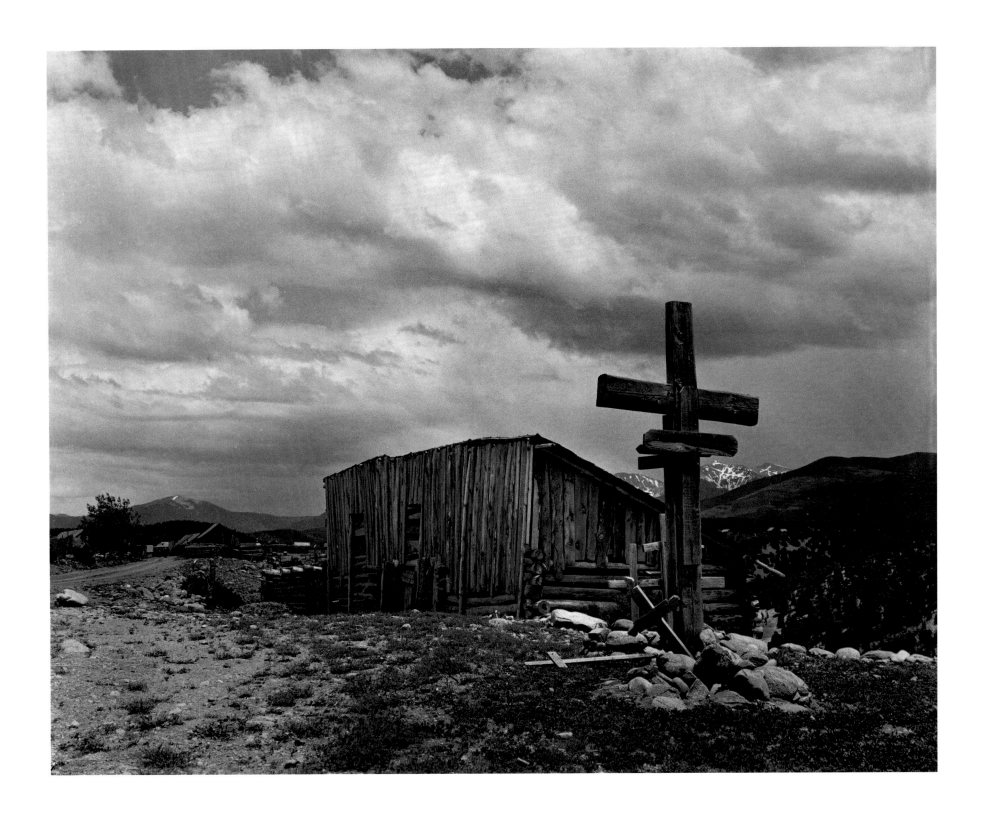

161 *Las Truches, New Mexico, 1941*

162 *Ranch with Haycocks, Sonoma County, 1937*

163 *Corral at Pismo Beach, Oceano, 1935*

164 *Taos Pueblo, New Mexico, 1933*

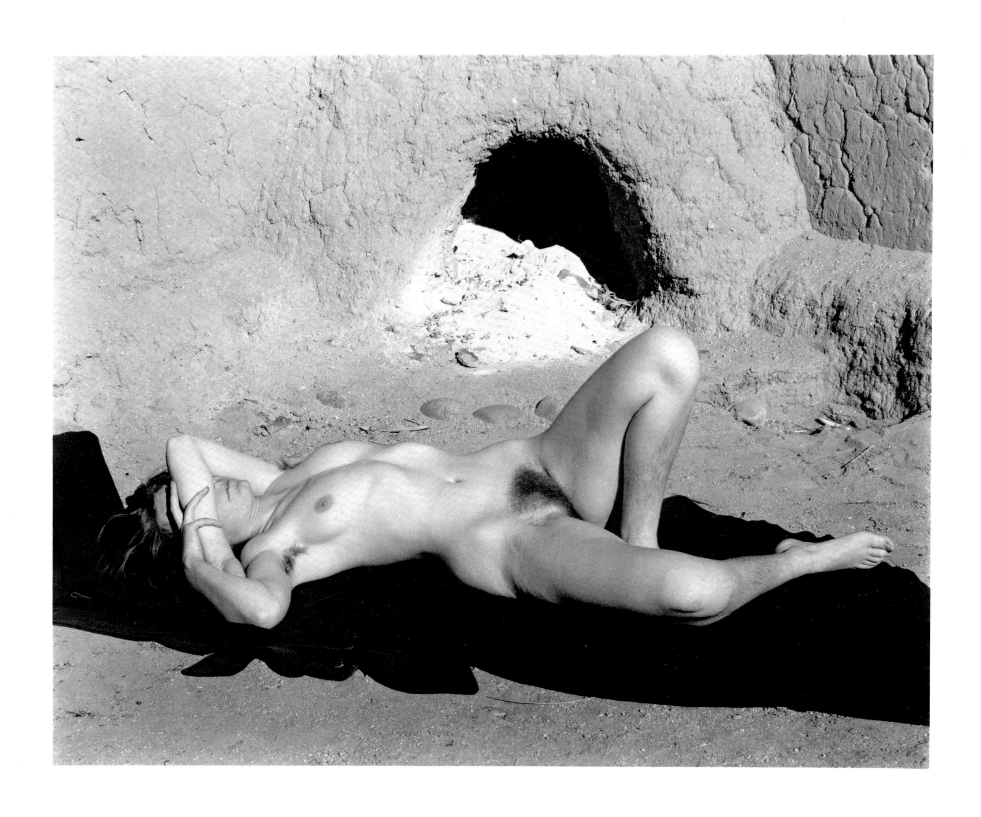

165 *Nude, New Mexico, 1937*

When I first knew Edward, I used to experience a shock of non-recognition *whenever I saw "the original" of a Weston photograph. At Oceano I looked for those mountains of pure white sand laced with sharp patterns of intense black shadow, and found only drab tan sandhills. The dramatic stone monuments at Point Lobos often turned out to be such insignificant bits of rock that even Edward had difficulty finding them again. People I had thought arrestingly handsome or fascinating in a Weston portrait seemed quite ordinary-looking when I met them. It seemed to me that I was being hoodwinked by a master illusionist. Then, as I continued to follow the process from the sighting of the photographic quarry to its being served up in a print, my beholding eye became conditioned, and I began to see things Edward's way: the dunes became dramatic for me, the small rocks heroic, and the people as handsome as their portraits.* Charis Wilson.

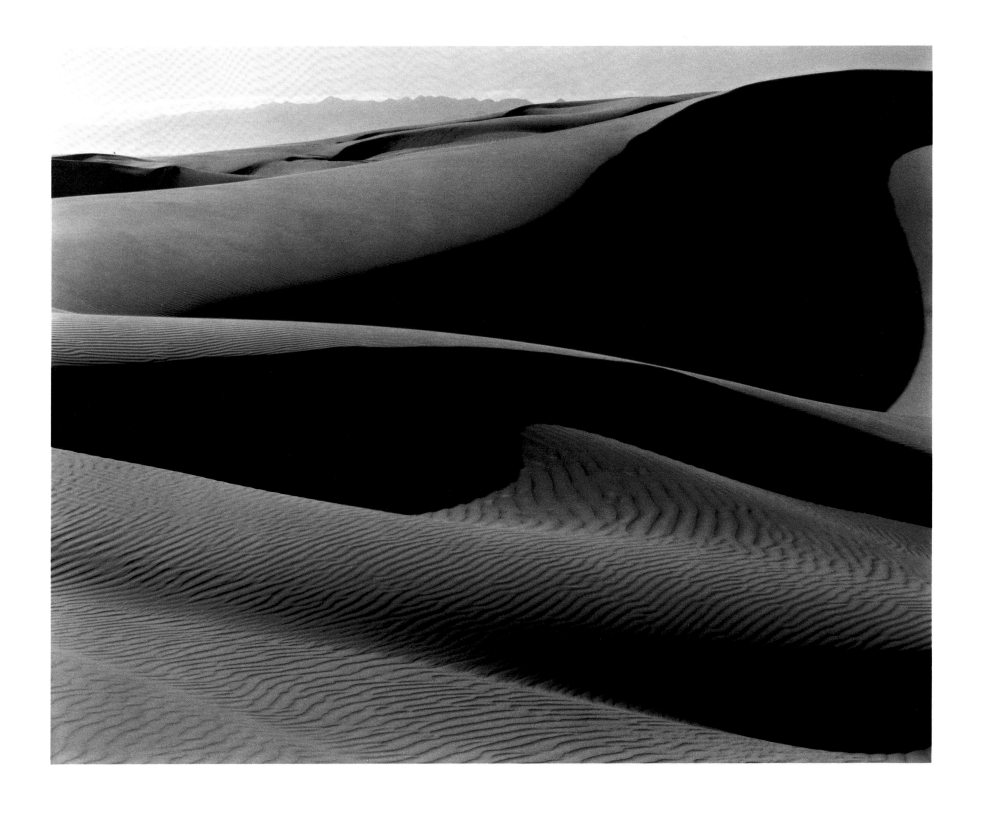

167 *Oceano, 1936*

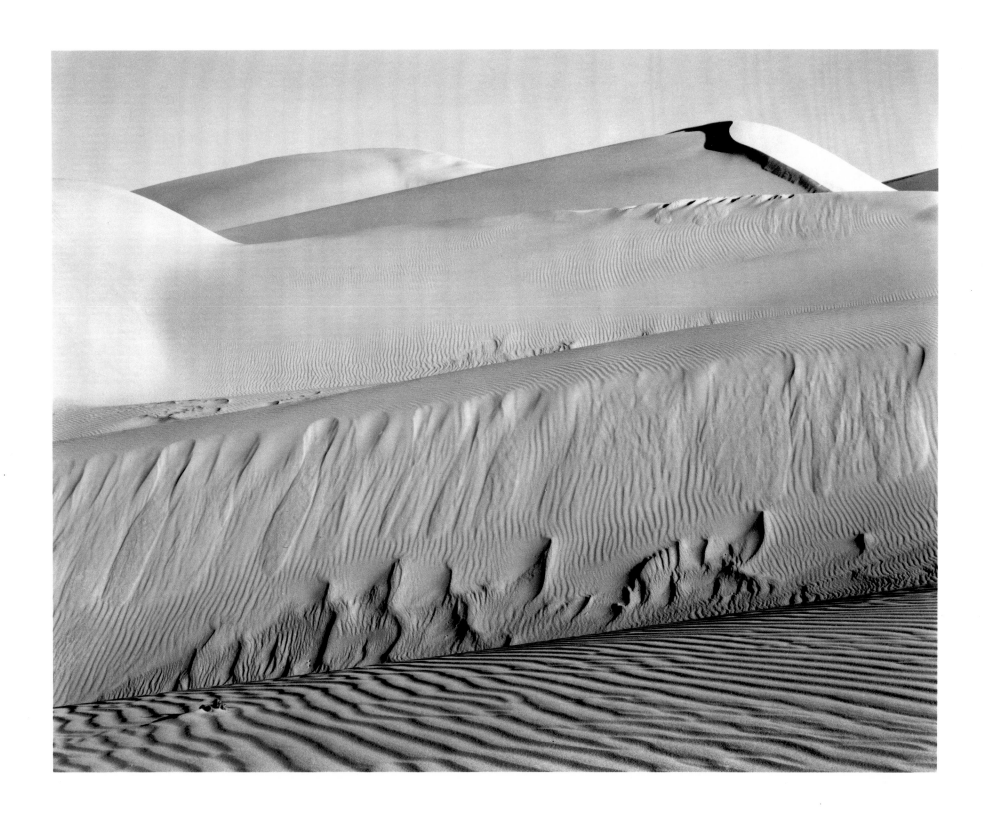

168 Dunes, Oceano

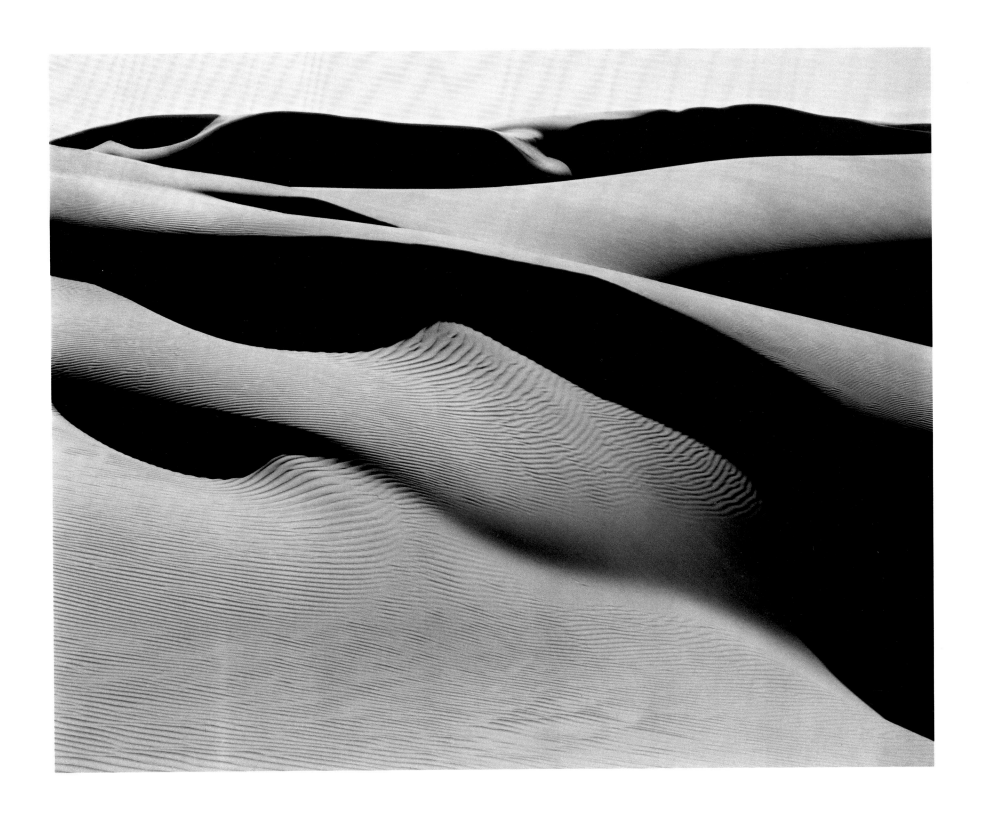

169 *Oceano, 1936*

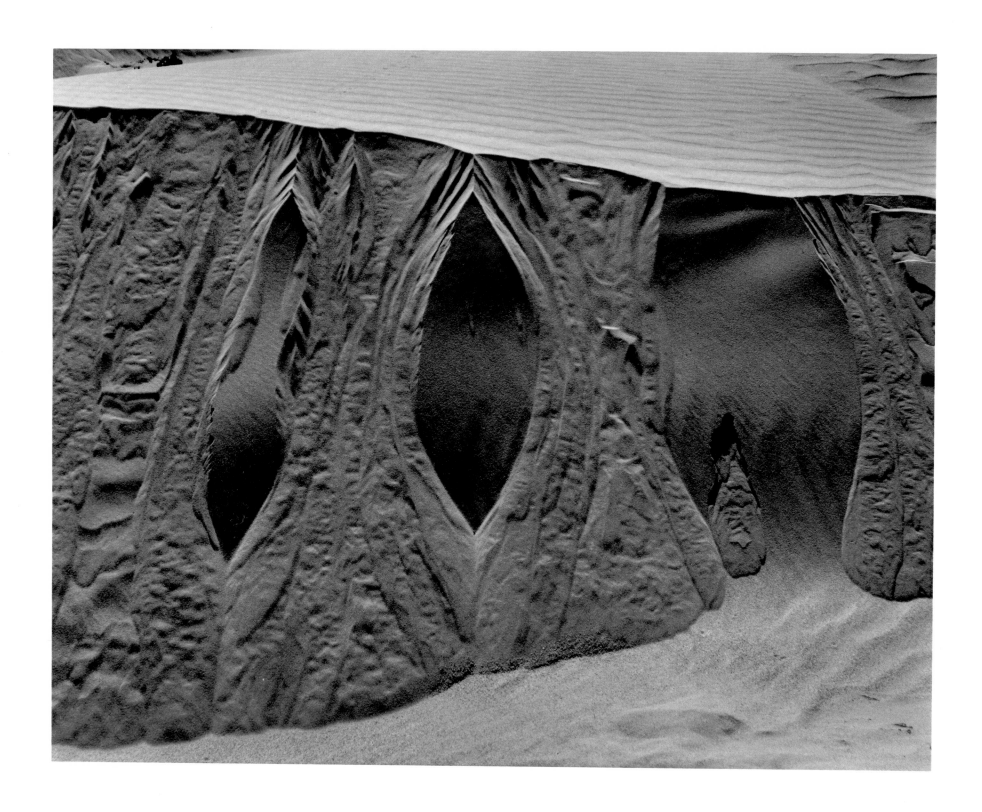

170 *Dunes Oceano, 1936*

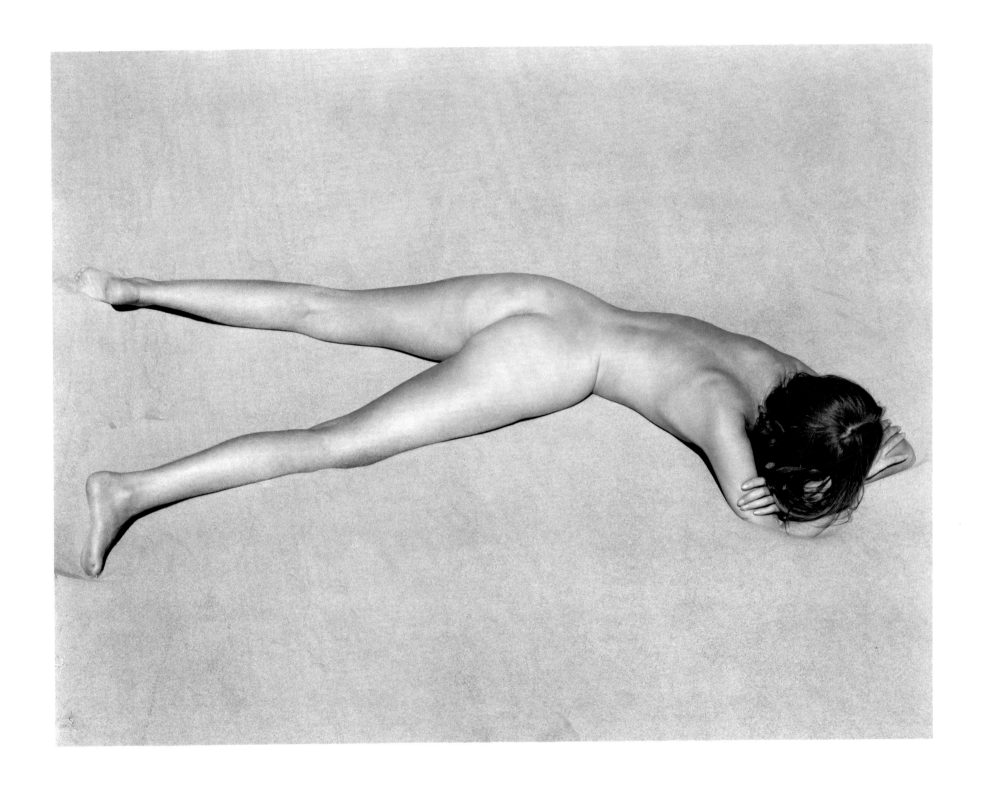

171 *Nude, 1936*

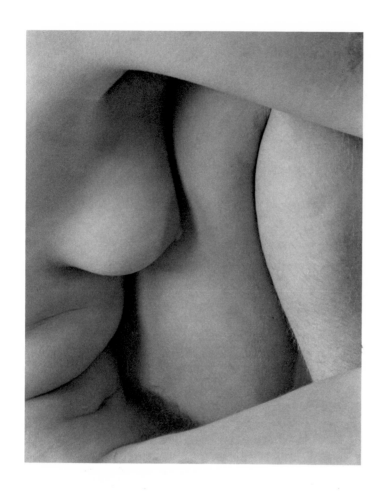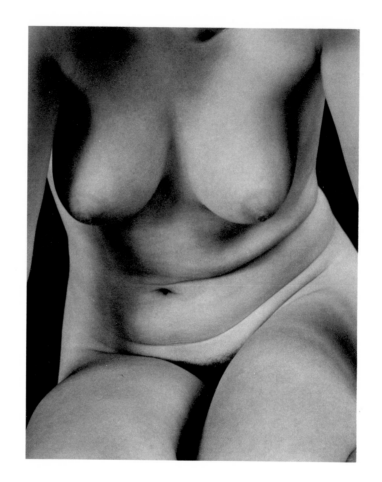

172 Nudes, 1934

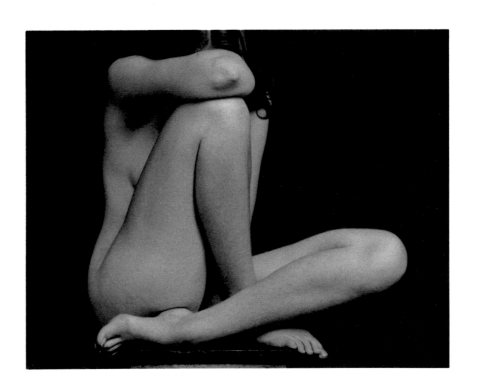

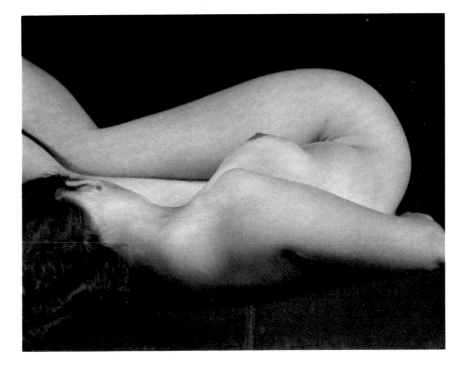

173 *Nudes, 1934*

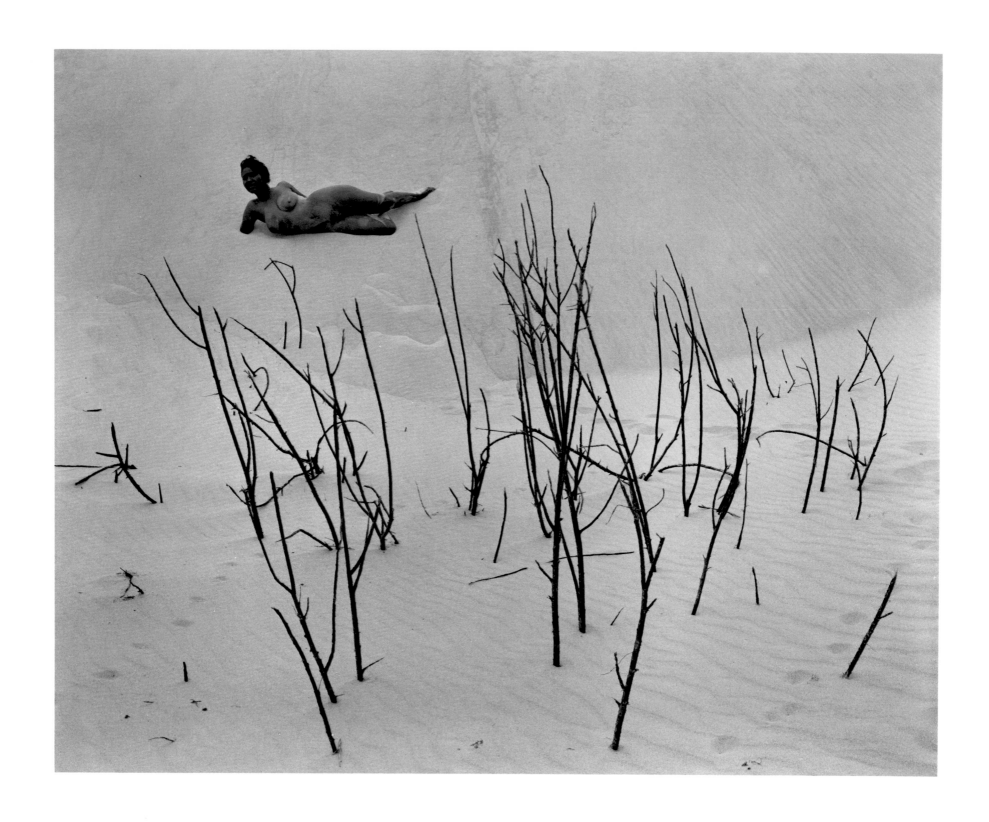

174 *Nude on Dunes, 1939*

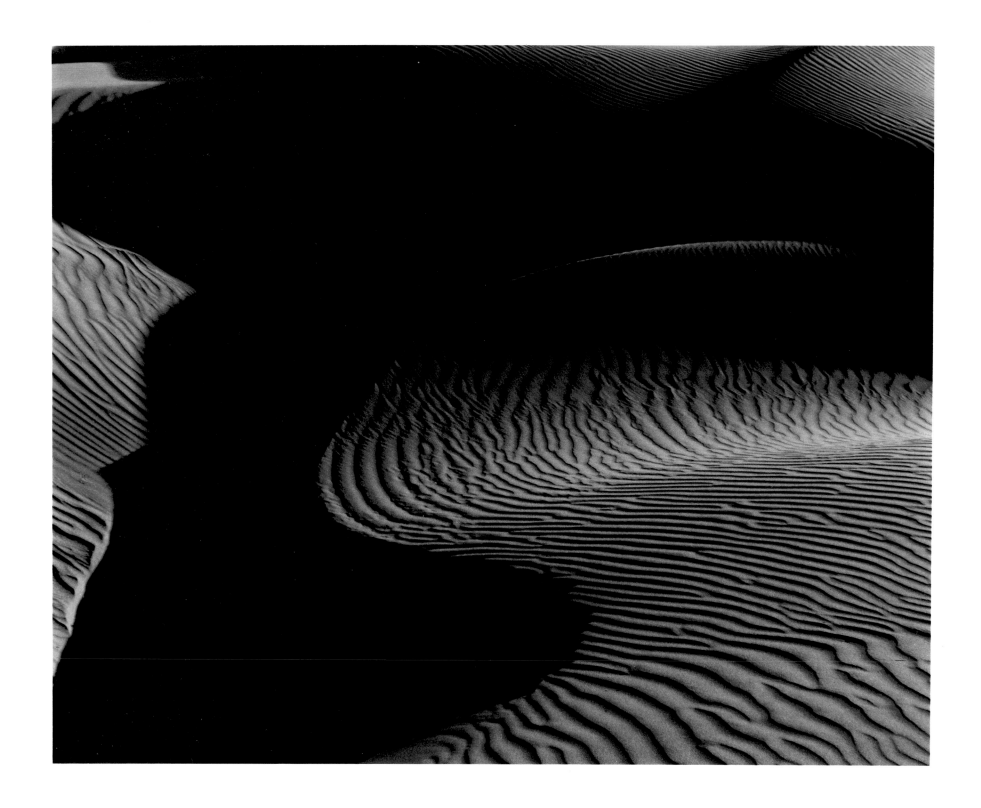

175 *Oceano, 1936*

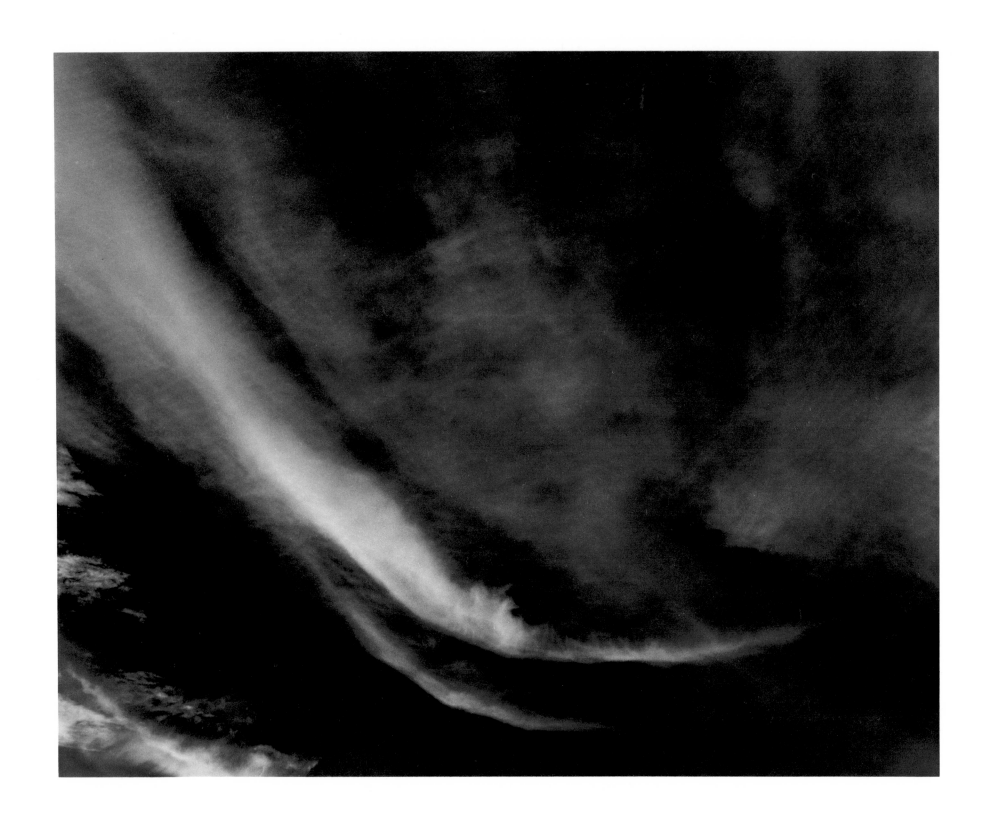

176 *Clouds, 1936*

177 *Clouds, 1936*

178 *Clouds, 1936*

179 *Clouds, 1936*

"I wish to continue an epic series of photographs of the West, begun in about 1929; this will include a range from satires, on advertising to ranch life, from kelp to mountains. The publication of the above seems assured."

With this concise statement, my father answered Part 4, "Plans for Work," on his application for a Guggenheim Fellowship.

Although the Fellowship Committee had decided the year before that they would no longer consider applications from photographers for 1936 Fellowships, due to the number of applications, Weston received the following letter, dated March 18, 1937:

Dear Mr. Weston:

I am delighted to write you that today the Trustees, on the nomination of the Committee of Selection, appointed you to a Fellowship of the Foundation in the following terms:

Project: The Making of a Series of Photographs of the West.

Period: Twelve months from April 1, 1937.

Stipend: Two Thousand Dollars.

The honor of being the first photographer ever to receive a Guggenheim Fellowship was followed by a second nomination in 1938, thus enabling my father to complete his project.

With this new-found freedom from "having to make a living from portraiture," he plunged into the project of photographing the West with tremendous energy and enthusiasm.

During the next two years, he traveled thousands of miles throughout California, Oregon, Washington, Nevada, New Mexico, and Arizona, exposing over fifteen-hundred 8 × 10 negatives, the largest body of work he had ever made, for such a short space of time. The subject matter that came before his lens was almost unlimited, ranging from the concretions of the desert to the junipers of the High Sierra; from the ghost town of Rhyolite to the gentle farms of the Eel River country.

He photographed them all: the South Coast; the North Coast; the Colorado Desert; the Mojave Desert; Yosemite; Aspen Valley; and above all, one of his favorites, "Dante's View, Death Valley," where he exposed over 275 negatives.

Guggenheim Itinerary

April, 1937
 Carmel
 Death Valley
 Zabriskie Point
 Furnace Creek
 Los Angeles
April 26, 1937
 Mojave Desert
 Palm Springs
 Twenty-Nine Palms
 Hemit, California
 Colorado Desert
 Salton Sea
 El Centro, California
June, 1937
 Los Angeles
 Elizabeth Lake
 Red Rock Canyon
June 29, 1937
 Ventura
 Carmel
 San Francisco
 Yosemite
 Mammoth Lake
 Lake Ediza
 Mono Lake
 San Francisco
 Redwood Highway
 Tomales Bay
 Mendocino
 Eureka
 Oregon
 Fort Bragg
 Elk
 Russian River
 High Sierra

August 24, 1937
 Lake Tenaya
 Mt. Whitney
 Owens Lake
September 14, 1937
 Mother Lode country
September 19, 1937
 Donner Pass
 Tomales Bay
 Fairfax
September 28, 1937
 Sacramento
 Mt. Lassen Park
 Mt. Shasta
 Klamath River
 Moonstone Beach
 Garberville
 Eel River
 Ukiah
 Tomales Bay
 Albion
 San Francisco
 Los Angeles
 Mojave Desert via U.S. 66
 Colorado River
 Arizona
 Santa Fe, New Mexico
 Aspen Valley (near Tesuque)
 Taos
 Albuquerque, New Mexico
 Prescott, Arizona
 Jerome, Arizona
 Los Angeles, California
 Salton Sea
 Borego
February 9, 1938
 Yosemite
 Los Angeles

March 7, 1938
 Death Valley
 Rhyolite, Nevada
March 27, 1938
Renewal of Guggenheim
 Placerville
 Volcano
 Yosemite
 Point Lobos
 Death Valley
 Los Angeles (M.G.M.)
 Vancouver
 Oregon,
 Columbia River
 Crescent Beach
 Clear Lake

181 *Lake Tenaya, 1937*

182 Stump, Moonstone Beach, 1937

183 *Juniper, Lake Tenaya, 1937*

184 *Juniper Bark,* 1937

185 *Lake Tenaya Country, 1940*

186 *Fern in the Redwoods, 1937*

187 *Redwood Stump, 1937*

188 *False Hellebore at Lake Ediza, 1937*

189 *Bandon, Oregon, 1939*

190 *Eel River Ranch, 1937*

191 *Tomales Ranches, 1937*

The warning sign on this desert road which traverses sixty miles of the old Butterfield stage route, was not sufficient to prevent this desert tragedy. Why this man attempted to cross the desert on foot in the broiling sun with the nearest water eighteen miles away, is and may remain a mystery. He had reached water, but too late—we found him dead.

Working on my project as a Guggenheim fellow we had crossed the Colorado Desert to Carrizo Station photographing at a leisurely pace all the way. The temperature was very high, but I don't mind dry heat and we felt secure with ten gallons of water. The road was so bad that often we could only go two miles an hour. One car passed us all day.

The old Carrizo stage station is half a mile off the road. At the turnoff we found a message fastened to a stake in the middle of the main road. We got out and read: "Please help sick man at Carrizo Station." The note was dated that day. We turned off to investigate.

At Carrizo was water. A creek usually underground had come to the surface with this year's heavy rains. All that we found of the old stage station were a few adobe bricks. A large cottonwood and a eucalyptus, planted years ago, remained. We found no sick man. Turning to leave, we drove closer to the cottonwood; I saw feet sticking out, and there he was. One shoe was off—both were worn out.

He must have died that day. But whatever aid he got came too late; hunger and privation had wasted his body and the merciless sun had dried him up. But he was quite beautiful in death. I made the enclosed photograph. E.W.

193 *Grass against Sea, 1937*

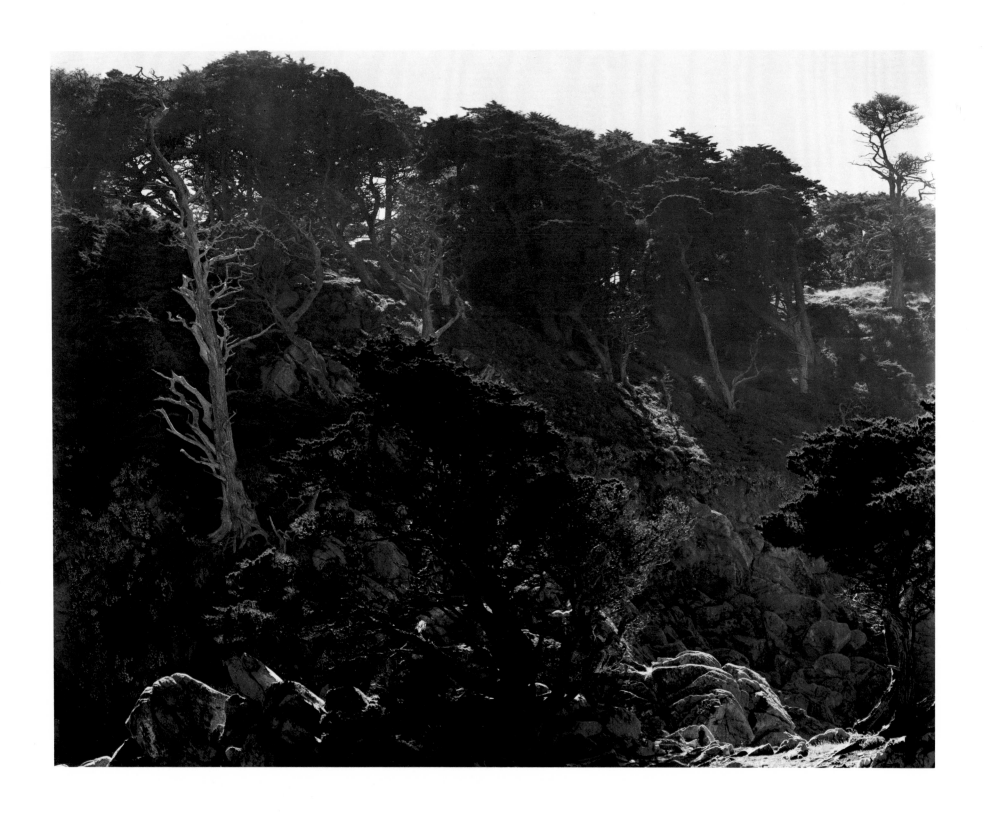

194 *Fog and Cypress, 1938*

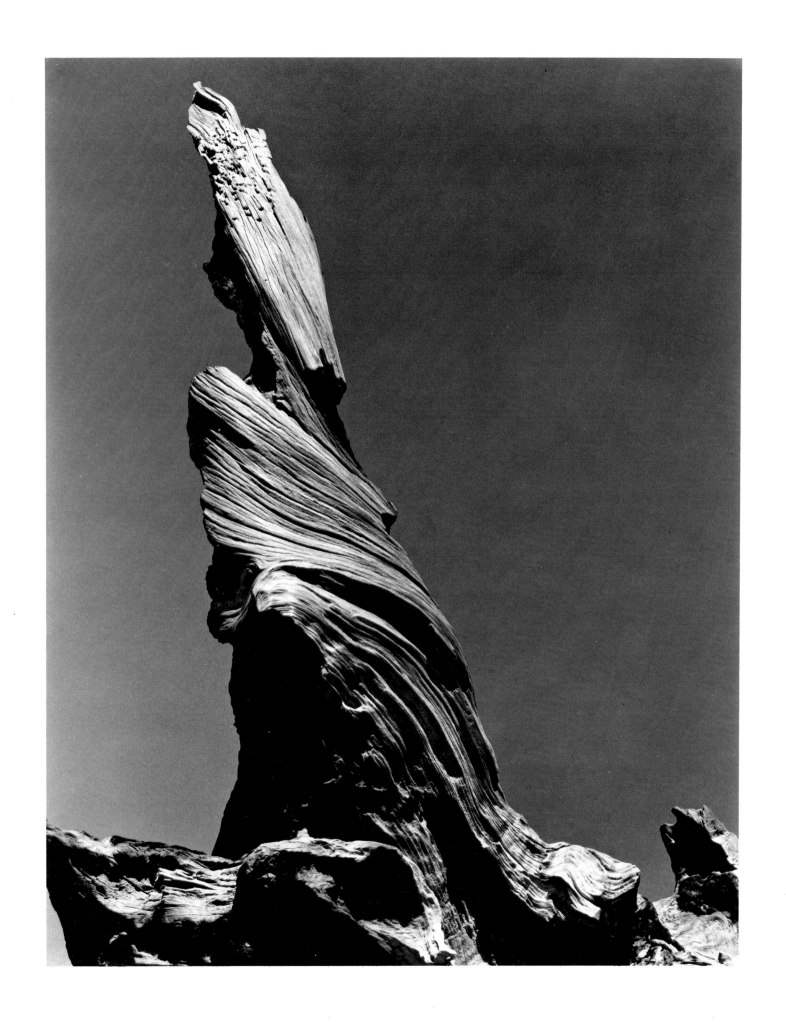

195 Stump, Crescent City, 1937

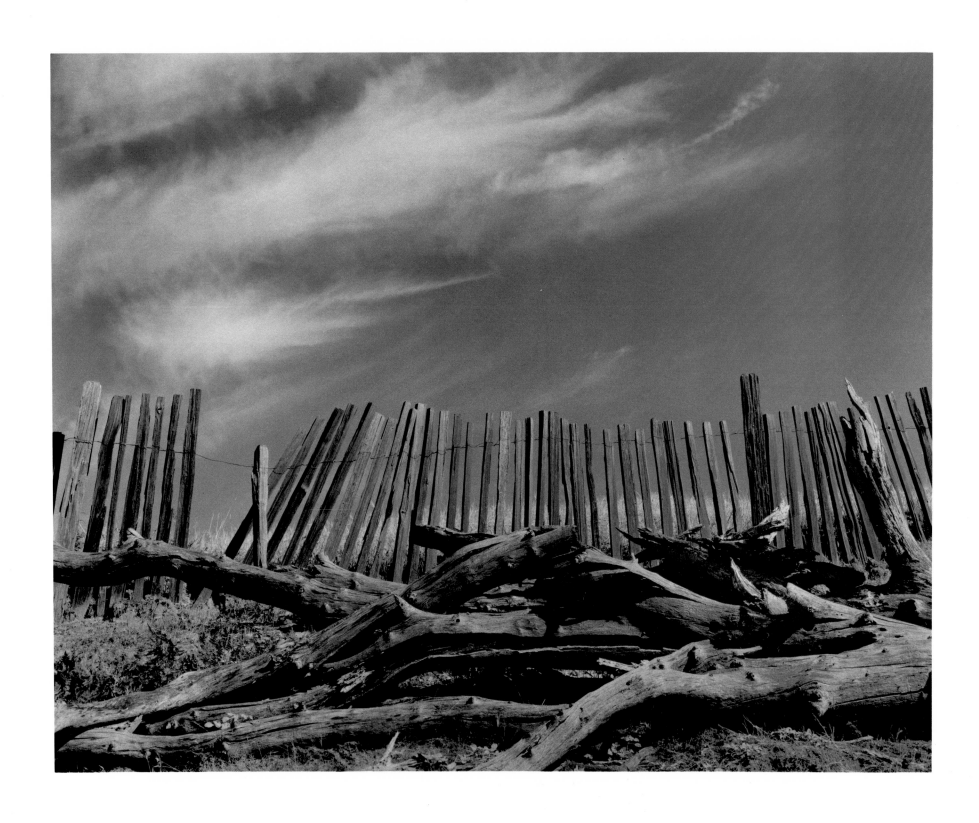

196 *Rancho Sonoma, 1937*

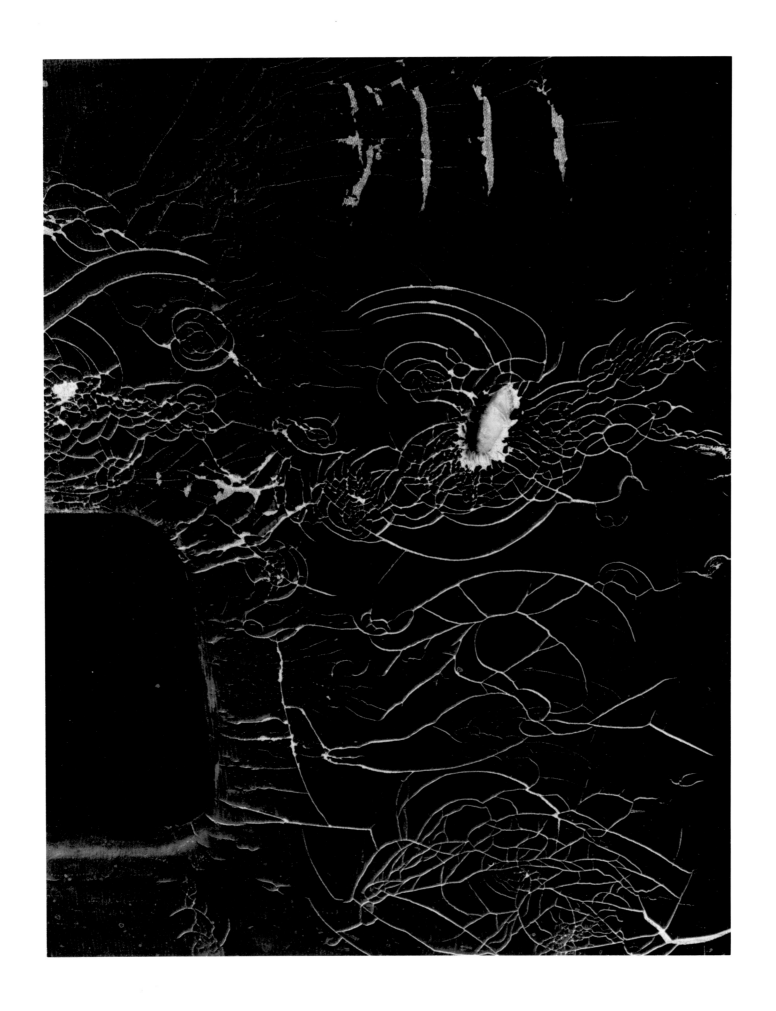

197 *Burned Car, Mojave Desert, 1937*

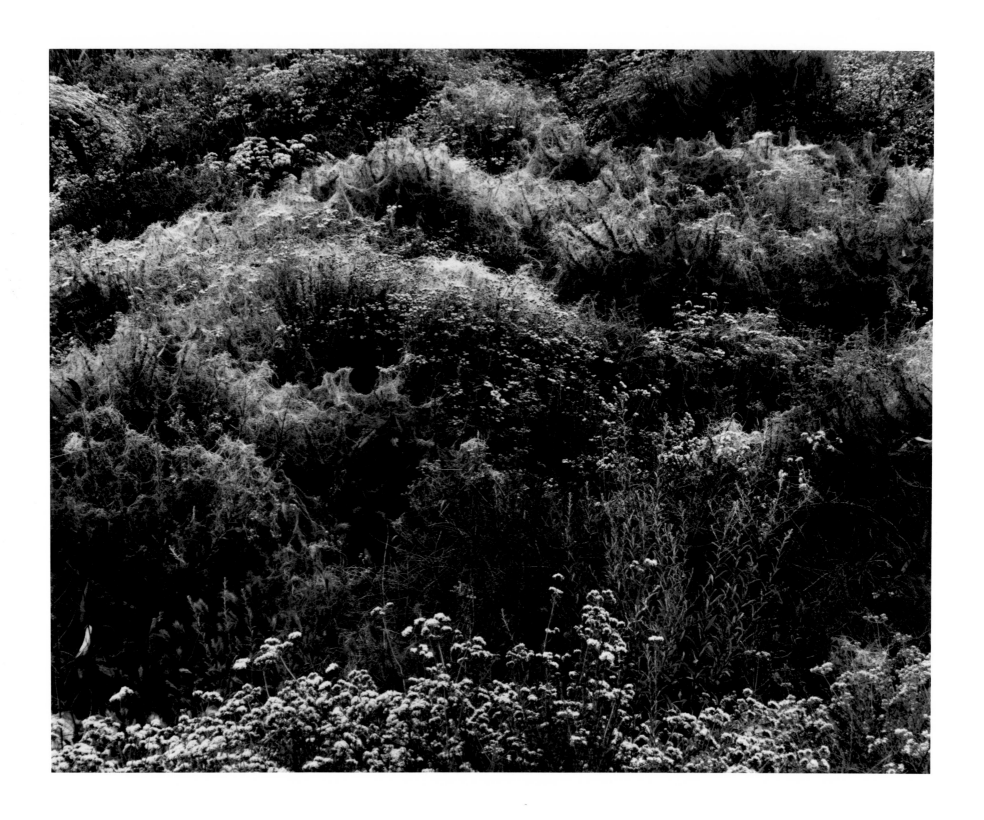

198 *Wild Flowers, Laguna Beach, 1937*

199 *Dead Man, Colorado Desert, 1938*

200 Slaughter Wheel, Meyers Ranch, Yosemite, 1938

201 Yosemite, 1938

Man is the actual medium of expression—not the tool he elects to use as a means. Revelation—the fusion of an inner and outer reality derived from the wholeness of life—sublimating things seen into things known. E.W.

203 Aspen Valley, 1937

204 Taos, 1937

205 Aspen Valley, 1937

206 Ice, Tesuque, New Mexico, 1937

207 *Moonstone Beach, 1937*

208 *Wrecked Car, Crescent Beach, 1939*

209 *Albion, California, 1937*

210 *Lassen National Park, 1937*

211 *Salinas, 1939*

The white and static clouds hang over the landscape as though permanent, unchangeable.

The camera does not reproduce nature, not exactly as seen with our eyes, which are but a means to see through as impersonal as the lens, and must be directed by the same intelligence that in turn guides the camera. E.W.

The Guggenheim trips were like elaborate treasure hunts, with false clues mixed among the genuine ones. We were always being directed by friends to their own favorite sights or views or formations. Sometimes these tips paid off with real Weston prizes; sometimes the recommended item proved a dud, but Edward discovered something to delight him along the way; and sometimes neither one happened, and we drove for miles with no payoffs. By that time, I had reached the point of taking no pleasure in scenery that didn't call Edward's camera out, so he didn't risk missing much when he settled back against the seat saying, "I'm not asleep—just resting my eyes"; he knew my eyes were at his service, and that the moment anything with a "Weston" look appeared, I would stop the car and wake him up.
Charis Wilson.

213 *Panvamints, Death Valley, 1937*

214 *Ubehebe Crater, Death Valley, 1938*

215 *Dunes, Death Valley, 1938*

216 *Zabriskie Point, 1938*

217 Rhyolite, Nevada, 1938

False fronts are no novelties. Half the timber of our frontier towns was one-dimensional. Architectural hypocrisy is the funniest part of our culture, and movies have always reflected us as we reflect them. A million years have passed since Edward Weston photographed these outdoor sets at MGM in Culver City. Since then, they have become far more real than they ever were. The great sound stages are soundproof blocks of silence set in a concrete desert. They look dead, but they are merely immortal, preserved forever in shining coils of film; artifacts of an illusion. Ben Maddow.

219 MGM Studios, 1939

220 MGM Studios, 1939

221 MGM Studios, 1939

POST-GUGGENHEIM 1939 to 1948

The last ten years of Edward Weston's photographically productive career were beset by the most intense emotional and physical occurrences of his life: World War II scattered his four sons far from his reach; he was divorced from his second wife, Charis Wilson; and finally, he came to realize that he was afflicted with Parkinson's disease, an illness which would inevitably incapacitate him and cause his death. Despite these disturbances, he managed during these years to produce his most varied and controversial work.

In 1938 he moved back to Carmel, into a $1000-studio that Neil built for him on Wildcat Hill, one mile from his beloved Point Lobos. He set about the task of printing the tremendous backlog of negatives from his Guggenheim trip, and at the same time, managing to take several trips across the length and breadth of the country.

Although he traveled through Oregon and Washington in 1939, doing fine work, the most exciting photographs were done on the North Shore of Point Lobos. Instead of the usual close-ups, he now turned his camera on the gnarled cypress trees, clinging to rock walls covered with stonecrop.

In 1941, commissioned by The Limited Editions Club to illustrate Walt Whitman's, *Leaves of Grass*, he traveled ten months, twenty thousand miles, through twenty-four states, working from the Deep South to the rock-bound coast of Maine. Although he found a great deal of material to work with in many of the states, the majority of his negatives were taken in the South, particularly in the cemeteries of New Orleans and the old abandoned plantations of Louisiana.

During the war years, 1942 to 1945, unable to work at Point Lobos, and feeling very bitter about the war, he did a series of satirical nudes, entitled: "What We Are Fighting For," and "Civilian Defense." These, along with such portraits as "Exposition of Dynamic Symmetry," 1943, caused the staunch supporters of the so-called "Edward Weston Purist approach" to pass furtive remarks: "...that possibly Weston was not well," and, "that it is obvious that the War has taken its toll." Such rumors brought a twinkle to his eye, and he would do another disturbing "Un-Westonian" photograph.

After the war, in 1946, I moved from Los Angeles to Carmel, in order to be his assistant. Even though Parkinson's disease was slowing him down physically, his mind and speech remained sharp and clear. Our photographic outings to Point Lobos became fewer and his "negatives exposed" decreased at the same rate, until, finally, he made his last negative in 1948.

What do you think has become of the young and old men?
And what do you think has become of the women and children?

They are alive and well somewhere,
The smallest sprout shows there is really no death,
And if ever there was it led forward life, and does not wait
* at the end to arrest it,*
And ceas'd the moment life appear'd.

All goes onward and outward, nothing collapses,
And to die is different from what any one supposed, and luckier.

Has any one supposed it lucky to be born?
I hasten to inform him or her it is just as lucky to die, and I know it.

Leaves of Grass, Walt Whitman

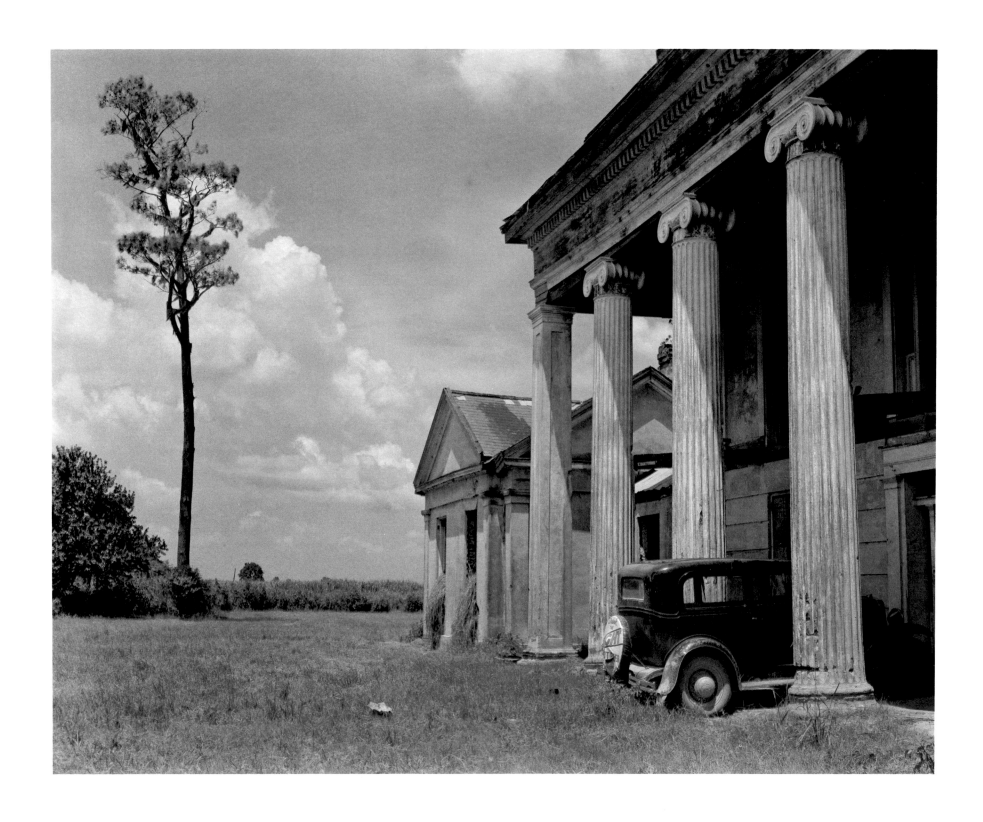

223 *Woodlawn Plantation, Louisiana, 1941*

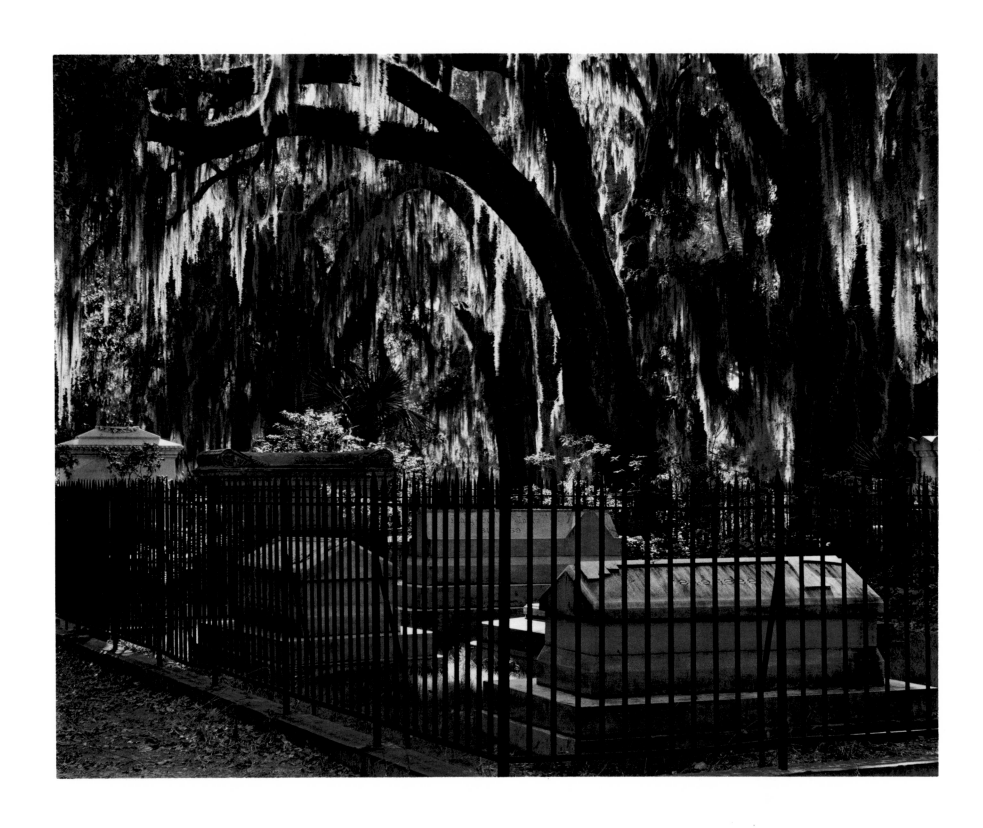

224 *Bonaventure Cemetery, Savannah, 1941*

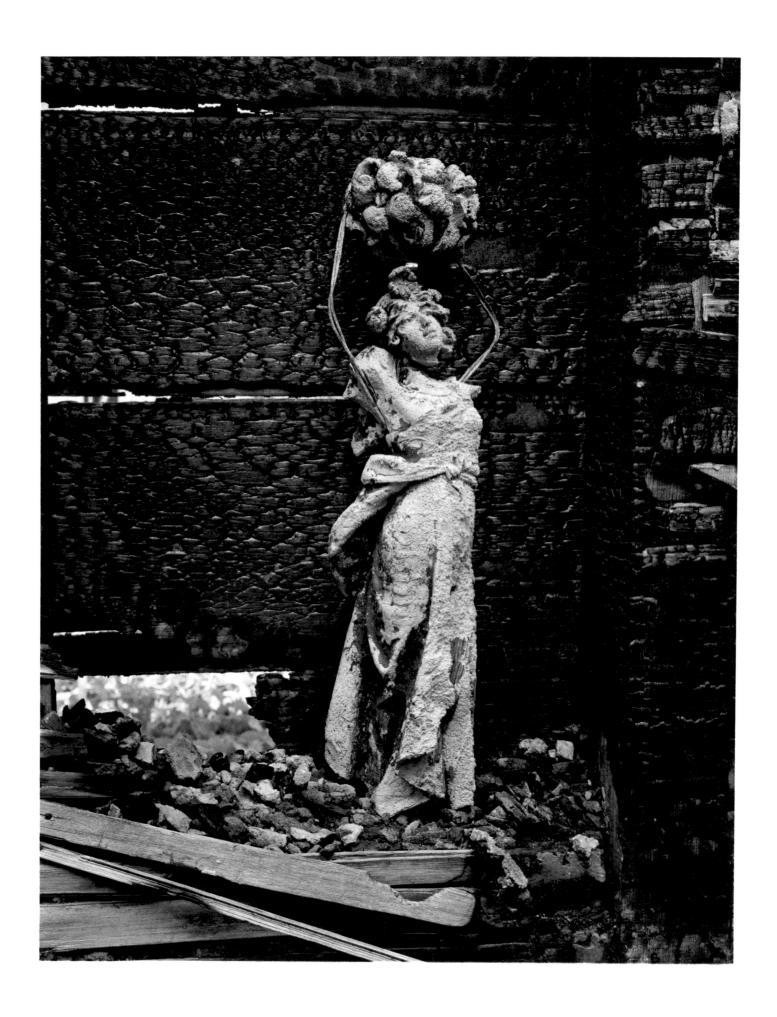

225 *Meraux Plantation House, Louisiana, 1941*

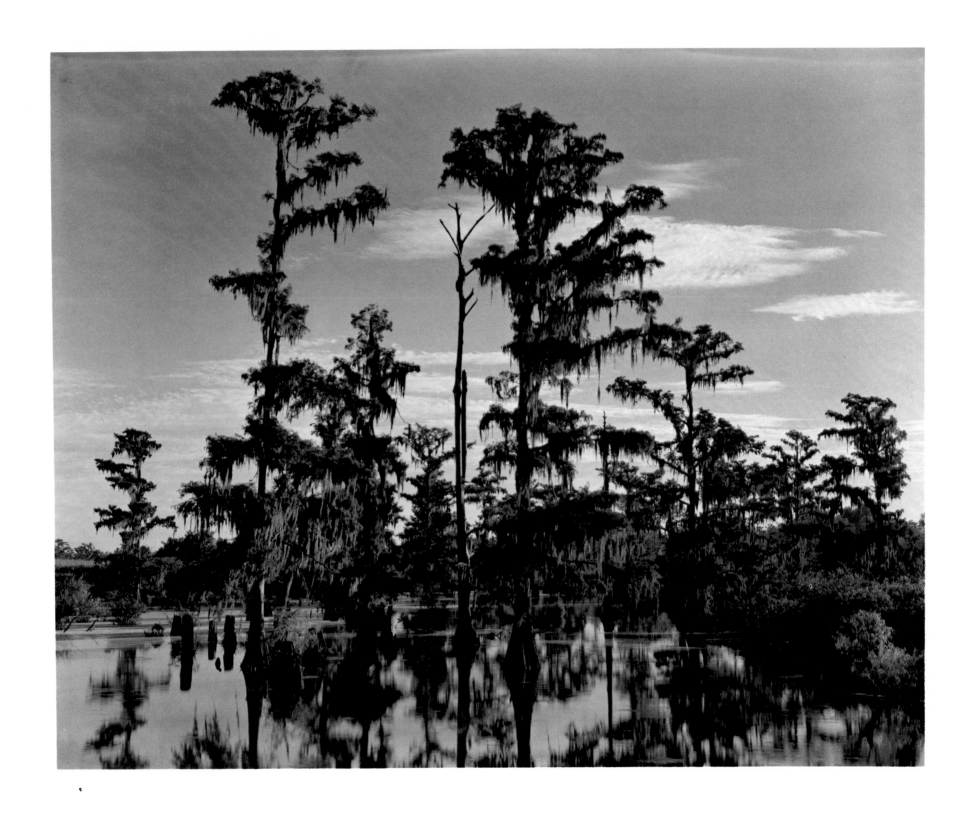

226 *Louisiana, 1941*

227 Giroud Cemetery, New Orleans, 1941

228 *New Jersey, 1941*

229 St. Roche Cemetery, 1941

230 St. Roche Cemetery, New Orleans, 1941

231 Contraband Bayou, Louisiana, 1941

232 *Mr. Fry Burnett, Texas, 1941*

233 Mr. and Mrs. Fry, Austin, Texas

234 The Summers, Tennessee, 1941

235 *Union Station, Nashville, Tennessee, 1941*

236 *Stone Sculpture by William Edmondson, Tennessee, 1941*

237 *William Edmondson, Tennessee, 1941*

238 *Pittsburgh, 1941*

239 *David McAlpin, New York, 1941*

He especially liked to find the coded messages, the surfaces behind surfaces, the depths below depths, that gave ambiguous accounts of the nature of things. He loved the Atget photographs that looked into store windows in Paris and combined the world within with confusing reflections of the world without. It was the kind of conundrum he found irresistible. You can see it in the pond at Meyer's Ranch with its calligraphy of bent wire, reflections of unseen fence posts, and clouds mixed with reeds in the water, or his own manufacturing of Lily & Rubbish where he separates the outer and inner worlds with a broken pane of dirty glass, poking fun at romantic formulas, while giving a virtuoso rendering of his own romantic vision. During the last years he was able to photograph, he was particularly taken with situations where an interface separated life and death, as in the great dead pelican floating on a tide pool, where small live creatures scurried about beneath, or in the nude floating in the swimming pool at my father's home. Charis Wilson.

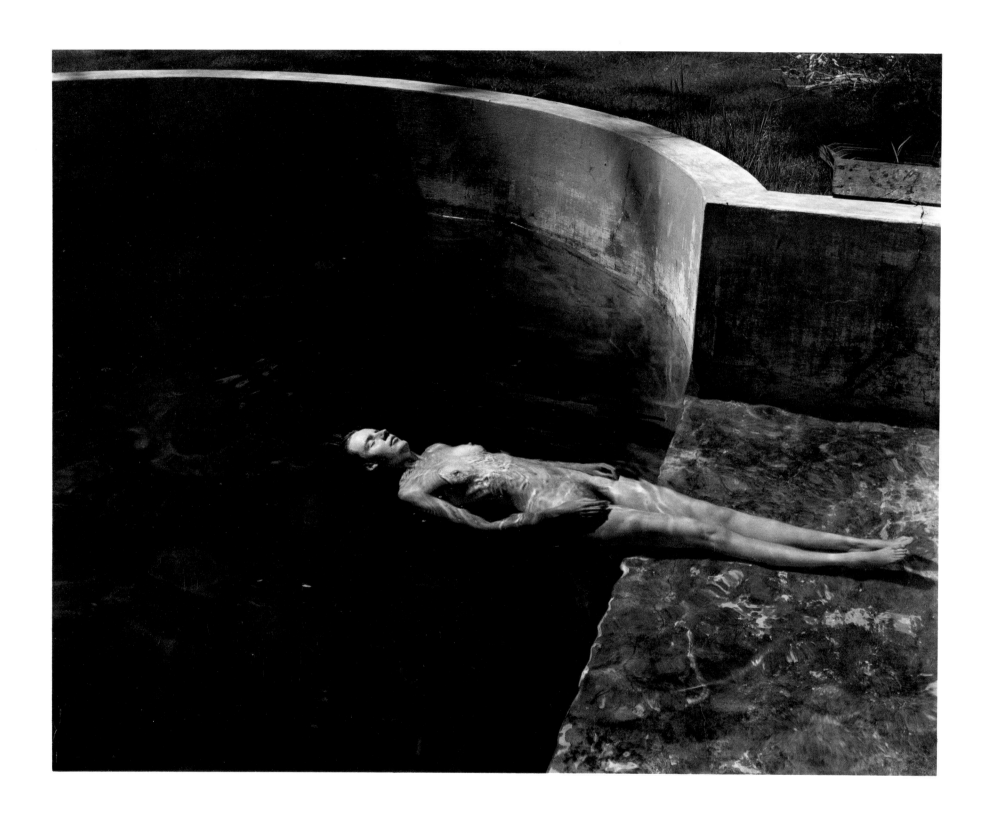

241 *Nude Floating, 1939*

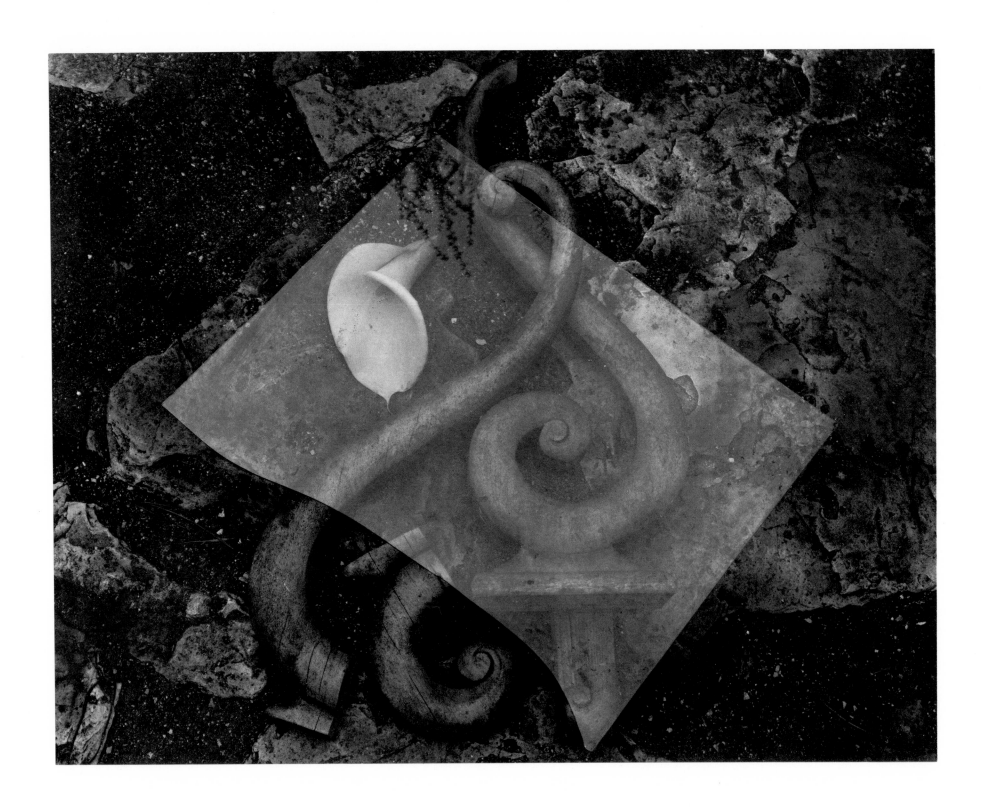

242 *Glass & Lily, 1939*

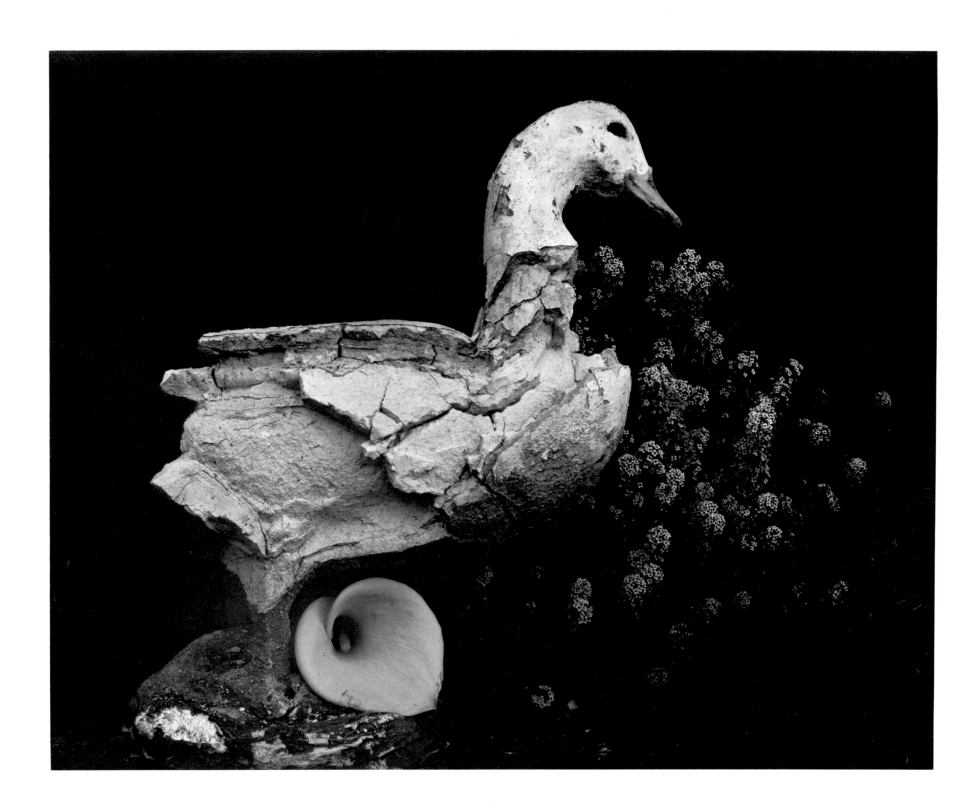

243 *Duck & Lily, 1939*

244 *Cliff with Seagull, Point Lobos, 1946*

245 *Stonecrop, Point Lobos, 1944*

246 *Pelican, 1945*

247 *Point Lobos, 1939*

248 *North Shore, Point Lobos, 1946*

249 *Cypress, Point Lobos, 1940*

250 Point Lobos, 1944

251 North Shore, Point Lobos, 1946

Text continued from page 84

two emotions:

> Ramiel is worn out with the extra confusion. He is high-strung and takes matters too seriously. Last night an episode took place which I deeply regret, for it may have lasting consequences. I was in bed, trying to direct the dish-washing, general cleaning up before bed-time. The boys were arguing among themselves over respective duties, which led to teasing and half-playful blows. Ramiel in his excitement slapped Neil,—something I have not done for years, and always regretted, had terrific reactions, when I did. The boys are not going to forget this,—punishment, in their eyes, without authority.
>
> If Flora gets wind of this, I will not hear the end of it. One of my big quarrels with her was over the slapping of Neil by Ruth Shaw. And I have always protested that she—Flora—resorts to blows. Children must, and can, be handled without beating. But it takes infinite patience.

But this incident had no lasting effect on Edward Weston's deep affection for Ramiel. In Mexico, five years before, he'd written Flora about Ramiel:

> You must take this into consideration—that Ramiel is an integral part of my life—that wherever I go he will not be far away—I do not ask you to accept him or see him—but I wish to be fair to you—I want no misunderstanding.

And Weston retained this sort of loyalty to his close friends for the whole of his life, except for Hagemeyer, whom he found intolerable at last. In 1931, some fifteen years after they had met—an impassable eternity in Weston's life—the two men quarreled, though they never actually broke apart:

> Before 5:00—the last day in this studio. I feel somewhat depressed. Of course I should not, useless to worry!—But I do,—some.
>
> It all comes down to my personal work,—in this way: Johan is definitely coming back—this means that he will make every effort to reestablish himself,—he is broke, he is bitter toward me because of my frank letter telling him how to conduct himself if he came to convalesce here. He makes portraits of women more flattering than mine, so out-of-focus that they reveal nothing. Of course I can do this too, but only by reviving my past. Then, his work will be cheaper than mine, a point in his favor these hard times. But his advantage will be in being the underdog!—Which will make him fight for recognition. And here is where my personal work enters in. He cares little or nothing for his personal expression, he will spend all of his effort and time in getting "business." I will not! I begrudge every moment so spent. Also my rent and other expenses will be about thirty-five dollars more a month than heretofore.
>
> Well—let me figure my advantages. I will have a much better location, a sign which can be seen down Ocean Avenue, two showcases in the center of activity, more publicity than ever before, locally and internationally, and the goodwill of the community, which Johan lost by his actions, bitter denunciations when he left, thinking never to return.
>
> But all I ask is that my personal work will not be even temporarily sidetracked. It has been already too much this spring. It must go on, and on!

Weston continued to concentrate on his work; brushing aside the hurt silences, the squabbles in the kitchen, the distractions of love. Sonya fixed lunch, and either she or Henrietta Shore drove him and his heavy camera (with tripod it was over forty pounds) to Point Lobos, which was then privately owned.

On one such occasion, Sonya and Henry Shore and Jean Charlot were at the Point; the latter two artists sketching; Sonya and Weston photographing. Suddenly, Henry screamed. She had lost her footing and had slid downward on the loose shale; below her was the slope of the cliff, and the rocks and the sea at the bottom. Her squat body had lodged, temporarily, around a sapling half-way down. Sonya tried to pull her up, and Charlot ran to help her, and slipped, too. With his glasses broken, and blood on his face, he managed, with Sonya, to hoist poor, heavy Henry up to safety. And all the time, Edward Weston, at some distance, went on working with his camera, his head under the cloth; unaware until lunchtime of what had happened.

On his forty-fourth birthday, Weston became a grandfather; the son of Chandler and his wife Maxine:

> I am a grandfather!! Edward Frank Weston—the fifth Edward in succession—arrived on my 44th birthday . . . strange coincidence—if it is coincidence. Almost, it seems, there must be a deep significance in this sharing of birthdays.

When his grandson, and several of his sons came to stay with him in Carmel, his wife Flora (for they were not yet divorced) wrote them:

> Dear "Lads Three":—Have wished to write all day—also fix up the clean clothes for Carmel—but—a fasting headache has kept me flat—I am *well* otherwise.
>
> Chan and Brett packed all day Saturday. B's hands blistered and broke from ropes on such-a-load—hardly room for our precious Baby Ted, a replica of our "first born." The boys were *treasures* to me every minute—You have made "Men" of them. So patient with their fussy "Mom." I look forward with joy to their return in three weeks for Ramiel. He has been a dear also—Had him twice to dinner—once all night—I feel my headache returning so must cut this short—Boys read it to Dad—if he has time to listen.
>
> I am missing my "Big Babes" more than they will ever know. It is best for you to contact Dad, Carmel, and environs. There is nothing

here but an impatient old woman who, tho' eratic, just worships her darling sons—Will see you Christmas at Santa Maria. Love Mother. The girls are proving efficient in this move?

Edward Weston's calm, gold and silver days in Carmel were an invention of his own will. He demanded simplicity and order so he could work. He was probing deeper and further into the materials to be found along the Pacific Coast and in the desert where he photographed the astonishing eroded rocks in what is now Joshua Tree National Monument. These, too, were sculptural discoveries, because microcosm and macrocosm can be equalized with the enormous interpretative possibilities of the camera. In his travels, he discovered Big Sur, a promontory along the coast:

> . . . a steep tortuous road high upon the cliffs overlooking the Pacific, then down into valleys, hardly more than canyons, where great redwoods, majestically silent, doused the light. The coast was on a grand scale: mountainous cliffs thrust buttresses far out into the ocean, anchored safely for an eternity: against the rising sun, their black solidity accentuated by rising mists and sunlit water, the ensemble was tremendous. But I lack words, I am inarticulate, anything I might write down would sound as trivial as "ain't nature grand." I hope the one negative made from this point will, in a small way, record my feeling. My desert rocks were much easier to work with, and quite as amazing, or more so. They were physically approachable, I could walk to their very base, touch them. At Big Sur, one dealt with matter from hundreds of feet, too many miles distant. The way will come in time to see this marriage of ocean and rock.

On the whole, he found these seascapes too flat and broad. They are, in fact, extremely difficult to photograph, but one is tempted by the romanticism of the sea, the recurrent and audible rhythms, the taste of the salt wind. In a photograph, it all tends to flatten out into one arc. On the other hand, in a painting, one can reassemble the vertical elements, crowd them closer together, link them curve by curve, move them or reverse them, or erase them. It is impossible to do this with a camera: one has only the possibility of contracting space with the wide angle lens; an effect which is strangely amateur and cute, unless it is given as violent a foreshortening as Bill Brandt did in his seashore nudes.

Weston put down several thoughts on this problem of landscapes:

> I take exception to the statement that the elements often "are not sufficiently under the control" of the worker, and further "a painter can easily move a tree ten feet" but, "a photographer has to move himself and his camera."
>
> Landscape—which requires a tree to be moved, is only one of many [approaches] open to the photographer. What about portrait and still life for instance? But let's consider landscape as the focal point of the argument: I have seen painters search all day for the right combination of objects, the most favorable light, suited to the limitations of their medium. When found, a tree may be moved ten feet or left out entirely. The photographer however can add to his composition, if he can't subtract. A figure can be added to the scene to balance the wrongly placed tree. If such devices do not work, and moving the camera is not a solution, why bother with the particular scene when there are hundreds of others within walking or at least driving distance? I never find time to do all the scenes that are good even with the facile camera. You are only limited by your own seeing. Other expressions have extreme limitations, yet are successfully used. The camera is a machine to be used.

The truth is that Weston was much more at ease closer up to his subjects. One has only to view, for example, his great series of dry cypress roots ("like flames," he wrote), and in particular, the series of beautiful, grave, somber kelp studies. He would rush down to the beach at Carmel after a high tide or a storm to see what luck had arranged; and it had often arranged a Weston or two. The various tangles of kelp (one group, in particular) have the almost identical structure of his Armco photographs of 1922; a massive horizontal opposed by multiple verticals. If one looks at his photograph of the Gulf Oil Refining Co., one can easily imagine that the great steel loops are simply the tubes of giant seaweed. They are all—and the comparison is Weston's, and is accurate—very much like a Bach fugue; or more justly, maybe, like one's total memory of the fugue. The arts that proceed in real time—like music, dance, drama, or that combination of the three called cinema—are all fundamentally different from the arts whose effect is instantaneous or nearly so: painting, sculpture, pottery, lyric poetry, architecture. The difference is mostly in the viewer's perception. In these anti-temporal arts, the spectator is free to apprehend the whole thing at once, and then to wander off in several directions and at any pace. He takes a more active part in extending time, as opposed to the theatre where time is extended by the artist.

So Weston went out to explore, discover, and choose among the infinitude of possible negatives. Once having chosen his subject on the ground glass, he then opened the lens and fixed and preserved his vision forever. Now it is for the viewer to hold a Weston photograph at arm's length, and himself explore inside of it, discovering sub-worlds within the Weston universe.

But it is important to remember that even with the most abstract, the most minimal piece of art—say, an all-black or an all-white canvas or, indeed, an all-Venetian red or burnt umber canvas—it is quite impossible to disentangle the human emotion it evokes. And this is just as true of the melancholy, proud counterpoint that one might feel in Weston's shell, toadstool, cloud, or succulent.

So, though it is said over and over again, and by people who are most prolix about photography, that it is impossible to express the power of Weston's photographs in words, it is equally impossible to deny the feelings that one has after looking at a Weston print. The ground tone of the kelp studies, of the eroded rocks, of the cypress limbs and roots, is, in the early thirties, very strong, confident, assured. In Weston's vision at this time, there

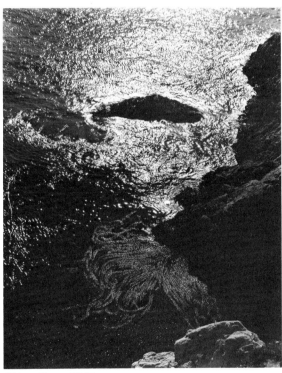

China Cove, 1940

are no doubts, but also no sentimentalities. The flame, the flame-like, the organic forms, the convolutions of rock, the flow patterns frozen in the slowness of mineral time—these are all discovered by Weston, and, metaphorically, chiselled out of their opposing union of light and dark. It is a drama that seems to be inside of the rock itself, inside the textures of the dead tree, inside the structure of the dry, dead bird, the unseen wind, the striations under the sea, the death of the uprooted, enormous seaweed.

Then, beginning slowly in the thirties, Weston began to turn

his camera away from the sea and toward the cliffs themselves, particularly those at Point Lobos. There is no particular subject; the light is diffused; one feels the fog at one's back. These photographs of the cliff that fronts the sea—where areas of black are overwhelming, dominant, the bright lines being a bit of stubborn life; a broken sapling, a tiny rosette of stonecrop—have been compared, several times, to the last quartets of Beethoven. That is very apt, in the sense of their dark complexity; but untrue in that they were not spun out of Weston's head; he wasn't blind as Beethoven was deaf. He walked, climbed, set the tripod, lifted the cloth, stared at the ground glass, tilted the front or the back; and discovered, focused, exposed, developed, printed out, studied, and rediscovered; and so, over and over again.

Sonya records how simple his darkroom procedure was. For years he adjusted the printing light by clipping one or more layers of tissue paper over the bulb; his son Neil built him a rheostat, finally. The prints were never simply exposed by contact with the negative. "You must have detail in the highlights," he would tell his sons. Paul Strand used to do much the same thing, but in another way: he would paint red dye, sometimes in multiple layers, to hold back certain bright areas; or when he worked with the very slow platinum papers, he would sometimes focus sunlight through a magnifying glass along an edge; for instance, when he wanted the contrast of dark hills against a bright sky. So there was always, and sometimes a great deal of "dodging": holding back the light over a particular area of the print by means of the hand; or a bit of wire to hold a shape of paper, in order to create a shadow with a blurred edge, and thus lessen the exposure across a particular portion of the negative.

If the doctrine of photographic purity was not already seen to be illusory, the practice of dodging proved it logically absurd; this in spite of Edward Weston's often misread dictum: "My final result is fixed forever with the shutter's release."

Retouching was something else again; and Weston hated it, and for bitter personal reasons. Once he actually put up a notice in his studio that he would do no more retouching of personal portraits; and this at a time when, as usual, he needed money badly. He wouldn't always obey his own announcements, but it made him feel a lot better.

In the autumn of 1932, Willard Van Dyke and his wife Mary Jeanette Edwards, her father J. P. Edwards, Ansel Adams, Edward Weston, Imogen Cunningham, Sonya Noskowiak, and Henry Swift,

founded a group on Weston's expressed theories. As Minor White put it in his acute analysis (*Image*, October, 1956), it meant "pre-visualization . . . imagining the print while looking at the scene." What followed from this theorem was expressed by Edward Weston, himself, in the leaflet he wrote in 1934 for The Los Angeles Museum. He called for direct contact printing, absolutely no manipulation (though he himself had frequently done enlargements, generally by making an enlarged negative from an enlarged print and then printing by contact from that "second generation"); and he prescribed absolute optical sharpness from front to back in every plane, the use of large cameras to provide large negatives, and, what is a consequence to all these, a rich infinity of detail.

It is worth quoting at length from Weston's rather rare pamphlet, for these ideas are still very influential:

> The invention of photography was the inevitable result of necessity; the need of a changing world for another technique, a means of expression through which, in certain essentials, a clearer communication, based on contemporary premises could be established. The new scientific approach to life demanded a method of recording which could meet the quickened tempo of the day; a means of unlimited print duplications (mass production); an art form which would be a synthesis of the apparently irreconcilable viewpoints of science and aesthetics. In fulfilling these requirements photography has extended horizons and created a new world-vision. . . .

> David Octavius Hill, a Scotsman, made a series of photographs, mostly portraits, which even today are recognized as outstanding examples of fine photography. These portraits should have indicated the unique possibilities of the medium, thus serving as a guide to photographers of that day, and those to follow. Perhaps Hill's influence was negligible because his approach was instinctive rather than affirmatively intentional. One way or another his work was unheeded and forgotten, and for many years photographers, blind to the significance of their new adventure, indulged in abortive attempts to imitate the particular qualities belonging to painting and other arts, until photography, stigmatized by these travesties, lost all recognition as an original art form. . . .

> Imitation must eventually die from its own false assumptions, but in an age of confused aims, misrepresentation, and indifference, it dies hard; so it seems necessary to note that exhibitions of pure photography are all too rare, that the medium still suffers from misguided workers, who in turn mislead the public, to the detriment of photography.

> In viewing an exhibition of photographs one must seek those examples which justify their existence as fine photography by achieving a correlation between meaning and expression which is free from all irrelevant connotations, all suggestions of other forms of expression. They will not be difficult to recognize because photography is such a basically honest medium that even a tyro can detect falsifications. Look for the exquisite rendition of surface textures beyond the skill of human hand, beyond the seeing of human eye; or consider the uninterrupted sequence of subtle gradations from black to white. Realize that these qualities can be recorded in fractions of seconds at the very instant when they are most significantly revealed and felt; that this same split-second technique can be used to capture illumined expressions of the human face and fleeting gestures. In the application of camera principles, thought and action so nearly coincide that the conception of an idea and its execution can be almost simultaneous. The previsioned image, as seen through the camera, is perpetuated at the moment of clearest understanding, of most intense emotional response.

> The chemico-mechanical nature of photography precludes all manual interference with its essential qualities, and indicates a fully integrated understanding of the aesthetic problem before exposure. The conception must be seen and felt on the camera ground glass complete in every detail; all values, textures, exact dimensions must be considered once and for all, for with the shutter's release the isolated image becomes unalterably fixed. Developing the negative and making the final print, completes the original conception. This is the procedure in straight, real photography. . . .

> The mechanical camera and indiscriminate lens-eye, by restricting too personal interpretation, directs the worker's course toward an impersonal revealment of the objective world. "Self expression" is an objectification of one's deficiencies and inhibitions. In the discipline of camera technique, the artist can become identified with the whole of life and so realize a more complete expression. . . .

> Far from being limited to unqualified realism, photography admits the possibility of considerable departure from factual recording. A lens may be selected to give perspective at great variance with the eye. The addition of an indicated color-filter will change or even eliminate certain values. The choice between films, plates, printing papers, and chemicals, available in endless variety, affords full opportunity for emphasis or for divergence from nature. All these are relevant to straight photography, and justified if used with intention.

> Faced with this choice of technical equipment, the artist selects those means best suited to his ends—and always with full understanding that his tools are no more than means. One may easily become lost in the fascinating technical intricacies and difficulties of photography and so make them the end. Due to these difficulties, as well as to widespread confusion of purpose amongst photographers, very few workers have stood out among the countless thousands of photographers as historically important. To be sure, a child can be taught to make creditable records within a few weeks; but to acquire a technique adequate to the consummation of intention may well be considered, as in any art, a lifework.

For all landscape, still life, in fact any stationary subject, I use an 8 × 10 camera on tripod. The camera is fitted with several lenses for various purposes, but the one I have used most often in recent years is a slow rectilinear lens costing $5.00; I mention this cost because of a prevalent opinion that an expensive lens is prerequisite for fine work. Of course I have no objection to the finest apparatus procurable, and a fully corrected lens is sometimes a necessity. I use panchromatic films, pyro-soda developer, and print contact on glossy Chloro-bromide paper. For portraits, or any animated subject, I use a 4 × 5 Graflex fitted with a faster, fully corrected anastigmat lens; all other data being the same. . . .

The final examination of the projected image is all important in straight photography; at this moment one uses the experience of a lifetime; for—as has been noted already—the shutter's release determines all succeeding procedures. This way of working bars accidental successes, demands quick seeing and decisions. A photograph so conceived on the ground glass has a vitality and integrity not to be found in one depending upon subsequent changes, such as enlarging portions of the negative, alterations or corrections by retouching, or any phase of manual interference. One form of "improvement" to be decried is in the use of printing methods or papers which have in their own right exquisite textures thus tending to hide or even destroy the intrinsic beauty of the negative.

If the subject to be photographed is alive. . . . I use a camera of the reflecting type, in which the image is seen on the ground glass up to the very second of shutter-release. Since I never "pose" a subject but rather wait for significant moments—and they happen continually—it becomes less possible to start with preconceived ideas. The moment presents and suggests what to do, and how to do it. The slightest movement, the lift of a hand, the flicker of an eye, must not escape. The concentration required is comparable to that of a painter making a quick sketch, grasping essentials in a few spontaneous lines. The photographer, however, may have to effect a full integration within a few seconds. . . .

It must be stressed that man, himself, is the actual medium of expression, not the tool he elects to use. The hand directing brush, chisel, or camera, does not act without guidance. In the 15th century Leonardo da Vinci protested when the "intelligentsia" defined painting as a mechanical art because it was done by hand! The human eye, too, is just as mechanical, quite as nonselective in its seeing as the camera lens; in back of the eye as well as the lens, there must be a directing intelligence, the creative force. . . .

An excellent conception can be quite obscured by faulty technical execution, or clarified by flawless technique. Look then, with a discriminating eye, at the photograph exposed to view on the museum wall. It should be sharply focused, clearly defined from edge to edge—from nearest object to most distant. It should have a smooth or gloss surface to better reveal the amazing textures and details to be found only in a photograph. Its values should be convincingly rendered; they should be clear-cut, subtle or brilliant—never veiled. These physical characteristics of an authentic photograph are repeated for final emphasis.

If the example viewed has all these qualities, and yet is not pleasing, the competent critic will not blame photography; he will attribute the failure to a photographer who could not affirm his intention, who could not correlate his technique and his idea—who was not an artist.

What Weston said and what he did were often at odds; his practice leapfrogged ahead of his theory, and by the time it was in print, he might easily have changed his mind. His allegiance to the *f*.64 group, whose homes were The Van Dyke Gallery in San Francisco, and The Ansel Adams Gallery in the same city, was a bit shaky. He even threatened, Van Dyke said, to return to soft focus. No group could possibly have held his allegiance; because he felt himself an aristocrat. He even thought that he was marked to be one of those who would create an elite race in America:

What I am now, where I stand, in this epochal time, fast-changing world, I frankly don't know. I certainly am not for the capitalist, nor the sovereign mass. The communists I know are "mouthing Puritans." I do know where I stand re my work, though the "radicals" [political] don't think so. Funny, I have always been considered a radical by academic artists, but the communists probably would damn me as "bourgeois liberal,"—because I do not portray the worker's cause.

Despite all criticism, my work is functioning. I receive continued and growing response from sensitive persons from all walks of life— yes, I do know my work has revolutionary significance, despite its lack of literary connotations. Peter Steffens said that Trotsky believes that new and revolutionary art forms may be of more value in awakening a people, or disturbing their complacency, or challenging old ideals with constructive prophecy of a coming change. I am not quoting him, rather using my own ideas to explain his thought as given to me. Now I must locate his own reference.

We also discussed the reason for the unhappy, disturbed condition of so many American artists. It cannot be economic distress alone: artists have always been willing to suffer privation for their work. And besides, the most flagrant examples of a tortured psyche I know of, belong to artists with economic security. Their condition in every case seems to me to be because they are not functioning in terms of their racial psyche, the collective subconscious. They have hangovers from European or other native ties, they are not assimilated, adapted to this soil. That they were American-born, even for several generations, makes no difference if they are still in the process of becoming adapted. The way of seeing and the means must grow

from our own needs. All of the artists I have in mind are easel paint-
ers. They have stacks of paintings stored away. The fact that these
are not purchased with money means nothing to these artists. But the
fact that they are unsought means everything. The artist must have
an audience, must give. I am happy in my work because I am giving,
changing the lives, the viewpoint of hundreds. So does any fine pho-
tographer. Photography, as Walter Arensberg said, has brought a new
world vision. People want my work, buy it, would buy more if times
were better. So my work is functioning, is needed.

Photography is peculiarly adapted to the American psyche. No
argument as to whether it is art or not can destroy its value. The fact
is, it is not a medium which has reached the end of its value as an
expression: it is vital in that it belongs to an epoch, a race in the
making, the becoming.

But he was too restless to adhere to any doctrine, even, and
maybe especially, his own. The future would have its own stric-
tures; they would be necessary, in fact, simply in order to limit
photographic possibilities to a human number.

He thought a great deal, obviously, about basic photographic
theory, but it did not prevent his work from progressing or, for
that matter, his renown from spreading. He had over thirty exhib-
its of his work during this period. Notable ones were at the Del-
phic Gallery in New York City in 1930 and 1932, the first of
which was arranged by his friend Orozco with Alma Reed, who
owned the gallery.

In the very serenity of these accomplishments, he wrote, on
September 2, 1930, to Miriam Lerner, who was living in a small
French town:

Chandler is going to work and study with me for a while. Marriage
was too much for such children. . . .

Sonya is still with me—a record time. Why it is hard to say. So
many reasons enter in. We are compatible, she is sincere, doing
good work in photography, in fact one of my most promising appren-
tices. I desire a life without distraction, to give to my work.

Actually my love at this time of my life is very abstract, non-pos-
sessive: not the result of impotence my dear, so I defend myself to
you!—rather an increasing desire to protect my work from all dis-
tracting elements.

I love you and think of you—Edward.

He wrote in his Daybook on April 14, 1932:

These days are so inexpressibly beautiful, no fog, but yesterday a
quickly clearing April shower, which gathered unheralded, washed
air and refreshed earth. The sun is almost hot, it penetrates luxuri-
ously, one feels to be actually growing, expanding along with the
wild flowers, so profuse this year. I have never seen the oaks such a
tender green, glistening with life, nor the pines so festooned with

candelabra. The wild lilacs are a mass of lavender bloom, wild iris
line the roadside, the fungi are extraordinary in size, color, variety.
Recently at Point Lobos I saw what must be a rare bird, an albino
among its kind, a white jay. In the twenty-eight years I have lived in
California I have never seen one before. At first I could not believe
my eyes,—that saucy, raucous call, the swaggering, jaunty airs, and
that glistening white bird. So I sat me down and watched him quietly
for half-an-hour. He came quite close, there was no mistake—here
was a snow white jay,—only the side of his tail feathers seemed a
shade darker, a light grey or grey-blue. It was a thrilling sight.

My 8 × 10 camera has gone on to Chandler; it served me well for
ten years, all through Mexico, my finest period here in Carmel,—a
friend, through which I have seen and recorded many a fine nega-
tive. But I did not feel sentimental over the parting,—like saying
farewell to an old love, one knows that a new one will come to com-
pensate. And I have already ordered a new camera, the finest made,
a Century Universal, Folmer-Schwing. I think I have earned it.

But this paradise of love and peace and work was about to fall
apart—again. "I am a prisoner in Eden," he wrote.

VII.

On October 14, 1931, "a damp, cold, grey day," Edward Wes-
ton wrote in his journal:

I am returning to old habits, early rising, from 4:00 to 5:00. I hope
this means renewed creative energy . . . Sonya is away, visiting her
parents. . . . She is industrious, thoughtful, sensitive, and loves me,
I'm sure. She has indications of going far in a creative way. . . . Do
I miss her? Yes and no. I miss her as much as I would anyone: but,
though my friends mean very much to me, I have grown away from
any need for their presence,—indeed to be alone is a condition I
welcome, greatly desire. To know that my friends love me and I
them, to see them at rare intervals, is enough. More and more I am
absorbed in my life's work. . . . Praises be that Sonya is a quiet lit-
tle mouse.

There was a certain harsh determination in his entries of late
1931 and early 1932, and one is inclined to suppose a strong
link between sexual restlessness and dissatisfaction with his
place in human society; it's likely that the second is the cause,
and the first the effect. But we must not discount the fact that we
are primates, who, alone among mammals, are not governed in our
sexual appetites—one is tempted to say—by anything at all; but
certainly not by the lunar calendar of oestrus. Love has its greed,
and therefore its satiety. Edward Weston's life may seem replete
with love affairs; yet, when I mentioned to a woman of my ac-

quaintance who lived in that period and in that particular intellectual society, that I was astonished at their number (which I reckoned to be somewhere about twenty, or even thirty), she said, ". . . is *that* all?" I realized, then, how unexceptional the mere number really was. And one cannot really credit Edward Weston for inventing sexual adventure; nor, or so he says, did he ever pursue it as such.

Weston raised a great deal of money to settle his oldest son Chandler, and Chandler's wife and child, in the town of Santa Maria, California, where his son set up a photographic studio. Weston went to visit them, as well as his son Brett, who was then working in Santa Barbara with his wife Eleanor. On May 16, Weston made mention in his Daybook of his latest love—L.:

> After ten days visiting Chan—Max—Teddie and Brett—Eleanor—L. The latter contact, unexpected, at least in the direction it took, and very beautiful. Our meeting on the 8th took a rapid course which left nothing to desire on the next day but a complete fulfillment . . . L. will be here soon. Not so easy, an affair in Carmel. Nor would I hurt Sonya for worlds: she has been too fine and square with me. I must conclude that I cannot remain a faithful husband to anyone. Yet I never go out hunting affairs: they seem presented to me, —inevitable.

A month later:

> Over a month since an entry—and what a month! The consummation of love between L. and Edward. I say "love," meaning no less. I feel that few humans are granted such good fortune in finding and knowing each other. L. wrote me she was coming north. I found pressing "business" in S. F. We met on the train at Salinas. That night, it was May 25, we came to know each other. . . . A gentle rain is falling— as it was when we last parted. But this time there is no definite future. A farewell note came yesterday, just a month, to the day, from our first night together: "A temporary au revoir," she writes. And: "Bless you, my love, I take you to me and I love you with my whole being—Your L." . . . What can be the meaning of all this!—this cutting short of a stalk just starting to bloom? Is this love to but live in our memories,—or is the cutting with reason, a test?—or to force our roots down into richer, firmer soil, a preparation for future blooming?
>
> I ask myself, if I had been free, would I have allowed L. to go to another without protest? I am sure not! And she, being loyal, having some real or imagined obligation, would have been torn asunder. And if I had "overpersuaded" her, successfully—what then but sore hearts, scandal, to who knows what end?
>
> Sonya is my problem. I love her now as a *best* friend, a true one, never was there truer. But would she accept this change? She has given me the most peaceful "married" life I have ever had, three years of it. She has stood by me, worked for me, saved for me. We

are companionable, physically and mentally. Why then this desire to change, to go from a comfortable arrangement, a reasonable adjustment, into the unknown!? Or should I say unknown? Do not L. and I know each other, even though our days have been few together? Yes!

> I have been "untrue" to Sonya once before: the first year. But I knew the adventure for what it was, a passing excitement. W. and I met at a party. Wine and familiarity, her evident willingness, my curiosity, led to a week's "romance." A difficult one to achieve. Climbing out the window after I had retired for the night. Creeping up the creaking studio stairs. Getting safely back to bed. I was a welcome rebound from her first affair. She was a charming child, who had been well taught. There was no basis to continue on.
>
> But recently, before meeting L., on the way to a party at the Highlands, I sat in the back seat of a car with P. She snuggled close, dropped her head on my shoulder, and I, almost too astonished, caressed her hair. I had known P. for three years, with never the slightest hint of this. But I was willing—no great desire—more curiosity. I photographed her soon after. Kisses followed. We went to a cottage in the Highlands. Once there, she said, "No, it's not the right time." I was but slightly impassioned, so shrugged my shoulders,—to myself: could she come to my studio at night? I hesitated,—there was no hesitation with L., for her I would take any chance. Finally I gave her a key, which has not been used. Never the "right time." A psychically different person, P. Admitting she likes to make the conquest —wanting my assurance that I would do anything without being shocked—explaining that she loved to sleep with a man without doing anything—that she liked women too—In fact I don't think she was sure what she wanted. And I was not interested enough to press "my" suit. Lately she has shown renewed desire. It's too late. I am too filled with L. I will be true to her "in my fashion."

Then, on July 6, he feels the sting of his mid-American conscience:

> Fog, thick, wet, has shrouded Carmel for almost two weeks. It has brought to me most definitely that this is no permanent place for me. Will any one place give me lasting interest, a home? Or any one woman? Strange question, the latter, following my recent love affair. But now is just the time to question. I do doubt my ability to remain for long in one place. The very nature of my work, requiring fresh fields to conquer. Or am I making excuses for a desire to change that has come over me?
>
> I know that I have homemaking instincts, yes, and marital ones. I should have a permanent home to return to—and a wife to return to?

The affair with L. (very likely, Lois) had its own problems:

> L. has been in a serious mental state, and I seem to be, and gladly am, one of the few points of contact which might lead her to a rebirth.

But, by January 18, 1933, even the weather was encouraging:

Pouring today; much needed,—this rain . . . Sonya has gone. . . . Just Neil and I left. It is well. I like to be alone; it has connotations of adventure! And this rain augments the feeling I have of something pending. Maybe Sonya is having the adventure. I hope so; then my conscience might be eased. But am I not expressing that thing one is *supposed* to have,—a conscience? Actually, I have never felt guilt over my philandering; only a desire not to be discovered for *her* sake; not yet at least. And I could feel quite as guilty toward L., from whose arms I went to H. in L. A. To be sure, it was unpremeditated, and we had both reached a delightful intoxication but that does not absolve me from the guilt I should feel,—and don't! Yes, and before going south I made love to both S. [Sybil] and X. [Xenia]! Am I then so weak that I fall for every petticoat? Am I so oversexed that I cannot restrain myself? Neither question can be dismissed with a "yes." First, I can go long periods with no desire, no need; then I see the light in a woman's eyes which calls me, and can find no good reason —if I like her—not to respond. I have never deliberately gone out of my way to make a conquest, to merely satisfy sex needs. It amounts to this: that I was meant to fill a need in many a woman's life, as in turn each one stimulates me, fertilizes my work. And I love them all in turn, at least it's more than lust I feel, for the months, weeks, or days we are together. Maybe I flatter myself, but so I feel. So what will you answer to this, Sonya?—and L.? L. is my most difficult problem; for I am in a position which amounts to saving her sanity, if not her life. I am not conceited in this; it is all too true. She lives for the day when we can be together. And if it can become possible and I cannot remain true to her—from past records it would seem improbable—what then? I love her, yes, but so have I loved others; and they all pass, not the love, but the emotion, the flame. I love Sonya, but only with tenderness, the calm affection of a friend. And that is not enough for most women, not even the emancipated; they are basically conservative no matter how intellectually radical.

The very next day, Weston made a fascinating connection between his work and his loves: he had gone to Los Angeles where Merle Armitage took him around to promote the new book, which included thirty-nine Weston plates, splendidly and carefully reproduced:

> It has been a veritable sensation. If I could not detach myself, hear the applause as one of the audience, I might be sunk by homage. But even when I think the praise deserved, something always answers within me, "Well, what of it?" Maybe even this is vanity! However, I think not. This book, like an exhibit, marks the end of a period. I turn the pages, each plate an old friend, each recalling redletter days,—and know that I must go on from these, leave them as I leave my love affairs, still loving them, but with no regrets.

Upon his return to Carmel, he began the new month on a note of exhilaration:

> The first of February opened to a new page in my book of loves: S. came to me! We had hours of exceeding beauty. I could easily wax emotional! How we can continue I can't foresee; the danger in her coming here at night is too great,—would be fatal to both of us if she were seen. And her striking carriage, her Junoesque figure could be recognized from a block away.
>
> I have worked with my new 4 × 5 Graflex: made sittings on successive days of Sybil, Sonya and Xenia.

To this confusion of love and photography, we owe a great many of Weston's 4 × 5 nudes, which, in his own words, "Go beyond any I have done."

> I slept at home last night—or should I call home the place where I become domestic, where I eat and sleep by the fire afterwards?—But I slept none too well and arose at 5:00. My life has been crowded every moment these last weeks with work and adventure. A new love seems always to bring with it new work! And so it seems to be working out. How I am going to take proper care of three women remains to be seen. I place my difficulties in the hands of the good Pagan Gods. The coming into my life of was dramatically sudden. I had always felt that it would happen sometime; I have been drawn to her for three years,—since she was a child—albeit a mature one of sixteen. And she was attracted to me, that was evident. I sensed her virginal desire for experience, and wanted to initiate her, but at the time there were—or I thought so—too many difficulties. Then she went away, returning after a year or so,—with experience. Seeing the light in her eyes, I soon found a way to be with her alone. There was no resistance to the first kiss. But still there were difficulties,— or again I thought so; Carmel is so small a place! Matters drifted along, with only an occasional surreptitious embrace,—until Saturday night (2:25) when—slightly tight—"bingy" she called her condition—she took the initiative and came to me.
>
> I had just returned to the studio, tired from a sitting of Robin, had turned back my bedcovers, when a tap-tap came on my door. I turned on the lights and quickly turned them off, seeing who stood there, and sensing at once, why. She was delightfully the child, though a very poised one, in explaining her call. She was delicately apologetic for coming to me, yet direct and frank;—not the least brazen. She knew what she wanted, and what I wanted—but she knew my difficulties and so cleared the way.
>
> I assured—that having acquired knowledge through experience it was obviously a duty—and a pleasant one—to hand on to her all that I knew! So we wasted no more time in talk. I am not exaggerating when I say, that she had the most beautiful breasts I have ever seen or touched; breasts such as Renoir painted, swelling without the slightest sag,—high, ample, firm.
>
> —stayed the night. We slept but little. She moved me profoundly. A dear child, with a desire to learn, no inhibitions, much passion.

But nothing, at the moment, went any further; she was a delicious adventure, like the other letters of the alphabet. His work continued. He did three drawings—"all to do with myself, my subject matter, and camera"—and sent them to the Beaux Arts Gallery in San Francisco which was having an exhibit of non-artists. He then planned a trip to New Mexico with Willard Van Dyke and Sonya, but remarked that he had to go to Los Angeles first, to do some portrait sittings, "and to see the children, and L."

Sonya was now his safety catch at home, and his protection against the lovesick maidens hungering in the woods:

> At the very height of all my recent work, when I was near to physical and mental exhaustion, I received a letter from L. asking me to come to a definite decision, write her my intentions. It was the last straw! But it brought much to a focus. I wrote in a more definite way —albeit a bit hysterical—than I would have at a calmer moment. I gave her to understand that the possibility of our actually living together was more remote than ever; that if we ever did, she must realize that I have never been noted for my constancy; that now my greatest desire and need was to be absolutely alone for awhile,—that I had been too long pushed and pulled in every direction,—that I could not stand another responsibility, another complication. And then I asked her for once to be the strong one, to help me, as I had tried to help her. I knew she would either rise or fall on this latter request. And she rose! Told me that my letter was the best thing that could have happened to her. It must have given L. a hard jolt, such as she needed,—we all need at critical times.
>
> I suppose my enthusiasm of the moment, plus desire to help her, even save her, led me to give L. false hopes. Will I ever learn to be careful!?

They were poor, as usual. Sonya cooked and shopped and managed, and worked in the studio, as well. They bartered prints for food. Sonya once did a portrait of a truckman in return for a load of firewood. When he brought the print of his sweating, tieless face to his wife, she sent him back to have it done again—this time he wore a white shirt and a tie and carried a small hand mirror to check on his appearance after the plate was taken.

Still, the cruelties of the Depression affected the household less than one might expect. Although Weston was in a marginal occupation, Carmel, then as now, was inhabited by people with money, and while the Depression certainly worried them, they were troubled more by their consciences than by their stomachs. Edward Weston, with his farmhouse domesticity and his largely vegetarian habits, was able to get along on very little. Welfare payments, to families on relief, were about four dollars a week per person, but the Roosevelt government, concerned about the growing anger of the intellectuals, gave intellectuals jobs at a somewhat higher rate. In January, 1934, his friend and publisher, Merle Armitage, who was a Regional Director of the Fourteenth Region of the Public Works Administration (a curious branch of the U.S. Treasury), got Weston a job:

> Dear Edward:
>
> Greetings! You are on the payroll of the Public Works of Art Project, as of yesterday, January 11, at $42.50 per week. The fiscal week is from Thursday to Wednesday inclusive, so your first pay check will be in your hands on Monday, January 22, unless you happen to be in Los Angeles on Saturday morning, January 20. In that case (let us know if you are coming), we will hold your check here, and will issue it to you Saturday morning at the time of our regular "pay-off."
>
> Please get yourself sworn in before a notary (oath of office inclosed) and return it to us PDQ. Notaries here are making special fee of 25¢ instead of regular 50¢ charge.
>
> Use your own judgment as to what kind of work you want to do, as long as it can reasonably come under the heading of "The American Scene." Let us know your plans.
>
> Regards, Merle.

Weston did some landscapes for the "Project," but grumbled when he had to go down to Los Angeles to photograph frescos and paintings:

> Such halcyon days could not last. Merle was actually overstepping his privilege in putting me on as an artist . . . I went down twice; exciting at first, though hard, exacting work, long hours; but finally I resigned, for it seemed senseless to be down there, the while I was supporting my overhead here, and chancing the loss of sittings, one of which might more than equal a month's work on the P.W.A.P.

It's tantalizing to consider how little effect the Depression had on Edward Weston's attitude toward his work. It was not a question of insensitivity: I think he simply saw no way to incorporate disasters into his aesthetic. It is a commonplace in science that new theories never convince by mere and probable truth. What happens is that the older scientists simply die off; the young accept the new constructions, and in their turn, hold onto them for an academic lifetime. It is a humbling truth that our work and our attitude toward it, and the habits connected with it, are the most deeply conservative of all human values; as deep as the customs of food and drink, and perhaps connected with them; and far more invariable than sex.

The Depression did have its own photographic conscience. The talented group of photographers assembled by Roy Stryker,

of the Farm Security Administration, were men and women already committed to social observation; which, of course, was already a broad tradition in photography, and one invented by the amateur: by the social reformer, the anthropologist, and the explorer. The angry, positive tone of this tradition was expressed by Rexford Tugwell, years later:

> It was clear to those of us who had responsibility for the relief of distress among farmers during the Great Depression and during the following years of drought, that we were passing through an experience of American life that was unique.
>
> At least we hoped it would be unique; and we intended not only to bring the resources of government to the assistance of those who were distressed or starved out, but to make certain that never again should Americans be exposed to such cruelties.

The most interesting of the dozen photographers, born of this era, were Walker Evans, Dorothea Lange, and most especially, Ben Shahn, whose photographs, to my mind, are a good deal more important than his painting. Evans saw and recorded the bleak and touching minutiae of Appalachian life: the nail in the plank, the figured oilcloth on the table, the ragged dress, and the curiously blind gaze of the sharecropper. Lange, on the other hand, gave the poor a beautiful and frowning dignity, while Shahn caught something else on his negatives—the surrealist patience of personal disaster—the dark, shaded look between cap and stubbled beard; the stained windshield of the open Ford that cuts a woman's face into two visions. In these photographs the generalization is bound to, and is one with, the scratched, used, dusty detail. However, this was not Edward Weston's eye, and we have no record of his comment upon these widely published photographs; nor can we blame him for this. His attention was on the arrow, not on the bowman, nor on the victim transfixed.

He resigned from the P.W.A.P. after several months, to return to his own work; but the experience was not without its pleasure:

> I had two delightful adventures in Los Angeles; one a renewal with X., a memorable night; another with a most passionate, and pathetically repressed virgin. This adventure, started just before I left, never reached fulfillment. I feel that if the time had been propitious, and with more time, the story would be different. X. on the other hand is delightfully unmoral, pagan,—a grand person to love.

All was as it was before; except that it was not. On April 20, 1934, he wrote:

> The busier I am, the more vital and interesting my life, the less time I find to write down my experiences, naturally. Since January, so much has happened. Perhaps most important, from the effect it will have upon my future, is the step I took to regain my personal freedom and its achievement. First L. wrote me,—a sadly beautiful note, telling me that she realized that we could not go on, that we must start on another basis. She must have sensed this from our last contact. When I have nothing more to give, I do not easily simulate. My reply must have been too unemotional, showing all too ready acceptance (I had made up my own mind months past), because her answer showed that I had caused her a great hurt. Oh, these difficult relations which involve the tragic—because misunderstood—differences between man and woman.
>
> This step toward my freedom, though I did not literally take it, I actually did. She sensed that I held out no hope; this plus my lack of ability to act a part unfelt, caused her to take the initiative.
>
> But I did take the first step with Sonya. On our fifth anniversary, April 17, just passed, I wrote her frankly that I must have my freedom, that I could no longer live a lie; of course granting her the same. She rose to the occasion in fine spirit, better by far than I had expected, considering her jealous nature. Perhaps she too had already realized, and become partially reconciled to the fact that she would always have to share me. I told Sonya, and mean it, that I had no desire to live with any other woman, that she was an ideal companion; but that others in my life were as inevitable as the tides, that I rebelled against being tied, that if her jealousy stood in my way, we would have to part.

It reminds one, somewhat unkindly, of Mr. and Mrs. Charles Darwins' quarrel about God, when their relationship came to leaving letters for one another in their common kitchen.

The truth was rather simple: in December of the previous year, Weston had met a young girl, Charis Wilson, who was the daughter of a (then) famous and well-to-do popular novelist, Harry Leon Wilson, who lived in Carmel and owned extensive property there:

> On April 22 a new love came into my life, a most beautiful one, one which will, I believe, stand the test of time.
>
> I met C. [Charis Wilson]—a short time before going South on the P.W.A.P. work, saw her at a concert, was immediately attracted, and asked to be introduced. I certainly had no conscious designs in mind at the time, but I am not in the habit of asking for introductions to anyone which means that the attraction was stronger then than I realized. I saw this tall, beautiful girl, with finely proportioned body, intelligent face, well-freckled, blue eyes, golden brown hair to shoulders,—and had to meet her. Fortunately this was easy. Her brother was already one of my good friends, which I, of course, did not know.
>
> I left for the south before our paths crossed again. While there, a letter from S. said she had a new model for me, one with a beautiful body. It was C.—Poor S.—How ironical. But what happened was inevitable.

The first nudes of C. were easily amongst the finest I had done, perhaps the finest. I was definitely interested now, and knew that she knew I was. I felt a response. But I am slow, even when I feel sure, especially if I am deeply moved.

I did not wait long before making the second series which was made on April 22, a day to always remember. I knew now what was coming; eyes don't lie and she wore no mask. Even so, I opened a bottle of wine to help build up my ego. You see I really wanted C., hence my hesitation.

And I worked with hesitation; photography had a bad second place. I made some eighteen negatives, delaying always delaying, until at last she lay there below me waiting, holding my eyes with hers. And I was lost and have been ever since. A new and important chapter in my life opened on Sunday afternoon, April 22, 1934.

Charis Wilson's response was a young girl's poem, naïve, honest, and clever:

What time ago was it
I thot, hoped, began (slowly) to believe—
What time ago could this have been when now
I am so full of you
I make no gesture freely
My thots curl round your eyes
And catch in clouds inside your eyes
And your eyes look out of me at
Me looking out of them at you
And so
What time ago.
12M4232434

The letter and numbers are a code Charis invented; the small deception of troubled lovers. I would decipher this sequence to mean: "12" midnight, between April 23 and April 24, of the year, 1934. Sonya was still living with Weston then, so for Charis there was the uncomfortable routine of signals, infinite minutes of waiting, and, once in a while, rapturous chance; but not often enough:

74,520p
. . . which means I've just left you, and am in my official surroundings—not feeling at all like going up to the house, working on songs, talking to the family, explaining where I've been all afternoon and cetera.

I'd rather sit here for an hour and write and then go buy a sandwich and drive down to the beach and eat it, and swim and walk and lie in the sand and think and feel and generally go to pieces as we have it

you just walked by below and waved. god how I resent it. This being without, the interminable barbed-wire fences and keep off the grass signs. there's, after all, no use talking about it, or being irritat-

ed by it, or resenting it. I think we can always get what we want if we want it enough. There is a lot to be said about wanting. . . .

And when he had gone away:

61,734,525 p
all of which if you remember how to read my key signatures means that you left about fifteen minutes ago. we went back into the house and she said i hate goodbys and i was casualashell while watching her looking for something. else. im up in my office now wondering if a vacuum knows how much emptier i am right now than a vacuum ever is. i'm supposed to be doing the sales report now, and then she is coming by and we are going to the fiesta and i hate it and wish i weren't going but as long as i am i hope i get tight, tho not so tight that i wont be able to work tomorrow. tho i know i wont be able to

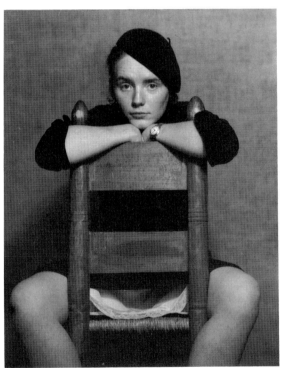

Charis, 1935

work tomorrow anyway and you know why or if you don't you should. It would amuse me to finish this and mail it as I mail the report because She will be with me and would see me mail it, and oh hell. I'm sorry to be prattling on like this but its only because I feel so nastily empty inside rather as tho id like to cry which wouldn't be any help to anyone. I'll stop acting like a godamfool now,—I apologize.

Sonya, no doubt, knew what was happening, and in her painful dignity, chose to ignore it. Yet when she and Charis were together, they would quarrel over a word (the word Charis used was "epexegetically"), with Sonya and Hagemeyer on one side, attacking Charis on the other side. Charis was a new sort of a person,

common in Europe at the time, but just beginning to flourish in America: well-to-do, well-educated, quick, frank, aristocratic, but coarse and open about sex and the less interesting functions.

If she kissed Edward Weston's grown sons in public, it was a mock lesson—the kisses were not strictly maternal. She thought of herself as a sexual hell-raiser and, interestingly, thought Weston's sister May was, too. Some of Edward Weston's friends liked her extremely; and some did not. But her effect on Weston was overwhelming. He would do anything for her but marry her. The notes he wrote to her are not yet available, but when Charis Wilson writes the book of her own life, I would guess that it will confirm this judgment. The disparity of their ages was dramatized by Weston in a camera study of an arrangement on a table: a Japanese straw slipper hung on a white sake bottle, a cup, an envelope partly addressed to Charis, another letter with a wax seal, a 5.6 Plasmat lens, Weston's pince-nez glasses, a Mexican box that contained love letters, and two sets of Edward Weston's writing, including a chart which he had drawn up.

This seeming mystic chart simply referred to the relative distance between their ages as they grew older. Yet even with this dispari-

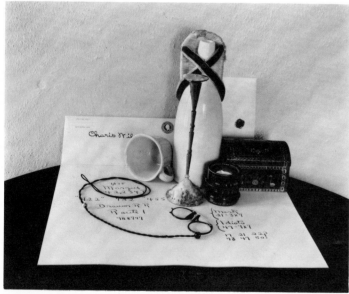

Valentine, 1935

ty, their attraction for each other was very strong. Edward Weston was at the top of his career, famous and loved; Charis was exceptionally beautiful and, by no means, shy.

Weston made few nudes between 1928 and 1933; his eye was bent more toward the great peppers, rocks, and trees. However, in 1933 he made sixty-two nudes; in 1934, another sixty-eight; and

twenty more in 1935. In 1936, he returned to the great dunes at Oceano and photographed Charis in a glowing series of odalisques. The texture of Charis's body and that of the sand seem interchangeable—warm and fine, in the simplicity of black-and-white, not only the same texture, but almost the same scale. There is love in these body portraits, faceless though most of them be. The woman is sand and mortal; the sand is sensual and immortal. Together, looking at several in succession, dunes and women interact in a terrestrial and immobile dance.

For all this happiness in work and love, money problems still depressed him, as did the feeling that old relationships were fading away. He heard little from Sonya and Ramiel, for instance, and longed, in his own peculiar way, to "step out" again and renew old friendships; instead, he immersed himself more and more in his work.

During the early years of the thirties, Weston made a series of portraits, "each one a success, I would say." A good number of the sitters were famous persons: James Cagney, Gary Cooper and his wife, the powerful little flamenco dancer Carmen Amaya, the great Los Angeles dancer Carmelita Maracci, Robinson Jeffers, Orozco, the dancer Harald Kreutzberg, Muriel Draper, Gieseking, the San Francisco philanthropist Albert Bender, Jean Charlot and his new wife Zohmah, and Igor Stravinsky. Weston had also met and spoken with the great dancer/choreographer Martha Graham, but she alone refused to be photographed; curious, because both she and Weston were at pinnacles in their careers. It may be that she was afraid that Weston would want to photograph her nude and she would never permit it—with the exception of a single photograph by Imogen Cunningham—thinking her body unattractive without the marvelous drapery of her costumes.

In June, 1934, restless again, no matter what the pretext, he moved away from Carmel and opened a studio with his son Brett in Santa Monica, a beach suburb of Los Angeles. He wrote to Miriam Lerner, by this time an art editor for *Asia Magazine* in New York City; the envelope was sealed with black wax, and enclosed a tiny rose: "Are you not amazed to receive a note from your viejo amor?" He wrote her again, to say that he hoped to get a U. S. government job, "doing soil erosions . . . but we couldn't come to terms." He added, gallantly: "I'll never forget you—the days—the nights—"

Most love affairs grind down into locked positions of mutual hatred; it is in the very nature of their illegitimacy. Edward Wes-

ton refused to let this happen. He continued to write to many of his old loves, easily and tenderly, and they often answered him the same way. He wrote to Sonya after they had parted, sometimes by letter, but more often by penny postcard:

Sonya darling:
The robe is worthy of all superlatives. I am very much excited over it,—the first decent bathrobe I have ever owned. Thank you dear girl for a beautiful job . . . I thought to see you down here ere this. Still a possibility? I hope so. Almost, no, over a year since we have met.

Harald Kreutzberg, 1932

Robinson Jeffers—Tor House, 1929

Jean and Zohmah Charlot, 1933

If you don't come soon we may be moved. The Landlord has raised rent, so I may leave by the first. Matters are not so good now. Back to beans. Certainly have had ups and downs this year.

You will like my new work done at Dunes, Oceano, also new clouds. . . . As you can imagine, the Olympic games have greatly interested me, especially the Ethiopian front.

Expect to see Marcel Duchamp tonight at Walter's, which event I'm anticipating. . . .

My love ever—Edward.

Late in 1936, under the prodding of Charis Wilson, he applied for a Guggenheim Fellowship. In a note to the editor of *U. S. Camera* (written two years later), he wrote:

My project was purposely worded in a manner which left me absolutely free to do anything I wished to do from a cloud to an old shoe. My "desire to go out and make a picture," with no restrictions of time, place, or money, was the reason I applied for the Guggenheim Fellowship in the first place. . . . In applying for the fellowship I stated that the work I wanted to do could be just as well done in Alaska or Brazil,—I chose California because it offered tremendous variety and would be less expensive than foreign travel.

On March 18, 1937, the Guggenheim Foundation wrote him:

Dear Mr. Weston:
I am delighted to write you that today the Trustees, on the nomination of the Committee of Selection, appointed you to a Fellowship of the Foundation in the following terms:
Project: The Making of a Series of Photographs of the West.
Period: Twelve months from April 1, 1937.
Stipend: Two Thousand Dollars. . . .

It was the first award to a photographer in the history of that Foundation, and surely long overdue. But two thousand dollars, even by the standards of that depressed year, was hardly enough. The awards were based on living costs for writers and painters and historians, and took no account of a photographer's technical needs. As Charis noted:

Edward's equipment is simplicity itself, but take the single item of films: 8×10's—by the case—come to twenty-seven cents apiece. In the months we had spent planning this campaign, we had distributed and redistributed the dollars and cents until they made for a maximum of photography and travel. Trailers and station wagons had been dropped early in the reckoning, and along with them, hotels, autocamps, and restaurants.

By following the seasons we expected to camp out most of the time. We got cheap kapok sleeping bags and a small tent, the latter for use when it rained or when we wanted to maintain a permanent camp for awhile. But the back-to-nature movement was to stop short of camp cooking; to save all the daylight hours for photography we needed food that could be simply and quickly prepared. Canned food was to be our mainstay, supplemented with ready-to-eats such as dried fruits, cheese, crackers, honey, nut butter. A two-burner gasoline stove, a nest of cooking pots and plates, and a thermos, made up the culinary equipment; a bucket, a five-gallon desert waterbag, a pint canteen, shovel and axe, railroad lantern, and flashlight, completed our outfit. Total cost: fifty dollars.

In spite of all these economies, they had to buy a car that would run. This problem was solved by the editor of *Westways* (an illus-

trated house organ of the Auto Club of California), who agreed to buy ten photographs a month for his magazine. So the year's travel was now a certainty; but not for Charis. Three weeks later, she wrote Weston a letter, though she was still living with him in Los Angeles:

Perhaps in writing the words will come out that fail me in speech. Now, as you go out the door, I am still on the fence, wondering and hoping.

I wrote long ago (and once said to you)—love (to me) is a building—two people build a structure—each must bring equal bricks and build equally—till one day one will tire of this and pull the whole thing down—

And now I know something of love I think the same. And today more than ever I know the heights that can be reached—and want this for us.

And it's you Edward—I love—and want to build with—and it is what I want for my life—where I want to go—

And now I feel we should both say for a last time—yes or no. . . .

Humbly Edward, I beg you to tell me what you want most—with no prejudice for what I feel and say—simply the truth of your wanting. Do this for me because I love you.

Charis

What she meant, of course, was marriage; but she didn't use the frightful word. In reply to this moving and courageous letter, Weston began the legal proceedings to divorce Flora, and with this promise, Charis agreed to go on the Guggenheim trip.

Cole Weston, who was eighteen at the time, and, despite a family tradition, had graduated from high school with honors, was elected to do the driving. They headed for the desert—Death Valley, in fact. The trip itself, and the second one, financed by a renewal of the Guggenheim the following year, had none of the personal drama that usually surrounded Edward Weston. The account of the travels, written by Charis in the book, *California and the West* (published in 1940), is delightfully chatty, readable, and full of the anecdotes of rustic characters. The flavor is "honeymoon America," all the more extraordinary because the two protagonists are Edward and Charis, both colorful personalities, living together in the relentless intimacies of "making camp." On April 24, 1938, in the town of Elk, California, he and Charis were married. He wrote (in a postcard to Sonya): "Just returned from North Coast with one-hundred-and-one new negatives and a bride." His announcement to Miriam Lerner was the same:

Dearest Miriam:

Just returned from last "Guggenheim" expedition with 100 new negatives and a bride! You may have read—it was supposed to be a secret!

I have often thought of you, but thinking of my closest friends—and you will always be—is about as far as I get. To write a letter is an event.

I am now faced with printing 500 of my fellowship photographs for a permanent collection in the Huntington Library. Working "odd moments," this will take me from one to two years—I asked for three.

Besides, I have a monthly article for *Camera Craft* and a twenty-four-page feature for the next *U. S. Camera Annual*. Betwixt and between I take up my old grind of professional portraiture. Not that I don't like to make portraits, but—. . .

Tina has cut off all of her old friends. I have not heard from her in years—I think she is right considering her place and position. She would not be the same Tina to us, we would not be the same to her. Better to have memories.

Me too—I have been a (nonpolitical) anarchist since my twenties. But we are pretty well alone these days. . . .

Kisses, love, and "powerful" embraces to you darling—and a hope that it will not be too long—Edward.

Edward Weston made upward of fifteen-hundred negatives in the first year of these travels, and returned to Carmel later in 1938. His sons—mostly Neil, for he was the marvelous craftsman

Edward Weston's Home, Carmel Highlands, 1940, by Beaumont Newhall

in the family—built them a simple house on Wildcat Hill, overlooking the Pacific Ocean, on land owned by Charis's father. Here he began to print from this plenitude. His attitude toward his photographs was rather benevolent:

Anyway as a photographer, I couldn't let you think that I *had* to do several hundred pretty-pretties to get a wow—that I worked with a blind spot at any time. I sometimes fool myself technically—landscapes are the most difficult things to consistently achieve what you

propose to—but I rarely fool *myself* in seeing. God knows I may fool others!

One thing I don't think you got from seeing the prints so far done from my G. years—and that is my approach, my attitude, which I started with and held to during the year. Briefly I might state my "case" as this: that I would—and did—do anything that appealed ·to me during the year even though I knew it had minor importance. I did not *have* to do the lesser things in order to achieve the ones with an "umph"; I did them because I felt—and feel—they belonged with this kaleidoscopic, mass-production year, for which I had a more or less definite plan. But there is one thing in which my whole philosophy (if I have any) is involved; that I must and do know on the ground glass before exposure whether my result will have ughgh. I am not God Almighty, but I am seldom fooled.

Question comes, should I show the minor results? Yes and no. Yes, because they were made to be seen, but only if someone wants to browse for a week, get "ug ghh" from the highlights and be pleasantly entertained by the halftones. No, if I have a one-man show of 50 prints, or someone is here for only an hour and I wish to knock 'em dead, or if a book should be published with only 50 to 100 reproductions.

The photographs themselves present an interesting problem of evaluation: for one thing, in spite of our sizeable population, our enormous cities, and our position of power equal to any other country in the world, the United States is still relatively empty, particularly in the West. There, barren land and desert is broken only intermittently by mountain, submarginal farm land, and a fair number of towns crowded into four corners. This fact, graphic indeed when one flies from coast to coast at night, where the inhabited places are lit by arrays of lights with the sparkle of false jewels, is perfectly evident, too, when one travels the back roads, mile by asphalt mile.

In my opinion, therefore, Weston faced a somewhat different problem with the Guggenheim assignment than he had dealt with previously. The sculptural mysteries of Point Lobos, the incunabula of peppers and squash, the cabbage leaf as ribbed as an ancient mountain, the concentrated and voluptuous lines of a nude that seem to converge with the unseen magnet of the *mons veneris*—these are not native to the endless horizons of the open West. The photographer must rely, instead, on three other photographic qualities: the variety and contrast of tonal values; the extension of sky and distance, beyond that which one sees within the frame; and finally, human contexts and connotations.

Of the last, there are a fair number of examples: rural jokes; a

giant Hot Coffee cup; relics such as a burned car, a dead man with the beard that sprouts in *rigor mortis*, the arches of the abandoned house at Rhyolite; and the implied idiocies of a motion picture set (which is, in fact, the most functional of the five photographs I've cited). On the whole, though, this series represents a small percentage of Weston's Guggenheim negatives. In fact, one is led to believe that they were not intended, as a nude or a shell would be, as individual experiences for the viewer, as they

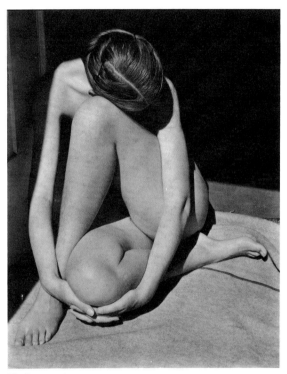

Nude, 1936

were, no doubt, for Weston. The Guggenheim landscapes, by analogy to the way he saw them, should be seen one after another, viewed as beautiful tracking shots; a continuity of experience rather than an intensification. By way of comparison, Weston's shell photographs had a typical exposure of four and one-half hours, while the Guggenheim landscapes were generally exposed for a single second. In this context, one photograph meets and overlaps another in the mind; the individual photographs—very clear and beautiful—together form a landscape. There are, of course, exceptions: the false hellebore in a close patch of blossoms, where one can almost see, so strong is the sensation, pale green and creamy white; and at the opposite pole, the wooden slaughter wheel, where the carcass was hung to be butchered, with two more wheels in the foreground through the spokes of which one sees (finally) the horned skull of the animal, peeled

and eaten a generation ago.

Given these exceptions, and there are others, one would be stupid to state any absolutes about the work of so foxy a genius. The four hundred prints that Edward Weston made on commission for the Huntington Library, from his Guggenheim negatives, are, in a mnemonic sense, a composite panorama of the original, empty, dry, western America, and as such, are generally more popular than much of his earlier work.

For six years after their return from the Guggenheim Project, Weston and Charis flourished among the cats and flowers and fogs of Wildcat Hill. As Nancy Newhall (who was Photographic Curator at the Museum of Modern Art) wrote when she was introduced to the Westons by the photographer Ansel Adams:

> It was dark when we reached Carmel . . . Charis, her long hair loose and shining, came out to greet us. . . . There were jubilations and embraces. Then we all went into that wide-roofed room and the firelight. Supper was a celebration. Afterward, Charis showed us the half-finished text of *California and the West*. Then Edward set up a simple easel, adjusted the light, put on a green eyeshade, and began showing us some of the photographs selected for the book. They were brilliant; the variety of vision was astonishing. . . . When the prints were safely back in the cabinets, Charis opened the firewood hatch and called. Cats began to leap in, so fast they became a torrent, cats of all sizes, colors, and ages. . . . The Weston way of life, we learned, involved the minimum time and effort in the kitchen or at the dishpan. Breakfast was coffee; you could help yourself to fruit and bread and honey if you liked. Lunch was eaten in the hand—a hunk of cheese, a few dates, an avocado. Around four o'clock, when light gets bleak in the west, there was a cry for "Coffee!" At nightfall, all hands dropped work and joyously collaborated to make supper a feast. I found this simplicity and freedom exhilarating, . . . we . . . went to Point Lobos with Edward, and to see Lobos with Edward was to see Dante's *Inferno* and *Paradiso* simultaneously. The vast ocean, dangerous and serene, pale emerald and clear sapphire, sucking in and out of caves full of anenomes; tidepools flickering with life or drying inward into crystals and filaments of salt; the cliffs starred with stonecrop; the living cypresses dark as thunderclouds, with the silver skeletons of the ancient dead gleaming among them—and in those days one could wander at will over Lobos. Then as the apocalyptic moments of the fog closed in and became cool twilight, back to the little house and coffee, firelight, the latest pages from the [Charis?] typewriter, and more prints. . . .

In 1940, *California and the West*, with ninety-six reproductions, was finally published. The reviews were warm, both for Edward Weston and for his wife.

As a consequence of his Guggenheim years, Weston got a commission from the Limited Editions Club to travel across the United States and illustrate, with fifty photographs, a very limited and expensive edition of "Leaves of Grass." The "Good Grey Poet" (Walt Whitman) of the Eakins photographs would have been fascinated by Weston, for Whitman, too, was a self created man, who, it is rumored, reviewed his own book three times—twice favorably.

But the astonishing fact is, that in the midst of this full and happy and famous year, Weston's photographs were, a good half of them anyway, astonishingly, and quite frankly, funereal. Many are studies of cemeteries; but even the landscapes and the houses are dank and decayed; the old couples standing on their warped porches; and even the cheerful Edmondson is a sculptor of grave monuments. Was something already wrong? In 1940 he began another series at Point Lobos, but he turned his camera away from

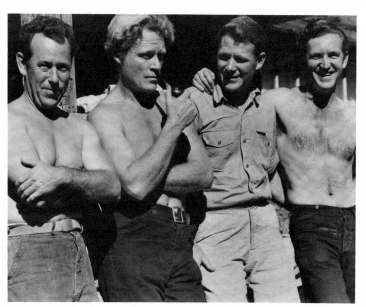

Chandler, Brett, Neil, Cole, 1946-48

the bright ocean and toward the dark and mystical cliffs, toward the fog, the wet stone, and the stonecrop. This group is probably as great as anything he had ever done, and perhaps the best he was ever to do. Minor White compared these photographs to the last quartets of Beethoven. True, but one speculates in what way Edward Weston had become deaf and brooding and fixed upon the eternal. Or was this merely the obsession of all artists, appointed to be our surrogate dreamers, tremblers, and sweaters—to confront corrosion and decay?

Weston and Charis logged twenty thousand miles and twenty-

four states, in ten months, on the "Leaves of Grass" project; and there is no record of the number of negatives shot. Certainly it was far less than in either of the Guggenheim years, but, the logistics of the trip itself were the same: sleeping bags, hand food, outdoor living.

Late in 1941, before their trip was finished, the Japanese attacked Pearl Harbor, and the United States went to war on three continents and a whole archipelago of islands. Those of us who were there at the time, remember that we were going to beat the little yellow men in two, or possibly three weeks. Weston didn't share this enthusiasm. Against Charis's opposition, they went home to Carmel where they remained till the war ended. His sons entered the services: Neil, because of his history of migraines, shipped out as a civilian seaman; Cole went into the Navy; and Brett ended up as a cameraman attached to the bare, new Signal Corps barracks on Long Island. Weston, himself, became an airplane spotter at Point Lobos, which had been converted into a military reservation.

His photography now took a nasty turn. To what extent did he take Charis's bright, acid jokes seriously? There are funny

Nude Behind Screen, 1943

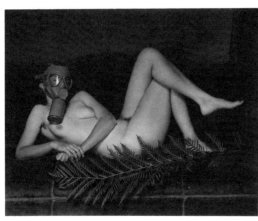
Civilian Defense, 1942

nudes of Charis in a gas mask; funny nudes standing in the doorway of their Wildcat house, with Charis's brother playing a flute in the side window; and Charis nude behind a screen window with two funny broken shoes walking away on the pipe outside. And then there was the cat series: various arrangements of various cats in open boxes; cats and satires—imitation children and imitation jokes. Technically beautiful, they demonstrate, however, the bad taste of technique alone. He wrote to Nancy Newhall, in

angry defense of this latest work:

Sorry to have upset you (and Sibyl!) with my "back yard setups and their titles." You guess that the war has upset me. I don't think so, not more than the average dislocation. I am much more bothered by the antics of some Congressmen and -women, or by radio "commercials." As to Point Lobos, it has been open to the public for months, but I have had no desire to work there. No darling, don't try to pin pathology on me.

Your reaction follows a pattern which I should be used to by now. Everytime that I change subject matter, or viewpoint, a howl goes up from some Weston fans. An example: in the E.W. Book [Weyhe] is a reproduction of "Shell & Rock—Arrangement"; my *closest* friend, Ramiel, never forgave me for putting it in the book because it was "not a Weston." Another example: when I sent some of my then new shell and vegetable photographs to Mexico, Diego asked if "Edward was sick." And finally (I could go on for pages) when I turned from shells, peppers, rocks—so called abstract forms—Merle Armitage called my new direction the "hearts & flowers" series.

So I am not exactly surprised to have you condemn (though I don't get your "Surrealist" classification; now Nancy!) work which will go down in history. "Victory" is one of *the* great photographs on which I will stake my reputation. I could go on, but you might think me defensive. I could explain my titles (I really had fun tacking them on *after* "creation") but surely explanation would insult you; I need not say that "What we Fight For" is *not* what *I* fight for.

But:

—A brief message from your local air-raid warden . . . I have a beard too: it's six weeks old, Charis thinks it's mighty pert. I like it because the color is good—red with white patches, kind of like a pinto pony— . . . We are expecting a first-class naval battle almost any day offshore. We will give you ringside seats on our roof or we can all go out to Point Lobos with lunch and watch from there. Ho, Hum, I'm just wound up, and have a place to go which is the darkroom; and since it's foggy outside, and I can't sunbathe, and I don't want to weed in the garden, I might as well print. Doesn't sound very enthusiastic—guess I'm exhausted after some weeks of nasty printing when everything went wrong . . . Charis . . . thinks nothing, nobody, is worth getting mad over and about,—but I love to get mad and feel suppressed or repressed (Zohmah Charlot would know the right word) if I can't fight or at least talk aloud to myself. I have to go way out among the pine trees where Charis can't hear me if I want to express myself.

The wholesale arrest, forced sales, and transportation of all Japanese, young and old, from the west coast to desert concentration camps, made Edward Weston furious. He wrote to *The Monterey Daily Herald:*

To the Editor:

Destroy Togo and Tojo with my blessing, but I protest with every ounce of decency in me the advertisement you ran for the "Monterey Bay Council on Japanese Relations, Inc." How could you accept such a dastardly approach to race riots . . . and on the eve of the San Francisco Peace Conference!? The rooting out of disloyal Japanese is the work of our very efficient F.B.I., not that of a vigilante group.

Who are the members of the "council"? Why don't they come out in the open? They hide their real intent under a sop to the innocent by excepting "Those [Japanese] in the uniform of the armed services . . . etc." Phooey! Are we to exclude all Germans and Italians too?

I think the "Prayer of Peace" by St. Francis, printed alongside the "council" excrement, should bring many a cynical laugh.

Yours—Edward Weston.

It was a new note for Weston, who had reserved his anger for injustice to his friends.

Tina Modotti, incidentally, had long been in political trouble, and Weston's communication with her was, therefore, infrequent and secretive. In 1929, in Mexico City, while she was walking with her lover, a young Cuban revolutionary named Julio Mella, an assassination squad shot him to death from a moving car. By the exquisite logic of politics, she was deported from Mexico. She went to Berlin, but with the success of Hitler, journeyed to Moscow, and, thence, as a communist party activist, was sent to the political storm centers of Poland, Austria, and Spain. With the disastrous end of the Civil War, she went into a Spanish refugee camp in France, and in 1941, was readmitted to Mexico, along with her second husband, who was also from Udine, Italy. She had had one heart attack, and after a party in Mexico City in 1942, she took a taxi to go home. When the driver opened the door of the car, she was dead. On her tombstone is a poem by the great Chilean poet, Pablo Neruda: "Hermana, no duermes, no, no duermes, tal vez tu corazon"—Sister, you are not asleep, no, you are not asleep, nor is your heart.

This was not the only loss among Weston's extraordinary friends. There were rumors, too, that his friend Ramiel McGehee had died of an overdose of sedatives. On Wednesday, December 29, 1943, Weston got a long letter from Merle Armitage:

The shock of course was the passing of Ramiel. I got a Hertz car and drove down there on a Tuesday, to be informed by his sister that he had gone to bed on the previous Sunday night, and never woke up. We shall both miss him dreadfully. He was a dear friend, and we

had been associated so closely in working on the books, and he was so eager to live and assist me in projects when the war had terminated. Now that he is gone, I wish I could have done more for him, yet I know that considering all my responsibilities, I was able to do all I really could afford, including sending him a check almost every month. However, I shall not grieve over Ramiel. He had a full rich life, and the last two or three years he was not himself. He had lost the zest for living, the Rabelaisian gusto, and as you know, after your visit in 1939, he was far from the Ramiel we had so loved and admired; in many ways, his passing is best for him. But we shall think of him often, and no one will exactly fill his place. When I can, I hope to be able to complete a book of Chinese poems he had laboriously collected and translated, as a memorial to him.

After a lapse of ten years, Edward Weston wrote the last note in his Daybook on April 22, 1944:

Many deaths have saddened these last ten years, but two were especially poignant to me—Tina and Ramiel. Tina returned to Mexico to die. Ramiel went to sleep in his little Redondo home after a long painful struggle. Tina and Ramiel always linked in my mind, always clasped to my heart.

At the end of the war, a friend of his, Dr. Kocher, was returning from the service to his home in Carmel; he was on final leave, and still in uniform. He was very fond of Weston and remembered one of the Weston parties where everyone dressed up as babies, and the prize was a nude of Charis. Dr. Kocher was crossing the open square of a shopping center in Carmel when he saw Edward Weston coming toward him. He marked the slight shuffle of his gait and the forward position of his head, and said to himself, "Parkinson's Disease." The two men met halfway across the square and embraced warmly; they had not seen one another for a couple of years. Weston drew back and said to Dr. Kocher, "Charis has left me."

VIII.

The break with Charis had been developing for a long time and was based, really, on the unexpungeable difference in their ages. Weston complained once about the visit of his little grandson, saying, "I've had enough of babies." Charis, however, had never had a child and could not agree. Yet, as Willard Van Dyke noticed, Weston was very dependent on her:

I once said to her, Charis, quit making yourself so indispensable. Because I had a feeling that she, being so much younger than he,

would not want to stay with him forever. She had a right to want to have children, and he had had his children, and I found that I looked forward to the time that they would separate and I knew that this would be a terrible blow to him, as indeed it was. I think that she was very good for him during the years they were together and I think she had a right, certainly, to her own life.

Deeper, maybe, than this age consideration, was Edward Weston's certainty, held since boyhood, that he was no ordinary person; that he had a duty to fulfill; that the little world of Wildcat Hill should quite naturally swing around him, and not for vain reasons, but simply because he had great work still to finish. Duty and ego were thus sewn together.

Even after the separation, Weston and Charis exchanged letters. One such letter was written to Weston while he was staying at the old family house in Glendale. Charis's letter was typed in italic capitals on Edward's stationery:

Dear Edward:
Your letter makes me realize I have been up to my old trick of trying to put myself in your place and do your thinking for you. I'm sorry if I was preaching at you: I didn't mean to do that.

You say "awaken to a picture of yourself." Do you imagine I have not been scanning that picture in all its bitter, gruesome details, for the past month? And do you imagine that has been a pleasant pastime? My problem is simply to learn how to live like a decent human being—to be my own rock of Gibraltar—and it is going to take hard work to do it. The reason I wrote as I did about you and your plans, is that I have enough sins to account for already, and I cannot bear the idea that in working them out I should be doing further harm to you.

"The house is yours from stem to stern" still goes. I have not reversed myself. If you *want* to live here and *can* live here, I think you should. My doubts on the practicability of it for you were the doubts of that part of me that still stays married to you in my thinking: I don't like to see you in a position of dependence on others for your basic necessities of daily life. I asked you to think carefully about it before deciding, and even as I asked, I realized that it would be impossible for you to do it there.

Please understand, Edward. I have been going through a difficult upheaval: a reexamination of all my actions, ideas, ways of thinking, trying to find myself and to establish—not to "get back to," because I have never had one—a normal way of life.

While I was in the midst of this, I could not see you; for many reasons, but the main one: I have loved you very deeply, and beneath all the wreckage and mess that our union has generated, I still love you. But since we are so ill-adapted to living together, I must force myself to put that love in its proper place in relation to the rest

of my life and activities. And, perhaps because I have become a weak character, I could not do that with you near me.

Now the worst of it is over. There is a long road ahead, much work yet to be done, but at least I am reasonably prepared to face it and am getting my feet on the ground.

So let's begin again on house, property, arrangements, and do it properly. Your letter sounded as though I were pitching you out on your ear, like a Mrs. in the funny paper. *It's yours to decide as much*

Nude, 1945

as mine, and we should be able to work it out in a way that satisfies both of us. We can't do that on a basis of your saying, "Now that I know your desires."

If you think the best and quickest way to get it settled is to come up here now, and talk things out here, then come ahead. I am sorry about being so fierce on the "come to move in or move out" subject, but I was desperately glaring at the amount of work ahead, the little time for doing it, and the need to know whether it will be I who move out or you, so I can really settle down to continuous work.

I desperately didn't want to see you again until I had some problems worked out clearly enough to feel sure of myself. But I am straightened around enough now that I would rather see you at once than feel that you were only agreeing to my dictates on how to handle things. That is the last thing I want.

The kitty Bubbles came today and I and the younger generation are mad about them. Older cats look amazed and distrustful. Also today, more than a dozen more copies of *Minicam*.

The blow indeed was bruising, especially to Edward Weston's friends; it smashed their conception of life on Wildcat Hill—"the little house with the big mood." Weston wrote to the Newhalls:

Dear friends:

You will never again have coffee with Charis *and* Edward on Wildcat Hill. We are divorcing. Charis will stay on the Hill. As for me, I have no immediate plans, in fact, find it almost impossible to make them. . . . This is about the worst time to make a change! . . . We began to break down as a team as far back as the Whitman trip. We have had almost twelve years together, most of them of much beauty. I think the fault can be divided fifty-fifty.

Love and besos and abrazos—Edward.

The letter came as a great shock. Nancy Newhall spoke of their reaction to the news:

We had all been aware of divergencies and discords on Wildcat Hill, but that they would lead to divorce never occurred to us. So suddenly? So finally? That warmth, beauty, simplicity, to which we had all made pilgrimmage—gone?

Ansel Adams, Weston's vital, independent neighbor, and fellow photographer, answered:

. . . both E. and C. are strong enough to meet almost anything, but I can't help feel that it was a potentially wonderful and creative combination, and that something happened which *might* have been avoided. I suppose it boils down to Charis's sympathy for a more intellectual direction of thought as against Edward's consistent naturalism, plus a frustrated maternal complex relieved by all those cats, plus the fact that Edward, subconsciously at least, may feel he is at the end of a creative era in his life and a new era depends on a new orientation. Anyway, I am truly sorry.

In December, 1945, Weston replied to a letter from Ansel Adams:

Dear Ansel:

I have read your letter over and over. It moved me deeply. Men should retain the right to weep when occasion demands.

I will not protest your appraisal of me, my work. I *want* to believe everything you say!—even though I don't think *there is ever a "greatest."*

You are right; neither Charis nor I want or need sympathy. We remain to each other best friends.

Charis and I will I'm sure be better friends as a result of this separation.

More when I see you—Writing difficult.

Love—Edward.

Preparation went forward for his great New York show at The Museum of Modern Art; and for the accompanying book of his photographs, long delayed by World War II. Two hundred and sixty-seven prints were to be shown, with forty reproduced in the museum book (although only twenty-four were finally included).

There had been a minor storm-in-a-paper-cup in the Museum bureaucracy about the inclusion of some of his nudes that actually showed pubic hair. He wrote:

Dear Nancy and Beau:

Note re "public hair" (this is a new classic) considered. I knew of course of post office law. "No one can influence us except by changing our views about what *is* proper," directed in my direction?

By all means tell your Board that P. H. has been definitely a part of my development as an artist, tell them it has been the most important part, that I like it brown, black, red or golden, curly or straight, all sizes and shapes. If that does not move them let me know.

I am getting nowhere fast on the subject of printing. Have ready to ship platinums for show all remounted, about thirty—

My innards are the same—thanks—

In spite of the turmoil, the show opened on February 12, 1946. If, as a consequence of those hairy triangles, the Republic then suffered the popular fate of Rome, it was not recorded. The retrospective was beautifully mounted and designed, and it was reported that Edward Weston, who had flown to New York City for the show. . . .

Sold somewhere between two and three thousand dollars worth of prints so far! Edward feels like a millionaire. State of mind rather better than on arrival. State of health still poor, shocking all friends.

Weston's return to Wildcat Hill, empty now except for occasional sons and cats, depressed him deeply. Every artist will recognize the brief post-work euphoria, and the empty despair and false humility that follows shortly upon it. But in Weston's case, the double disaster of Charis's departure and the slow illness he carried in his neurons, was reason enough for his gloom. He wrote to the Newhalls:

I can do some Ektachromes! Why don't I move? I ask this of myself. Starting all over in a new place is not too easy now. Just thinking of change brings on inertia. I'm sentimental about the place. My major life work has been done here. Just from a "business" angle change would be bad. And there are probably deep down reasons which will not surface. All these thoughts are tied up with what I *would, should* and *can* do!

But enough—

This is a long letter for me to write—

It carries much love—Yr friend—Edward.

Late in 1946, he got out to Point Lobos and did a number of Kodachromes for Eastman Kodak; but he had to persuade himself to do it:

So many photographs—and paintings too, for that matter—are just black and whites tinted. The prejudice against color comes from

people's not thinking of *color as form*. You can say things with color that can't be said in black and white.

I never expected to take up color photography; though I had been unconsciously thinking about it—you don't stop thinking about a thing because you don't do it. George Waters, then with the Eastman Kodak Company, wired me asking if I would be interested in doing one or two photographs of Point Lobos in color. I wired back that I knew Point Lobos better than any man alive but I didn't know color. If he could convince me his product was foolproof, I'd try it out. He didn't wait; he sent me two dozen Kodachromes air express, practically forcing me into it—for which I've been eternally grateful. I spent a couple of pleasant mornings using up the two dozen and sent them to Los Angeles to be processed; I wanted to see what they looked like before I sent them to George. My first batch—I remember looking at them just like an amateur looking at his first drugstore print—"Gee, they came out!" I sent thirteen of that first batch to George and he bought seven—from two mornings' work! I decided I liked color.

Eastman printed these Kodachromes, but on the whole they were undistinguished. He had not yet learned to negotiate this new turn in his career.

Weston's eye was always alert to color however, and he often wrote vivid descriptions:

Tonight a full moon, brilliant, almost dazzling—around it a delicate green light and, still further encircling, a halo of orange. . . .

I am to have one of my dreams fulfilled—a whitewashed room; the furniture shall be black, the doors have been left as they were, a greenish blue, and then in a blue Puebla vase, I'll keep red geraniums! . . .

One carpet of an intense green and red vibrated so violently as to actually dizzy me. I could hardly look at it.

Vision, of course, is primary. Males are often red-green color-blind to one degree or another, but there is another sort of color blindness endemic to museum curators: a snob rejection of color on the grounds that it is all a form of *Kodakitsch*. This is photo-secession all over again, and makes no distinction between the millions of backyard-green-grass-blue-sky-baby-in-a-cute-yellow-bathing-suit color photographs, and the hundreds of beautiful and sensitive color prints made by amateurs with the same stock.

Weston, with his developing illness, did not do good color work until three years later, when he then began to use 8 × 10 Ektachrome transparencies. He sent this note to Bruce Downes, a consultant to *Popular Photography*:

Dear Mr. Downes:
This is a P.S. to my note of yesterday.

The answer is simple to state, if not easy to achieve: produce a result in color which could not have been done better, or at all, in black and white.

Those of us who began photographing in monochrome spent years trying to *avoid* subject matter exciting *because* of its color; in this new medium, we must now *seek* subject matter which is exciting *because* of its color.

We must see color as *form*, avoiding subjects which are only "colored" black and whites.

Greetings—Edward Weston.
P.P.S.—this is not the last word!

In 1946, Weston took a trip with his former pupil, Willard Van Dyke, who was making a film of Edward Weston at work, entitled *The Photographer*. They went to Death Valley where Weston had been on his first Guggenheim trip. Everyone remarked that he looked better than he had in years, and perhaps the exhilaration of working in the open air really did help him. Before he left on the trip, Merle Armitage wrote him a long note; he was planning a second book on Weston, eventually published as *50 Photographs Edward Weston*:

Dear Edward:
Often it is easier to talk to a stranger or to one whom is just an acquaintance . . . than to a very close and loved friend. The very closeness brings a self consciousness that's hard to penetrate. This is a prelude to what I want to say about your forthcoming trip with Willard Van Dyke. . . .

. . . this trip to recreate some of your life in film should be a joyous and a happy thing. But I wonder, knowing the present state of your spirits, whether or not it will be. You said to me coming back from Henry Miller's that possibly *you* needed a psychiatrist. I don't think you do, although I may be wrong . . . but you certainly do need *something* to break the spell of depression and untruth which now has fastened itself unnaturally upon you. Elsa and I have naturally worried about that . . . and you would be surprised to know how many times we have wanted to speak, or to write. For we both feel that something, or somebody, has cast a sort of hypnotic spell which has fastened itself on you, and which you have been unable to shake off.

For the sake of your family, and your friends, and all those who love you, in addition to your own mental ease, we all pray that you will overcome, by some method, this depression which is so unnatural and so evil. You are a great person, Edward, you are a kind person, and you are one of the true and noble people who walk this earth. Knowing this . . . is there not some way you can push aside the falseness of your present attitude? Our particular prayer is that

this may be accomplished before you set out on that unique experience with Willard.

 With love—Merle Armitage.

Weston made several color landscapes in Death Valley, and on his return to Carmel, continued to work with Ektachrome, doing several close-ups at Point Lobos: a beautiful photograph of an

Willard Van Dyke, 1945

old, yellowed boot hung on a wall in the old ghost town of Bodie (he drove in a nail to give it a dark counterpoint); and then before a wooden door on which his sons had wiped their wide paint brushes, he photographed an intense young girl with dark hair and violet eyes—Dody Warren.

Meantime, Weston was slowly, very slowly, losing control of his own body. Early in 1948, Ansel Adams wrote the Newhalls:

> Phoned Edward yesterday. Sounded fine. Sends love to all. Am a bit worried about him because he has Parkinson's disease [*paralysis agitans*] and it seems to be getting worse. Brett is worried and wishes he could get his dad to see a doc. But dad won't. Unfortunately, there is nothing that can be done about it. Dr. Sturm recognized his condition when he was in Yosemite; thought Edward was aware of it. But his handwriting is ever so much better and general mood sounds fine. The disease may take a very slow course—we hope. There is some research going on at California Medical School, and I have sent Brett the name of the Doc. I think they have figured out something to slightly quiet things down, but the basic cause is a progressive deterioration of the nerves of the spinal column.

In fact, that wasn't the basic cause at all: Parkinson's Disease is a transmission defect in a group of neurons in the midbrain, the integrative center for muscular coordination. The motor nerves receive mixed signals, the muscles tend to become rigid, fixing the back in a crooked, forward posture; and at last, even the muscles of the face contract into a mask-like expression, and the hands, and then the feet, begin to tremble at the smallest effort. It is arrested, these days, by a powerful drug, L-dopa, which can cross the blood-brain barrier; but in those days the best that could be done was to prescribe antispasmodic drugs; or there was a drastic operation on the brain itself, cutting out a whole bundle of connections. Edward Weston, suffering the effects of three successive hernia operations, refused to have anyone put a knife to his brain.

The best, or the worst thing about the disease, was its slow progress; and it was certainly painless. Perhaps it began somewhere in the forties, even before Charis left. Nancy Newhall thought so and tried to put the two events—Charis's leaving, and Weston's illness—together:

> The passage on Parkinson's disease in the home medicine books Charis left behind were heavily marked up. So Charis knew; perhaps Jean told her. Did she tell Edward? And did he tell her she must leave him while still young enough to make a new life for herself? Or, since they were in discord already, was the terrible prospect unbearable? Had he been living since 1945 with this spectre?

The black-and-white photographs he took during this time were black indeed: eroded rock on black sand; trees gripping into a black cliff against the invisible sea-wind. Stieglitz had died in 1946. In 1947, he got a note from Jean Charlot:

> Dear Edward:
>
> . . . When I went to visit Diego on his scaffold (he is painting at the Palacio Nacional) I called "Diego!" and he turned around and said, "Your hair is all white," and when he opened his mouth to say that, I saw that most of his teeth were missing.

Weston wrote to Ansel Adams:

> Dear Ansel:
>
> Your letter meant a lot to me—they always do. But I don't like to have my friends distressed about my condition. Whatever has happened to me, I've brought upon myself, and only I can lift myself out of the abyss. You will be glad to know that I'm seeing a doctor tomorrow, armed with the literature and letters from Nancy and you.
>
> That part of your letter devoted to photography is full of meat. Wish I could pour myself out to you in return, but alas, even this short note is a laborious effort.
>
> Good news of the Guggenheim renewal. I hope you will do the best work of your life. I feel you will. Mine was done between the ages of 45 and 60.
>
> Alas Lackanookee! Love—Edward.

It is not astonishing that he attributed the fault of his (then) incurable disease to himself; for if one brings it about, one can, perhaps, undo it. This belief was entirely consistent with his whole will-dominated life. Yet by 1950, he experienced real despair, as Adams reports:

> The other day at Edward's, after listening to a newscast, Edward said, "If we just had a big flood now it would settle everything."

He began to think more and more seriously about his own biography, writing letters to a number of his old loves, asking them for

Ansel Adams, 1943

letters and their memories. When he wrote to Christel Gang, he must have also inquired about the death of Ramiel McGehee. She answered:

> Hi, Darlin':
> . . . Vocha's notion about suicide is emotional nonsense. In the morning of the *same* day that I was notified of his sudden death (which was in the afternoon, by Vocha—) I received a letter from Ramiel, looking forward to our meeting the latter part of that week, and our visit to Chinatown. As it was near the holidays, we had planned to go slumming there and shop a little in the stores, which you know he so loved to do—I am convinced that he took an overdose of his medicine . . . he told me he was no longer going to the Clinic for treatments, was doing it himself— . . .
> . . . The only remark I have to make, Eduardio, is that I love you dearly—and that your work has always been an inspiration to me in my own humble efforts and my longing for creative expression. I think you are a pretty wonderful guy, you little monster—.
> Luff and a big hug—Christalita.

Another, the same year, came from "L."—Lydia Parker:

> Edward:
> How to answer your request? I hardly know. Ours was rather a unique experience, not easily put into words. Of course vivid memories come to me of wonderful things we shared—that exquisite blue day on the beach when we discovered one another—the San Francisco-Oakland trip on which we tossed your old Ingersole into the Bay and with it all care, a prelude to our joy to come. There is the sound of birds in the early morning and a small boy's harmonica. Bach—especially "Jesu, Joy of Man's Desiring," rain on the roof in Carmel. Many little but poignant incidents, but more than anything, of course, the wonderful meeting and infusing of spirit—something that takes you clear out of this world and seems a vision of something great to come. . . .
> . . . It used to be a matter of terrible regret to me that, chiefly on account of my neurosis, ours couldn't have been a broader experience, but at that I question if it could have been any deeper. . . .
> Love & blessings—Lydia.

A third came from "M."—Marcella, whom he knew in 1925:

> Edward darling:
> Are we not a fine pair? I am fed up with the swinging door into various hospitals with my name on them—
> I love you—always have and always will—you were so very very kind to make the effort to write to me. You will probably never quite realize—how much it meant to me. . . .
> . . . Are you not proud of you for many reasons? I am.
> Edward, what and where is Margaret—the wispy dear one before the Mexican pattern? And Justana? He was my pal, believe it or not.
> I wish I could be a gentle benediction and send you healing.
> My fondest, dearest love to you always—Marcella.

A fourth reply, much more formal, came from Bertha Wardell:

> My dear Edward:—
> Your letter was like the embodiment of a thought. I had had a letter in mind to you ever since reading the article about you in *American Photography* last summer. I was delighted that you were given your due as the greatest of living photographers. . . .
> . . . I am, of course, flattered that anything I might have said about your work still is important. Your success has always been to me your gift of selecting exactly the right *way* of dealing with your subject. . . .
> . . . We met sometime in 1922. The fall of that year, I believe. It was then that you did the portraits of me. . . . Then the next contact was when you returned from Mexico in 1928–29.
> In a curious way I am reminded of your work when I look at a fine Chinese blue and white vase that I enjoy every day. The Chinese artists drew their power from the long contemplation of objects until they had penetrated and had been penetrated by the reality of them. You achieve the same powerful effect by the choice of a detail which represents the particular whole, and, what's more, all related whole. . . .

. . . The warmest affection goes to you, Edward, and the affectionate remembrance of things past. . . .

Love—Bertha.

One wonders, in this renewal of the past, whether she was not repeating an aesthetic common to that whole social group of intellectuals whom Edward Weston knew in the twenties. The painter and photographer Barbara Morgan, at Weston's exhibit at the University of California in 1927, said that the great vegetable studies he had done were (using Kant's phrase) an expression of *ding-an-sich*—the thing-in-itself. It was a concept that Edward Weston took for his own, and he was to express it over and over again, certainly as early as 1931:

> I am no longer trying to "express myself," to impose my own personality on nature, but without prejudice, without falsification, to become identified with nature, sublimating things seen into things known—their very essence—so that what I record is not an interpretation, my idea of what nature should be, but a revelation—an absolute, impersonal recognition of the significance of facts.

This notion is as old as Plato; which means it was a good deal older, but there was a peculiarly American version of it: the idea that nature and natural objects—a tree, an apple, a flower—could be truly apprehended by a more piercing vision, one that penetrated the temporal shell and saw the dazzling, blinding heart of the universal; Brahma, in fact, transplanted to the New England snow. Thus Emerson:

> The first quality we know in matter is centrality,—we call it gravity,—which holds the universe together, which remains pure and indestructible in each mote, as in masses and planets, and from each atom rays out illimitable influence. To this material essence answers Truth . . . and the first measure of a mind is its centrality, its capacity of truth, and its adhesion to it.

And even more broadly, Emerson said:

> There is no object so foul that intense light will not make beautiful. . . .

And in his Journal (September 11, 1860):

> . . . All opaque things are transparent, and the light of heaven struggles through.

Edward Weston was often (and it made him angry) compared to Thoreau; but the connection was less in the way he lived than in what the two men believed. Thoreau wrote, in *Walden:*

> . . . We require that all things be mysterious and unexplorable, that land and sea be infinitely wild, unsurveyed and unfathomed by us because unfathomable . . . there needs no stronger proof of immortality . . . the light which puts out our eyes is darkness to us.

Only that day dawns to which we are awake. There is more day to dawn. The sun is but a morning star.

There is a sense in which Weston is one figure in the procession of American mystics, which began, one might argue, with the American Indian (for they believed, too, that this world is not a real world, but the shadow or simulacrum of the eternal), and is the center of Hawthorne's, Melville's, and Faulkner's thought, as well. Whether it is an illusion or not doesn't really matter. The vision of the ideal was not in the object Weston photographed, but in his head. It was an operating concept; it worked. The tension between the real and ideal is, of all the arts, strongest in photography. It appears to be three-dimensional: we look through it as if through a window; but it is also plainly a two-dimensional sheet of paper with marks on its surface. And the drama of this fact gives even the simplest photograph, and certainly the most profound, a universal power. Weston often spoke of these matters, although he was by no means a sound scholar.

Dody, 1947

Weston began to lose, not merely the ability, but also the will, to photograph. In 1947, a twenty-year old named Dody Warren came to see him, hoping like so many others, to be his pupil; she offered to live near him and help him, and do the menial work in payment for her lessons. It didn't work out until 1948, and then, only after she had parted from her husband. Except for an eight-month absence, she lived on Wildcat Hill for almost three years.

Weston fell in love with her, as was his custom, but he'd grown too old and frail and shaking from his disease to get anything but a daughter's adoration. Brett held off for a long time out of filial respect, but one day in April, with Dody dressed up in her best for Edward's birthday, Brett took her to dinner and dancing, and the ancient taboo was broken.

There was, for consolation that year, the beautiful volume, *My Camera on Point Lobos*, with thirty photographs, marvelously printed from metal plates, and conceived and produced by Ansel Adams.

But Weston's illness, dragged him inexorably down. He wrote to Nancy Newhall:

Nancy darling:

30 nudes to you air-express. A large addition to your original pile. Despite the mount conditions (pretty bad) prints are in fair to good shape. They will probably never again be reprinted by me. So do warn those concerned.

If I have been slow, blame me. Need I say more!? But also, Brett got a "green fracture" of a lower rib (Chandler squeezed him); Dody had the "flu"; and the cats had kittens! O well, as I said, blame me. It sometimes takes me an hour to write this much of a letter, and ten minutes to button my pants.

And then to Ansel Adams:

Hello yourself!! What a wonderful typewriter!

It's a girl, born yesterday morning. [The girl was Charis's—she was married to a union organizer.]

I have much to say to you. One item via Jeffers—"We are safe to finish what we have to finish." Maybe I'm finished; I'm sure you are not.

Love—E.

And then, on September 8, 1952:

Dear Beau & Nancy:

Hope this reaches you in France! On top of Project printing, came the death of my sister; then Kraig [Neil's wife], and baby Jana were stricken with polio, and rushed to S.F. via ambulance. Kraig lost the use of both legs, and Jana one leg. The future?

For the first time I made a negative count. Guess? I saved more than I guessed—3000 (approximately). From these Brett will print five sets of 1000 each. My hope is to keep the sets intact, but who will want, or have room for 1000 "Westons"? Perfectionists will howl that no one person could make 1000 photographs, worth saving, in a lifetime—and I might agree! But I do think 999 of them are of interest and quality worth saving, and who is to take out that one extra? . . .

. . . My writing is getting cramped.

So—just—all love—Edward.

The Newhalls visited him and later commented on his worsening condition:

What happened to Edward since I last saw him was distressing physically, and deeply moving spiritually; he had accepted his fate and was resolved to bear it. . . .

. . . Edward was visibly frailer day by day, the shaking more perceptible, his voice weaker. Indeed, if he received some emotion-stirring message, especially over the phone, he would choke up and his

Cats on Steps, 1944

voice die away. He was not yet so uncontrolled that he refused to go out, or have any but old friends come to him. Nor, when for some reason, we all went out, would we yet come back to find he had been dancing in a corner for half an hour, unable to turn himself. . . .

. . . It was Brett who patiently brought out the prints and showed them, occasionally reminding Edward of some circumstance of their making. It was a heart-breaking and wonderful experience—not nearly as bad as it was to become later. Even then the three of us had occasionally to rush somewhere to conceal our tears.

Somehow Edward found the energy to take me through his printing routine. The once immaculate darkroom was now so furred by hypo crystals it looked like Jack Frost's workshop. I started to clean up. Edward stopped me. "If you know how, you can work even in a place like this," and proceeded to show me how to keep the whole printing process from contamination.

He had made no photographs for a long time, of course; even if Cole lifted him up to the ground glass, his hands couldn't turn

the knobs. He sat, mostly, and talked, till his voice, too, began to give way. Meantime, the cats had multiplied to something like thirty, and were fed with bits of liver from Weston's own hands. As he grew weaker, a series of young men were hired to take care of him, cook his meals, and help him walk; and the cats became part of their duties. Weston knew their intricate geneology, their incestuous loves and hates. He was a prisoner inside himself.

Later, a buzzer was installed in Neil's house next door, so his father could call him at night if he fell and couldn't get up. His handwriting now had the tremor of an earthquake tracing, yet he still wrote letters to some of his closest friends:

> Dear Beau—
>
> Mailing today quite a few prints to select from, one, another version of "Hills & Poles." Most of them are not spotted or trimmed. If I had trimmed them I would find subsequent mounting more difficult. If I had spotted *all* of them, or had them spotted, it would have taken more time than Brett could spare from the "Print Project." Forgive me.
>
> Bad jitters today, I hardly need say.
>
> Abrazos y todo—Edward.
>
> Margarethe Mather died Xmas day—

He wrote to Miriam Lerner in February, 1953:

> Miriam dear:
>
> It was good to hear from you at Christmas time. Thank you for remembering me.
>
> I never go south anymore, in fact I rarely leave Wildcat Hill. Maybe an occasional "movie"—that's about all. My "jitters" keep me anchored. It also inhibits my writing, as you can see.
>
> But I think of you, wonder how you are, what your life is now, are you successfully married?
>
> I have not looked at or through a camera for several years. A real penalty I pay—and for what?
>
> Have you Betty's and Brandy's address? (I have not forgotten how to spell, not every word!)
>
> This is not much of a letter, but it carries my love.
>
> Remember me to your husband.
>
> Yrs—Edward.

The next year, there was a curious disaster. The cats had gotten into a screeching fight inside his house, and the floor, as a result, was covered with fur, blood, and excrement. Weston, stooped, frail, and shaking, couldn't stop them. The sons came and drove the cats out of doors. Brett then took his rifle and methodically killed them, one by one. Edward Weston sat in a chair in his small house, listening to the shots echo from the hills. He wrote the Newhalls:

> Dear Nancy and Beau:
>
> I have been too devastated by the *slaughter* of my 16 cats to write. I feel confident that at the most six could have been sacrificed to save the rest. Princess, Dotty, Wuxtry,—I had intended that they should go, and four kittens had prospective homes; but to take such cats as Mardi Gras, Halloween, Puddin, Courty, Banshee, was too much.— Enough! I'm wound up. I spent three nights dreaming about the finish of the Cats of W. C. Hill. Courty sat before me with her solemn, prophetic eyes, saying, why did you do it, why? Halloween came next, from a great distance it seemed; he was dusty and weary from his long run, and he too faced me accusingly. But enough! . . .
>
> . . . Nancy . . . Please know that the Daybook is still in your lap, that I have not had any change of heart. . . . This is my last will and testament. What more can I say? Keep this letter. I may not get

Rocks & Pebbles, Point Lobos, 1948

> the words down in my will. This paragraph applies to Beau too. I would like to feel that he had his nose in it.
>
> I'm weary after the cats and diary—
>
> Much love—Edward.

In 1954, Flora came to live in Carmel, in a house built by her sons; Neil, mostly. She came frequently to visit her ex-husband; and so, of course, did his four sons. They would burst in merrily and seize the small man from his chair and dance about the room with him in their arms.

He would wake up screaming sometimes, locked in nightmares, dreaming that his own arm was a snake he had gripped in the other; or that the raccoons (he imagined he could see whole troops of them in moonlit woods) were devouring his cats.

In 1956, he wrote once more to Miriam Lerner:

Dearest Miriam:

My "clear, firm handwriting" is a white lie. It is labored, every pen stroke has to be planned in advance. . . .

He sent one last tremulous card to Ansel Adams:

Dear Ansel—

This, as is obvious, can't be considered a letter. I wish it were, then I could commence the long hard row back! Back to where I ask you? Well, one can't just sit still no matter how soft the cushion.

Love—Edward.

At the end of October, 1957, Ansel Adams got a postcard from the collector Dick McGraw, who, with others, had been contributing to a fund to help support Edward Weston. He wrote that Weston was in very bad shape, and had refused, now, even to take his medicines. He was right, though possibly for the wrong reasons: the fact was that the medications were mostly antispasmodics, and they did little or nothing to halt the slow march of the disease toward the respiratory system.

Two months later, very early on New Year's Day, 1958, Weston got up somehow and sat in a chair. When the sun had risen, he was dead.

He was cremated, and his remains thrown ritually on the beach. His sons and their children watched as the ashes were taken by the Pacific tide, washing over the blue-green anemones that adhered to the rocks. Sea, stone, and shell are all as mortal and changeable as any human being. Nothing escapes this wave of alteration that we, in our vanity, call death; neither the neutrino nor the galaxy—all whirl down into the sink of entropy. We make our peace with death by ceremony. Indeed, it is our common necessity; for birth, adolescence, marriage, anniversary, and funeral—each has its formality to ease our ineluctable passage. Yet there is something of ourself that remains. Even the meanest have dared to stand, walk, work, and love against the mute indifference of the heavy, whirling, changing universe. We are outnumbered, billions upon billions to one; but in the very act of our defiance, we change the natural world, too.

There is a famous and controversial print done by Weston in 1931, when he took a shell out of his studio and carried it several miles, and put it in the nestling curve of a series of dark rocks at Point Lobos. McGehee hated the print, regarded it as contrived. But what he disliked, I think, was its hypnotic drama, for the shell in that setting has become immense, while the stone landscape changes its nature and becomes velvety. As in any

conflict, the antagonists are transformed by one another. In this way, Edward Weston has transformed all of Point Lobos for us. What was once a nice wilderness of mineral corrosion, a confused upheaval of sand, kelp, pebbles, fog, tree, and pelican, different

Edward Weston by Cole Weston

at every tide; and, nowadays, the sepulchral divers in their black rubber suits—has had a beautiful order imposed upon it by Edward Weston. In that sense, too, he was a very great, spontaneous, and powerful chooser and thinker. This small, intense, selfish, and gentle man, with his photographs of women, rocks, and vegetables, has changed the way we look at our own experience.

In order to do this, he had—sometimes slowly, sometimes violently—to change himself; to burst painfully out of his old skin and to become, outwardly, what was coiled inside of him. In his last photographs of Point Lobos, we see the dark brilliance of his final vision. It remains there, not only in the prints, but, in fact, in the way we see them. His long wrestling with himself—with the strangling, loving arms of his childhood, with his exuberant, romantic, and greedy sexuality, with the degrading business of portrait salesmanship, with lifelong financial worry, and with the consequent bitterness and periodic fear—all ends in a victory that is now passed on to us as a gift.

Edward Weston, out of the pulse of his own strength, lived and created for the fifty years of his artist's life; and in some deeper sense—at Point Lobos most of all—still does.

1886 Born, Edward Henry Weston, March 24, to Edward Burbank Weston and Alice Jeanette Brett, of New England descent, in Highland Park, Illinois.

1902 First photographs, in Chicago parks, with Bulls-Eye #2 camera, given by father.

1903 Left Oakland Grammar School; worked for Marshall Field & Co., Chicago, three years. Continued to photograph.

1906 To California for holiday; decided to stay. Worked with surveyors on railroads in Los Angeles and Nevada. Decided to become professional portrait photographer; started by house-to-house canvassing with post-card camera; photographed babies, pets, funerals, etc.

1908/1911 Attended Illinois College of Photography; worked as printer for commercial portraitists in California.

1909/1919 Married Flora May Chandler, January 30. Four sons born: Chandler, 1910; Brett, 1911; Neil, 1914; Cole, 1919.

1911 Built and opened studio in Tropico (now Glendale), California.

1914/1917 Commercial and pictorial success: received awards and prizes; demonstrated techniques before professional societies; won medals and honors in pictorial salons with Japanese and Whistlerian motifs.
Elected to London salon, 1917. Many one-man shows.
Discontent with own direction, intensified by exhibition of modern painting at San Francisco Fair, 1915.

1919/1921 Ceased to exhibit with commercial and pictorial associations.
Experimented with abstract motifs: unusual angles and lightings, fragments of nudes and faces.
Exhibition at Shaku-Do-Sha, Los Angeles, and at California Camera Club, San Francisco.

1922 March—one-man show in Mexico City at Academia de Bellas Artes, enthusiastically received. Decided to live in Mexico.
October—visited sister in Middleton, Ohio; first industrial photographs.
November—to New York; met Stieglitz, Strand, Sheeler.

1923 August—to Mexico with Tina Modotti and Chandler; opened portrait studio, first in Tacubaya, then Mexico City. Met Rivera, Siqueiros, Orozco, Charlot, etc.; accepted as vital contributor to Mexican Renaissance. Massive realization with Mexican forms.
Exhibition at "Aztec Land" in Mexico City.

1924/1925 Began statements of important later motifs: unposed portraits; close-ups of still life, trees, rocks, clouds.

1925 Returned to California for six months; studio in San Francisco with Johan Hagemeyer. Industrials; 8 × 10 unposed portraits.

1926 To Mexico; photographed markets, *pulquerias*. Traveled through country with Tina and Brett; photographed sculpture on commission, landscapes, clouds, etc., for himself.
November—returned to Glendale.

1927 Began series of extreme close-ups: shells, vegetables, nudes in motion.

1928 Began series of California motifs: Mojave Desert, trees, etc.
To San Francisco; opened portrait studio with Brett.

1929 To Carmel; opened studio with Brett.
First Point Lobos series: close-ups of cypresses, rocks, kelp.
Contributed foreword and, with Steichen, organized American section of *Deutche Werkbund Exhibition Film und Foto*, Stuttgart.

1930 Orozco to Carmel; arranged and installed Weston's first one-man show in New York Delphic Studios, October/November.

1932 Formation of Group *f*.64 with Ansel Adams and Willard Van Dyke.
First group exhibition at de Young Museum, San Francisco.
Art, by Edward Weston, published by Merle Armitage.

1933 Returned to larger motifs: landscapes, clouds, architecture in New Mexico and Monterey area. Employed for three or four months by U. S. Government Public Works of Art Project.

1934 Succeeded in establishing personal standards in professional portrait work; henceforth, all portraits are unretouched contact prints.

1935 To Santa Monica; studio with Brett.

1936 Oceano series: dunes, nudes.

1937 Awarded first Guggenheim Fellowship for a photographer. Freed from commercial portrait business for first time. Traveled and photographed in California, Arizona, New Mexico, Nevada, Oregon, Washington.

1938 Fellowship extended. Married Charis Wilson, April 24.
Returned to Carmel, to house on Wildcat Hill, built by son Neil. Spent most of year printing 1500 negatives from Guggenheim Project.

1939 New Point Lobos series and series of 8 × 10 portraits in landscape.

1941 Traveled through South and East for special edition of *Leaves of Grass*. Trip cut short by attack on Pearl Harbor; returned to Carmel; served as air-raid plane spotter at Point Lobos.

1942/1945 Defense activities. Photographed in backyard: satires, cats, portraits, nudes in landscape.
Beginning of long illness (Parkinson's disease).

1946 Major retrospective exhibit at Museum of Modern Art, New York. Monograph, with bibliography, list of exhibitions, published by Museum.

1947 Experimented with color photography. Traveled with Willard Van Dyke as subject for his film, *The Photographer*.

1948/1958 Last photographs at Point Lobos; last negative, "Rocks and Pebbles, 1948."
Worked on printing 1,000 selected negatives. (This project was never actually finished. The prints were made under Weston's direction, but done by Brett, Cole, and Dody Warren.)
Illness grew more incapacitating and severe.

1950 Major retrospective in Paris.

1952 *Fiftieth Anniversary Portfolio* produced with Brett's help.

1955 Eight sets of prints made from 1,000 negatives considered the best of his life's work, with Brett's help.

1956 *The World of Edward Weston*, directed by Nancy and Beaumont Newhall, circulated by Smithsonian Institution.

1958 Died, January 1, at his home on Wildcat Hill.

BIBLIOGRAPHY

Articles:

Reproduction of "Atala" by Edward Weston. *American Annual of Photography*, 1913.

Mortimer, F.J. Comments. *Photograms of the Year*, 1914, pp. 10, 17. Reproduction.

Reproduction of "Let's Play Hookey" and "Son" by Edward Weston. *American Annual of Photography*, 1914.

Reproduction of "Atala II" by Edward Weston. *American Annual of Photography*, 1915.

Notice of Award to Edward Weston for "Child Study in Gray." *Camera Craft*, October, 1915, p. 411.

Notice of Salon Honors to Edward Weston. *Photo-Era*, September, 1915, p. 158.

Portraiture demonstration by Edward Weston. *Photo-Era*, April, 1916, p. 203.

Review of London Salon. *British Journal of Photography*, October, 1916, p. 517.

Edward Weston's notes on high-key portraiture. *British Journal of Photography*, October, 1916, pp. 582-3.

Bland, W. R. Comments. *Photograms of the Year*, 1916, p. 14. Reproduction.

Review of "Nude with Black Shawl" by Edward Weston. *Photo-Era*, March, 1916, p. 149. Reproduction.

Reproduction of "I Do Not Believe in Fairies" by Edward Weston. *American Annual of Photography*, 1916.

Review of portraits at the London Salon. *British Journal of Photography*, September, 1917, p. 484.

Weston, Edward. Letter describing portrait technique. *Photo Miniature*, September, 1917, pp. 345-6.

Reproduction of "Toxophilus," "A Decorative Study," and "Violet Room" by Edward Weston. *American Annual of Photography*, 1917.

Mortimer, F.J. Comments. *Photograms of the Year*, 1917–1918, p. 12. Reproduction.

Bland, W.R. and Muir, Ward. Comments. *Photograms of the Year*, 1918, p. 9. Reproduction.

Tilney, F.C. Comments. *Photograms of the Year*, 1919, p. 32. Reproduction.

De Rome, A.T. Review of Edward Weston's "Anthony Anderson." *Camera Craft*, March, 1919, pp. 89–95. Reproduction.

Edwards, John Paul. Review. *Camera Craft*, May, 1919, pp. 177–85. Reproduction.

Brenner, Anita. "*Edward Weston nos muesta nuevas modalidades de su talento.*" *Revista de Revistas* (Mexico), October, 1925.

Siqueiros, David Alfaro. "*Una transcendental labor fotografica.*" *El Informador* (Guadalajara, Mexico), September 4, 1925.

Rivera, Diego. "*Edward Weston y Tina Modotti.*" *Mexican Folkways*, April/May, 1926.

Weston, Edward. "Photography." *Mexican Life*, June, 1926, p. 16. Reproductions.

Millier, Arthur. "Some Photographs by Edward Weston." *Los Angeles Sunday Times*, January 21, 1927.

Edward Weston—Brett Weston (Exhibition catalogue). Los Angeles County Museum, Los Angeles, California, 1927. Reprinted in Spanish in *Forma* (Mexico), 1928, p. 17.

Weston, Edward. "From My Day Book." *Creative Art*, August, 1928, pp. 29–36. Reproductions.

Weston, Edward. "*Amerika und Fotografie.*" *Film und Foto* (Exhibition Catalogue), Die Deutsche Werkbund, Stuttgart, 1929.

Portraits by Edward Weston. *Carmel Pine Cone* (Carmel, California), October 25, 1929.

"Photographs: Pepper; Egg Slicer; Cypress; Bones." *Theatre Arts*, 13 (1930), pp. 1073–6.

Exhibition of Photographs: Edward Weston (Exhibition catalogue with foreword by Lawrence Ban-Becking). Delphic Studios, New York, 1930

Millier, Arthur. "Realism or Abstraction?" *Los Angeles Times*, February 9, 1930.

Weston, Edward. "Photography—Not Pictorial." *Camera Craft*, July, 1930, pp. 313–20. Reproductions. Reprinted in *Photographers on Photography*. Ed. Nathan Lyons. Englewood Cliffs, N.J.: Prentice-Hall, 1966.

"Photography—Not Pictorial; Excerpts." *Art Digest*, October, 1930. Reproductions.

McBride, Henry. "Photographs That Are Different." *New York Sun*, October 22, 1930.

McMullen, Frances D. "Lowly Things That Yield Strange, Stark Beauty." *New York Times Magazine*, November 16, 1930, pp. 6–7, 20. Reproductions.

Weston, Edward. Statement. *The San Franciscan* (San Francisco, California), December, 1930, pp. 22–3. Reproductions.

Edward Weston, Photographer (Exhibition Catalogue with excerpts from press notices). Denny-Watrous Gallery, Carmel, California, 1931.

Martin, Ira. "What Are the Moderns Thinking About?" *Light and Shade*, June, 1931, pp. 4–7, 11–4. Reproductions.

"Edward Weston: An Estimate." *The Daily Carmelite* (Carmel, California), July 24, 1931.

Weston, Edward. Statement. *Experimental Cinema*, No. 3 (1931), pp. 13–5. Reproductions.

Schindler, Pauline G. "Weston in Retrospect." *The Daily Carmelite* (Carmel, California), July 29, 1931.

"*Fotografias de Edward Weston.*" *Contemporaneos* (Mexico), September/October, 1931, pp. 160–2.

Adams, Ansel. "Photography," review of Edward Weston Exhibition at the M. H. de Young Museum, San Francisco. *The Fortnightly* (San Francisco, California), December 18, 1931, pp. 21–2.

Weston, Edward. Catalogue statement. *Photography (by) Edward Weston*. Delphic Studios, New York, 1932.

Armitage, Merle. "Art of Edward Weston." *Creative Art*, May, 1933, p. 306. Reproductions.

Adams, Ansel. Review of *The Art of Edward Weston*, edited by Merle Armitage. *Creative Art*, May, 1933, pp. 386–7.

Bulliet, C. J. "Photos Make a Bid To Be Ranked Art." *Chicago Daily News*, September 16, 1933.

Aragon Leiva, Augustin. *"La fotografía y la fotografía en México."* *El Nacional* (Mexico), December 5, 1933.

Weston, Edward. *Photography* (Leaflet). Enjoy Your Museum series, No. 2c. Pasadena, California: Esto Publishing Co., 1934.

Statements by Johan Hagemeyer, Una Jeffers, Henrietta Shore, Lincoln Steffens, and others. Edward Weston Special Number, *The Carmel Cymbal* (Carmel, California), April 17, 1935.

"Obituary." *Nature*, September 19, 1936.

Weston, Edward. Letter to Mr. Moe of the Guggenheim Foundation, dated February 7, 1937, in elaboration of his initial proposal for a grant. *The Photo-Reporter*, May, 1971.

Haz, Nicholas. "Edward Weston, Purist." *American Photography*, February, 1938, pp. 77–82.

Welles, Thomas. "Edward Weston: A Word Portrait of the Man." *The Camera*, September, 1938, pp. 151–4.

"Sorties and Surfaces: New Prints by the California Photographer." *Time*, June 16, 1939, p. 56. Reproductions.

Weston, Edward and Charis Wilson. "What Is a Purist?" *Camera Craft*, 46 (1939), pp. 3–9.

Weston, Edward and Charis Wilson. "Photographing California." *Camera Craft*, 46 (1939), pp. 56–64, 99–105. Reproductions.

Weston, Edward and Charis Wilson. "Light *vs*. Lighting." *Camera Craft*, 46 (1939), pp. 197–205. Reproductions.

Weston, Edward and Charis Wilson. "What Is Photographic Beauty?" *Camera Craft, 46 (1939), pp. 247*–55. Reproductions.

Weston, Edward and Charis Wilson. "Thirty Years of Portraiture." *Camera Craft*, 46 (1939), pp. 399–408, 499–560. Reproductions.

Weston, Edward. "My Photographs of California." *Magazine of Art*, January, 1939, pp. 30–3. Reproductions.

Weston, Edward. "A Statement." *A Pageant of Photography*. San Francisco: San Francisco Bay Exposition Co., 1940.

Weston, Edward and Charis Wilson. "Of the West: A Guggenheim Portrait." *U.S. Camera Annual 1940*, pp. 37–55. Reproductions.

Weston, Edward. "Photographic Art." *Encyclopaedia Britannica*, 1941. Vol. 17, pp. 769–99. Revised, 1954, by Beaumont Newhall.

Halliday, F.H. "Edward Weston." *California Arts and Architecture*, January, 1941, pp. 16–7. Reproductions.

Weston, Charis Wilson. Review of *California and the West*. *California Arts and Architecture*, January, 1941, p. 8. Reproductions.

Weston, Edward and Charis Wilson. "Portrait Photography." *Complete Photographer*, 8 (1942), pp. 2935–40. Reprinted in *Photographers on Photography*. Ed. Nathan Lyons. Englewood Cliffs, New Jersey: Prentice-Hall, 1966.

Abbott, J. "Acquisitions: Five Photographs by Edward Weston." *Smith College Museum Bulletin*, June, 1942, pp. 17–9. Reproductions.

Weston, Edward and Charis Wilson. "Seeing Photographically." *Complete Photographer*, 9 (1943), pp. 3200–6.

Newhall, Beaumont. "Edward Weston in Retrospect." *Popular Photography*, March, 1946, pp. 42–6, 144, 146.

"One-Man Show at Museum of Modern Art." *New Yorker*, February 23, 1946, p. 19.

Greenberg, Clement. "Camera's Glass Eye." *The Nation*, March 6, 1946, pp. 294–6.

Downes, Bruce. Camera's Glass Eye: Reply with Rejoinder. *The Nation*, April 27, 1946, p. 518.

"Photographs Exhibited." *Worcester Museum News Bulletin* (Worcester, Massachusetts), November, 1946, p. 6.

"At the Museum of Modern Art." *Art News*, March, 1946, p. 48. Reproduction.

"Picasso of the Camera." *Newsweek*, February 25, 1946, pp. 92–3.

Weston, Edward. "From My Day Book; Alfred Stieglitz." *Stieglitz Memorial Portfolio*. Ed. Dorothy Norman. New York: Twice a Year Press, 1947, pp. 25–6.

"Stieglitz-Weston Correspondence." *Photo-Notes*, Spring, 1949, pp. 11–5.

"Resolution and Fine Detail." *British Journal of Photography*, May 27, 1949, p. 236.

Wright, G. B. "New Western Collections." *American Photography*, August, 1950, pp. 32–4. Reproductions.

Deschin, Jacob. "Weston Show." *New York Times*, March 5, 1950.

Newhall, Beaumont. "Edward Weston, le Maître." *Photo-Revue* (Paris), February, 1950, pp. 27–9.

"Revealing to Others the Living World." Review of *My Camera on Point Lobos*, by Edward Weston. *The Living Wilderness*, Summer, 1950, pp. 10–2. Reproductions.

Weston, Edward. "What Is Photographic Beauty?" *American Photography*, December, 1951, pp. 739–43. Reproductions.

Warren, Dody (Dody Weston Thompson). "Weston, Strand, Adams: With Editorial Comment." *American Photography*, January, 1951, pp. 48–53.

"Portrait." *American Photography*, August, 1952, p. 18.

Newhall, Nancy. "Edward Weston and the Nude." *Modern Photography*, June, 1952, pp. 38–42, 107–10.

"Heads Honors List." *American Photography*, January, 1952, p. 7.

Deschin, Jacob. "Weston at Home." *New York Times*, March 30, 1953.

Warren, Dody (Dody Weston Thompson). *"Edward Weston: 50 ans à la recherche de l'objectivité."* Photo Monde (Paris), November, 1953, pp. 42–7.

Weston, Edward. "Color as Form." *Modern Photography*, December, 1953, pp. 54–9, 132.

Hall, Norman and Burton, Basil. "Guest of Honor: Edward Weston." *Photography Year Book: 1955* (London), pp. xii-xvi, 1–6.

"Retrospective Portfolio." *Popular Photography*, February, 1955, pp. 66–74.

Goldsmith. Arthur A., Jr. "The Technique of Edward Weston." *Popular Photography*, February, 1955, pp. 66–75.

"Weston's First Color Photos." *Life*, November 25, 1957, pp. 16–9. Reproductions.

"Studies of Human Form by Two Masters: John Rawlings and Edward Weston." *Great Photography, Series 1* (New York), 1957, p. 127. Reproductions.

Pollack, Peter. "Edward Weston: A New Vision." *The Picture History of Photography*. New York: Abrams, 1958, pp. 322–3. Reproductions.

Neugass, Fritz. *"Un grand photographe n'est plus: Edward Weston (1886–1958)." Le Photographe* (Paris), April 20, 1958, pp. 223–5.

Downes, Bruce. "Edward Weston." *Popular Photography*, April, 1958, p. 54.

Special Weston Issue. Ed. Lew Parella. *Camera*, April, 1958, pp. 147–81.

"From the Daybooks of Edward Weston." Ed. Beaumont Newhall. *Art in America*, Summer, 1958, pp. 43–5. Reproductions.

White, Minor. "On the Strength of a Mirage." *Art in America*, Spring, 1958, pp. 52–5. Reproductions.

Maloney, Tom. "Edward Weston, Master Photographer, 1886–1958." *U. S. Camera*, May, 1958, pp. 66–8. Reprinted in *U.S. Camera Annual*, 1959, pp. 54–62.

Stackpole, Peter. Comments on Weston in "35mm. Technics." *U.S. Camera*, April, 1958, pp. 10–1.

Turroni, Giuseppe. *"Ricordo de Edward Weston." Fotografia* (Italy), September, 1958, pp. 19–20.

Neugass, Fritz. "Edward Weston." *Fotografia* (Italy), September, 1958, pp. 17–8.

Newhall, Beaumont. Biography and discussion of Edward Weston. *Masters of Photography*. New York: Braziller, 1958.

"Edward Weston: Photographer." Ed. Nancy Newhall. *Aperture*, 6, No. 1 (1958). Reproductions.

Steichen, Edward. "Photography." *Art in America*, Winter, 1958–9, pp. 43–5. Reproductions.

"Weston's World." *New York Times Magazine*. May 15, 1960, pp. 102–4. Reproductions.

White, Minor. "The Daybooks of Edward Weston: Ed. by Nancy Newhall, A Review of Vol. 1." *Aperture*, 10, No. 1 (1962), 39–40.

Kramer, Arthur. "Edward Weston: Tools and Techniques of the Greatest Craftsman." *U.S. Camera*, December, 1962, pp. 58–61, 88. Reproductions.

Newhall, Beaumont. "Weston in Mexico." *Art in America*, Summer, 1962, pp. 60–5. Reproductions.

Kramer, Hilton. "The Daybooks of Edward Weston, Vol. 1: Mexico, Edited by Nancy Newhall." *The Nation*, August 11, 1962, pp. 56–7.

Hattersley, Ralph. "Weston's Picture Is About Freedom, Yours and Mine." *Popular Photography*, September, 1962, pp. 70–1.

Racanicci, Piero. "Edward Weston." *Popular Photography–Edizione Italiana* (Milan), September, 1962, pp. 41–57. Reproductions.

Jacobs, Lou, Jr. "Edward Weston, Writer," review of *The Daybooks of Edward Weston, Vol. 1: Mexico. Infinity*, October, 1962, pp. 19–21. Reproductions.

Adams, Ansel. Review of *The Daybooks of Edward Weston, Volume 1: Mexico. Contemporary Photographer*, Winter, 1962, pp. 44–8. Reproduction.

Newhall, Beaumont. *The History of Photography*. New York: Museum of Modern Art, 1964, pp. 122–9.

Adams, Ansel. "Edward Weston." *Infinity*, February, 1964, pp. 16–7, 25–7. Reproductions.

Hattersley, Ralph. "Edward Weston: A Book Review." *Infinity*, October, 1955, pp. 19–29.

"Edward Weston: Photographer." Ed. Nancy Newhall, *Aperture*, 12, Nos. 1–2 (1964).

Downes, Bruce. "Edward Weston: Photographer—A Book Review." *Popular Photography*, December, 1964, pp. 154–5, 186–7.

Caulfield, Patricia. "Way-Out Weston: New Look at an Old Master." *Modern Photography*, November, 1965, pp. 78–81. Reproductions.

"John Simon Guggenheim Memorial Fellows in Photography, 1937–1965." *Camera*, April, 1966, pp. 9–11.

"Discovered: New Weston Letter." *Popular Photography*, November, 1966, p. 16.

Green, Eleanor. "Edward Weston." *Fotografias de Edward Weston/Brett Weston* (Exhibition catalogue). Museo de Arte Moderno, Bosque de Chapultepec, October, 1966. Reproductions.

An Exhibition of Work by the John Simon Guggenheim Memorial Foundation Fellows in Photography (Exhibition catalogue). Philadelphia College of Art, Philadelphia, Pennsylvania, 1966.

"Le Dictionnaire des photographes: Edward Weston." Terre d'Images: Le Mensuel de la Photographie (Paris), November, 1966, pp. 18–23.

Green, Jonathan. "The Daybooks of Edward Weston: California, Edited by Nancy Newhall." *Aperture*, 13, No. 2 (1967), pp. 118–9.

Ackley, C. S. "Four Photographs by Edward Weston." *Boston Museum of Fine Arts Bulletin*, No. 344 (1968), pp. 69–75. Reproductions.

Bunnell, Peter C. "Photography as Printmaking." *Artist's Proof*, 9 (1969), 24. Reproductions.

Weston, Cole. "Edward Weston Dedicated to Simplicity." *Modern Photography*, May, 1969, pp. 66–71.

Deschin, Jacob. "Weston Prints in Show-Sale." *New York Times*, September 14, 1969.

Mann, Margery. "Brett Weston: Shaping Himself in his Father's Image." *Popular Photography*, March, 1970, pp. 27–8. Reproductions.

Thompson, Dody Weston (Dody Warren). "Edward Weston." *The Malachat Review* (University of Victoria, B. C.), April, 1970, pp. 39–64. Reprinted in *Untitled* (Carmel, California), The Friends of Photography, 1972, pp. 3–24.

"Gallery: Photographs." *Life*, September 24, 1971, p. 7.

"Photographs of Women." *Camera*, February, 1972, p. 32. Reproductions.

Massar, P. D. "35 Photographs: Exhibition at the Metropolitan Museum of Art." *Metropolitan Museum of Art Bulletin*, April, 1972, p. 224. Reproductions.

Kramer, Hilton. "Edward Weston's Privy and the Mexican Revolution." *New York Times*, May 7, 1972.

Thornton, Gene. "Accepted Today, Revolutionary Then." *New York Times*, May 14, 1972.

Books:

The Art of Edward Weston. Ed. Merle Armitage. New York: E. Weyhe, 1932. Statement by Edward Weston, 39 plates. Statement by Weston reprinted in *Photographers on Photography*. Ed. Nathan Lyons. Englewood Cliffs, N. J.: Prentice-Hall, 1966.

Armitage, Merle. *Henrietta Shore*. New York: E. Weyhe, 1933. Article by Edward Weston.

Adams, Ansel. *Making a Photograph*. London: 1935. Preface by Edward Weston.

Stravinsky. Ed. Merle Armitage. New York: G. Schirmer, 1936. Eight Portraits of Stravinsky by Edward Weston.

Schoenberg. Ed. Merle Armitage. New York: G. Schirmer, 1937. Two Portraits by Edward Weston.

Designed Books. Ed. Ramiel McGehee. New York: E. Weyhe, 1938. Portrait by Edward Weston.

Armitage, Merle. *Fit for a King: The Merle Armitage Book of Food*. New York: Longmans, Green, 1939. Four photographs of vegetables by Edward Weston.

Brenner, Anita. *Idols Behind Altars*. New York: Payson and Clark, 1939. Photographs by Edward Weston and Tina Modotti.

Seeing California with Edward Weston. Los Angeles: Automobile Club of Southern California, 1939.

Weston, Charis Wilson and Edward. *California and the West*. New York: Duell, Sloan and Pearce, 1940. Ninety-six plates.

Whitman, Walt. *Leaves of Grass*. New York: Limited Editions Club, 1942. Fifty photographs by Edward Weston.

Fifty Photographs. Ed. Merle Armitage. New York: Duell, Sloan and Pearce, 1947.

Weston, Charis Wilson and Edward. *The Cats of Wildcat Hill*. New York: Duell, Sloan and Pearce, 1947. Photographs by Edward Weston.

Stravinsky. Ed. Merle Armitage. New York: Duell, Sloan and Pearce, 1949. Photographs by Edward Weston.

My Camera on Point Lobos. Ed. Ansel Adams. Boston: Houghton Mifflin and Yosemite: Virginia Adams, 1950. Thirty Photographs by Edward Weston and excerpts from the Daybooks.

The Daybooks of Edward Weston, Volume 1: Mexico. Ed. Nancy Newhall. Rochester, N.Y.: George Eastman House, 1961. Reproductions.

Edward Weston, Photographer: The Flame of Recognition. Ed. Nancy Newhall. Rochester, N.Y.: Aperture, 1965. Photographs accompanied by excerpts from the Daybooks. Reprinted with additional plates, 1971.

The Daybooks of Edward Weston, Volume 2: California, 1927–34. Rochester, N.Y.: George Eastman House and New York: Horizon Press, 1966.

Of the West: A Guggenheim Portrait. n.p., n. d. Excerpted from *California and the West*.

Weston, Edward. *Eight Photographs*. Garden City, N.Y.: Doubleday, 1971.

This bibliography was prepared by Pat Fuller at the University of New Mexico under the direction of Beaumont Newhall.